**Contemporary History
of Garden Design**

To Garfield

Penelope Hill

Contemporary History of Garden Design
European Gardens between Art and Architecture

Birkhäuser – Publishers for Architecture
Basel · Berlin · Boston

Cover photo: Heather Ackroyd and Dan Harvey, Floating Field, 1997, Lake Åkerby (Sweden).
p. 5: Beth Galí, Fossar de la Pedrera, 1986, Barcelona (Spain).
pp. 6–7: Daniël Ost, Composition avec Zea Mays japonica multi-color et Eudodia Daniellii, 1998.
pp. 8–9: Samuel Eigenheer and Franz Pösinger, Le monde intacte brisé, Basel (Switzerland).
p. 262: Bernard Lassus, Les buissons optiques, 1993, Niort (France).

This book was originally published in French under the title
'Jardins d'aujourd'hui en Europe. Entre art et architecture'
(ISBN 90-6153-4941) and in Dutch under the title
'Tuinen van heden. Vernieuwende tuinarchitectuur in Europa'
(ISBN 90-6153-495-X)
by Mercatorfonds/Fonds Mercator, Belgium.
© 2002 the author and Mercatorfonds, Antwerpen
For the English edition:
© 2004 Mercatorfonds, Antwerpen and Birkhäuser – Publishers for Architecture
P.O. Box 133, CH-4010 Basel, Switzerland
Part of Springer Science+Business Media

A CIP catalogue record for this book is available from the Library of Congress, Washington D.C., USA
Bibliographic information published by Die Deutsche Bibliothek. Die Deutsche Bibliothek lists this publication in the Deutsche Nationalbibliografie; detailed bibliographic data is available in the internet at http://dnb.ddb.de.

This work is subject to copyright. All rights are reserved, whether the whole or part of the material is concerned, specifically the rights of translation, reprinting, re-use of illustrations, recitation, broadcasting, reproduction on microfilms or in other ways, and storage in data banks. For any kind of use, permission of the copyright owner must be obtained.

Printed on acid-free paper produced from chlorine-free pulp. TCF ∞
Design: Antoon De Vylder
Typesetting: De Diamant Pers, Herentals
Editing: Judy Boothroyd and Wendy Dallas
Scanning and Printing: Die Keure, Bruges
Binding: Splichal, Turnhout

Printed in Belgium
ISBN 3-7643-7117-X

9 8 7 6 5 4 3 2 1

http://www.birkhauser.ch

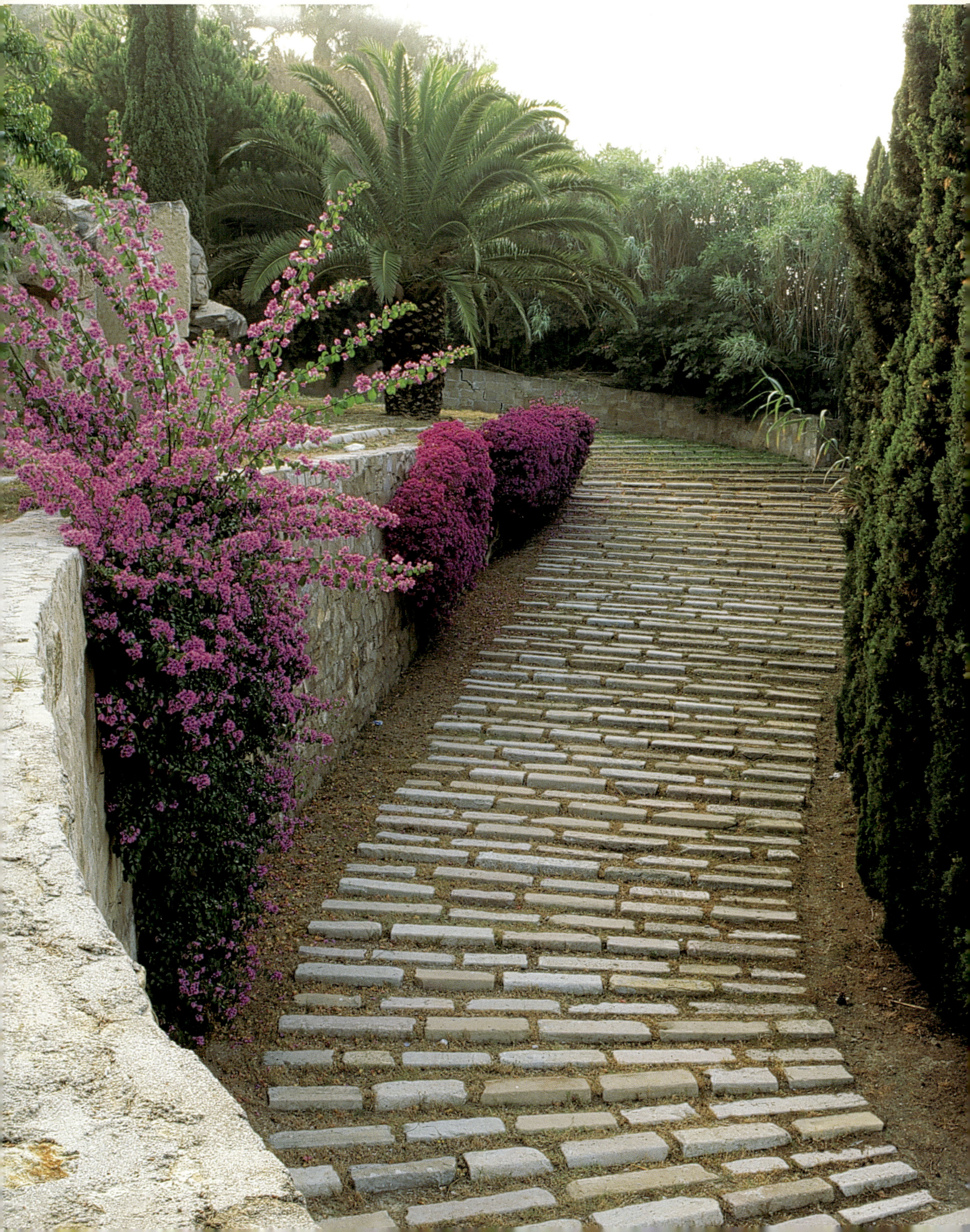

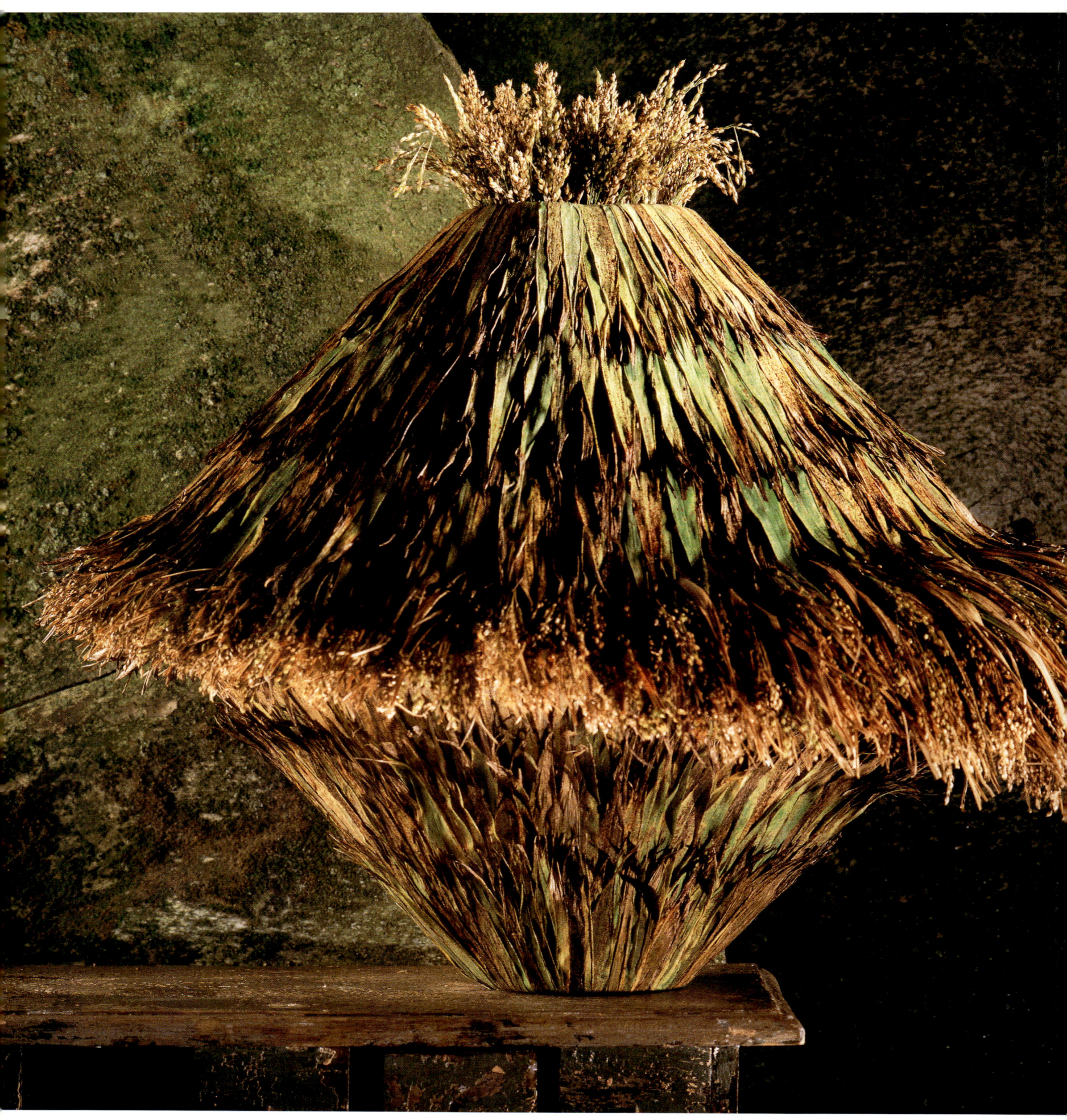

Acknowledgements

It is with great pleasure that I acknowledge the assistance, encouragement, wise suggestions and remarkable understanding of this book's objectives from the many designers I have interviewed during my research and writing. In addition to the designers featured, to whom I am deeply indebted for their time and assistance in discussing and showing me their work, I wish to thank the following landscape architects, designers and garden owners who helped and enthusiastically supported my research efforts:

Jeppe Aagaard Andersen, Carmen Añon, Marco Bay, Louis Benech, Miroslava Benês, Jean-Jacques Borgeaud, John Brookes, Andreas Bruun, Karen and Michael Bryant-Mole, Bonita Bulaitis, Luis Manuel dos Santos Cabral, Marc Claramunt, Françoise and Gilles Colas, Manuel Colominas, Anne Cox Chambers, Gianpiero Donin, Dörte Eggert, David Eigenheer, Jacques Evrard, Guido Ferrara, Carmen Fiol, Christophe Girot, Luciano Giubbilei, Jean Paul Goude, Biagio Guccione, Janis Hall, Kicki Hansen, George Hargreaves, Jordi Henrich, Malene Hauxner, Bengt Isling, Emmanuel Jalbert, Kernock Park Plants, Erika Kienast, Elmar Knippschild, Lucien Kroll, Bernd Krüger, Bernard Lassus, Göran Lindberg, Annemarie Lund, Miranda MacPhail, Mecanoo, Rita Mettler, Lynden B Miller, Catherine Mosbach, Cornelia Müller, Jeroen Musch, Norbert Müggenburg, Nicole Newmark, Franco Panzini, Jean-Paul Pigeat, Judy Pillsbury, Andrea Pochini, Anna Porcinai, Heiner Rodel, Joan Roig, Mark Rudkin, S.T. Raum a., Giovanni Sala, Leonardo Servadio, Philipp Satler, Robert Schäfer, Alexandra Schmidt, Lee Shostak, Ken Smith, Olga Tarrasó, Xavier Vendrell, Alessandra - Vinciguerra, Lindsey Whitelaw, Lodewijk Wiegersma, James Wines, Robin Winogrond, Peter Wirtz, Peter Zumthor, the staff at the Frances Loeb Library, Harvard University Graduate School of Design, the British Library, the Royal Institute of British Architects, Archiv für Schweizer Landschaftsarchitektur and the Bibliothèque René Pechère. I am also indebted to Carine Duprez for generously sharing her contacts.

I wish to thank photographer Nicola Browne whose rare talent beautifully captured the spirit and essence of the wonderful gardens in this book.

I would like to thank Professor John Stilgoe, Siobhan Loftus and Beatrice Del Favero for their time and invaluable feedback and encouragement of all or parts of this book. I have benefited greatly from their observations and corrections.

My appreciation goes to my publishers, Mercatorfonds and Birkhäuser, in particular to Jan Martens and Ann Mestag for their assistance through thick and thin, to Wendy Dallas for her meticuluos editing skills, to Michael Wachholz of Birkhäuser for his editorial assistance and to Judy Boothroyd and Thies Schröder for their horticultural expertise.

Finally I am grateful to my dear parents, family and all my friends for their support throughout this project as they suffered my preoccupation and anxieties over the research and writing. Most of all I wish to thank my husband Garfield and my son Cosmo for their constant love and support and for making me feel that anything is always possible.

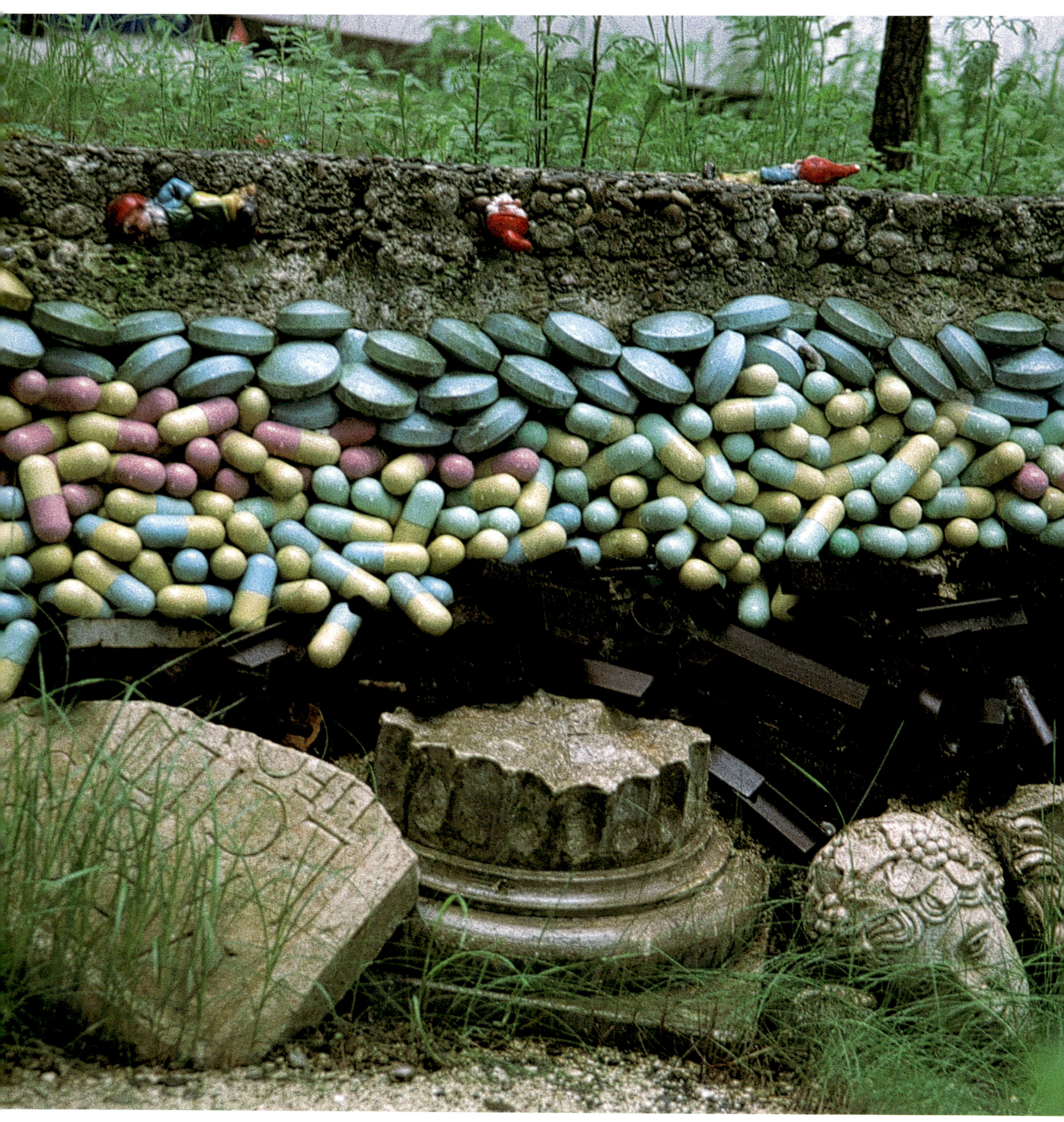

Contents

Introduction	11
Setting the Scene	27
New Designs on Classic Themes	49
Architecture and the Landscape	103
The Vertical Garden	125
Leaping the Fence	147
The Planting Revolution	169
Art and the Garden	191
The Contemporary Garden as Art	213
Forums for the Future	235
Glossary	254
Index	258
Bibliography	260

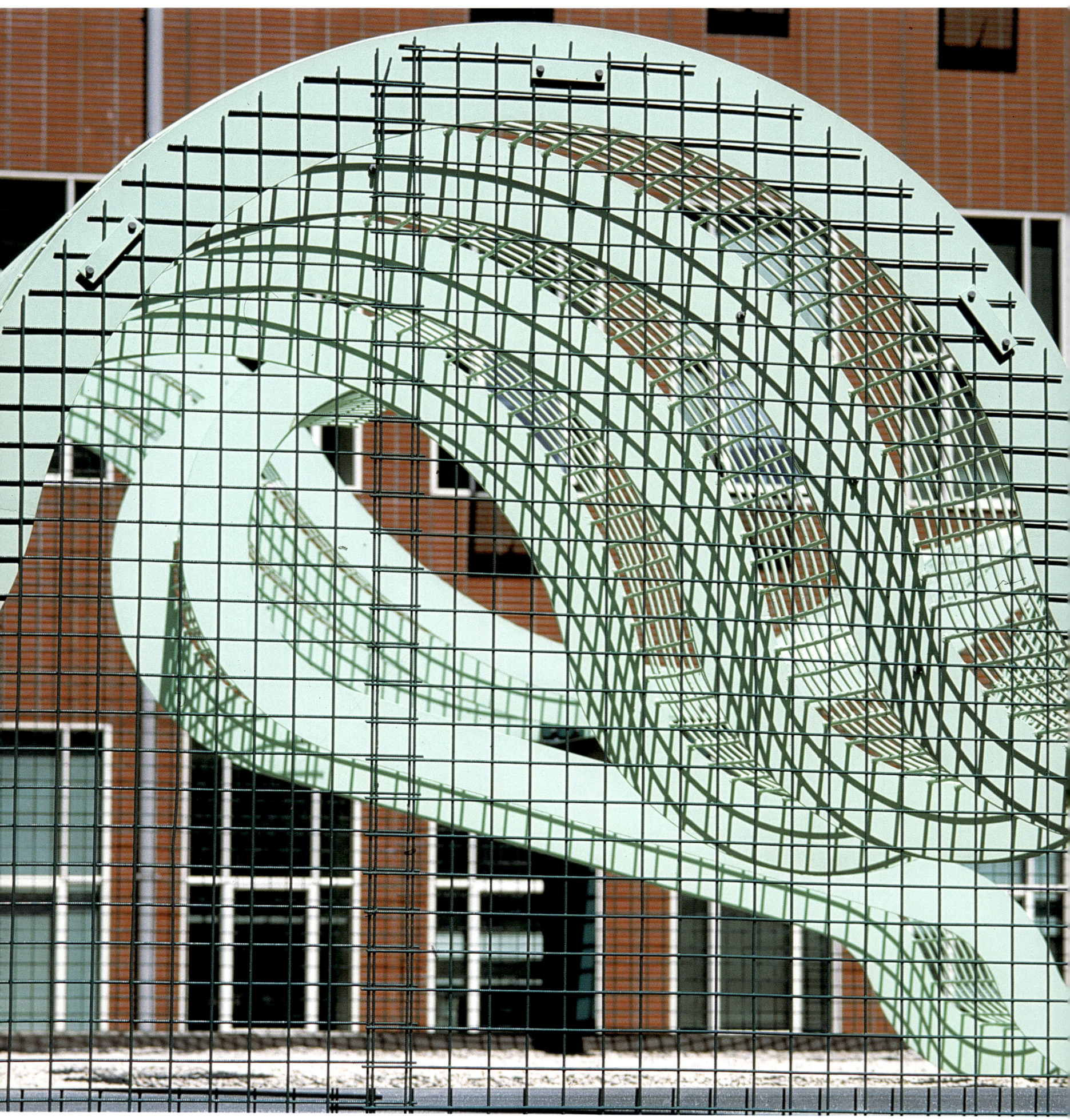

INTRODUCTION

Inspired by the undulating dunes of the Dutch coast, this vast three-dimensional steel labyrinth, part sculpture, part climbing frame for plants, was designed in 1999 by Dutch landscape architect Paul van Beek, together with Rodor, ozr & Partners and Ben Hijink, as the perfect foil for the modernist industrial building of Koninklijke Hoogovens in IJmuiden. Once completed, it will be swathed in the climbing plants Hedera helix and Wisteria sinensis.

A dramatic solution was devised by Paul Cooper in 1999 for private clients in north London who wished to use their garden as much at night as during the day: the space can be transformed after dark by lights and images projected onto a series of tall, opaque-white screens.

A new and vital enthusiasm is sweeping through garden design in Europe, at times drawing on the strength and accomplishments of the old and traditional, at others challenging conventional expectations of how a garden or a landscape should look. Where old themes are revisited, they are frequently interpreted with a twist or with modern verve; where new concepts are introduced, they are fresh, courageous and genuinely original.

This book sets out to identify the gardens that will make an important contribution to the corpus of distinguished garden design of our time. It will also discuss the new ideas and influences shaping the broader discipline of landscape architecture, highlighting the initiatives which are currently giving impetus to its development, and examine the reasons why it is acquiring a new importance as one of the richest of all art forms.

Here the term landscape architecture is used to describe the design of the landscape, embracing both private and public spaces, large scale and small, from gardens and parklands to urban and landscape development. Implied by this portmanteau term is an acknowledgement of the symbiotic relationship that exists between garden design, architecture, sculpture and art and, of course, most importantly, all branches of horticulture.

Until recently there had been no radical break from the past in modern garden design, as witnessed in art and architecture. Its vocabulary, theory and form belonged to previous eras, with only a few designers attempting to break with tradition in favour of innovation. It owes its regeneration to a wide range of influences, the most obvious being developments in the arts and sciences, modern communications, education and ecology, architecture and urban design, and the historical and social changes that have altered the face of Europe over the past hundred years.

Whatever its time or place, the well-designed garden should exemplify proportion, be appropriate to its site, show sensitivity to materials and display horticultural prowess. Today it must also be ecologically aware and sustainable. Above all, it must give pleasure. A garden is an experience to be enjoyed by the whole range of human senses; its appeal is universal and its attractions and guises infinite.

As well as reflecting the philosophical and psychological values that we regard as essential to the modern age, it must follow the mantra 'form is function', combining in its aesthetic both style and substance. The aim of contemporary garden design is

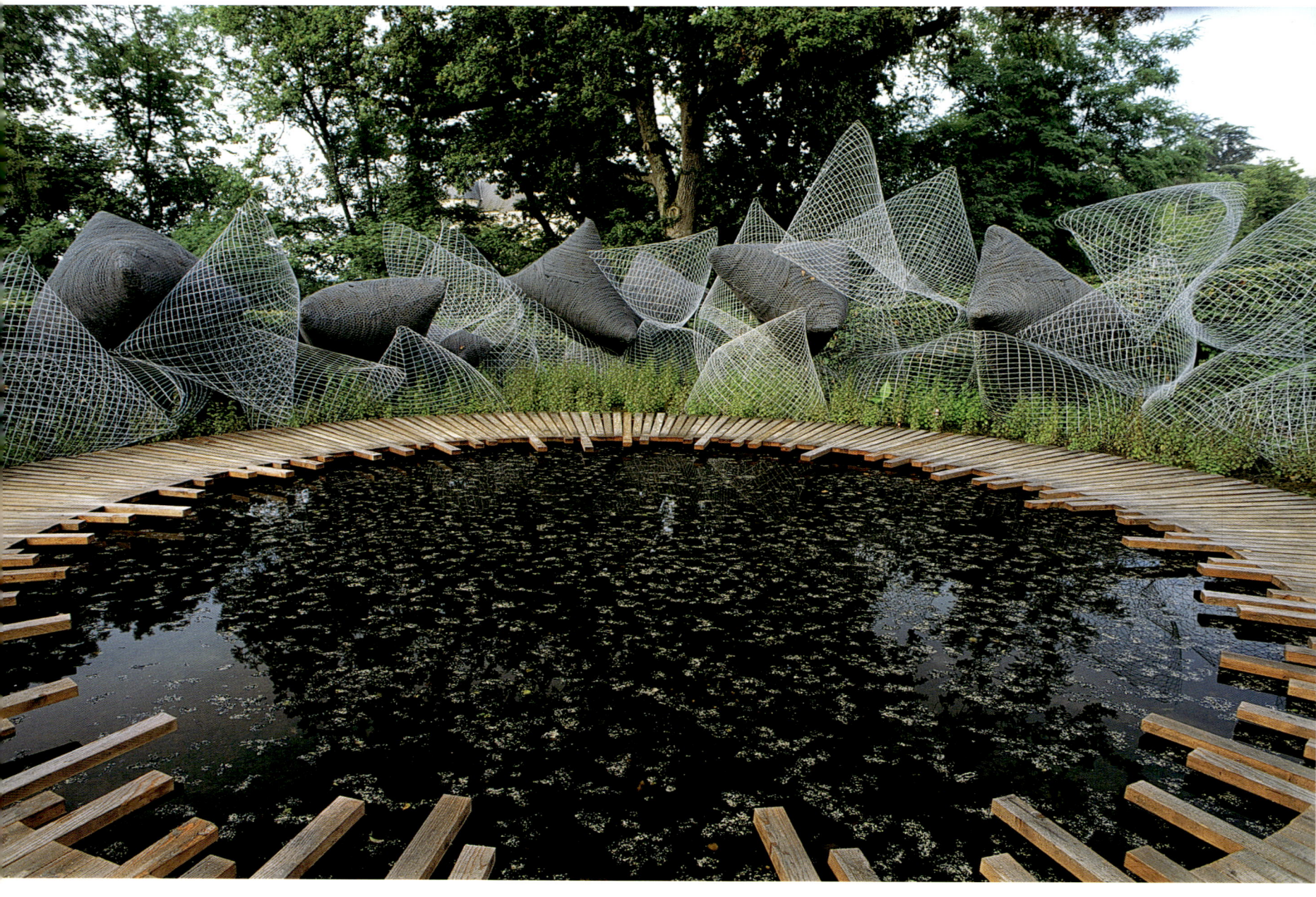

not simply to create attractive external spaces around a house but to integrate the house with its setting in terms of appearance, function and spirit, and to combine those objectives with sustainable, holistic design values.

There are many ways of defining a garden as contemporary, the simplest being that it is designed for our time, and incorporates modern influences, materials and trends. However, while a garden may reflect contemporary culture and be modern in spirit, it is never entirely defined by present-day attitudes. Its true character is more complex than that. It is an accumulation of ideas handed down from one generation to another throughout history, and it is constantly adding to that store of inherited wealth. Like every artistic creation, a garden is always open to subjective interpretation, but, while a painting, sculpture or building can be evaluated as a completed work, a garden can never be said to be finished. It is always in a state of change – growing, weathering and evolving over time.

The very idea that a garden takes time to create and mature runs counter to the way we live our lives today. People move house more frequently than ever before, so to design a garden that will not be seen at its best for at least a quarter of a century is pointless for the client who will soon move on. There is an increase in demand for quickly produced, low-maintenance gardens, especially in urban settings. Increasingly sophisticated growing and transportation

In 'Menta la Menta', the dark waters of a small, round pond are encircled by a ring of projecting wooden slats and by a bank of wire mesh pillows holding bright green clumps of acquatic mint. Designed by Italian landscape architects Marco Antonio, Gianna Attiani, Roberto Capecci, Daniela Mongini and Rafaella Sini as an experiment in the use of new materials, it was shown in 2000 at the prestigious annual 'Festival des Jardins' at Chaumont-sur-Loire, France.

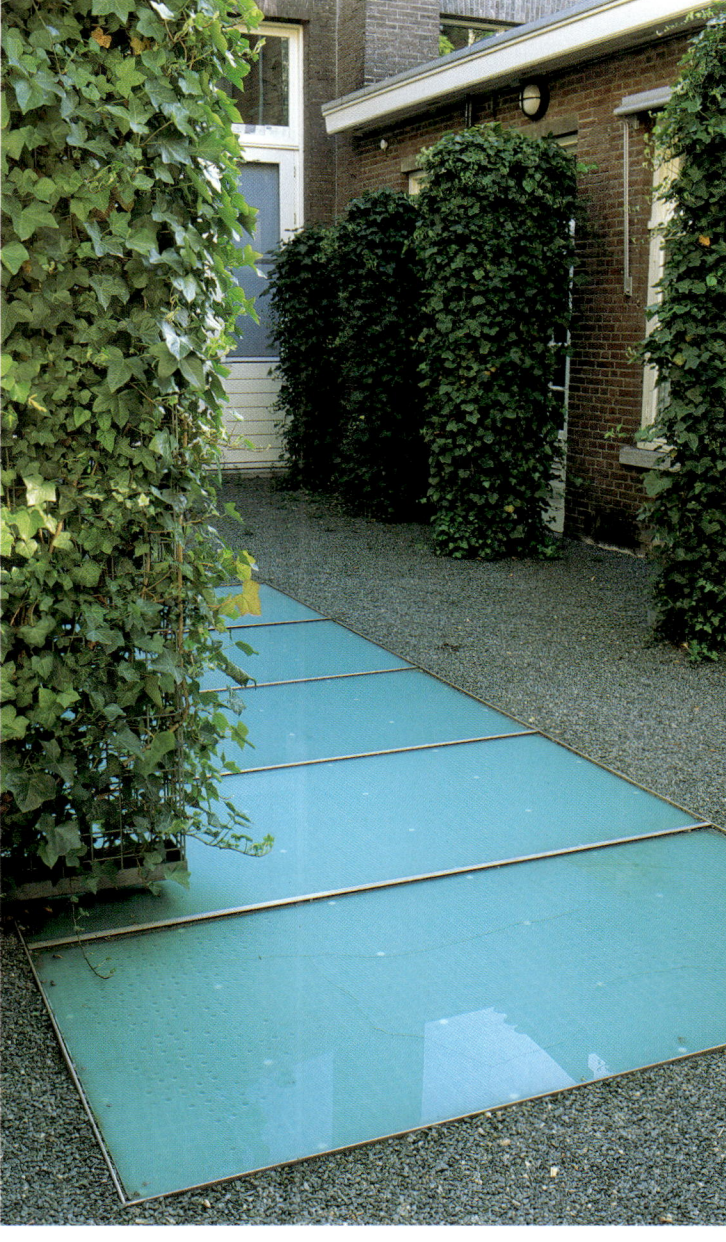

A basement garden in London designed by Julia Brett in 1998 combines a bas-relief by Stephanie Knight with a wall of graphic Japanese-style copper trellising. The oriental theme is carried through in the container-grown maple which is artificially lit at night and fills the small space with colour.

This small courtyard garden in Amsterdam was designed by Lodewijk Baljon in 1997 with the aim of introducing maximum light. Opaque sea-blue glass sheets, laid in a strip and set into a gravel surround to resemble a rectangular pond, have all the reflective properties of water but offer a simpler, more feasible solution in a confined space. Dense, evergreen pillars of ivy, grown on meshed metal frames lining the walls, intensify the colour of the glass sheets on the ground.

techniques now allow nurseries to supply fully mature plants and trees to garden designers, which means that with the appropriate funds the appearance of a mature garden can be created almost instantly.

Although the kudos of a designer-created garden in a rural setting has never been in doubt, the appeal of a customized garden for an urban dwelling, however small, is on the rise throughout Europe. For most people, garden space is limited, and designs today are generally on a smaller scale than in the past, with few commissions for vast estates. Surrounding buildings, the proximity of neighbours, limited daytime use and difficult access for building materials are all considerations influencing the creation of

The plans and models of French landscape architect Yves Brunier (1962–91) were characterized by a dynamism and artistic flair that marked a turning-point in the contemporary approach to presentation. In his professional work at the Office of Metropolitan Architecture (OMA) and in his collaborations with Isabelle Auricoste, Brunier's unconventional, hastily drawn, black line sketches were combined with collages of paper cut-out hedges and trees against finger-painted skies, often using household items such as cotton buds or whatever came to hand to demonstrate an idea more vividly.

Blending almost imperceptibly into its watery surroundings, La Triballe was built by its owner, French architect Jean Kling, along strictly ecological lines in a remote part of the Forest of Orléans, France (1991–94).
A combination of ancient techniques and modern technology were employed in the construction of its sod roof – wood, concrete and recycled plastics forming the substructure for a dense covering of hardy plants: among them are sedums, grasses such as Festuca glauca *and a range of perennials including* Sanguisorba minor, Saponaria ocymoides *and cerise-pink* Dianthus deltoides.

urban gardens. These factors have contributed to the continuing popularity of the oriental, particularly Japanese, garden, which lends itself to small-scale reproduction and the use of hard, often synthetic, materials.

The concept of the garden as an art form in which change and renewal are characteristic features invites the use of an almost infinitely diverse range of materials as part of its design vocabulary. This diversity is enhanced still further by the interchange of ideas fostered by international competitions and the fact that garden designers are working increasingly in a global forum. Since the 1990s an ever larger number, both in Europe and the United States, have achieved an international reputation, and have been commissioned to produce both private and public projects overseas.

Universities keen to expand their prestige and their students' horizons invite foreign landscape architecture professors to teach and hold studio workshops. Though the level of expertise taught in landscape architecture schools across Europe continues to vary dramatically, this unleashing of talent and cross-border academic movement encourages countries without recognized university degree courses in landscape design to raise their standards to an international level. However, new theoretical considerations need to be addressed, and the teaching of interdisciplinary planning, ecology and technical skills all need to be developed in order to maintain landscape architecture's new level of recognition.

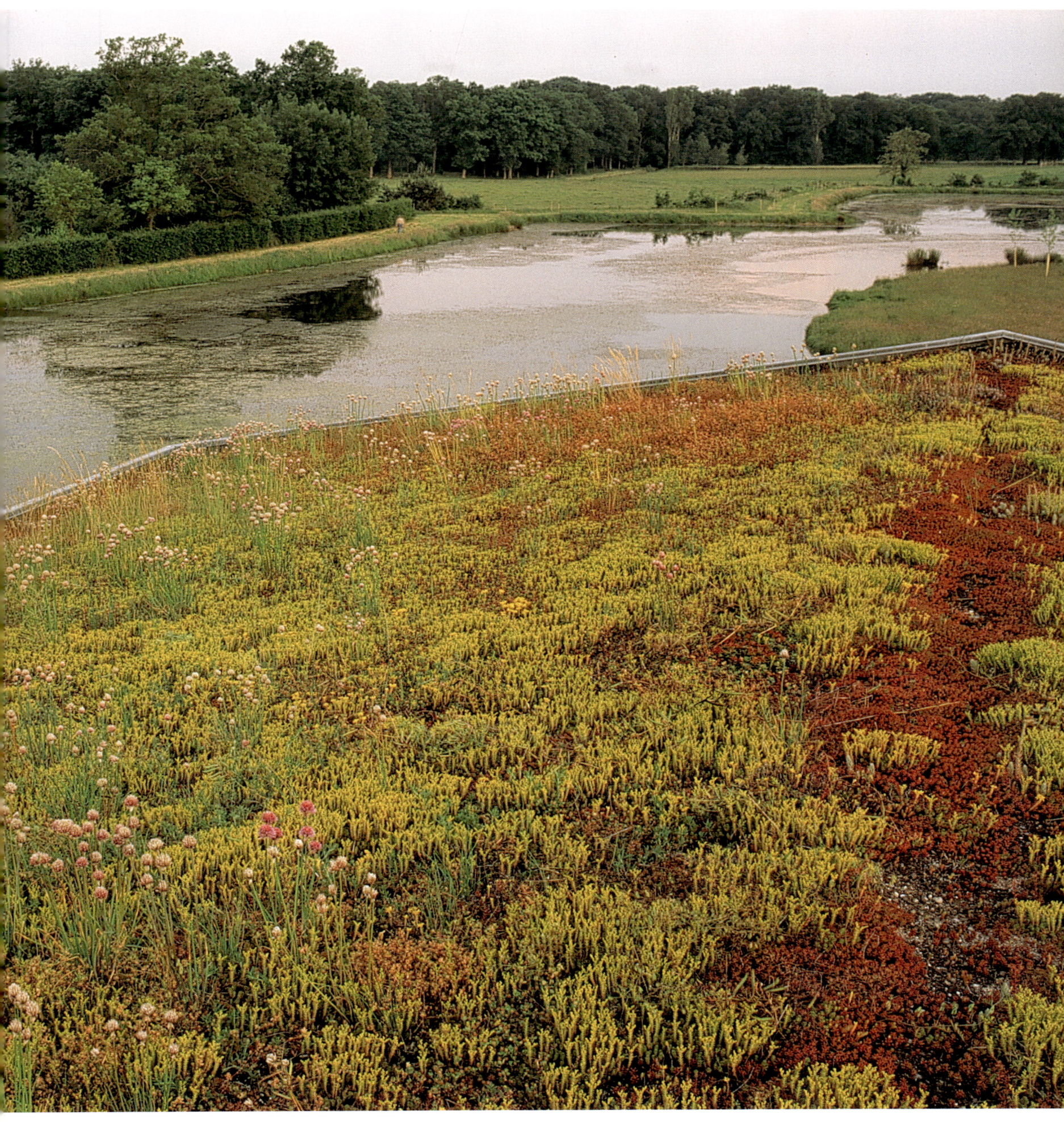

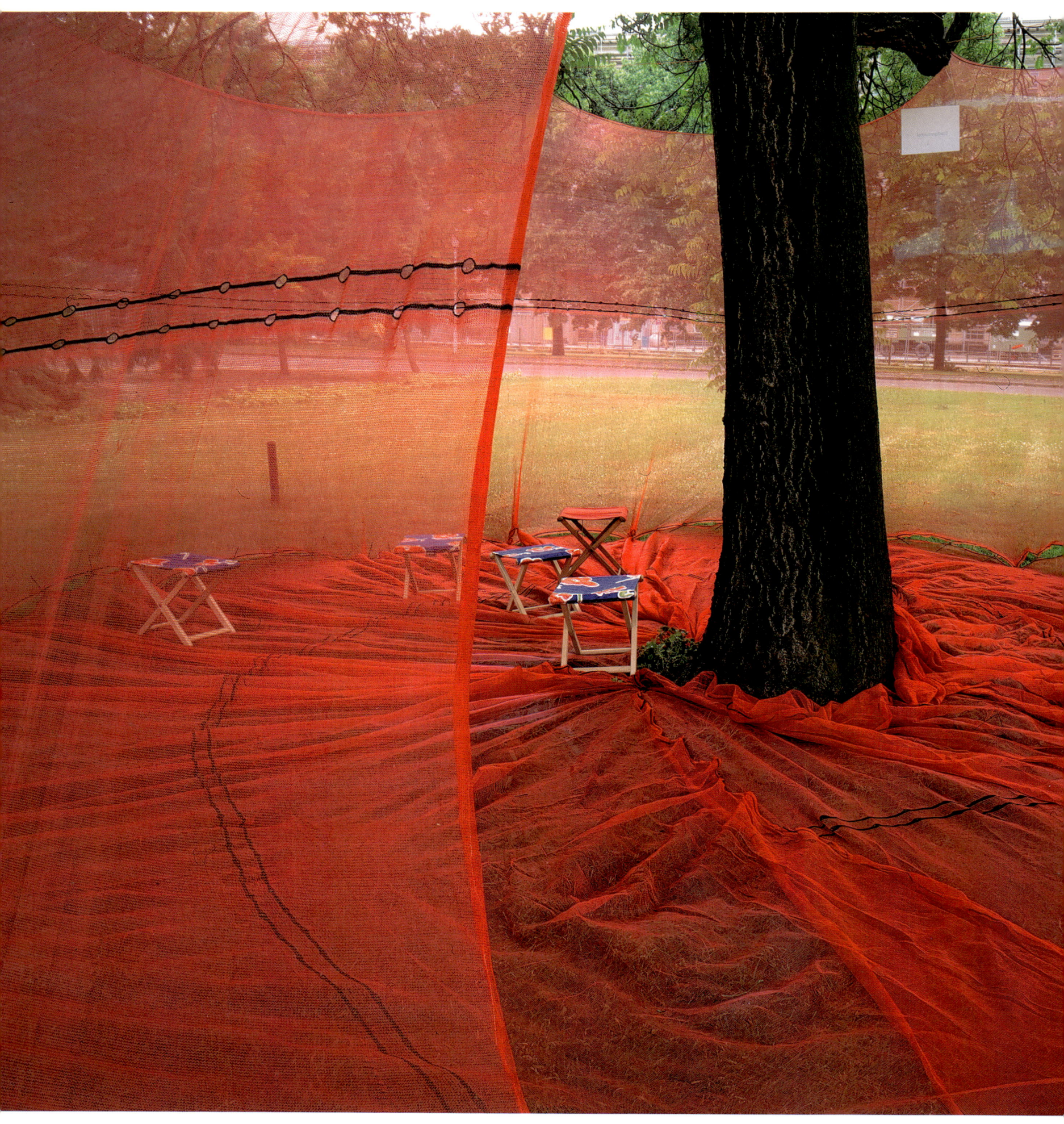

Experimenting with the movement and tactile qualities of fabric in relation to the landscape, Martine Sgard and Suzanne Gabriel draped vivid red drifts of gauze around a tree in the garden of the Staatsratsgebäude to create 'Le Salon Rouge' at the 1997 Temporäre Gärten show in Berlin.

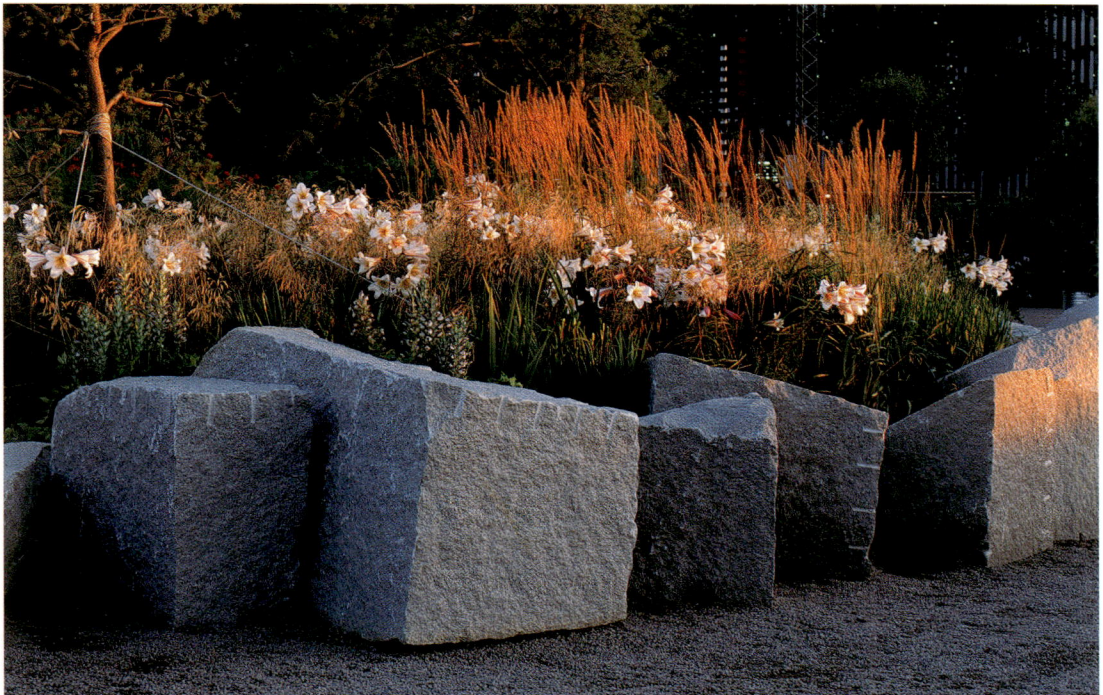

Angular rocks were used by Ulf Nordfjell to highlight a simple planting scheme of Lilium regale *and* Deschampsia cespitosa *at the Hedens Lustgård (Heden's Paradise) modern garden exhibition in Göteborg, Sweden, under the direction of Kristina Hulterström. Two football pitches in the centre of a park were transformed for the show, which lasted from June to September 2000.*

André Le Nôtre and Lancelot 'Capability' Brown are still cited as influential artists of garden and landscape design in Europe, but it is only since the last decade of the twentieth century, spurred by heightened public interest, that garden design has reacquired its proper status after a period of neglect. In the intervening years it came to be regarded more as a national pastime than as a serious design medium. People often fail to appreciate that garden design involves both art and science. Historically, garden designers were held in high esteem for their scientific knowledge as well as their design capabilities. Their understanding of plant sciences and hydraulics was often as comprehensive as their knowledge of aesthetics. Today's designers are trained in the same wide range of artistic and scientific disciplines, and are also required to be equipped with the skills to use all aspects of information technology.

Unparalleled access to information has changed the way we view our world. We can see how the landscape looks from a mile above the ground and how a garden will appear in a decade. Images of practically everything on the planet and beyond are available through photography and film, and information about what is happening around the world is immediate and continuous. Yet, paradoxically, while this increases our desire for instant results, it simultaneously deepens our need to return to the values of nature. Perhaps this very polarity partly explains our wish for a garden to be a refuge, as consciously contemporary in its design as we want it to be but steeped in an atmosphere of tranquillity and calm, a retreat from the chaos of an over-productive world and the pressures of modern living.

Our lives are being shaped by the visual images offered by advertising, books, magazines and television; we are constantly fed with ideas on how to

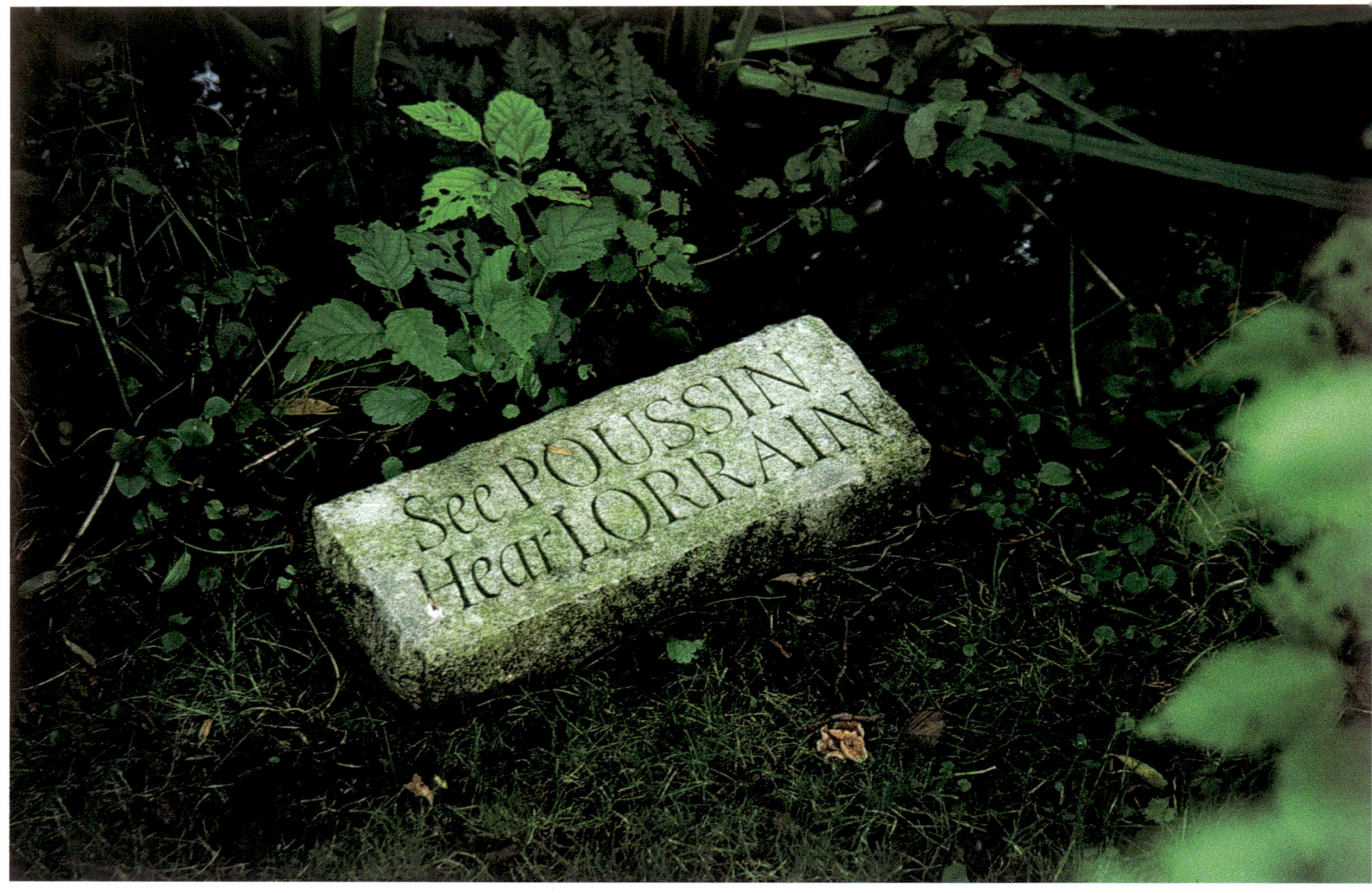

dress, what to eat, how to live, how to decorate our houses and, most recently, with a vast quantity of information on how our gardens should look. This is not a new phenomenon, but the sheer volume of material available today is unprecedented. Ever more popular across Europe are television programmes focusing on designs that are relatively easy for most people to achieve, introducing new if somewhat formulaic features and giving advice on the selection of plants appropriate to an individual site. They do not provide a blueprint for the contemporary garden, but they do encourage interest in the subject, which benefits from wider attention, and they help to promote the work of the best of today's garden designers. There is, however, likely to be a backlash against these television-inspired gardens as our ideas become more refined and our new-found knowledge allows us to differentiate between imitation and genuinely good design.

Horticultural shows are now recognized venues for exhibiting the best in plant cultivation and garden design, and are becoming increasingly well attended as populations age and people have more time to devote to their gardens. Gradually, in the 1990s, the doyens of traditional garden shows observed a sea change in popular attitudes towards the acceptance of more contemporary and inventive design ideas. These changes were in part spurred on by the increasing number of garden festivals throughout Europe which aim to exhibit the work of innovative landscape architects and introduce emerging artistic talent.

Ian Hamilton Finlay started work on his classical garden, 'Little Sparta', at Stoneypath in Scotland, in 1966. It incorporates painterly allusions and literary texts which demonstrate that the inspirational traffic in garden design can run both ways: that gardens not only inspire writers and artists but can also draw on their creative work for inspiration. In this cryptic elegiac inscription Finlay invites the viewer to recall the seventeenth-century landscape paintings of Elysian antiquity by Nicolas Poussin and Claude Lorrain.

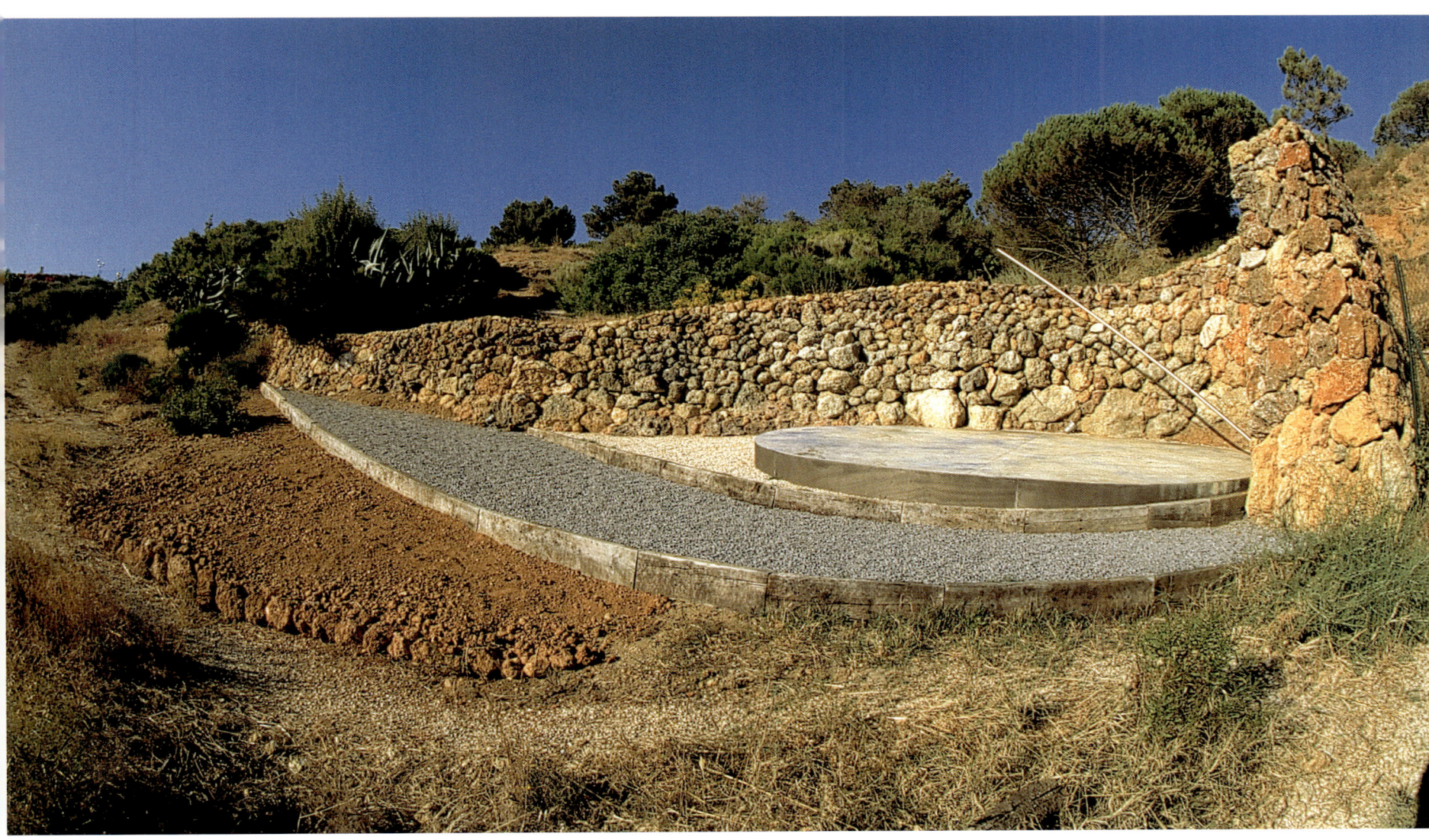

Maurizio Russo's Five Element Garden in Portugal, constructed in 1997, is used periodically for Tai-Chi workshops and combines the principles of the ancient Chinese art of movement with the philosophy of geomantic orientation, identifying five directional points with colours, animals and the primary elements. This eastern corner of the garden represents the Blue Dragon and consists of a thirty-metre retaining wall of local rock curving around terraces filled with blue and white gravel. At the centre is a sundial, its stylus pointing to the symbolic neck of the dragon.

Although garden shows have flourished for many years, the temporary open-air show presenting modern design is largely a phenomenon of the 1990s. The novelty of outdoor exhibitions, as well as offering the advantage of greater, more flexible, space, has stimulated not only garden designers but also architects, artists, writers and dancers to produce work that responds to the open-air setting in all its variety.

The designs of people such as poet and artist Ian Hamilton Finlay, architectural theorist Charles Jencks and sculptors Paul Cooper and Niki de Saint Phalle have made an important contribution to the revival of landscape architecture.

Land artists such as Robert Smithson and Walter De Maria, who first took their work from the gallery

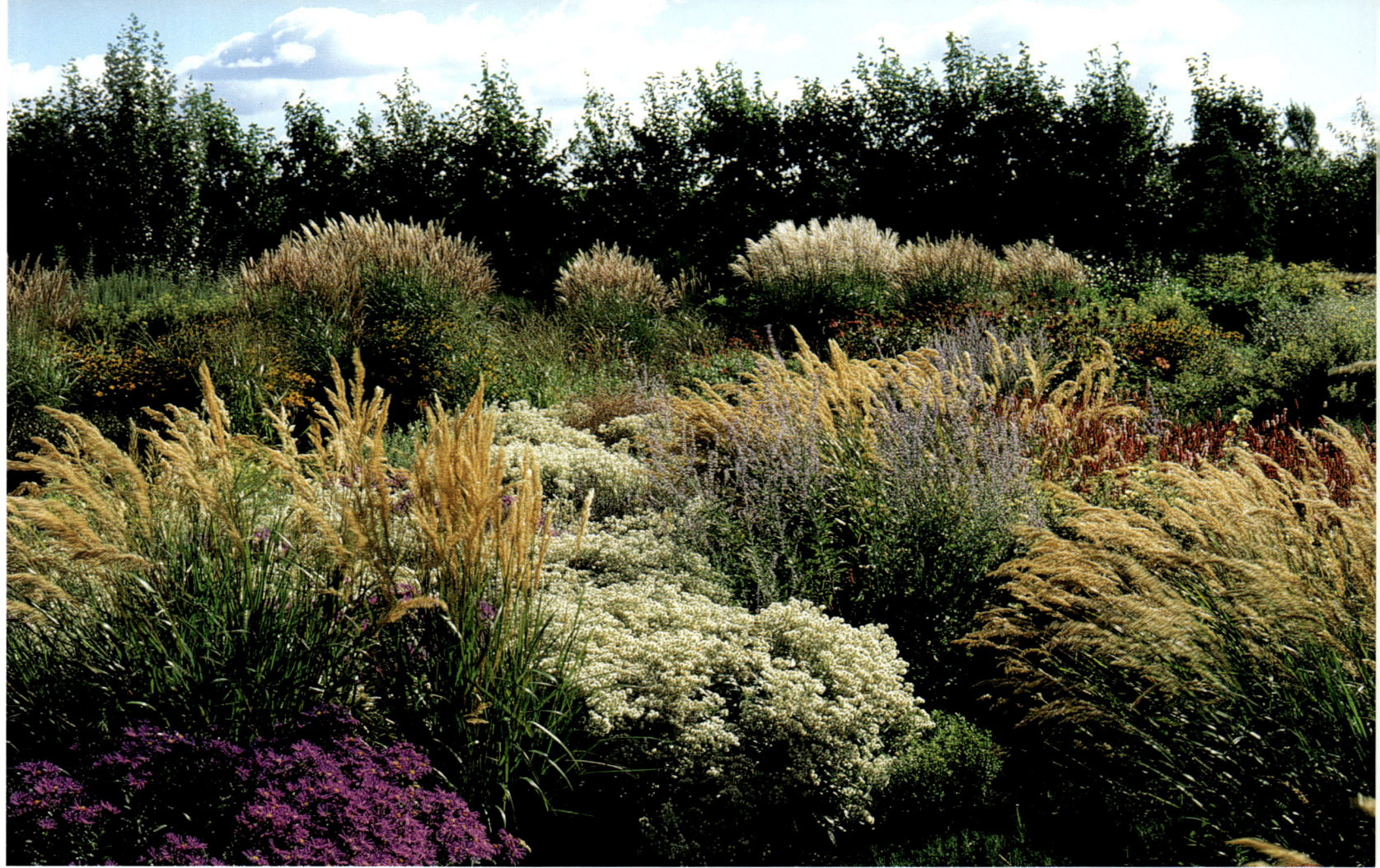

The Ryton Organic Garden near Coventry in the English Midlands, opened in 1986 and run by the Henry Doubleday Research Association, promotes and carries out research into organic methods of gardening. Here, Stipa calamagrostis, Anaphalis triplinervis, Perovskia 'Blue Spire' and Aster amellus 'Veilchenkönigin' thrive in perfectly balanced soil conditions.

into the landscape in the 1960s, and modern artists exploring nature such as Richard Long and Andy Goldsworthy, are also influential.

These developments have contributed to a move away from the purely horticultural emphasis which prevailed in the nineteenth-century, when exotic plants from all over the globe became the focus of the fashionable garden, and turned to art and philosophy as influences on the contemporary garden, as they had been in earlier times. Harking back to the English eighteenth century, when the landscape inspired poetry and painting, a range of artistic disciplines are frequently being united in a single setting, both to complement each other and to show that gardens and the landscape can once again offer a source of inspiration to the arts.

Though the influence of art is undoubtedly significant for garden design today, plantsmanship remains its most essential aspect. Horticulturalists and designers are pioneering ideas on the growing of plants for their structure rather than simply for the beauty of their colours. Colour remains an important element in the creation of atmosphere, but the individual form of plants is seen as making a vital contribution to the style and drama of a contemporary design.

The use of native plants, especially in wild flower meadows, has become increasingly popular in the West over the past few decades. As a result of the damage caused to the environment through the use of artificial pesticides and herbicides and the consequent loss of so many indigenous plant species,

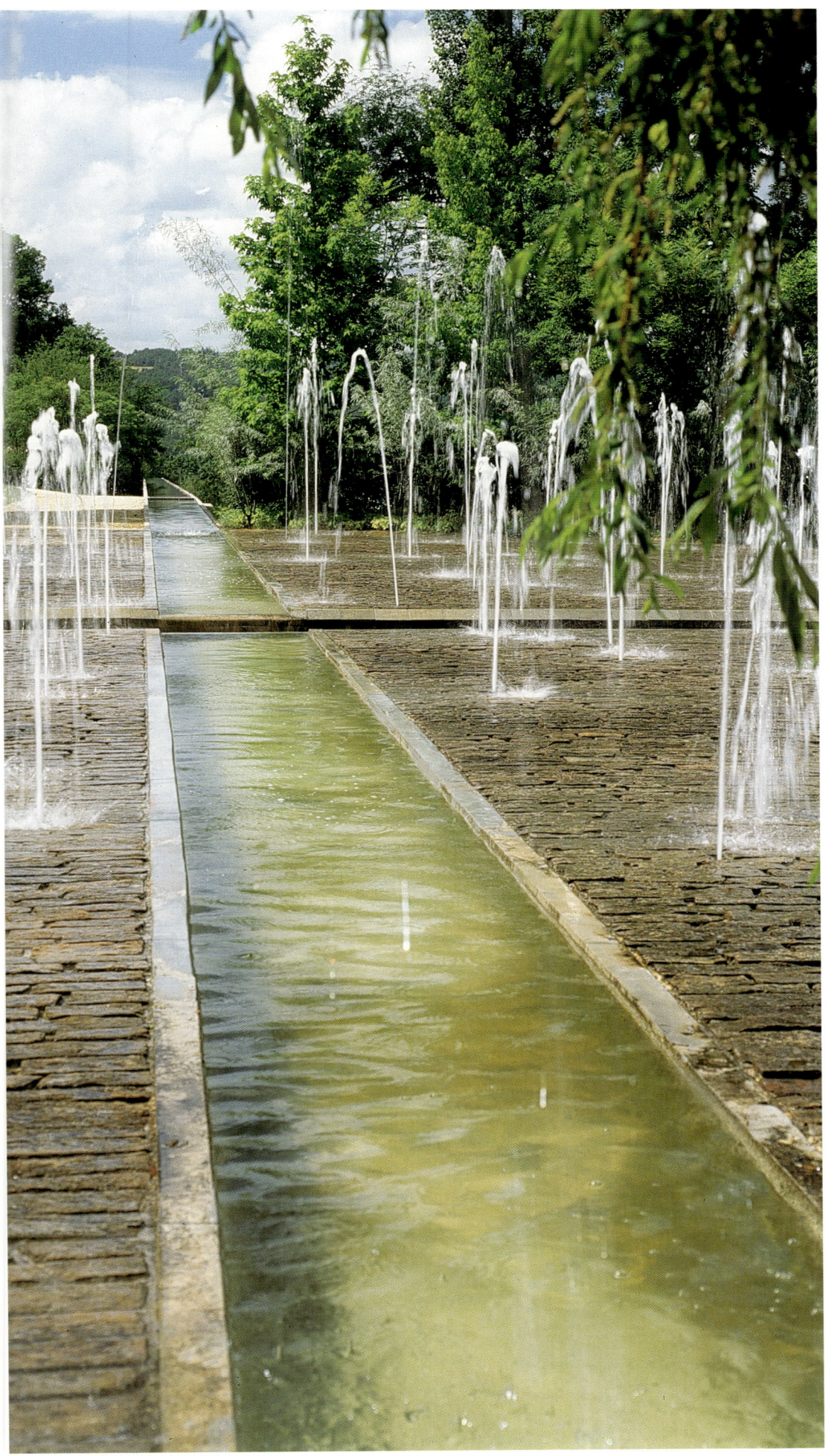

A water channel, designed in 1995 by American landscape architect Kathryn Gustafson at the Terrasson-Lavilledieu park in the Dordogne, south-west France, takes the eye along a straight axial line, extending the view into the far distance in much the same way as formal French gardens of the seventeenth century sought to do. Jets of water spring from the paving on either side, echoing the vertical lines of a frame of trees which accentuate the perspective effect.

there is now a greater appreciation than ever before of those that remain and the need to preserve them. Interest in their future has been further stimulated by experimental wild flower gardens in Britain, Germany and America, which aim to encourage wildlife back to gardens and to find a more environmentally friendly way of gardening. Experiments are being carried out to show how planting schemes can be incorporated into architectural projects to clean and recycle air by natural means and to provide an ecological form of internal climate control.

Exciting new concepts and design perspectives are currently emerging from all corners of Europe and the United States, and the aim of this book is to draw them together and identify not only the direction in which contemporary garden design is mov-

Attilio Pierelli's Icarus *(1967), a mirror-like, stainless steel sculpture in the form of a slender, concave column culminating in swallow-tail wings, throws back the colour and images of an overhanging sequoia tree in the garden at La Serpara, the home and open-air gallery of Swiss sculptor Paul Wiedmer in northern Lazio, central Italy.*

*At the Chaumont-sur-Loire Garden Festival in 2001, Alexandra Bonnin made a temporary installation using the faded needles of the umbrella or stone pine (*Pinus pinea*), scattered beneath the trees on gravel terraces in shades of russet and ochre as a study in colour, texture and contours.*

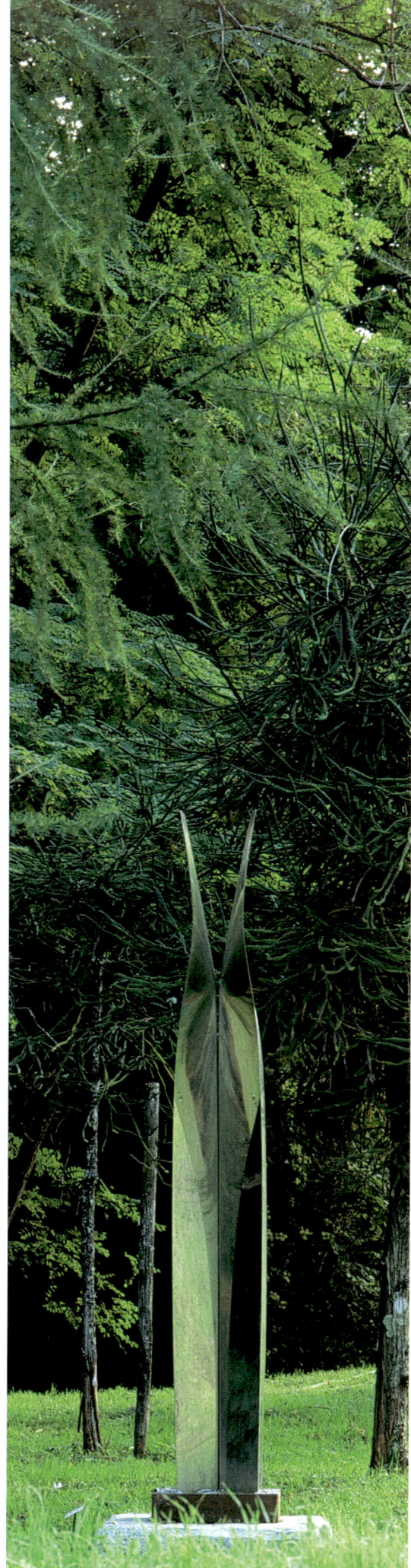

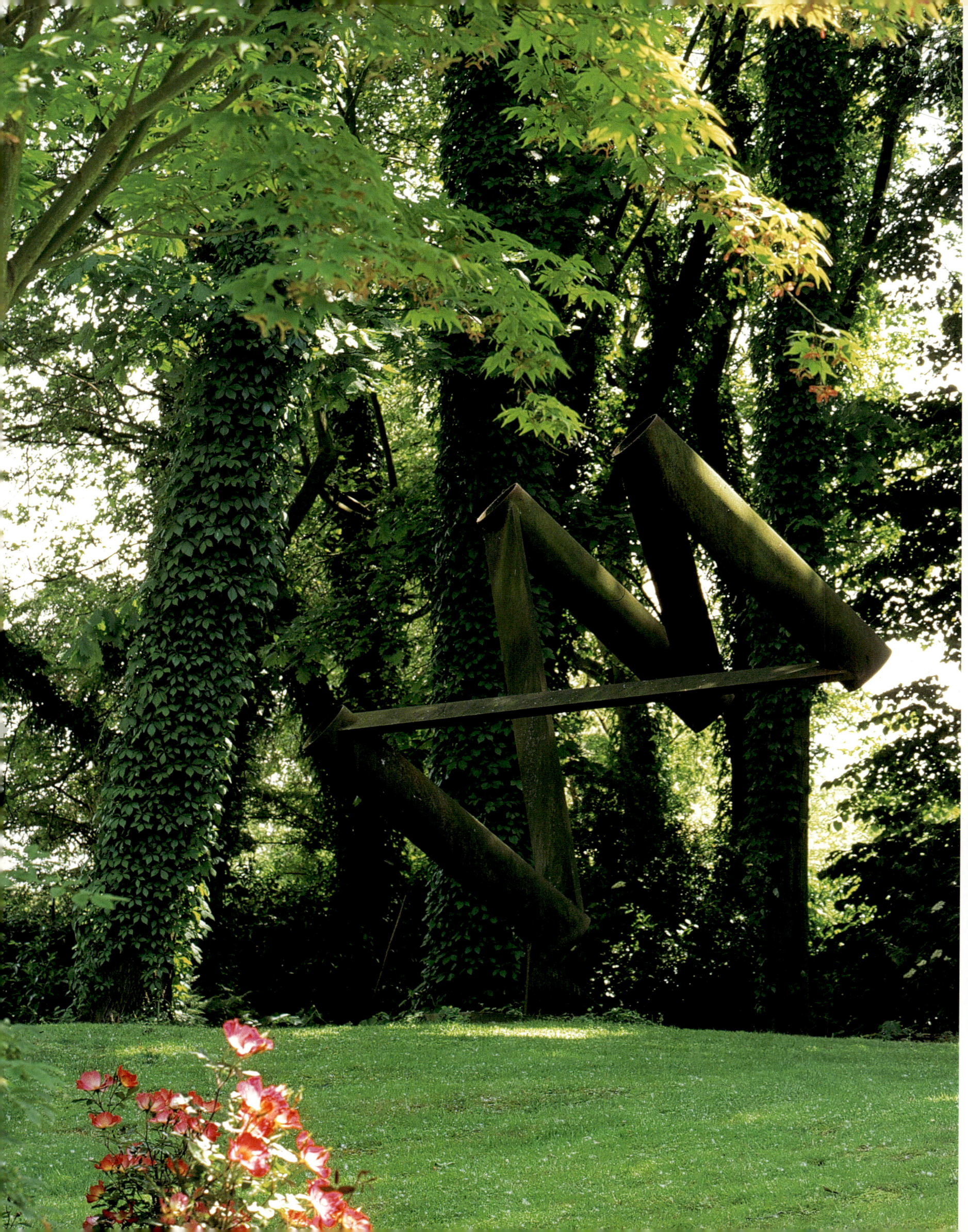

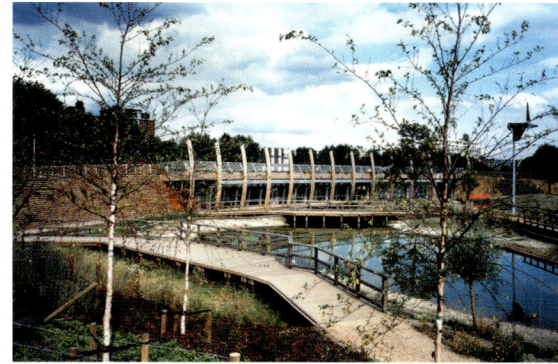
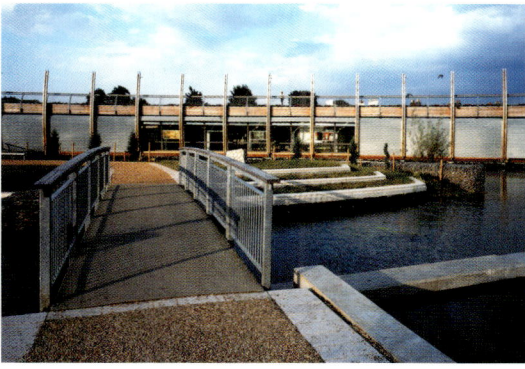
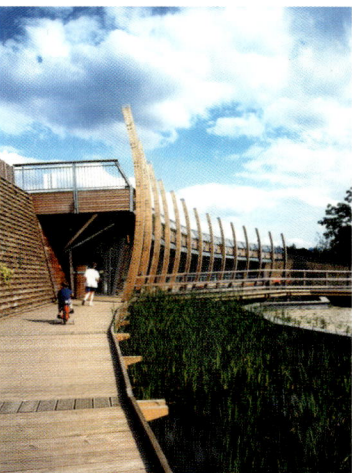

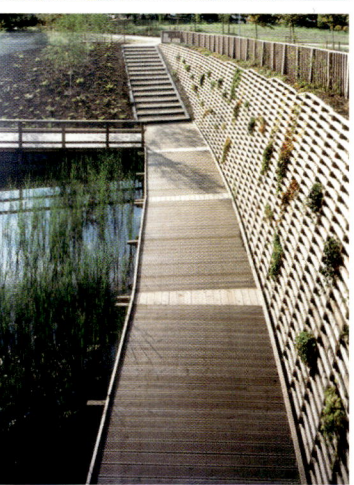

Mile End Park, a narrow ribbon of land in London's East End, occupies a canal-side site one-and-a-half kilometres long, and was conceived as part of the city's Millennium initiative to rejuvenate the area. Designed by interdisciplinary architects and planners Tibbalds TM2, it is one of the United Kingdom's first forays into contemporary landscape design for a public area and incorporates innovative ideas such as art and ecology centres with earth-roofed pavilions as well as taking imaginative advantage of its waterside location.

Italian sculptor Pino Spagnulo created this work for a private garden designed in 1996 by landscape architect Ermanno Casasco in Piedmont, north-western Italy. Inspired by natural forms and by the spatial relationships between elements in the landscape, the sculpture reaches out long limbs almost like branches extending from the trees around it, setting up a spatial tension between the art work and its surroundings.

ing today but also the spirit that inspires it. Essential to an understanding of that spirit is an awareness of the conditions that have nurtured it. The first chapter of the book is therefore devoted to an outline of the artistic and architectural movements of the twentieth century that have moulded the development of the garden, and to a brief tour of those European countries which have importantly influenced its evolution. Examples of a wide range of gardens and landscapes, both private and public – including parks, cemeteries and urban spaces – are cited in the chapters that follow, as are certain specific architectural projects, chosen for their impact on private sector design across Europe, which cannot be excluded from a book on contemporary gardens. Many of the examples given are new in matter but not in concept; they are developments of landscape architecture and garden design ideas rooted in traditions many centuries old. However, it is the way in which the ideas are used and the materials with which they are built that together form a new design philosophy.

Even accepting new ideas and the break from old conventions, the question about contemporary gardens remains: what determines whether a new design is good or bad? Judgement can, of course, be as fallible as it is subjective. Gardens must stand the test of time if they are to be enjoyed by subsequent generations; they must withstand the elements, allow for growth, remain adaptable and fulfil their function if they are to be cherished in years to come. Time will also reveal whether the public acclaim currently afforded to the image of the contemporary garden will overcome the scepticism surrounding its often controversial components.

Whatever the future holds, the present offers much to admire and excite us. Modern garden design owes its vitality more than anything to the talents of the new generation of designers, skilled in a wide range of disciplines. Praise is owed to them for injecting it with new life and thanks must be accorded to those responsible for commissioning and funding their work.

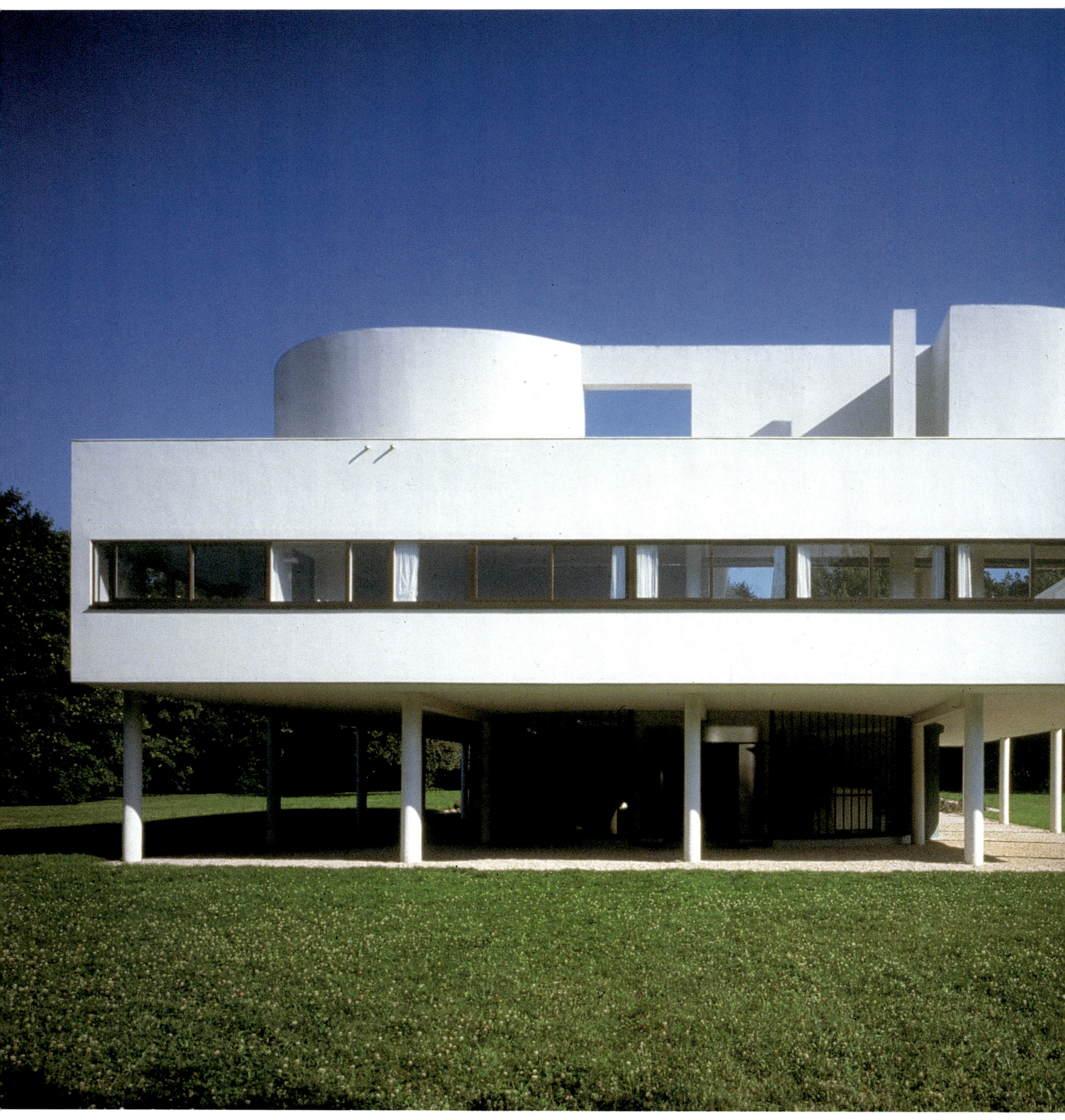

Setting the Scene

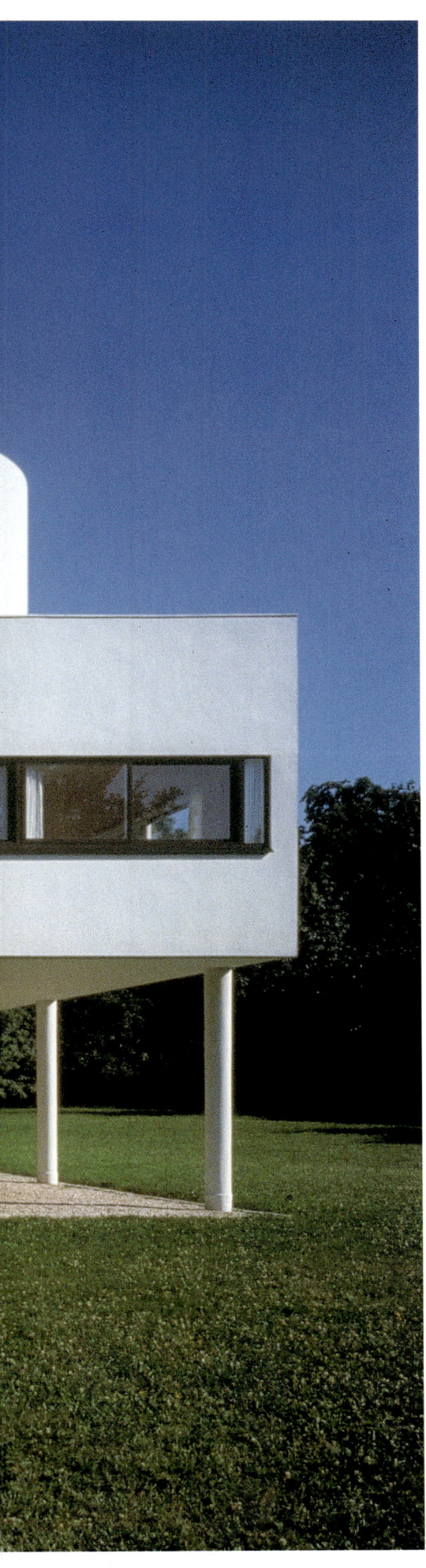

One of the seminal works of twentieth-century architecture, Villa Savoye at Poissy near Paris (1928–9) epitomized Le Corbusier's Modernist ideals in its contrast of mass and void. The villa is elevated above the ground on load-bearing columns, allowing an uninterrupted flow of land beneath and around it that effectively isolates the building from its environment.

As with any other art form, garden design is a reflection of the cultural, political and economic currents of an era, mirroring the attitudes and ideas of its time. In order to put contemporary gardens into their proper context, it is necessary to review the design changes that have taken place in the course of the twentieth century as well as to look at the traditions carried forward from previous centuries. Although this book concentrates largely on developments in Europe, it also refers to the work of a few designers from further afield, especially the United States, who have significantly influenced the direction of contemporary landscape architecture.

Despite political turmoil across Europe, garden design held its ground throughout the nineteenth century, sustained almost exclusively by the wealth and traditions of the aristocracy and landed gentry. As an antidote to the social and physical upheaval of the period and as a response to industrialization, urban parks began to be laid out in cities throughout Europe during the mid-nineteenth century; across the Atlantic, meanwhile, Frederick Law Olmstead (1822–1902) and Calvert Vaux (1824–95) designed one of the world's most famous city parks, New York's Central Park, in 1858.

During the twentieth century, continued industrial expansion, two world wars and a technological revolution all brought about massive demographic change which in turn demanded new solutions to housing. These factors also signalled the end of the traditional culture in which the grand private garden or landscaped park reigned supreme, and consequently heralded huge changes in the future of garden design. The rise of the small, suburban garden, the discovery of new plant species in far-flung corners of the world, an increase in botanical experimentation, the importation of images from Japan and the fashion for chinoiserie, all had a marked impact on thinking and practices in garden design.

Designers of private gardens in Britain largely

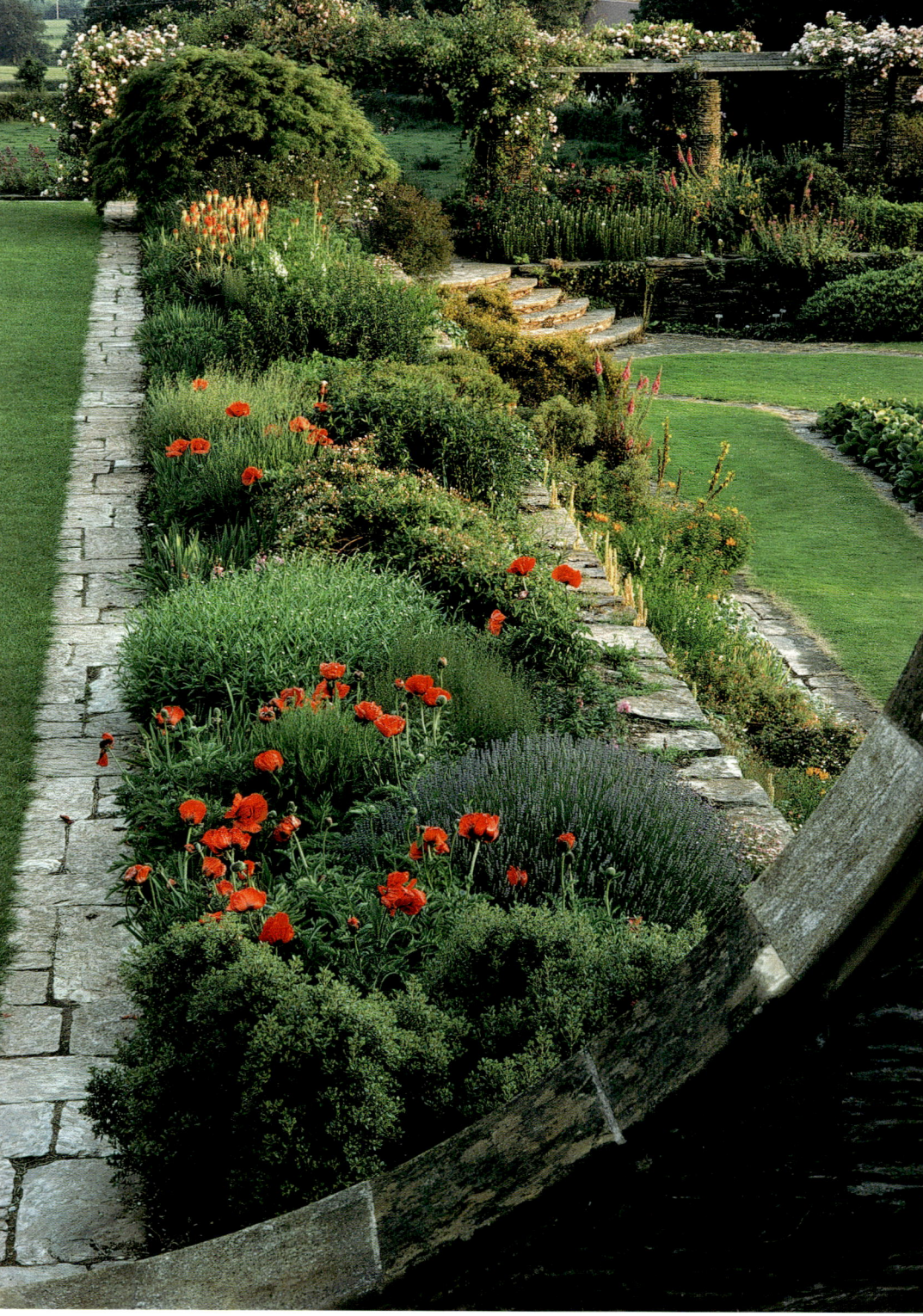

aligned themselves with the Arts and Crafts Movement, led by the English poet and designer William Morris (1834–96), which aimed to bring together all branches of the arts and reassert the importance of craftsmanship. The traditional tendency throughout Europe towards garden restoration and the pursuit of the picturesque was stimulated by the crafts revival and by the desire to return to a more natural way of living as a reaction to the ethos of the machine age.

At the same time, investigative artists found new forms of expression in painting and sculpture. The early twentieth-century avant-garde movements of Cubism, Dadaism and Surrealism took on a more abstract aspect, with a simplication of colour and form. This can be seen in the work of Piet Mondrian (1872–1944), who produced asymmetrical rectangular grids using only the primary colours of red, blue and yellow, and in the bold, clear outlines and strong colour used by Expressionist artists and designers such as Paul Klee, Wassily Kandinsky and Bauhaus teacher Johannes Itten.

Architects of the 1920s were stimulated by the ideas of the Bauhaus School, founded in Weimar and championed by Walter Gropius (1883–1969). The bedrock of the Bauhaus teachings was the application of technology and prefabrication and the rational and intelligent use of contemporary materials. Abstract form and functionality were its key elements, inspiring artists across many disciplines to adopt one universal design style. Notably, landscape design was low on its list of priorities.

The Arts and Crafts Movement, which looked to the past, was an anachronism to the emerging Modernist architecture. So while garden design remained entrenched in the romantic idyll, its most closely associated art form underwent revolutionary changes. The seamless alignment between architecture and garden design, which had enjoyed centuries of solidarity, broke apart, and arguably the rift has not yet been wholly repaired.

The Modernist period was preoccupied with scientific objectivity in a search for clarity and purity in design. The latest technology enabled architects and designers to create innovative and exciting

Architect Edwin Lutyens and garden designer Gertrude Jekyll formed one of the greatest design collaborations of the twentieth century, Lutyens laying out the structure of the gardens for his highly distinctive country houses and Jekyll displaying her painterly skills in the creation of magnificent perennial borders. The results of their teamwork can be seen in the gardens at Hestercombe in Somerset, first laid out in 1904, which have recently been restored to their original glory. Brilliant red poppies light up the subtle shades of blue and green on this terrace planted with a range of low-growing evergreen shrubs.

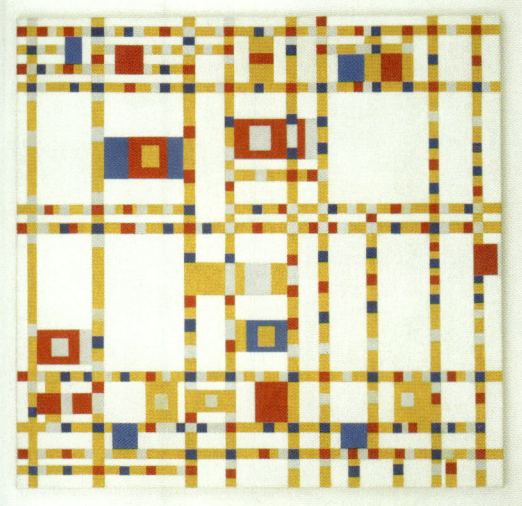

Broadway Boogie Woogie (1942–3) by Piet Mondrian, whose abstract paintings based on rectangular grids inspired other artists, architects and even garden designers to adopt a similarly minimalist use of colour and line. (Oil on canvas, 127 x 127 cm: Museum of Modern Art, New York)

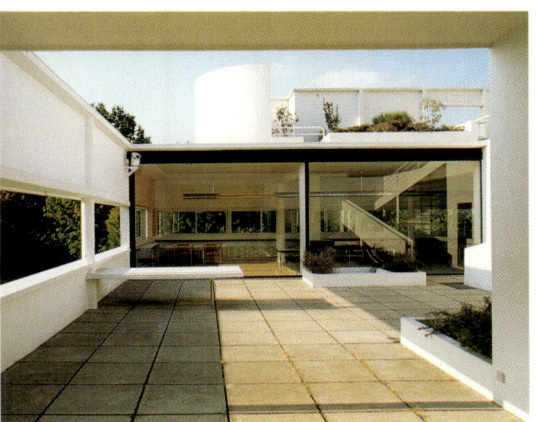

Above: The roof terrace of Le Corbusier's Villa Savoye incorporates only a hint of foliage and no flowers into its linear, uncluttered design. To the Modernists, landscape and architecture were incompatible and sharp distinctions were drawn between them.

Below: In contrast, cantilevered over a mountain stream at Bear Run, Pennsylvania, Frank Lloyd Wright's Falling Water (1937–9) was ahead of its time in its integration of house and landscape in a form of 'organic architecture'; though its design philosophy was admired even when it as first built, it was decades before it was widely adopted in place of the prevailing mantra of machines and technology.

Above: Continuing the reference to nature, Finnish architect Alvar Aalto's 1959 design for La Maison Carré in Bazoches-sur-Guyonne, near Paris, exemplified his belief that architectural design and the natural forms of the landscape were inextricably linked, and that a holistic approach was the only way forward.

Below: Simple, wide-stepped terracing carpeted in grass and clover falls away to the east of La Maison Carré, fluently extending the garden towards the woodland while retaining its architectonic structure.

forms in which the proportions of space were paramount and interiors uncluttered, the known and familiar was rejected and historical idioms and classical references were banished. Modernist concepts took firm root at the Berlin School, another major centre for the avant-garde, under its leader Ludwig Mies van der Rohe (1886–1969), while Swiss-French architect Le Corbusier (1887–1965) set up his headquarters in France, which in the 1920s remained the artistic capital of the West.

Born Charles-Edouard Jeanneret, Le Corbusier dominated Modernism in France and overseas with his large, open volumes of glass and masonry presented in box-like structures. He regarded landscape and plants as buffers between buildings. The relationship of Modernism to the landscape was enlightened by Le Corbusier's 'Les Cinq Points d'une Architecture Nouvelle'. This concept, which was announced in 1926, focused on a free plan, achieved by means of *pilotis* (load-bearing columns, or stilts, that elevated the mass from the ground), horizontal sliding windows and a roof garden. The *pilotis* allowed the area below the building to remain open, and to that extent the design incorporated the landscape; the roof garden consisted of an expanse of greenery which supposedly restored the area of land occupied by the building, and the large windows offered a link between interior spaces and exterior scenery.

Villa Savoye, in Poissy outside Paris, designed by Le Corbusier in 1928–9, is in its simplest interpretation a parallelepiped raised on stilts, the key elements in the design being proportion and volume. The roof garden incorporates natural materials into its design but references to the landscape are minimal. There was no room for flowers or embellishments in the Modernist ideology; indeed, the majority of the movement's proponents saw the building as an isolated monument, in sharp contrast to its environment. The integration of a building into an urban or rural setting made no sense.

While the powerful influences of Le Corbusier, Walter Gropius and Mies van der Rohe and their fixation with the machine continued to spread, there were nevertheless a few architects throughout

Europe and America who were designing new and exciting buildings that referred to nature rather than technology.

In America, Frank Lloyd Wright (1867–1959) was developing an imaginative and inventive style of architecture shaped by the ordered lines and influences of Japanese design. Wright's later study of the Japanese view of nature as the essence of beauty and harmony became the foundation of his design aesthetic. Closed but reflective Japanese gardens of raked pebbles and carefully placed stones fitted the new ideas of Modernism in the West and helped to expand the use of hard landscaping materials. The Japanese Exhibition in London in 1903 introduced stone lanterns and pergolas planted with wisteria and other climbing plants, elements which were rapidly adopted into the Western garden repertoire.

Spanish architect Antoni Gaudí (1852–1926) integrated his whole design philosophy with nature, studying the growth habits of plants and incorporating intricate details of flower stems and tree bark as well as seasonal changes in the landscape in his designs. Parc Güell, built between 1900 and 1914 on the outskirts of Barcelona, expressed a child-like vision of nature and the human form as well as revealing the naturalistic influence of the Art Nouveau movement based in Brussels, Paris and Barcelona. Gaudí's extraordinary columns comprised of prehistoric plant forms, troglodytic cave arches and bridges festooned with leaves and flowers, helped to narrow the gap between the natural and the man-made.

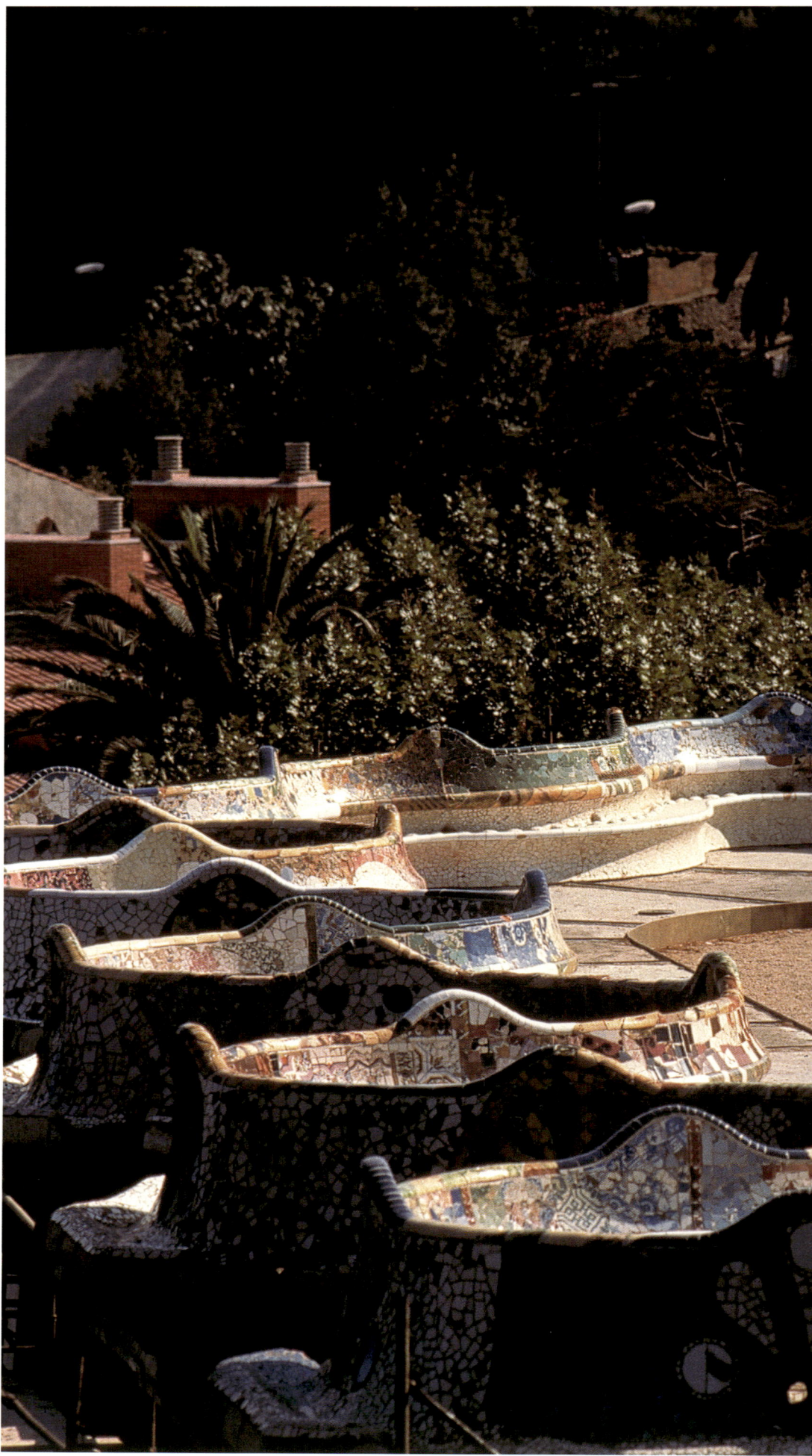

Influenced more by Art Nouveau ideas than by the high Modernist principles sweeping through architecture in the rest of Europe, Spanish designer Antoni Gaudí created the remarkable Parc Güell in Barcelona in 1900–14. In its use of hybrid naturalistic forms and decoration, it was also the fruit of Gaudí's in-depth botanical studies and infinitely creative imagination. Here, a terrace walkway is bordered with a convoluted series of intricately patterned ceramic forms reminiscent of the plate-like leaves of the water lily.

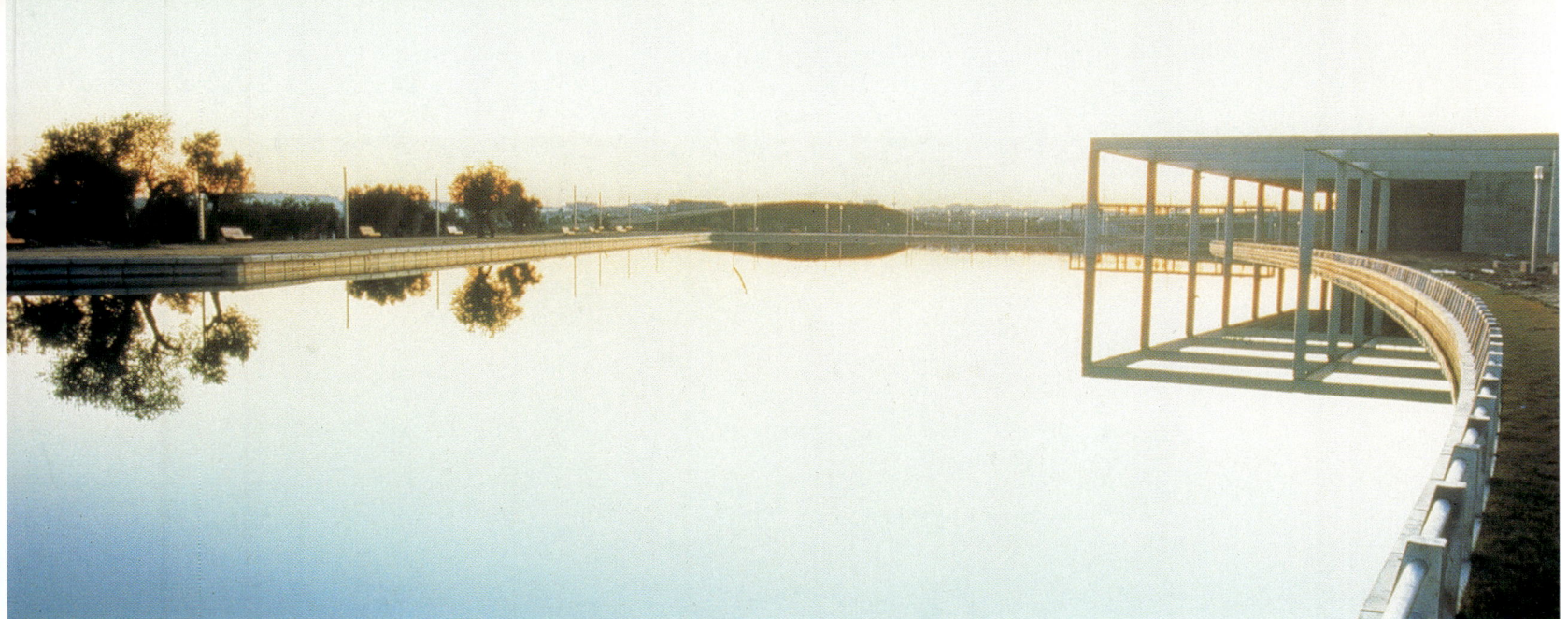

The design of the Parque Juan Carlos I (1992) in Madrid consists of a vast series of walkways around a circular expanse of water. Its architects, José Luis Esteban Penelas and Emilio Esteras Matín, devised its form as a means of encompassing the ancient elements of the site – such as a centuries-old olive grove – within a modern plan. The walkways represent the four seasons, and here the Winter Walk can be seen jutting out over the water between a series of vertical supporting columns. In the distance is one of the five earth mounds, created when the lake was excavated, which break the flatness of the landscape and serve as viewpoints throughout the park.

The garden of the Villa Noailles in Hyères, southern France, incorporates saw-tooth motifs, cubes, chequerboard patterns and intense colour in a Cubist masterpiece designed by Gabriel Guévrékian in 1926. The garden was directly inspired by the collection of paintings the villa was built to house.

PRE-WAR EUROPE

The Influence of France

As the work of Le Corbusier stimulated building design in the 1920s and '30s, another small group of French architects applied lessons of modern art, particularly Cubism, to the garden. For them, Cubism was highly influential in showing a way to break from the traditions of their discipline. Among them was Gabriel Guévrékian (1900–70) whose triangular 'Garden of Water and Light' was shown at the 'Exposition des Arts Décoratifs et Industriels Modernes' in Paris in 1925. Using the Cubist motifs and vocabulary of Braque and Picasso, he designed blue and red basins, a revolving glass sphere and water fountains to express ideas of motion. A year later Guévrékian was commissioned to create a garden at the Villa Noailles in Hyères by Charles and Marie-Laure de Noailles. Reconstructed in 1990, this project was clearly inspired by their large collection of Modernist paintings.

The Villa Noailles garden was intended to be seen as an autonomous, artificial design, isolated from the villa and its surrounding landscape by its geometric plan. Planting beds, set at various levels and arranged in a chequerboard pattern in the triangle formed by the convergence of the garden walls, not only made a strong visual impact but also created the optical illusion of movement. Painted forms and flowers provided the important element of colour: mauve mosaic tiles and tulips, slabs of red, grey, yellow and blue, with orange trees framed by a background of white concrete, created a series of startlingly vivid images. Although the design followed the long tradition of the formal French garden in demonstrating its control over nature, it was thoroughly modern in its asymmetrical forms and organized patterning and in its daring placement of a sculpture by Jacques Lipchitz, *Joie de Vivre,* of a man and a woman embracing.

In 1926 André and Paul Véra created a small garden with Cubist influences for the Noailles near Paris and, in the same year, interior designer and bookbinder Pierre-Emile Legrain produced a landscape design using a serrated border based on a Cubist motif in Saint-Cloud.

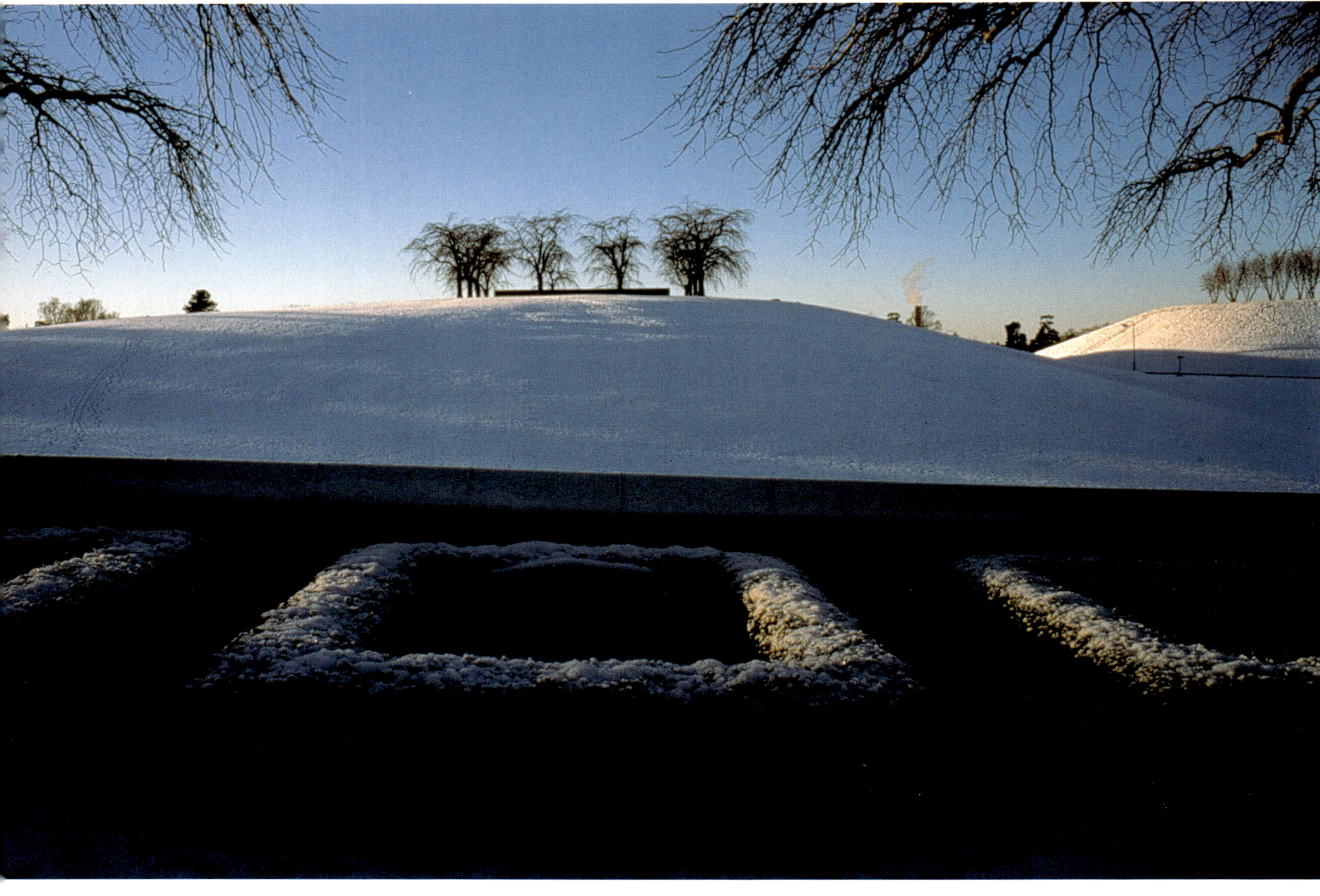

Gunnar Asplund and Sigurd Lewerentz's influential 1915 design for the Woodland Cemetery at Enskede, south of Stockholm, seamlessly integrated the landscaping into the natural environment, which was seen as a key objective in Swedish landscape architecture. Small enclosures of low, clipped hedging, beside the walkway leading to the chapel, can be seen in the foreground.

At the 1925 Paris Expo, architect Robert Mallet-Stevens, together with sculptors Jean and Joël Martel, designed a garden that employed similarly contemporary motifs. Innovative yet highly formal, it was composed of sunken lawns with four identical cast-concrete trees. The concept was as much a comment on the experimental trends then taking place in architecture, and on the use of new production materials, as a revelation of concrete trees as objects of art in the garden setting.

The American landscape architect Fletcher Steele, who visited the 1925 Paris Expo and travelled extensively in Europe in the 1920s, absorbed new ideas from European designers who were breaking away from the classical traditions and invigorating garden design with a new sense of space. In 1924 Steele wrote *Design for the Small Garden*, transporting some of these new ideas to America, where the *Ecole des Beaux-Arts* tradition remained the choice of the wealthy landowning class. Steele's own garden at Naumkeag, Stockbridge, Massachusetts, created in the 1930s, was clearly influenced by his European travels.

Swiss, German and Dutch Initiatives

The Swiss Werkbund, the Arts and Crafts Movement which took the lead in Switzerland in reforming garden design, held an influential exhibition in Zurich in

1918 which prompted a move away from the traditional alpine model of garden design to incorporate architectural elements. It included work by Gustav Ammann, who also designed a garden for the later show, Zürich Gartenbau-Ausstellung (ZÜGA) in 1933, which consisted largely of free-flowing, naturalistic shapes. However, the rise of German National Socialism led Switzerland to reject modern landscape architecture in the late 1930s and return to the romantic ideal. At the end of the war the Werkbund regrouped with a number of distinguished artists, designers and architects, including Johannes Itten, Le Corbusier, Alfred Roth and landscape architect Ernst Cramer, and again became a dominant force in modernizing Swiss landscape design.

German designer Willy Lange (1864–1941), whose ideology focused on the nature garden, published *Die Gartengestaltung der Neuzeit* (Architecture for the Modern Garden) in 1907, which incorporated ideas influenced by scientific achievements in plant development. He designed gardens to be understood as art and as an interpretation of nature, not an imitation of it.

Progress in the growing of perennial plants brought about not only a change in German garden design but also, in the middle of the nineteenth century, a marked increase in the importation of perennials to Germany, particularly from England, for the gardens of newly created suburbs. In 1938 Karl Foerster (1874–1970), one of the greatest plant breeders of the time and a central figure in the Bornim Circle, a group of landscape architects from the early Modern Movement in Germany, published *Neue Blumen – Neue Gärten* (New Flowers – New Gardens), which signalled the introduction of these newly cultivated perennials.

In the 1920s Foerster teamed up with landscape architects Hermann Mattern (1902–71) and Herta Hammerbacher (1900–85) to develop the concept of site and function, a specific style of design that remains influential in German garden design today. It arose largely as a response to the ever-worsening environmental conditions in industrialized cities, the trend towards one-family housing and the development of the suburb after the First World War. Termed the 'Dwelling Garden', the movement took a sensitive line in respect of the conservation of indigenous plants and the natural environment as a whole.

In Holland at around the same time, the Dutch horticulturalist Mien Ruys (1904–99) was experimenting with plants at her father's nursery. She established an experimental garden at Dedemsvaart in 1925 to examine how plants could best be combined to show their form and texture to advantage. Her perennial borders were so prolific and structured that no other type of hedging was required around the garden, an innovation in Holland where the hedge was viewed as an integral part of the design. Today Buro Mien Ruys upholds the Ruys style of design at Dedemsvaart, which continues to be run as an experimental garden by landscape architects Hans Veldhoen and Anet Scholma.

Scandinavian Style

In 1915 Swedish architects Gunnar Asplund and Sigurd Lewerentz won an international architecture competition to design the Woodland Cemetery in Enskede, south of Stockholm. Regarded today as a seminal work, the design is sparse, clear and light, displaying the key characteristics of Swedish design as well as elements of Modernism.

The 1930 Stockholm Exhibition was heralded as a breakthrough in introducing a new vocabulary for landscape design as well as architecture in a movement termed Functionalism, which proposed that the contrived elements of a design should be so fully integrated into the natural setting as to be virtually indistinguishable from it. It was an ideology based upon the traditional Swedish affinity with the landscape. For around two decades, from the early 1930s to 1950s, the so-called Stockholm School modernized Swedish landscape design, and, like its architecture of the same era, made a considerable impact on design throughout Europe.

Sweden, which had not been involved in a war since the early nineteenth century, had ample opportunity to develop a solid democracy, and throughout the early part of the twentieth century it demonstrated its social awareness by creating an extensive park system, emphasizing the outdoors as the key to Swedish life and culture. The new parks were imaginative and simple, carrying forward the functionalist ideals. Major figures in its development were Holger Blom, one of the designers of the Malarstrand lakeside promenades, Erik Glemme and Sven Hermelin, who aimed to design landscape where no human intervention was visible.

Denmark's tradition of garden design dates back to the Renaissance, and over the course of history has absorbed influences from Italy, England and France. However, by the turn of the twentieth century, the influence of Modernism was taking hold here too in response to rapid changes in society. Two highly influential Danish landscape architects of the period were Gudmund Nyeland Brandt (1878–1945) and Carl Theodor Sørensen (1893–1979). Brandt's ability to introduce diversity and Sørensen's skill in the placement of plants to exploit the flow of the land are viewed as major influences on subsequent Danish landscape architecture. Emphasis on social equality and lifestyle in Denmark resulted in a number of new parks, housing estates and allotments, such as those at Naerum, north of Copenhagen, laid out by Sørensen in 1948, which reflect the transformation of natural and agricultural landscapes into functional design.

The importance of Japanese design was widely recognized by Finnish architect and furniture designer Alvar Aalto (1898–1976), who combined nature with architecture to link his buildings firmly with the landscape. His use of organic forms was hugely influential in the rest of Europe and also in America. Aalto's Maison Carré in Bazoches-sur-Guyonne near Paris, designed in 1959, followed the contours of the land in its angular lines with broad steps softened by plants and flowers.

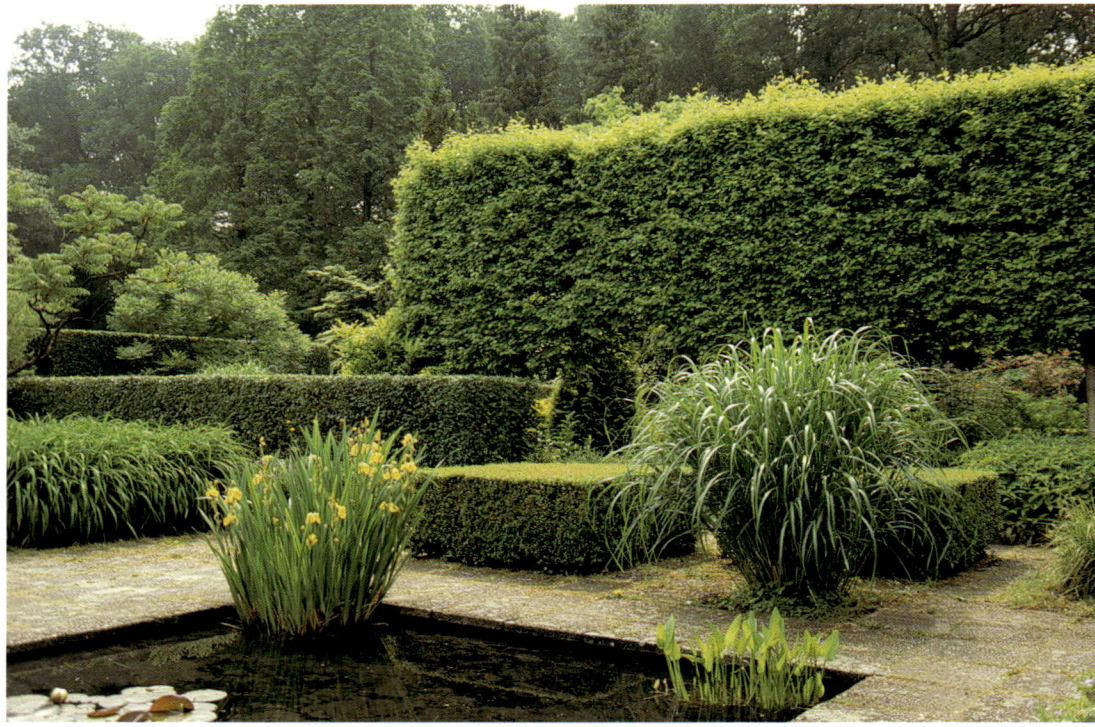

The British School

The most significant influences flowing through Britain in the early part of the twentieth century were derived in large part from the Irish gardening writer William Robinson (1838–1935), who wrote extensively about the natural flower garden, where plants self-seeded with little or no human help. His work had a widespread impact not only in Britain but also in Germany, the United States and Scandinavia. Although not new, Robinson's concept fitted with the ideals of his generation in stepping away from the formal bedding arrangements and nursery-raised specimens which had been in vogue in the late nineteenth century and allowing plants an almost free rein in governing the design.

The great British designer Gertrude Jekyll (1843–1932) blended the precepts of architectural symmetry and balance borrowed from the *Ecole des Beaux-Arts* with Robinson's concept of the wild garden to produce her own unique style, identified by magnificent borders planted in drifts of subtly graduated colour. It was a style that sat comfortably with the new patrons of garden design, the wealthy middle classes, who wished to establish elegant homes and gardens. Jekyll was a prolific writer as well as designer, and through her books her work reached a wide audience in both Britain and America. In 1893 Jekyll formed a partnership with one of the great architects of English country houses, Edwin Lutyens (1869–1944), who developed the precepts of the Arts and Crafts Movement into a distinctive domestic architectural style of his own. Although borders on the scale of Jekyll's are rarely created today – her most famous, at her own garden at Munstead Wood in Surrey, measured sixty metres long by four metres deep – her concept of colour lives on.

Other key figures in the British horticultural world were plant-hunter Ernest Wilson (1876–1930), responsible for bringing to Britain over a thousand ornamental species from intrepid plant-hunting expeditions, and Frank Kingdon-Ward (1885–1958) and his wife Jean Macklin, who introduced over one hundred new rhododendron varieties to the West from numerous trips to the Far East.

A focus on horticultural prowess meant that Britain's response to modern art was slow. Despite the fact that the fine arts had been a vital influence on British garden design for the previous two centuries, the Modernist Movement had little impact on landscape architecture, and the Arts and Crafts style retained its popularity throughout the first half of the twentieth century. There were stirrings of change, however. A small group of British landscape designers formed what today is called the Landscape Institute in 1929, aiming to promote landscape design as an art form. Architects and town planners, who were better established in their professions than landscape architects, were encouraged to join the association. One of the founding members was Geoffrey Jellicoe (1900–96), who became a driving force in raising the profile of garden design and establishing it as a recognized art form.

As well as being a great horticulturalist, Jellicoe was an influential writer who believed that Modernist and classical interpretations could be used simultaneously in garden design. Other significant figures of the time were his wife Susan Jellicoe and Russell Page (1906–85), who created magnificent

Gustav Ammann's project for the 1933 ZÜGA garden exhibition in Zurich marked a turning point in Swiss design, moving away from the rather rigid style that preceded it and introducing free-flowing shapes, curving pathways and contrasts of height and texture in the planting scheme.

The Mien Ruys experimental garden at Dedemsvaart, Holland, was founded in 1925 by the plantswoman and designer after whom it is named. Mien Ruys devoted much of her life to research into plant combinations and characteristics, establishing new ways of planting to create structure and spatial harmony. Here, iris light up a rectangular pool backed by the layers of clipped hedging that give the design its architectural balance.

Painstakingly restored from a wilderness, the garden at The Manor, Upton Grey in Hampshire, southern England, is now believed to be one of the most perfect and authentic Gertrude Jekyll gardens in existence. Designed in 1908, it exemplifies the masterful planting and colour combinations for which she remains famous. A bank of silver-blue sea holly (eryngium) is complemented by a scattering of white peonies, roses and lilies throughout the garden against a background of the gentian-blue spires of delphiniums.

gardens in the great British horticultural tradition both in England and around Europe.

One of the earliest substantial pieces of theoretical writing on modern landscape architecture in Britain was Christopher Tunnard's *Gardens in the Modern Landscape*, originally published serially in *Architectural Review* in 1937 and 1938. Tunnard defended the need for landscape architecture to work in conjunction with urban and recreational planning and put forward sound reasons to update landscape architecture in line with changing lifestyles, other art disciplines and modern science. Tunnard's writings on landscape architecture appeared comparatively late in the chronology of the Modernist Movement, yet his ideas had great significance. Since garden design throughout history had been influenced to a degree by artists, he believed that the work of contemporary painters and sculptors too should have an influence on garden design. Tunnard worked on the design of several gardens with artists such as Willi Soukop, Henry Moore and, after he had emigrated to America, with Alexander Calder.

Trans-Atlantic Currents

The publication of Tunnard's book made a strong impact on three young American designers, Dan Kiley, James Rose and Garrett Eckbo, who in 1939 wrote an article in the *Architectural Record* quoting his ideas. Kiley, Rose and Eckbo were landscape architecture students at Harvard at a time when revolutionary changes were occurring as the result of the arrival of Walter Gropius to head the school of architecture. Their enthusiasm and search for modern expressions in design caused them to reject the *Beaux-Arts* formalism that they were taught in the landscape department and align themselves with the architecture school. Their essential prerequisite for landscape architecture was to link lifestyle and site; this brought about a sea change that trans-

formed the garden from a visual pleasure ground for the display of plants into an extension of the house, integrating the garden into everyday life.

Garrett Eckbo published *Landscape for Living* in 1950, and in 1955 Californian landscape design's chief proponent, Thomas Church, wrote *Gardens are For People*, both of which helped to change attitudes towards landscaping across America and subsequently throughout Europe. Their work also challenged the theory that historical European design traditions should continue to shape contemporary garden design internationally. American landscape architects needed to break free from the limitations imposed by European models, and explore their own rich and varied heritage in order to develop independent new gardening styles.

The new principles of American design were based on robust geometric arrangements and, more importantly, the blending of interior and exterior spaces. Magazines such as *Sunset,* a popular lifestyle magazine, produced centrefolds of Californian-style gardens, as designed by Church and others, with the now iconic images of kidney-shaped swimming-pools, terraces around the house and outdoor recreational and eating areas. All these elements had an enormous influence on international garden design for years to come.

Post-War Change

In the period immediately following the Second World War, Europe embarked on an immensely ambitious building programme, creating millions of new suburbs and towns. A great many homes had a small plot of land in which to make a garden and this in turn stimulated a new interest in plants. After years of wartime deprivation in cramped city dwellings, where every available piece of land had been given over to vegetable growing, new homeowners wanted colour. Knowing little about horticulture, they nonetheless set about making flower gardens. The sudden increase in demand for nursery-produced roses and flowering plants to grow from seed led to the advent of the garden centre, which has grown into an ever-expanding business since the war.

Magazines and books provided essential information to people hungry for advice on what to grow in their new plots. Among British writers of the time were Peter Shepheard, who published *Modern Gardens* (1953), and Margery Fish (1892–1996) whose book *We made a Garden* (1956) was one of many in which she advocated the use of rare or unusual plants. Rosemary Verey (1918–2001), another highly regarded plantswoman and writer,

Thomas Church, a leading mid-twentieth-century exponent of landscape design in California, was one of the first to break away from European traditions and establish a new American style. The El Novillero garden, which he designed in 1947 for the Dewey Donnell family, stands high on a hill overlooking a panoramic view of San Francisco Bay. The free-form kidney-shaped swimming pool, which forms the central feature of the garden, was to become an icon of design throughout Europe in the years that followed.

The abstract structural elements of Ernst Cramer's 'Poet's Garden', exhibited at the Zurich garden exhibition of 1959, included grass-covered pyramids and earth cones, sculpture, a rectangular lake and a simple white chair reflected in the water. It established a decisive break from the conventions of the past and remains an important landmark for Swiss landscape architects today.

produced a number of books on horticulture and garden design which have helped to stimulate British and American interest in the subject still further. Sylvia Crowe published *Garden Design* (1958), in which she analyzed the abstract qualities of gardens, and, with Brenda Colvin, worked on the development of self-sufficient plant communities, influencing a new generation of designers such as John Brookes and Anthony du Gard Pasley.

By the 1960s architectural Post-Modernism was making its way steadily across Europe and America, prompting a reaction against the use of industrial materials such as glass, steel and aluminium and a reversion instead to more traditional building materials, while its most striking feature was its eclectic range of references to earlier styles. But questions of style and surface decoration had little to do with the environment, and a new school of thought was gradually emerging in garden design which recognized the importance of environmental science and emphasized the preservation of the landscape.

In 1962 American Rachel Carson (1907–64) wrote *Silent Spring*, in which she challenged the agricultural and landscape practices of scientists and the government. Carson sparked an uprising against pollution and the destruction of the environment, questioning many accepted farming practices and notions of industrial progress. In 1969 Ian McHarg (1920–2001), Professor of Landscape Architecture at the University of Pennsylvania, published *Design with Nature*, which examined the new thinking emerging in response to the environmental crisis: suddenly management of the landscape and control of ecological problems were seen as the top priority, with design taking second place.

Concurrently in the 1960s, creativity in a different but nonetheless connected form was taking place in the deserts of America. Among the greatest influences on modern landscaping were the exponents of Land Art, who rejected the confines of the gallery in favour of the wide open spaces of the Mid-West. Land Art was site-specific, influenced by and created for a location, and it sought to present features of the landscape as artistic images in themselves. It thus drew attention, whether directly or otherwise, to the value of our natural heritage and the dangers posed to it. As part of the move towards a greater awareness and concern for the environment, a handful of architects, including American James Wines and his company, SITE, and Emilio Ambasz, began to explore sustainable building practices, alongside the American land artists Michael Heizer, Nancy Holt, Walter De Maria, James Turrell and Robert Smithson. In Europe, Richard Long produced a number of dramatic pieces of Land Art, while sculpture was also focusing interest on the landscape through the work of Henry Moore, Barbara Hepworth, Ben Nicholson and others.

In 1964 The Museum of Modern Art in New York published *Modern Gardens and the Landscape* by Elizabeth Kassler, a seminal work that brought together the finest achievements in landscape architecture of the Modernist Movement. It highlighted the work of three international designers whose imaginative and daring new ideas in landscaping were to prove lastingly influential: Brazilian artist and landscape architect Roberto Burle Marx (1909–94), Mexican architect Luis Barragán (1902–88) and Japanese-American sculptor Isamu Noguchi (1904–88).

Burle Marx's talents lay in his free-flow planting schemes using large swathes of plants in bold, dramatic curves. His style blended seamlessly with the Modernist architecture introduced to Brazil by Le Corbusier and others. Barragán was a traditionalist in his perception of the garden as a peaceful sanctuary, a personal refuge, but his designs employed architectural features, particularly walls, to great dramatic effect. His work was celebrated in 1974 in an exhibition titled 'The Architecture of Luis Barragán', held at the Museum of Modern Art in New York and mounted by Emilio Ambasz, then Curator of Design. In his innovative work, Noguchi explored differences in the treatment of landscape in the art of the East and West, and was captivated particularly by the idea of 'sculpting' space. His first major garden commission was for the UNESCO Headquarters in Paris, designed between 1956 and 1958, which incorporated a large stone sculpture inscribed with the Japanese calligraphic symbol for 'Peace'.

Modern France, Switzerland and Austria

Established in the late 1970s, the Ecole Nationale Supérieure du Paysage at Versailles became a landscape think-tank from which many new design concepts emerged in the decades that followed. The development of the school at Versailles coincided with the French government's new policy towards landscape design and the resulting proliferation of public commissions. Landscape architects were re-invested with much of the importance they had had in previous centuries and found themselves called upon to design new, high-profile public spaces.

A new confederation was formed to recognize the dialectical relationship between landscape and public space and to encourage designers to create projects adapted to specific locations. Principle among those who helped to realize this aim were Michel Corajoud, Alexandre Chémétoff and Christophe Girot. Others were to follow: the design team of Michel Desvigne and Christine Dalnoky; Jacqueline Osty; Emmanuel Jalbert of Agence In Situ, in Lyon; Gilles Vexlard and Laurence Vacherot of Latitude Nord.

Prompted by a political desire to remain one of Europe's most beautiful and talked-about centres of culture, France engaged in a number of vast urban development projects in the 1980s, and manifested what is possible when politics, administration and the community join forces with talented designers and architects and leave design initiatives to the professionals. From this impetus emerged the striking Paris designs by Bernard Tschumi for Parc de La Villette and by Gilles Clément and Alain Provost for their respective halves of the Parc André Citroën. Here, Clément developed his ideas on the 'Jardin en Mouvement', in which he promoted the use of fallow land for the planting and self-seeding of wild flowers, an initiative which has helped to bring about a radical change in garden design in recent years.

Until relatively recently Switzerland had no recog-

In his 1950s garden design for the UNESCO Headquarters in Paris, Isamu Noguchi drew on both his Japanese inheritance and the influences that informed his work as a sculptor to produce a scheme that combines spatial balance with graphic detailing. The large totemic stone (right), which stands in a rectangular pool, is carved with the Japanese calligraphic symbol for 'Peace'; a central feature of the upper section of the garden, it can be seen near the top right of the main picture.

nized university courses in landscaping or garden design, and gardens were consequently designed by people with diverse backgrounds, unrestrained by a horticultural or architectural education. As a result perhaps of this lack of controlling influences, gardens ranged from the ultra-modern to those inspired by nature and ecology, freely borrowing from a range of traditions and lifestyles, those in the south from the countries of the Mediterranean, those in the north from more puritan Germany. The mainstream continued along Modernist lines, highly innovative and adventurous in both design and the use of materials.

However, in the 1950s Ernst Cramer (1898–1980) established a new Swiss landscaping style that still remains influential today. For the Zurich garden show of 1959 he designed 'The Poet's Garden'. Now considered a seminal work, its abstract pyramids and geometric forms dramatically extended the vocabulary of Swiss garden design. The new direction established by Cramer was succeeded more recently by Dieter Kienast (1945–98), whose projects were characterized by open central spaces and clean, unambiguous lines.

Likewise in Austria, architects such as Hans Hollein and Roland Rainer bring ideas to the landscape forum, with artists Mario Terzic and Walter Pichler, whose experimental work in the 1960s used polyester, Plexiglas, PVC and aluminium to create objects in the landscape. Their contributions helped to establish landscape architecture as a serious art and academic discipline, moving away from the perception of landscape design as simply an aesthetic. Since the 1990s, landscape architects Andrea Cejka, Sepp Kratochwill, Maria Auböck and János Kárász and others have gained international recognition.

Swiss garden design is currently being led by landscape architects such as Roland Raderschall and Sibylle Aubort Raderschall, Stefan Rotzler, Paolo Bürgi, Guido Hager and Eduard Neuenschwander.

Per Friberg's 1977 Görlväln burial chapel and cemetery in Järfälla, near Stockholm, is a clear-cut, linear design, quintessentially Scandinavian in style, in which the architecture of the buildings and the long, stepped rill blend homogeneously with the slopes of the landscape.

Kathryn Gustafson established a readily identifiable style in the gardens she designed for the French corporate and public sectors, combining the natural flow of the land with strong planting schemes. Her design, completed in 1992, for the Shell Headquarters at Rueil-Malmaison on the Ile-de-Seine, combines the natural flow of the land with architectural shapes.

Among Swiss architects engaged in important landscaping projects are Jacques Herzog and Pierre de Meuron, Mario Botta, Peter Zumthor and Georges Descombes, who designed the park at Lancy near Geneva and part of the Swiss Path around Lake Urner, a collaborative project from twenty-six cantons to mark Switzerland's seven hundredth anniversary in 1991.

Mediterranean Europe
While Switzerland embraced the concepts of the Modernist ethos, Italy gave it a cool reception. Its fabulous heritage of Roman, Renaissance and Baroque design was difficult to push to one side, especially while it was endorsed by the ruling Fascist regime. The classical use of symmetry, proportion and volume continued to be incorporated into new Italian design up until the end of the Second World War, but by the 1950s a few architects had begun to break with tradition. One of a handful of examples of modern design was the 'Children's Labyrinth', designed for the Tenth Architectural Triennial in 1954 by Banfi, Belgiojoso, Peressutti & Rogers, a partnership set up in Milan in 1932. Rejecting many of the traditional aspects of their architectural training, they incorporated ideas from Walter Gropius, Le Corbusier and Mies van der Rohe into their designs whilst still retaining traces of Italian classicism. The result was some of the most pivotal works of the period, showing a subtle blend of traditional architecture with original modern design.

The most significant figure in twentieth-century

A bronze sculpture by Francisco López Hernández depicting a figure lying face down on a raft makes an imaginative addition to the lake, enhancing its air of stillness and serenity, in the gardens of the Villa Cecilia in Barcelona. A screen of vivid magenta bougainvillea stands out against the dense yew hedging along the edge of the water. Laid out in 1982–3, the gardens were designed by Spanish architects Elías Torres Tur and José Antonio Martínez Lapeña.

Italian garden design was Pietro Porcinai (1910–86), whose design doctrine advocated harmony between the built and the natural environment. Porcinai's planting schemes rejected the rigid formality of traditional Italian gardening style in favour of free-form shapes that embraced the surrounding countryside. Other key figures of the time were architect and designer Carlo Scarpa (1906–78), who in 1973 designed the emblematic 'Garden of Rest' at San Vito d'Altivole, north of Milan, and architect Gae Aulenti. Her brilliantly confident restructuring of the garden of the Villa Pucci in Tuscany, seamlessly combining Renaissance ideals with Modernist theories, helped to launch Italian landscaping into a new age.

Urban designers too have inspired Italy's traditionalism with new life and energy, as can be seen in the planning of public parks such as the Parco Amendola in Modena by Cesare Leonardi and Franca Stagi and the Parco della Fontana del Diavolo by Massimiliano Fuksas and Annamaria Sacconi. Alongside an active interest in restoration there is a growing concern with ecological issues in Italy, manifested in the sustainable urban designs of Guido Ferrara and Giuliana Campioni, for whom ecology is the basis of design. Other urban planners and landscape architects, such as Franco Zagari, Ippolito Pizzetti, Gilberto Oneto and Giovanni Sala, are demonstrating that Italian garden design can continue to value and exploit its immense heritage and at the same time break free of the restrictive weight of tradition that has until relatively recently tied it to the past.

In Spain too, modern developments were slow in coming. Until the 1970s, landscape architecture played no significant role in terms of either practice or education: largely stagnant throughout the early part of the century, it had relied heavily on the reproduction of English-style parks, although it did see a revival when French architect J.N. Forestier (1861–1930) was brought to Spain by King Alfonso XIII to plan new parks. Inspired by the Moorish paradise gardens, the Alhambra and the Generalife, Forestier laid out gardens in a series of compartments using local materials in angular modern forms. These were not revolutionary in style but did represent a new development in garden design. His Spanish masterpiece was the Montjuic Park in Barcelona.

The work of landscape architects had mostly been carried out by urban planners, architects, biologists or engineers. However, social reforms carried out in the 1970s meant that Spain's public areas began to receive similar attention to those of France, and plans for open spaces were developed on a previously unimaginable scale, drawing attention for the first time to Spanish landscape design as an independent discipline and earning worldwide acclaim. The Olympic Games in Barcelona in 1992 also proved a major catalyst for change, and since then the city has been an experimentation ground for new ideas in landscape architecture. It continues to be viewed as a model of urban planning regeneration, alongside Seville, Madrid, and Valencia, all of which have sponsored similarly innovative building and park design programmes.

A new park prototype, the Parc del Poblenou, which responded to the requirement for both formal and informal public spaces, was developed in Barcelona in 1992. Designed by Xavier Vendrell and Manuel Ruisanchez, it has opened up the harbour front so that the city can again focus on the view of the sea, much of which had become blocked by ugly modern buildings, with paths through the park following the contours of the wave-like dunes that run parallel to the shore. Olga Tarrasó and Jordi Henrich completed the award-winning design for the seafront in 1997.

Other new Barcelona parks and gardens include Parc de l'Estació del Nord by Andreu Arriola and

Carmen Fiol, where a Beverly Pepper sculpture is one of the principal features; the gardens of the Villa Cecilia, designed by Elias Torres Tur and José Antonio Martinez Lapeña, which also integrate works of art with the landscaping; the Fossar de la Pedrera memorial park, designed by Beth Galí; and Enric Miralles's Igualada Cemetery to the north of the city, which is a marvel of architectural design.

Urban planning, landscaping and architectural skills were all required for the design of the Parc del Nudo de la Trinidad, the work of architects Joan Roig and Enric Batlle, in order to fit the plan to its location in the middle of a motorway junction. Similar constraints led the design for the Parc del Clot, where an old railway site with a viaduct was transformed by Dan Freixes and Vincente Miranda.

In the private sector, Spanish landscape architects have proved themselves both innovative and appreciative of their cultural heritage: Fernando Caruncho in concentrating on the inherent qualities of the site, Manuel Colominas in exploiting the garden's potential for sensual delight and Teresa Galí in shaping gardens by natural means as opposed to human intervention. Bet Figueras, who designed the masterly Barcelona Botanical Gardens in 2000, has produced a number of brilliantly imaginative planting schemes for buildings designed by Oscar Tusquets Blanca, including the garden for the architect's own villa outside the city.

It was, however, still down to architects to design, reshape and regenerate much of Spain's urban landscape, and it was not until 2000, under the persistent guidance of Rosa Barba, that Spain's first professional landscape architecture degree was established.

Such initiatives clearly give an enormous impetus to the development of garden design, and to its recognition as a serious artistic discipline. In Portugal, for example, an injection of new blood was provided by the introduction of the landscape degree course established in Lisbon in 1945 by Professor Francisco Caldeira Cabral. During the 1960s Portuguese concerns about the environment and the reduction in economic resources fostered the development of models for the design and management of urban areas. The focus today is still on innovation in public landscape design: Manuel Sousa da Camara is studying sites in the south whose hydrological features may help to provide Portugal with the resources necessary to build urban parks, while Luis Manuel dos Santos Cabral is a leading light in the shaping of Portugal's urban fabric.

Northern European Expansion

Regeneration on a dramatic scale has taken place since the Second World War, especially in northern Europe, where vast rebuilding projects have altered the face of many cities. In Rotterdam, a need for expansion has been met by new urban planning schemes employing state-of-the-art technology in order to build on land reclaimed from the sea. Competitions inviting landscape designers, urban planners and architects to submit ideas for public parks

A trans-Atlantic collaboration between the American design company of Martha Schwartz Inc and German landscape architects Büro Kiefer won the Lehrter Bahnhof competition in 1999 to design a plaza for a new railway station in Berlin. Now under construction, one of the main features of the plaza will be a fish tank, eighty metres long and five metres wide, filled with native fish from the nearby River Spree. At one end of the tank a bulletin board will give regular up-dates on the state of the Spree water, thus alerting the public to pollution levels in the city's main river artery.

Jacques Wirtz's talent for creating abstract hedging shapes as soft and malleable in appearance as a natural sponge, carried forward the revolution begun in Belgium by René Pechère in the 1950s, when for the first time the hedge was treated as a feature of the garden rather than simply a structural division or perimeter screen.

and housing developments have helped to foster the development of radical and exciting ideas. Among the design practices that have thrived in this productive climate are West 8, under the auspices of Adriaan Geuze, MVRDV and Winy Maas, Mecanoo, Buro B+B, Lodewijk Baljon and ex-West 8 founding partner Paul van Beek. A number of Dutch and international design studios run by recently graduated designers have also been established in Rotterdam, a city perceived to be more receptive to new ideas and more willing to fund new projects than many other European centres.

Garden design is also flourishing across the broad flatlands of the Netherlands, with designer and nurseryman Piet Oudolf leading a resurgence of enthusiasm in perennial planting schemes. Oudolf's gardens are now known internationally for their great architectural value throughout the year.

Like Holland, Belgium's northern landscape is flat and open to the sky, needing barriers against the natural elements in order to grow crops or make a garden. This necessity has given rise to a feature which now exerts an important influence on modern garden design. The clipped hedge revolution began in the 1950s with Belgian designer René Pechère, whose public spaces and private gardens combined the use of the classical axis and vista with new and imaginative design. Jacques Wirtz developed these concepts, moulding hedging to the landscape in a way that created sculptural shapes and movement and transformed a once rigid symmetrical layout. Modern landscape design, led by Christian Vermander and Thomas Van Mol of 'buro voor vrije ruimte', Erik Dhont and urban designer Lucien Kroll, is flourishing in the economic resurgence that began in northern Belgium in the last decades of the twentieth century.

German reunification also led to a massive rebuilding and development programme, attracting a number of international landscape architects to collaborate with their German counterparts and a host of architects and urban planners. Rarely do opportunities occur for rebuilding on such a grand scale and the list of participants now reads like a veritable 'Who's Who' of the global design world. Berlin's urban landscape schemes, still largely under construction, will not gain exemplary design status until completed though they are already generating considerable interest worldwide.

Selected by international competition, Swiss landscape architects Luzius Saurer and Toni Weber designed the Spreebogenpark; DS landscape architects from Amsterdam devised the acclaimed scheme for Potsdamer Platz, constructed in 2002 and 2003; and American landscape architects Martha Schwarz Inc. has teamed up with German landscape architects Büro Kiefer to design the area immediately surrounding Berlin's Lehrter Bahnhof central railway station, complete with an impressive aquarium in the plaza area containing fish native to the nearby River Spree.

Elsewhere in Germany too, urban landscape architecture is moving in exciting new directions under the influence of Peter Latz, who created the award-winning Landscape Park Duisburg Nord, and the studios of Stefan Jäckel and Tobias Micke of ST raum A., Stefan Tischer, Kamel Louafi – designer of the Expo 2000 Hanover parkland –, Topotek 1, Häfner/Jiménez and Jürgen Weidinger.

Alongside this urban renewal programme, research into natural planting techniques continues in Germany's universities and nurseries, with experimentation in ecology, wild flower planting and the use of indigenous plants. Trial gardens at Weihenstephan, established under the guidance of Professor Richard Hansen of Bavaria's Technical University, are investigations of plant sustainability and have influenced the perennial planting schemes of landscape architects Brita von Schoenaich, now working in Britain, and Rosemarie Weisse, who designed the Westpark housing area in Munich. As well as carrying out valuable scientific research, Germany's academic landscape architecture programmes deserve praise for integrating design with such practicalities as planning permission requirements and the acquisition of resources to fund contractors.

Contemporary Britain

Following in Jekyll's footsteps are a number of eminent British horticulturists. Among them are Christopher Lloyd, a champion of unusual plant associations and positioning; Beth Chatto, whose investigations into plant origins have led her to create a remarkable gravel garden within her larger garden and nursery in East Anglia; and Penelope Hobhouse, who continues the tradition of horticultural expertise through both her practical work and her writings. A younger generation of designers includes Dan Pearson, whose planting schemes highlight the current awareness of the value of the natural landscape; Modernist architect and garden designer Christopher Bradley-Hole; Anthony Paul,

Deep island beds appear to float above the ground in Beth Chatto's gravel garden laid out in 1987 near Colchester in eastern England, where perfectly balanced compositions provide interest all the year round: here, flowering Yucca gloriosa *towers above clumps of Mexican feather grass (*Stipa tenuissima*) with* Allium sphaerocephalon *and verbascum spires contributing contrasts of shape and colour.*

Commissioned by English Heritage in 1986, Mark Anthony Walker's latticework design for the Contemporary Heritage Garden at Bishop's Palace, Lincoln, takes its inspiration from the geometric lines of the nearby vineyard, one of the oldest in Europe, and the architecture of the great eleventh-century cathedral.

whose work at the Hannah Peschar Gallery in Surrey combines landscape design with modern art; Baines and Hooftman of Gross. Max. in Edinburgh; and Kim Wilkie, whose land forms and sustainable landscape ideas are having a widespread influence on urban renewal projects.

English Heritage, a government body protecting the best of the country's legacy of historic buildings, landscapes and archaeological sites, has recently commissioned ten contemporary gardens for historic locations from Britain's leading garden designers. The Contemporary Heritage Garden Initiative was launched in April 1999 and in the first phase Isabelle van Groeningen designed 'the South Moat' at Eltham Palace and Rupert Golby 'Queen Victoria's Walled Fruit and Flower Garden' at Osborne House on the Isle of Wight. The second phase included the 'Medieval Terrace Garden' at the Bishop's Palace in Lincoln, designed by Mark Anthony Walker, and 'The Cockpit' at Richmond Castle, North Yorkshire, by Neil Swanson. Future projects include the nineteenth-century 'Governor's Garden' at Portland Castle in Dorset and the 'Wilderness Garden' at Witley Court in Worcestershire, intended as a setting for contemporary sculpture. Not only is this initiative a showcase for the imaginative work of the designers; it also offers inspiration for new ways in which traditional architecture and modern garden design can be brought together.

Modern Scandinavian Trends

In Sweden the landscape is very much considered to be everybody's garden, and landscape architecture is traditionally based on the adaptation, enhancement and embellishment of what is already there. In reality, Sweden inverted the idea of the paradise garden: instead of paradise being inside the walled garden in accordance with traditional thinking, the wonder of nature is outside the walls and is seen as the principal object of desire. Designers who are carrying this concept forward are landscape architects Per Friberg and Thorbjörn Andersson, artist Monika

Concerned as much with the space around an object and its relationship to the landscape as with its physical substance, Swiss sculptor and landscape architect Jürg Altherr created Ich und Du *(Me and You) in 1996–7. They are made of reflective, zinc-coated iron sheeting, each piece measuring nearly three-and-a-half metres square. The installation dominates its location, on the edge of an area of private woodland near Zurich.*

Landscape architect Martha Schwartz caused a design sensation in 1979 with her 'Bagel Garden', a satirical variation on the traditional parterre. In an existing formal garden in Boston, USA, she laid out ninety-six bagels, glazed and waterproofed, in an ordered row on aquarium gravel with purple ageratum between the rectangles of boxwood hedging.

Gora and educator Tiina Sarap-Quist, whose initiatives are inspiring a new generation of landscape architects and planners

Studying at Harvard in the early 1960s, Per Friberg was initially influenced by the design ideas of Kiley, Eckbo and Rose and later by the ecological designs of McHarg and Lawrence Halprin. On returning to Sweden, Friberg combined his overseas education and earlier studies in Sweden and Denmark with his own individual talent for creating naturalistic designs on a larger scale than had normally been seen in Scandinavia. His 1977 design for the Görlväln Burial Chapel and Cemetery, set in rolling landscape in Järfälla outside Stockholm, is simple in concept, with strong, graphic imagery. A rill several hundred metres long runs from a well at the top of a mound, where the memorial grove is located, to a lake by the chapel. The rill is stepped to enhance the effect of reflected light in the water. In a manner reminiscent of Frank Lloyd Wright, Friberg's clarity of vision and integration of the architecture with the topography of the site continues to influence modern Swedish designers.

An inherent affinity with nature has shaped landscaping traditions in Finland and Norway as well as Sweden, and has meant that the role of the garden designer has been seen principally as the protector of an existing landscape. With most urban projects designed by horticulturists rather than landscape architects, the design of Finnish parks has until recently lacked artistic flair, but this is now slowly changing with the acceptance of landscape architecture as both an art and an academic discipline, led by designers such as Tom Simons. Norwegian landscape architects are aiming to balance careful ecological management with imaginative and experimental landscape design, and designers and educators such as Ole Bettum, Arne Saelen and Bjarne Aasen are providing inspiration for this impetus.

Denmark is the exception to the Scandinavian open-nature policy. Here, the landscape is geometric and angular and, when viewed from above, the coun-

try is a tapestry of hedges dividing farmland and gardens, differing completely from neighbouring Sweden with its vast tracts of forests. One of Denmark's most influential designers is Sven-Ingvar Andersson, Carl Theodor Sørensen's assistant while he was Chair of Landscape Architecture at the Royal Danish Academy of Fine Arts from 1959 to 1963. Andersson takes the view that there must be a clear distinction between what is artificial and what is natural, and that simple, unpretentious solutions to the use of space and volume should be the basis of a garden's design, with ecology a significant factor. Together with designers such as Steen Høyer, Stig L. Andersson and Jeppe Aagaard Andersen, Sven-Ingvar Andersson is receptive to fresh ideas and influences, and his work demonstrates the simplicity and open-mindedness that is a hallmark of Danish design.

Both in the United States and in Europe, new influences are constantly being brought to bear on the theory and practice of garden design, injecting it with new vigour and giving rise to new forms of creative expression. The interchange of ideas between the two continents is now stronger than ever. In America, the universities of Harvard, Pennsylvania and Berkeley remain at the forefront of design teaching today, instigating healthy discussion of the theory and meaning of garden design and encouraging the spread of new initiatives. Since the 1960s ecological and topographical research has helped them to do this, and, under the guidance of Carl Steinitz at Harvard University, to establish an environmentally based school of American garden design.

Though the riches handed down through history are invaluable, the fundamental human need for self-expression will always ensure that new garden designs are in no way mere restorations or copies of ancient ideas. Each may pay tribute, though not always consciously, to historical precedents, but every good designer has a personal vision and originality is essential to its expression.

Recent European unity has helped to cross-fertilize ideas on garden design and landscaping but it is certainly not producing a uniform design dictum and thankfully never will. There are too many factors militating against the adoption of a pan-European style. Variations in climate, light, soil conditions, indigenous flora and landscape will continue to shape the gardening styles of individual countries, as they have always done, and differences in national lifstyle and attitudes, political agendas and, of course, design traditions will ensure that national and regional diversity will always be maintained. The one factor that will for ever be held in common is a reliance on the principles of good design, as the following chapters demonstrate.

The view looking towards Øresund is a feature of the garden designed by Lea Norgaard and Vibeke Holscher for the Louisiana Museum of Modern Art at Humlebaek in Denmark, which stands on the site of a nineteenth-century hunting park. Henry Moore's Reclining Figure Number 5 *(1963–4) is placed strategically at the water's edge.*

New Designs on Classic Themes

'Mother and Child' by Heather Ackroyd and Dan Harvey (1989). By shining light through a transparency, the artists reflected the figurative image onto a tray of grass seed in a bed of clay, their objective being to create an entirely organic work of art using the natural process of photosynthesis. The growth rate of the grass and the amount of chlorophyll it produces are directly related to the amount of light it receives, so the image is not simply translated to the surface of the plant but also affects the organisms on a molecular level.

A skeletal oak tree in the parkland at Wilton House in southern England was the subject of experimental work carried out by British artists Heather Ackroyd and Dan Harvey for the Salisbury Festival of 1999. Grass seed was sown in a clay mixture and moulded around the trunk and branches, temporarily investing the tree with a semblance of life.

Gardens are the product of centuries of tradition and experience and, as such, they serve as treasure houses of inspiration to be valued, enjoyed and freely plundered over succeeding centuries.

Since earliest times there have always been two categories of garden: one wild and mythical, the other domesticated. The ancient Egyptians, Persians, Greeks and Romans regarded certain natural clearings, woods and valleys as having a spirit of their own, which they believed was given by the gods. Such areas of untamed landscape were seen as mythical gardens and translated into folklore. Among the most celebrated were the Garden of the Hesperides, with its guardians of the golden apples, Homer's Garden of Alcinous, an island kingdom beloved by the gods, and the Elysian Plains of his epic *The Odyssey,* eulogized by William Wordsworth in his 'Departure from the Vale of Grasmere' (1803). Likewise, poetic images of eternal spring and the myth of the Golden Age, when man lived without law, war or toil, gave inspiration to later generations of garden makers searching for Arcadia, the epitome of beauty and tranquillity.

The domestic category was subdivided into a variety of garden typologies, often laid out symmetrically along geometric lines and including walled gardens for retreat and contemplation, gardens for the growing of plants for food and pleasure gardens for the rich and powerful.

The people of ancient Persia created walled enclosures in their desert settlements and divided them into squares by means of watercourses; called *chahar bagh,* literally quartered gardens, these came to represent the *paridaeza* or paradise garden – a walled oasis of plants and water that kept the wilderness at bay. Dating from 2000 BC, these gardens remained the model for the paradise garden through the centuries, interpreted and later elaborated in Moghul India and Moorish Spain. At the centre of the paradise garden was a spring that fed water to irrigation channels running north, south, east and west, symbolizing the four rivers of paradise, each quarter of the garden again subdivided into smaller sections.

The Egyptians planted trees and flowers around a perfectly symmetrical central pool, a formal layout

Galvanized steel pergolas give a contemporary feel to an inner city courtyard garden in Amsterdam, designed in 1999 by Lodewijk Baljon in collaboration with artist Marlène Staals. Thirty metres square, the space is dominated by the two frameworks, one higher than the other, which support apple trees trained over the top of them to form an undulating canopy of greenery. The garden was designed to be seen from the upper floors of the building.

that continued into the cloister gardens of the Middle Ages and the courtyard gardens of France and Italy, which served for the growing of fruit and vegetables as well as ornamental plants. Mazes and labyrinths are recorded in Egyptian tomb paintings and also at Knossos on the island of Crete.

The Greeks had a garden vocabulary that included words for colonnade, pergola and fruit orchard, adopted later in the Roman villa gardens with the addition of trellises, covered walkways, atriums and elaborate topiary work.

Hero of Alexandria wrote a book called *Pneumatica* around AD 100 which described ingenious and intricate garden fountains and water works, while at around the same time Roman writer Pliny the Younger documented in detail the layout of the Roman pleasure villa, including the elaborate water gardens created by expert Roman water engineers.

These traditional elements re-emerge in late sixteenth-century Italian villa gardens, such as those of the Villa d'Este and Villa Lante, which in turn influenced many other European gardens.

In China and Japan, garden design was based on a perception of the rhythms of nature rather than geometrical abstraction, and reflected the Buddhist view that people are part of a universal nature. Symbolic trees and rocks were traditional elements of the ancient Chinese garden as far back as 500 BC.

Classic Japanese gardens also adopted the essential elements of the landscape and reinterpreted them in stylized form, regarding the garden as the essence of beauty and communion with nature as a path to spiritual growth. At the garden of the Ryoanji Temple in Kyoto, designed in 1450, fifteen rocks were arranged on a surface of white pebbles in such a way that only fourteen were visible from any

French landscape architect Camille Muller used a blend of oriental influences and English cottage garden traditions to create a romantic haven from the inner city in this Paris courtyard garden. The slender canes of bamboo form a delicate archway over the path to the house.

Belgian landscape architects 'buro voor vrije ruimte' incorporated the ageless form of the spiral into a modern design for a clipped privet hedge (Ligustrum vulgare 'Atrovirens'), the 'Spiral of Archimedes', in this garden at Wortegem-Petegem in Belgium in 1981.

angle; only the enlightenment achieved through Zen Buddhist meditation allowed the last invisible stone to be seen by the mind's eye. The Ryoanji garden continues to be hugely influential today, both in terms of its use of hard materials and because the principles of its design offer an elixir to combat the stresses of modern life.

It is from these roots that most of the world's gardening traditions have grown and developed throughout history, and contemporary gardens are an extension of that evolutionary process, the best of them carrying their inheritance forward with an understanding of its history and origins as well as the means to adapt it successfully to modern needs. The fusion of the old with the new, reinterpreting ancient ideas in a wholly new guise – using all the facilities available to gardeners today – offers the opportunity for the best of both worlds.

Modern Applications

One of the earliest forms of roof construction in places devoid of timber is seeing a marked revival today because it is based on techniques that perfectly accord with modern thinking in regard to the environment: the sod roof provides an effective, ecologically sound form of insulation but also an excellent way of camouflaging a building so that it blends seamlessly with the landscape.

French architect **Jean Kling** wished to create an environment which totally unified living space and landscape on a remote and beautiful twenty-hectare site surrounded by the Orléans Forest, about 120 kilometres south of Paris. La Triballe stands in a clearing next to the most isolated part of the forest, where boar and other wild animals are more in evidence than people. A two-hectare lake was dug, the excavated earth being used to form low hills around the lake shore, which act as barriers between the house and neighbouring agricultural buildings.

The ground floor of the house is protected from the water by these artificial contours, while access to the lake from the boathouse in the basement is provided by an opening in the banks sloping down through the marshland. The house is angular and geometric and wears a coat of vegetation on its façades and roof, adopting the colours of the surrounding countryside with the changing of the seasons. Chestnut wood trellises allow climbing plants to grow unhindered and unclipped onto the roof so that they become as much part of the house as the house is part of the garden.

Climbing up the trellises are roses, clematis and honeysuckle, each façade planted with specific varieties to make the most of the different lights. To the south, luminous yellow blooms of *Rosa* 'Mermaid', profuse *R.* 'Phyllis Bide' and double-flowered pink *R.* 'Aloha' grow with evergreen *Clematis armandii* and *C. orientalis* subsp. 'Orange Peel', while a vine (*Vitis* 'Brant') climbs to catch the hot summer sun along the brick-pillared pergola extending towards the lake. Around the main entrance grows a profusion of satin-pink *Rosa* 'New Dawn' and *R.* 'Francis E. Lester', while the blush-tinted flowers of *Rosa* 'Madame Alfred Carrière' mix with vigorous evergreen honeysuckle *(Lonicera henryi)* on the north façade.

On this side of the house is a high bank made from earth excavated from the lake and planted by landscape gardener Jean-Pierre Benet of Saint-Cloud with a self-sustaining collection of ornamental grasses: among them are purple-silver *Miscanthus sinensis* and fountain grass *(Pennisetum alopeuroides),* interplanted with green spikelets of *Panicum virgatum.*

Jean Kling ensured that La Triballe, in the Forest of Orléans, was immersed in its natural surroundings by cladding both the roof and the walls of the house with vegetation. Chestnut trellising supports a range of climbing plants whose colours change with the seasons and help to provide camouflage. The large lake is edged with reeds and water plants that offer a habitat for wildlife.

The north walls of the house are festooned with climbing Rosa *'Madame Alfred Carrière', clematis and evergreen honeysuckle. Self-sustaining grasses, including the purple-silver* Miscanthus sinensis, *fountain grass* (Pennisetum alopeuroides) *and* Panicum virgatum, *cover a mound created by the excavation of the lake in a section of the garden designed by Jean-Pierre Benet.*

The ecologically sound sod roof is a thick carpet of perennial plants and grasses, chosen to withstand extremes of wet and drought. The climbing plants cladding the walls spill over the top of the trellising onto the roof, masking the geometric angles of the house.

A sweeping track flanked by evergreens leads from the garden into the Orléans Forest at La Triballe.

To the east, twenty swamp cypresses *(Taxodium distichum)* protect the bedrooms of the house from the summer sun and, once the leaves have fallen in autumn, let in the soft winter light. To the west, a regularly spaced line of hornbeams *(Carpinus betulus)* acts as the visual connection between the garden and neighbouring fields.

The roofing system, covering 225 square metres, is made of steep-pitched panels and consists entirely of organic materials. Kling collaborated with French company Soprema to create a fully insulated sod roof which forms a perfect marriage between the architectural design and the environment. In contrast with the ancient creators of such roofs, Kling was able to apply modern materials and technology to his design.

The roof is made of wood and concrete with a base layer of recycled plastics that form the substratum anchoring material. The vegetation is planted as seed, taking a year to sprout and develop a firm root system, and is temporarily held in place by biodegradable nets that also help prevent erosion. The thickness of the whole substrata is just twelve centimetres and the growing medium is a mixture of volcanic rock, minerals and organic matter. The plants are hardy species that can withstand both long periods of drought and extreme wet conditions and include a pale green mat of *Sedum acre, S. album* with its cigar-shaped leaves and *S. rupestre,* grasses such as blue-grey needle-leaf *Festuca glauca* and the perennials *Sanguisorba minor,* with slender stems of purplish flowers, abundant pink-flowering Tumbling Ted *(Saponaria ocymoides)* and cerise-pink *Dianthus deltoides.*

Planted between 1991 and 1994, the trees and shrubs are beginning to acquire enough volume to clothe the angles of the house. Walks laid out through the garden are made interesting by changes of direction and viewpoints set up along the way, enticing one to venture on in order to reach a particular object in sight and then to follow a new direction, lured by some further attraction. The overall effect achieves Kling's aim, namely to elongate the view into the distance and create a living space sympathetic to the natural landscape.

In Spain, the garden tradition is a highly complex mix of Christian, Jewish and Islamic influences, combined with those of the Moorish paradise garden which was well adapted to the need for shade. Then, as now, trees and pavilions offered protection from the sun, flowers stimulated the senses of sight and smell and fountains added the refreshing sound of water and cooled the air. The Spanish garden often consisted of a series of courtyards overlooked by shady galleries, thereby effectively increasing the living area of the house. In hot climates this layout

Fernando Caruncho's design for his own garden near Barcelona is a modern interpretation of the Spanish patio, with its central pool and perimeter walkway around an open courtyard. Steps lead up to the entrance doors, breaking the double line of clipped escallonia hedges that form a rectangular frame round the courtyard and complement the geometry of the house. The ochre-orange walls of the building blend with the autumn colouring of trees that border the garden beyond the courtyard.

offers the perfect balance of indoor and outdoor spaces, and is reinterpreted by Spanish landscape designer **Fernando Caruncho** in his own villa garden near Barcelona, which he designed in 1988–9.

Caruncho is considered one of the most innovative and inspiring of contemporary landscape architects, with the rare talent to capture the essential character of a site. Following his tenet that gardens must be lived in, this one is a haven for his family. Protected by a forest of holm oaks *(Quercus ilex)*, strawberry trees *(Arbutus unedo)*, bamboo *(Phyllostachis aurea)* and dark-leaf bay *(Laurus nobilis)*, the villa is an alliance of the traditional and the modern. The villa and central garden area follow a centripetal plan enclosed by a painted rich orange ochre wall. An outer courtyard is planted with a rectangle of *Stachys byzantina,* its woolly grey leaves forming a dense welcome mat with whorls of tiny mauve-pink flowers on leafy spikes through the summer. A flight of steps leads up to heavy wooden entrance doors flanked by troughs, some filled with water, some with gravel, which extend round the courtyard and frame the pool. Lining the walls are dense, clipped hedges of *Escallonia rubra* var. *macrantha*, its bright green leaves forming a dense mat covered throughout the summer in tubular, deep red flowers.

Inside the villa, the garden presents a clear spatial and geometric whole. The square shape of a central pool matches the outer walls, following the earliest representation of the mediaeval cloister gardens, designed for recreation and contemplation. Here, Caruncho designed the walkway around water, equally as contemplative, and also acting as a shaded link between the pool and the surrounding villa.

Linking one side of the house with the courtyard is a pergola which forms a shady, covered walkway round three sides of a terrace. Its roof is covered in *Wisteria sinensis, Trachelospermum jasminoides* and climbing *Rosa* 'Mermaid', whose large, luminous, light yellow blooms scent the air through the summer months, and beneath its stone piers are sweet-scented roses in large ceramic pots.

The garden extends on the other side of the house to a further expanse of water, a long pool, its edges outlined in stone and bordered by low, serpentine escallonia hedges. On the bank above it stands a small single-storey pavilion, its formal geometric shape contrasting with the smooth planting around

Set amidst waves of escallonia hedging, moulded into long, serpentine undulations, is a lacquer-red pavilion facing the water of the naturalistic pool and backed by a boundary screen of oaks, laurel, bamboo and strawberry trees.

The pergola, swathed in Wisteria sinensis *and* Trachelospermum jasminoides, *creates a shaded walkway between a wing of the courtyard and the villa, the scents of its sweet-smelling climbers mixing with the delicate fragrance of* Rosa 'Mermaid', *planted in large ceramic pots around the terrace.*

it. It has the appearance of a Japanese tea-house and is set against a backdrop of the tall trees that form a natural boundary to the garden.

This is a garden of the senses, filled with the sound of water and the intoxicating scents and colours of flowers. Colour plays an integral role in the garden, the painted walls and pavilion perfectly complementing the planting. Caruncho acknowledges echoes of the past in the courtyard design and rectangular pool, but his use of these classic elements, balanced by large swathes of planting, is wholly original.

At the Fondation Cartier in Paris, artist **Lothar Baumgarten** created the Theatrum Botanicum, a contemporary botanical garden with thirty-five varieties of trees and nearly two hundred species of French flora. It lies behind the stylish contemporary art gallery designed by French architect Jean Nouvel in 1994. Baumgarten's plan is based on a systematically organized arrangement of botanical species, planned and planted in a very precise way and steeped in historical, literary and artistic references. In many respects it resembles the plant collections of Venice, established in the fifteenth and sixteenth centuries, and the botanic garden of Padua, the first in the world, which was laid out in 1545 and still extant today.

Five elementary forms dominate the layout of the garden: the triangular shape of the site itself, the square formed by paving within it, the protruding rectangle of the walls of the building, the circle of an amphitheatre and the ellipse of a fountain. The planting scheme creates essential links with the architecture of the building, whose transparency allows the garden to be viewed from all parts of the interior as well as from outside.

This modern-day botanical garden holds the exceptional status of a work of art, a stipulation made by Baumgarten and set out in his contract prior to its inception. This status precludes other works of art from being exhibited within it, and although this reduces the potential use of the garden and exhibition space by the Fondation Cartier, it increases the garden's own standing and value in botanical and aesthetic terms.

The Landscape Garden

The formality that had characterized the gardens of the medieval, Renaissance and baroque periods in Europe gave way in early eighteenth-century England to the landscape style in which the garden aimed to imitate nature. Partly as a reaction to the Industrial Revolution, English landscape gardening sought to celebrate the glories of nature by devising vistas and planting schemes that reproduced the picturesque and the sublime.

Massive earth-moving feats were required to create the hills, valleys and lakes of an apparently natural landscape, and a degree of ingenuity was needed in order to make them blend seamlessly with the garden: the solution to this was the ha-ha, a ditch with a retaining wall between the garden and adjoining park or farmland. This allowed an uninterrupted view from the house and prevented animals – grazing cattle, sheep or deer contributed to the pastoral idyll – from entering the garden. An invention attributed to the Baroque garden designer Antoine Josèphe Dezailler d'Argenville (1680–1765), it was so called because of the surprise it engendered in those who encountered it by chance. The costs of maintaining grand landscape gardens largely led to the demise of the ha-ha in the early part of the nineteenth century.

The major proponents of English landscaping were William Kent (1685–1748) and Lancelot 'Capability' Brown (1716–83). William Kent's garden at Stowe in Buckinghamshire, with its valley of the Elysian Fields, its temples and monuments – designed by many of the leading architects of the day – is one of the most significant works of its time in summing up the art of English landscape design. Another is Stourhead in Wiltshire, begun in 1735 by Henry Hoare and completed by his grandson Richard Colt Hoare in 1783. Inspired by Virgil's *Aeneid,* it is laid out with classical temples and bridges and a large, irregular lake, and is magnificently planted with an enormous variety of deciduous and coniferous trees. Such romantic landscape gardens owed much to the art of French painters Claude Lorrain (1600–82) and Nicolas Poussin (1594–1665). Lorrain painted pure landscapes as well

The centuries-old concept of the botanical garden was reinterpreted by Lothar Baumgarten at the Fondation Cartier in Paris, a contemporary art gallery designed by Jean Nouvel in 1994. A sweeping amphitheatre, divided into a series of paved, planted and water-filled areas, encloses the back of the glass and steel building. The garden holds the exceptional status of a work of art, a contractual stipulation laid down by Baumgarten so that it cannot be used for any commercial purposes and thus preserves its integrity.

A meandering watercourse and a ha-ha built of Belgian blue stone divide an orchard from a meadow at Koekelare in Flanders so that the garden, designed by Eli Devriendt in 1997, appears to blend seamlessly with the landscape in the eighteenth-century English fashion.

as biblical and mythological subjects and was especially admired for his treatment of light, while Poussin was regarded as the founding father of French Classicism and one of the greatest masters of landscape painting of all time.

Belgian landscape architect **Eli Devriendt** has resurrected the English landscape ideal in a two-hectare garden in Koekelare, Flanders. From the house, the division between the orchard and a meadow where a small flock of sheep graze is not apparent, thanks to a retaining wall or ha-ha made of large boulders of Belgian blue stone. Built in angled sections across the field, it acts as the structural backbone of the garden.

Around the house, which was built at the turn of the twentieth century, are old species of native 'Jacques Roulin' and 'Radoux' apple trees, 'Reine Claude d'Althan' and 'Queen Victoria' plum trees, 'Early Rivers' and 'Hedelfinger Riesenkirsche' cherries, 'Lapins' and 'Noordkriek' black cherries and 'Saint-Rémy', 'Conference' and 'Bruine' pear trees. In the grass of the meadow, bulbs of *Fritillaria meleagris, Narcissus pseudonarcissus, Crocus tommasinianus, Galanthus nivalis* and *Leucojum aestivum* were planted in autumn 2001 to provide a swathe of spring colour.

Running from the eastern side of the meadow to its northern tip is a serpentine stretch of water like a moat. Beyond it, on the eastern edge of the garden, Devriendt created banks of earth, partly to screen neighbouring farm buildings and to provide a platform for planting, but also to form an undulating contrast to the predominantly flat landscape of the area. Here, indigenous trees and plants link the garden to the mature woodland to the north-east. Common alder *(Alnus glutinosa)*, goat willow *(Salix caprea)*, oak *(Quercus robur)*, wild cherry *(Prunus avium)*, hornbeam *(Carpinus betulus)*, holly *(Ilex aquifolium)* and privet *(Ligustrum ovalifolium)* are planted alongside berry-laden snowberry *(Symphoricarpos albus)*, hazel *(Corylus avellana)*, spindle *(Euonymus europaeus)* and white blossomed bird cherry *(Prunus padus)*. Raising the outer boundaries of the garden also helps to provide an uninterrupted

Devriendt created raised banks to introduce variety into the predominantly flat landscape and planted them with indigenous trees including common alder, goat willow, oak and hornbeam, to link the garden visually with the mature woodland around the property. A pontoon provides a landing stage for the birds that inhabit the waterway, and an observation point from which to watch them at close quarters.

Seen from the sheep pasture, the wall of the ha-ha, which rises over a metre above the ground at this point, makes a striking feature in the landscape as well as ensuring that the livestock stays within the meadow boundary.

The ground plan of Koekelare shows the house in the lower left-hand corner and the garden extending away from it in two distinct sections linked by the watercourse and woodland.

view from the house, leading one's eye over the ha-ha and on towards the public park to the north.

The garden is bounded on its western perimeter by a meandering pathway of dolomite gravel leading to a small wooded area cleverly integrated into both the garden and the park; here, a clearing has been made as a direct reference to the name of the nearby town of Koekelare, which in Flemish means a clearing in a wood. Another path loops back to the garden proper, giving a full view of the ha-ha, rising over a metre high at this point, a dramatic architectural feature standing starkly against the orchard and meadow.

Parterre and Patterning

The knot gardens of the medieval period were traditionally laid out on a formal rectangular grid pattern, intersected by pathways and ornamented with trellises and arbours. Look-out mounds, originally for defence strategies, were transformed into features that allowed the horizon to be brought within the garden perspective. Plants and flowers were often used for delineating spaces and devising motifs such as letters, coats-of-arms and even celebrated battle scenes, depicted in myrtle, lavender, rosemary, marjoram and other herbs.

These enclosed medieval gardens graduated at the beginning of the seventeenth century into the

In 1994 Swiss landscape architect Guido Hager laid out a parterre in a chequerboard pattern at the Barokgarten Herrenhaus in Grafenort, eastern Switzerland, that perfectly mirrors the façade of the building. The design is simple and effective, the small rectangular flowerbeds, planned by Swiss horticulturalist Nicole Newmark, lighting up the green expanse of lawn.

At Ampertshausen, near Munich, Peter and Anneliese Latz planted hedges of finely clipped box in sinuous, serpentine sweeps with moulded tops that give the garden movement and structure.

grand French *parterre* (meaning on or along the ground), which was distinguished from the earlier knot garden in its use of evergreen box hedging to create symmetrical compartments and free shapes, sometimes on a huge scale and often devoid of flowers. So fine were the curves and interlacing of the box patterning in some *parterres* that they resembled intricate embroidery; hence the name *parterres de broderie*, which came to be applied to them.

These formal arrangements were generally divided by wide sweeps of gravel leading the eye along endless vistas to fountains or other grand architectural features. They were intended to be viewed in their entirety from a central commanding position on an upper terrace or a flight of steps in front of the house. Such gardens had no wish whatever to appear natural. They were entirely artificial adjuncts to a rich man's house and there was nothing romantic about them. Their plans were based on pure aesthetics and their function was to impress, serving not only to demonstrate man's control over nature but, in certain cases, also to affirm man's desire to work on behalf of God in bringing order out of chaos.

Two spectacular gardens by Le Nôtre which epitomize this ideal of order are Vaux-Le-Vicomte, laid out in 1661, and Versailles, dating from the late 1690s. At Versailles, the essential elements of the garden, aside from its truly magnificent scale, are its sculptures allying Apollo with the Sun King, Louis XIV, and its water parterres and fountains.

No longer intended to be seen as a whole from a grand portico, the modern parterre has lost most of the intricacies of patterning and the symbolism it once had. However, the rhythm and structure of the original concept are not forgotten.

In the lush southern region of Germany, at Ampertshausen, near Munich, a nineteenth-century farmhouse was renovated and transformed into a house and studio in 1993 by landscape architects **Peter** and **Anneliese Latz** and their son Tilman. The garden was planted in 1994 and follows the contemporary principles of conservation and sustainability, achieving a sensitive balance between design and nature. It is characterized mainly by structure, texture and pattern. Finely clipped box hedges *(Buxus sempervirens arborescens)* combine with a collection of fragrant roses: the English *Rosa* 'Graham Thomas', old French varieties such as *R.* 'Madame Pierre Oger', *R. gallica* var. *officinalis* 'Versicolor' and *R.* 'Cardinal de Richelieu', and old garden roses, *R.* 'De Rescht' and *R. centifolia* 'Muscosa'. Between the rose bushes, self-seeding sweet williams *(Dianthus barbatus)* in many colours, from white to deepest red, appear in the summer alongside violet aquilegias.

The box hedging contrasts effectively with the other planting, which is profuse and random; clipped to form low, moulded shapes with curved tops, the hedges add movement and rhythm to the space as they weave in mirror images along their axis. At the point of their widest divergence is a doughnut-shaped hedge cupped by the serpentine outer hedgerows. From the house the hedging is angled away in parallel lines that, in late autumn and winter light, give the impression of smooth green waves. In snow, the pattern of the hedges is even more distinct, while in summer, when the roses are in full bloom, the dark green box provides the perfect backdrop for the flamboyance of the flowers.

Many flowers self-seed and metaphorically wander around the garden at will, creating links within the garden and also making connections with the countryside outside. In spring, white and silver-lilac flower balls of *Allium hollandicum* and *Allium christophii* hover above the hedges, together with the pretty bell-shaped flowers of pure white *Scilla campanulata*.

A wall constructed from red bricks found on site sets off the drift of spiked hollyhocks that shoot up in the early summer. Next to the garden is a group of small quince trees whose green leaves are almost hidden under the huge yellow fruits that appear in late autumn. The larger landscape around the garden is left to arable crops, and spaces around the fields are left unseeded in order to encourage as many different types of herbs and wild flowers as possible to flourish there.

Topiary and the Modern Hedge

The art of clipping hedges into decorative shapes dates back to the gardens of classical Roman villas and was revived in Renaissance Italy, where the grander gardens were comprised of certain standard features: an enclosed, private area, the *giardino segreto*, beside the villa; the lawn, or *prato;* the evergreen labyrinth; the orange tree garden; the grotto; and the grove of trees, or *bosco*. High, clipped hedges were used to create distinctions between these areas and to act as a foil for marble statues and fountains; they also helped to disguise the hydraulics of those surprise water features so popular in Italian Renaissance gardens.

Used ever since for boundaries, mazes, labyrinths, ornament and spatial definition, clipped hedges are still an important element in the garden design vocabulary. Modern Danish garden design has a close affinity with nature, but pastoral and romantic landscape gardening has never been a significant influence here. Instead, it follows a modern track, embracing social values and aesthetic ideals. Gardens tend to be small and bordered with hedging against the wind. Southern Swedish gardens are similar in character to Denmark's, unlike those around Stockholm and the northern shores, where gardens are open, embracing the surrounding landscape. The traditions of both countries come together in the garden of Marna's Have in southern Sweden, where Danish garden designer and artist **Sven-Ingvar Andersson** began a hedge garden around his country cottage at Södra Sandby, northeast of Malmø, in 1955.

The garden, which began life as an overgrown nettle patch, has taken shape over a number of years and is now the essence of a cottage garden, superbly complementing the half-timbered two-hundred-year-old house built in the vernacular local style. In a very Danish way, the design for the garden aimed to provide an enclosed and secluded green space which would offer protection against the winds of the area. Its structure is disciplined, and it steers clear of the tendency of Danish gardens to use colourful perennials over a wide canvas; here, geometry mixes harmoniously with free forms to create variety and contrast.

Trees are a key feature at Marna's Have, with the huge rounded crowns of glossy-leaved sweet

Trimmed hawthorns at Marna's Have in southern Sweden dominate the hedge garden designed by Danish landscape architect Sven-Ingvar Andersson. In spring, when the hawthorns are a mass of tightly clustered white flowers, the hedges seem to roll across the garden like breaking waves. The dip in the 'U' shape that forms the back of a topiary hen gives a view of the vernacular, half-timbered house.

chestnut *(Castanea sativa)*, beech *(Fagus sylvatica)*, hornbeam *(Carpinus betulus)*, and a number of varieties of dogwood, apple and willow. But its principal feature is its hawthorns. The main part of the garden dates from 1964, when six hundred hawthorns *(Crataegus monogyna)* were planted over an area of two thousand square metres to form a hedge garden that in spring is a haze of white blossom and in autumn a mass of bright red berries. Following in the best Renaissance traditions, Andersson created an original form of topiary by planting the trees on an irregular grid and allowing some of them to grow untrimmed while others were cut into sculpted shapes.

The hawthorns were strategically planted to form vistas throughout the garden: an opening to the west offers a view of the setting sun, and unexpected glimpses of the garden can be seen through oval shapes cut in a tunnel of hawthorns, the sunlight shafting through the holes to light up the green shade inside.

The garden slopes down from the south-west corner to the north-east in a fall of three metres, and Andersson has clipped the hedging over this terrain so that the top remains level. The result is that the hedge ranges in height from one metre at the south-west to four metres at the north-east, providing both sheltered, secluded areas and, where the hedge is low, views over the surrounding country.

To the north of the house, twenty large hawthorn trees are clipped to resemble chickens in a coop. Each plant is clipped into a 'U' shape, a higher upright branch forming the front and neck of the bird and a lower one its tail. The hens rest on gravel scattered with various low-growing plants including regularly clipped clumps of box *(Buxus sempervirens)*. Between the box are *Agapanthus umbellatus* and *Allium hollandicum*, *Lavandula officinalis* and *Aquilegia alpina*, overhung by clematis and roses and underplanted with anemones, crocuses and tulips.

Highly esteemed by other landscape architects as a key innovator in modern Danish garden design, Andersson has created a brilliantly inventive and appealing garden in which the hedges serve as functional windbreaks as well as giving new style to an ancient art.

Italian architect and landscape designer **Franco Zagari** has also reinterpreted the topiary of the Italian Renaissance in a garden on the Gianicolo Hill overlooking Rome, south-east of the Vatican. Now the Istitutum Romanum Finlandia and the Embassy of Finland in the Holy See, the villa was designed by Giulio Romano in 1518, and Giuseppe Valadier completed the modification to the façade in 1817. It is a classical building with all the symmetry and scale associated with Renaissance architecture.

Access to the front entrance garden is through imposing gates which open onto a semicircular courtyard in front of the villa, the right-hand side of which leads to a balustrade giving a spectacular view northwards over the city. A *Ginkgo biloba* tree is placed off-centre near a well, and *Wisteria sinensis* and *Pyrus communis* grow up nearby walls, softening the angular lines of the courtyard. Orientation around the space is dictated by the placement of topiary.

The area is divided into a grid, with regularly spaced rectangles filled with pebbled blue-green marble set into a brick surround, each proportionally the same dimensions as the façade of the villa. Such formal patterning is reminiscent of the seventeenth-century French parterre, where garden and architecture were part of an integral design. But there the association stops as Zagari's design is thoroughly modern.

Sun-loving star jasmine *(Trachelospermum jasminoides)* grows up three-dimensional iron grids placed over some of the marble rectangles. Each face of the grid is a parallelogram and together they form a block of greenery, clipped to resemble a normal hedge but hollow in the centre.

Nothing is as it appears as the whole garden slopes up towards the balustrade overlooking Rome, yet the three-dimensional shapes and surrounding walls, also covered in *Trachelospermum jasminoides*, the motif plant of the garden, are adjusted to appear the same height as at the entrance. The wall lighting is placed at a constant height, altering the perspective in line with the slope. Zagari's intention is optically to enhance the apparent space: to this end, he uses larger rectangles of marble near to the villa than those further away, thus seeming to stretch the garden into the distance.

It is in all senses the contemporary version of an Italian garden that tricks the senses, within the strict mathematical calculations of space and proportion so relished by the Renaissance masters.

A similar use of hedging to accentuate space is used for the gardens at the historic building of De Witte Lelie, a former bank transformed into six apartment buildings in Antwerp. In order to create the impression that each apartment has its own private garden, Belgian landscape architect **Erik Dhont** designed a series of different courtyard areas with influences and links to the past. A feeling of movement across the courtyards is created

Designed in 2000 by Italian landscape architect Franco Zagari, this enclosed garden on the Gianicolo Hill overlooking Rome is a contemporary variation on traditional Renaissance themes. Grand gates lead into an entrance courtyard paved with regularly spaced rectangles of pebbled blue-green marble set into a brick ground and balanced by clipped cubes of evergreen jasmine (Trachelospermum jasminoides).

The marble rectangles gradually diminish in size as the garden slopes away from the house, heightening the perspective effect and creating the illusion that the space is much larger than it is. The blocks of greenery appear to be conventionally hedge-like and dense but in fact the plants are grown over three-dimensional metal frames, hollow in the middle.

A hedge of Buxus sempervirens *forms a calligraphic green island in a sea of gravel in Erik Dhont's design for a courtyard garden at an apartment building in Antwerp (1996). Shallow trays like bird tables planted with houseleeks* (Sempervivum) *hover above the flat-topped topiary, balanced by the glossy green leaves of* Fatsia japonica, *which grows happily in this sheltered area. The only annual addition is the busy Lizzies (Impatiens balsamina) planted in tubs at each corner of the garden.*

*The boxwood hedge, lit up by the sun, gives the garden life and structure throughout the year, backed by the spindly trunks and bright green umbrellas of a group of Pagoda trees (*Sophora japonica*).*

by the asymmetry of the architecture and the varying heights of clipped *Buxus sempervirens* and *Carpinus betulus,* with holly bushes of blue-tinged *Ilex meserveae* 'Blue Prince' and dark evergreen *Ilex aquifolium* trimmed into spherical balls on long, thin trunks.

In one courtyard, abstract shapes of clipped boxwood hedge like giant children's alphabet pieces, are randomly positioned, each with shallow trays of houseleeks raised above it like bird-tables, creating contrasts of colour and texture. Pagoda trees *(Sophora japonica)* stand out against the perimeter walls, their rich green leaves hanging with tubular clusters of cream flowers in summer.

A wide selection of cottage garden plants adds diversity of colour and form in another courtyard. Tall, pale yellow hollyhocks *(Alcea rugosa)* and the white starry flowers of *Allium ursinum* give height and depth against the evergreen hedging, with early spring colour from the snowdrop *(Galanthus nivalis), Helleborus torquatus* and *Primula japonica* 'Alba'. Unusual plants such as the pineapple flower *(Eucomis bicolor)* and elegant *Smilacina racemosa* are mixed with more common lavender, rosemary, *Salvia nemerosa* and bright yellow celandine *(Ranunculus ficaria)*. Trellises create vertical green walls covered with the large, creamy white blooms of rambling *Rosa* 'Félicité Perpétue' and the vigorous autumn-colouring Virginia creeper *(Parthenocissus quinquefolia)*. The profusion of foliage and flowers softens the edges of the border and contrasts with the verticality of the building.

New Designs on Classic Themes 63

A new approach to hedging gradually became established in Belgium in the 1980s, when garden designer **Jacques Wirtz** introduced a remarkably simple but stylish alternative to the formulaic, angled, clipped beech, yew, box or hornbeam hedges that were traditionally employed to segment areas of the garden. Wirtz reinterpreted the natural wave form of an unclipped hedge, creating undulating shapes characterized by movement and depth that flow out to the boundary lines and bring hedging into the design of the garden as a principal feature. He also uses the traditional rectangular clipped hedge, alleys of pollarded limes and beeches, and rectilinear water features to create structure and depth.

The Wirtz style, now synonymous with the Belgian garden, is a masterful combination of old and new concepts that fits perfectly into the predominantly flat Belgian landscape.

The all-important technique of controlling view and direction by way of a central axis was applied by Wirtz to dramatic effect in his Carrousel Garden at the Louvre in Paris in 1996, designed as part of a project to revamp the famous Tuileries Garden. Here, he transformed the triumphal arch of the Carrousel with two groups of plane trees set among limes in the main gateway entrance. Inside the gardens, two spacious lawns are divided by yew hedges, simple sculptural forms of hedging to create a sense of movement and distance. These guide the eye towards three circular ornamental ponds surrounded by wide expanses of grass bordered with flowers.

Again in response to Belgium's flat northern

At his own garden at Botermelk in northern Belgium, laid out in 1970, Jacques Wirtz created long borders of clipped box and yew, whose rounded, billowing shapes were one of the principal features of the design and a radical departure from the formality of traditional topiary.

A contemporary garden on an ambitious scale was laid out in Belgium by landscape architect Denis Dujardin along the lines of an eighteenth-century garden tour (1995). Indicating the route are paths, planting schemes and this meandering watercourse lined with flat stone slabs and ornamental grasses.

landscape, architect Frank Delmulle designed a house like a spaceship, half-hidden on a south-west-facing slope in Flanders, which in turn inspired Belgian landscape architect **Denis Dujardin** to create a garden where movement and balance were paramount. For Dujardin, the creation of a garden is not an architectural or ecological undertaking, although both influences may be present to some degree in his work: it is ultimately the design of a theatrical set, intended as an exercise in the control of nature.

This is essentially an eighteenth-century-inspired garden tour, alternating between controlled vistas and open, sequential walks. The garden is an illusionist creation, enhancing perspectives and changing mood by means of the use of space and planting. The tour starts at the side of the house and ends at the rectangular lawn next to it, following a path

through flower gardens parcelled into several equal rectangles containing asters for cutting, flat-topped rusty-coloured vernonias, bell-shaped campanulas, thalictrum and spires of physostegia. It is edged by low concrete sheds with wave-like roofs, a motif continued in the undulating clipped box and yew hedges. Where inscribed statues and plaques served as markers and guides in the eighteenth-century garden, Dujardin uses the colours and characteristics of carefully selected plants to link the various areas of the garden and to serve as indicators to a particular vista or specimen plant along the route.

A severe, horizontally cut hedge of yew *(Taxus baccata)* divides a wooded area from the house and encloses a mixed grey and blue border, picking up colours from the interior of the house. Blue flowers of *Baptisia australis, Aconitum wilsonii, Amsonia tabernaemontana, Scuttelaria incana, Iris sibirica* hybrids, *Veronica virginica, Geranium magnificum* and the blue-leafed *Euphorbia characias* 'Lambrook Gold' grow in subtle harmony with the grey of the beautiful silver-leafed *Sanguisorba armena* and varieties of hebe. The yew hedge extends to the south-west, where it opens to reveal a view of the landscape beyond the garden.

The blue theme continues with coloured concrete stepping stones leading to a wood planted with the soft blue flowers of *Symphytum* 'Hidcote Blue'. A wide, sloping lawn sets off the graphic lines of tall grasses and the bands of white-petalled, yellow-centred Leucanthemopsis and bright blue cornflowers *(Centaurea cyanus)* that run parallel to the house. Drifts of bulbs light up these planting strips in early spring.

The stepping-stones disappear into the shrubbery, where a small wooden bridge leads over a concrete pond and wet zone planted with *Petasites japonicus* var. *giganteus,* yellow *Iris pseudacorus* and the giant-leaved, rampant *Fallopia wallichi.* Channels of water from the pond wash gently across the stones, enhancing the undisturbed woodland atmosphere and the sense of detachment from the real world.

Clipped yew hedges provide a vertical contrast to an expanse of open lawn. The grass here is cut in wide swathes, leaving areas of meadow that are cut just twice a year and form a natural reserve for Alpine moon daisies (Leucanthemopsis alpina) *and cornflowers* (Centaurea cyanus).

Stepping stones and an axial pathway bisecting an area of lawn are highlighted by a heavy early-morning frost in Dujardin's Flanders garden.

New Designs on Classic Themes

A flight of steps around an ancient chestnut tree leads onto the terrace designed in 1993 by Pierre Zoelly for a twelfth-century fortified castle at Brunegg in Switzerland.

Views and Reflections

One of the many ways of enhancing a view in a garden has always been by means of an architectural feature such as a folly, used as an eye-catcher at the end of a vista or as a focal point in an open panorama. Strategically placed gazebos and summerhouses, as well as offering shelter from sun and rain, also provided an ideal point from which to survey the garden and the wider landscape and they play the same role in gardens today.

The work of Swiss architect **Pierre Zoelly** is a synthesis between architecture and the forms of nature. For a twelfth-century fortified castle at Brunegg he created a modern gazebo which acts as a threshold to the castle, whose ancient walls and ramparts tower above it. The terrace garden on which it stands was laid out in 1993; a simple stretch of grass in the shadow of the walls, it hovers above the forest that sweeps down the valley. The open, south-facing edge of the terrace forms a straight line overlooking a steeply descending slope of rough woodland and is bordered continuously by a long and elegant larch bench. This seating has been cleverly devised to conceal the heating and cooling system for the castle which expels air down the hill away from the garden.

The approach to the terrace is down a flight of steps, angled sharply round a large, established chestnut tree and leading straight onto a thirty-six-metre lawn. A smaller horse chestnut creates a shaded area here for drifts of bulbs: autumn-flowering crocus *(Colchicum tenorei* 'The Giant'), with large goblet-shaped flowers, and in spring *Crocus chrysanthus* 'Blue Pearl', the beautiful double, bell-shaped *Fritillaria acmopetala* and *Leucojum aestivum*.

The north boundary of the garden, beneath a retaining wall, is planted with a scheme of blues, bronzes and deep reds designed by landscape architect Jane Bihr-de Salis. This includes the red-fruited strawberry tree *(Arbutus unedo)*, the powder-blue flowering shrub *Ceanothus x delileanus* 'Gloire de Versailles' and *Hamamelis x intermedia* 'Diane', a witch hazel that turns a stunning red in the autumn, complemented by *Clematis viticella* 'Purpurea Plena Elegans' and ivy ground cover *(Hedera helix)*.

Low mounds of silky green foliage of *Alchemilla mollis* blend with blue bell-flowered *Campanula lactiflora*, the taller steel-blue spheres of the globe thistle *Echinops ritro* and the deeper blue of *E. ritro* 'Veitch's Blue', while *Geranium pratense* 'Mrs Kendall

Positioned to take advantage of the spectacular view down the thickly wooded slopes to the valley is a classically proportioned gazebo built of glass, steel and sheet zinc, with a semicircular seating apse at the back, like a Greek exedra. The open, south-facing side of the terrace is bordered by a long larch bench which conceals the heating and cooling system for the castle as well as providing seating along the edge of the lawn where croquet is played.

Clark' forms a lavender-blue mass highlighted by the cream of the plume poppy *(Macleaya cordata)* and Solomon's seal *(Polygonatum multiflorum)*.

Centred at the western end of the terrace, with a view looking straight back towards the stately chestnut trees, is the modern gazebo of steel and sheet zinc, its open geometric shape fitted with a low pyramid roof and four pylon pillars, over which climb the showy blood-red double blooms of *Rosa* 'Dublin Bay'.

The gazebo was originally a small building giving a view over the surrounding area and this design has a semicircular seating apse at the back like a Greek or Roman exedra and allows views down the length of the terrace garden, where croquet is played, and southwards into the woodland. Zoelly designed the modern, classically proportioned gazebo as a functional and appropriately simple addition to its architectural setting. Two hazel trees *(Corylus avellana)* to the side of it arch over another flight of steps leading up to a walkway above the retaining wall, which then turns back towards the chestnut trees, giving a bird's eye view over the terrace and into the woodland beyond.

A bird's-eye view of Lodewijk Baljon's 1992 design for a long, narrow Amsterdam garden reveals the angled steps that divide the outside dining terrace near the house from the central trapezium section and the seating area at the far end.

Long mirrors like narrow windows hung on the brick walls at the end farthest from the house visually extend the garden and filter light into its darker corners.

The use of reflection has also been a feature of gardens for centuries, not just in the form of courtyard pools and water features of every kind but to augment light, to enhance a sense of space and as a purely ornamental device. In the medieval period, pieces of mirror and glass were hung up to ward off evil spirits, while small, coloured-glass mosaics were used in Italian Renaissance gardens to create illusion by means of *trompe l'œil*.

Dutch landscape architect **Lodewijk Baljon** used mirrors to enhance both length and light in a rectangular garden surrounded by buildings in central Amsterdam. In 1992, designer Sjoerd Soeters linked the ground and first floors of the house, built in 1900, by adding one large double-storey window façade. The first floor was cut back at an angle to the façade to make a balcony over the lower floor kitchen and dining area. At the same time, Baljon designed a garden with shallow, angled steps to create two diagonal divisions across the full width of the space, one forming a triangular terrace near the house and another dividing the central trapezium from the remaining triangle at the far end of the garden.

The effect of these divisions and changes in level is to accentuate the overall size of the space, an illusion further enhanced by a series of narrow, vertical mirrors hung on the end wall of the garden. Planted in clumps in front of the mirrors are varieties of bamboo – the yellow-grooved *Phyllostachys aureosulcata* 'Spectabilis', the white-striped and downy-leaved *Pleioblastus variegatus*, the delicate fronds of *Sasa palmata* and *S. tesselata* – which form a luxuriant haze of greenery that reflects and filters the sunlight.

The garden was originally designed for children, though now the sand pit is covered with clay tiles, the same as those that cover most of the garden and match the interior kitchen floor. Planting on trellises along the sides of the garden emphasizes its length still further and draws the eye towards the mirrors, which from a distance appear like narrow windows opening onto a landscape beyond the wall.

Gilles Clément and Guillaume Geoffroy-Dechaume won the 1990 competition for a park at the new business area of La Défense in Paris with a design for a dramatic wooden jetty extending westwards to the new Grande Arche and sheltering areas of island planting. Architectural groups of Gunnera manicata, Peltiphyllum peltata *and large thistles (*Onopordon acanthium *and* O. arabicun*), plants not usually associated with French parks, are interlinked with areas of Moroccan paving and create a jungle-like luxuriance under the awning of the promenade.*

The seventeenth century was a time of great inventions as well as wars and, as empires expanded, warmongering technology found applications that filtered into many walks of life. Significant advances in hydraulics, land surveying and the use of gunpowder, for example, translated in France into the construction of more and more elaborate fountains, the ability to dig long and perfectly straight canals and the introduction of fireworks and other special effects to create the impression of thunder and lightning in garden settings.

Optics, geometry and perspective had always been key elements in the formal French garden, and advanced technology meant that they could be exploited in dramatic new ways. Unlike pastoral views framed by planting schemes in the English landscaped garden or the symbolic views through stylized openings in the Chinese garden, the French garden aimed for infinity, including the sky as well as the foreground perspective in a vista designed to impress. The same precept applies of course to France's grand urban planning schemes, where long, straight avenues lead majestically to a focal point. A modern application of this principle, in a garden designed for an urban setting dominated by an axial view, can be seen in the park at La Défense in Paris.

The area to the west of the capital has long associations with royalty. In the sixteenth century, the French kings resided in the palace of Saint-Germain-en-Laye and, to reach the Louvre Palace, would travel through the area that is now La Défense. In 1664 Louis XIV commissioned Le Nôtre to redesign the Tuileries Gardens at the Louvre, and, as part of his grand scheme, Le Nôtre cut the axis westwards. Today this straight line, through the obelisk and up the Champs Elysées to the Arc de Triomphe, runs to the new business area of La Défense and its Grande Arche, designed by Danish architect Johann Otto von Spreckelsen in 1989.

As part of this impressive project, the axis was further extended westwards with the addition of a two-tiered public promenade behind La Défense; a jetty of steel and wooden planks, four hundred metres long and ending six metres above the ground, stretches above a garden filled with striking architectural plants.

Designed by French landscape architects **Gilles Clément** and **Guillaume Geoffroy-Dechaume** following a competition in 1990, the garden is linked to the surrounding urban architecture through its materials and graphic silhouettes, while its connections to the natural world are enhanced by its strong emphasis on the seasons. As the garden progresses westwards, the planting scheme reflects the gradual transition from spring to autumn.

Sheltered niches under the jetty are paved with large, hand-cut, sand-coloured paving stones imported from Morocco, interspersed with smaller cobbles, making an unusual textured surface to show off the seasonally changing colours of foliage and flowers planted in a series of island beds.

Giant leather-leaved *Gunnera manicata* creates a sense of exotica, backed by the umbrella plant (*Peltiphyllum peltata*) and large thistles (*Onopordon acanthium* and *O. arabicum*), with colour provided by *Alcea rosea, Salvia sclarea* and the blue spikes of *Anchusa italica*.

The upper walkway forms an umbrella over the garden, making it at once intimate and sheltered yet imposing enough to make an effective statement below the strikingly modern architecture of the Grande Arche.

FORM AND FUNCTION

In 1995, at Holten in Holland, Dutch designer Petra Blaisse and her company Inside Outside designed an exterior metal curtain lined with black voile for a house with all-round glazing that left it exposed to the sun and the gaze of passers-by; scissor-like carriers to open and close the screen were engineered by architects OMA.

The mesh curtain is fine enough to allow views of the garden from inside but softens the linear edges of the lawn and tall pine trees into a green haze which appears to bring the garden closer. Aromatic herbs and flowers in blues, purples and yellows create a carpet of colour and scent below the house.

New Zealand landscape architect Ross Palmer designed his own small London garden as an extension to the house, disguising neighbouring properties and high walls with ingenious planting. Floor-to-ceiling windows and the continuation into the garden of the concrete rendering used on the house serve to unite the two living spaces, and floodlights make the garden as usable by night as by day.

Gardens are unique expressions of our own individualism, the results of the age-old human struggle to tailor natural forces as far as possible to our personal requirements. They have different purposes to fulfil, different locations to suit and different aims and objectives to satisfy. They are, above all, the product of different imaginations.

A well-designed garden is a garden that works. In other words, it fulfils its owner's needs in creating a particular atmosphere or environment or in providing extra living, working or recreational space. It must also be aesthetically pleasing and, ideally, ecologically sound.

Lifestyles change with each generation and what suited previous tastes does not necessarily concur with prevailing ideas and attitudes. Whereas in the past a terrace, lawn and flowerbed were conventionally accepted as meeting the requirements of a garden, and constituted an exterior space quite separate from the house, now the walls between the house and garden are metaphorically dissolving and the garden is no longer seen as a separate entity.

First established in the United States in the 1950s, the concept that a garden should be regarded as an outdoor room was championed by designers such as Thomas Church, Garrett Eckbo and Dan Kiley, who pursued the ideals set out by architects in the Bauhaus School, advocating new technologies and building materials to an audience keen to embrace a new and hopeful post-war lifestyle.

Now that the integration of indoor and outdoor spaces has become the norm, the next stage in the garden's evolution is under way: increasingly complex demands are being made of it in order to ensure that it responds appropriately to the way we live.

Although the development of garden design has followed a different route from architecture through most of the twentieth century, contemporary design ideas are now finding expression as much in gardens as in architecture and other art forms. As building design, interiors and fashion have all moved towards a sleek simplicity and streamlining, gardens have naturally followed, taking on a similarly disciplined and rigorous clarity.

While a garden is a reflection to some degree of cultural trends and attitudes, there is something infinitely more appealing and interesting about a garden that is imbued with the personality of its creator than one that merely reflects a fashion or uses off-the-peg formula ideas. The elements chosen to adorn a garden reflect moods and aspirations, even social status, and over the past few years they have taken on a new aspect, influenced by industry, architecture and new technology.

Penny Howarth's London-based design company Field Day used planters and waterproof fake grass rugs to blur the distinctions between this house and its small courtyard garden. The planters, in modular concrete, wood and acrylic fibre, can be moved either inside or out, thus increasing the potential for variety.

Containers made of zinc, brushed aluminium and a vast variety of other materials are widely available through garden centres nowadays, and there is almost no end to the ways in which receptacles designed for other purposes can be adapted for the garden. Free-standing wall structures, boldly coloured painted surfaces, decking and opaque glass have all acquired a new status as materials of contemporary choice. Similarly, the range of available plants is constantly expanding. Large specimen plants with a strong architectural presence are increasingly being employed as the focus of a planting scheme, while ornamental grasses, bamboos and wild flowers have become increasingly popular, even fashionable, in recent years. Opportunities for self-expression are infinite.

Challenging the view that developments in garden design are still trailing behind those in the plastic arts, British designer and sculptor **Paul Cooper** is employing some radical new ideas using modern materials and technology.

A garden designed by Cooper in Finchley, north London, responds to the owners' desire to be able to use the garden not only during the day but also at night. To this end, he installed a series of five tall, upright, opaque-white Foamex screens, parallel to the house but set at varying distances from it amongst existing trees. By day these white screens take on the role of a modern art installation, creating vertical lines set against the natural forms of the garden. Sunlight throws shadows onto them from the branches of the trees, creating changing shapes as the sun tracks its course across the sky. But the main visual impact occurs at night. By lighting these screens to create different visual effects, Cooper has made the garden as enticing after dark as it is by daylight. Photographic images can be projected onto the screens from the back of the garden, to be enjoyed by people outside; coloured up-lighting can be thrown onto the front of the screens to alter the mood of the garden; and a projection point in the conservatory adjoining the house allows the night-time display to be seen and controlled from inside. Six optional extra screens can be added for greater privacy or to close off certain sections of the garden if desired.

A garden that comes alive with colour at night is this courtyard in Finchley, north London, designed in 1999 by Paul Cooper, in which a series of moveable screens can be artificially lit, either by up-lighters or by the projection of pictorial images.

By daylight the white screens take on the guise of an art installation, and, especially when colours begin to fade in the evening, stand out strikingly against the dark shapes of trees enclosing the garden. They can be lit individually, as a sequence of related images, or in any permutation that achieves the effect desired.

The dramatic use of lighting to create a futuristic open-air art gallery is modern and original and perfectly adapted to the owners' lifestyle: the garden is an indoor urban space transported out of doors, and it answers a common contemporary need, especially in cities, for a garden to make few demands but to offer a setting for evening and weekend relaxation.

In Golders Green, also in north London, Cooper designed a similar space in which blank Foamex walls positioned around the garden serve as canvases for the projection of a variety of images, offering constantly changing visual stimuli.

The garden consists of a small rectangle of shaded ground, surrounded by conifers, which has been transformed into a multi-storey, multi-functional space using raised walkways, a decking area for dining and an adventure playground. A stainless-steel waterfall backed by strips of undulating metal, also designed by Cooper, forms a central focal point by day, while at night the white vertical planes of the planters and walls become the screens onto which an infinite range of images can be projected – anything from works of art to images of flowers or simply sheets of pure colour. Both by day and by night the permanent features of the garden make it functional and pleasant, but it is the flexibility of the space – the fact that its character can be altered at will – that is the new and exciting factor in its design.

This split-level garden (1992/2001) designed by Paul Cooper in Golders Green, with decking, raised walkways and an adventure playground, is equally functional and attractive by day and by night. A cascade of water and undulating stainless-steel strips makes a dramatic, light-catching feature that links the different levels.

At night, the vertical faces of white planters and walls become the canvases for projected images; here, zebra stripes against the darkness transform the small London garden into an abstraction of an African plain.

Plans for the garden designed by the Raderschall partnership for a courtyard in Zurich, showing square planters for climbers ranged against the back wall and a scattering of clipped box plants (Buxus sempervirens) across the pale green granite floor.

In the nineteenth-century quarter of Zurich, Swiss landscape architects **Roland Raderschall** and **Sibylle Aubort Raderschall** designed a courtyard garden for a client who wished to enjoy an extensive collection of pot plants during the summer but in winter, when the pots were moved inside, wanted a minimalistic design based on structure rather than planting. It was completed in spring 2001, and its two quite different seasonal faces perfectly respond to the brief. Measuring eight by sixteen metres, the garden adjoins a new house designed by Zurich-based architect Theo Hotz and is surrounded on its other sides by older, industrial buildings.

The architects laid the floor with Verde Spluga, a green granite stone from Italy, with four-centimetre joints between the slabs where *Sagina subulata* has been planted in an infill of green gravel and allowed to spread. The garden is split into two levels, the upper terrace planted with *Buxus sempervirens* clipped into curved, organic shapes reminiscent of sleeping animals, the dark leaves contrasting with the pale granite floor. Three square chrome-nickel tubs are planted with three different plants: the creamy-white flowers of evergreen *Clematis armandii* and the deep-purple blooms of *Akebia*

A wall of basalt rock is kept black and glistening by a fine spray of mist from angled chrome steel pipes; the wide cracks made by cutting marks from the quarry will eventually fill with creeping Sagina subulata.

quinata, both vanilla-scented, are complemented by the third plant, *Aristolochia macrophylla,* with large, heart-shaped leaves and strikingly marbled maroon flowers. All climb vertical wires that travel across the terrace, forming a fragrant green canopy.

Along one side of the lower terrace is a wall of dark, fine-grained volcanic basalt, which appears to be suspended in space over a long rectangular pool. A constant stream of water runs down its surface into the water below. Four chrome steel water pipes, each set at a slightly different angle, spray a continuous fine mist of water onto the wall, keeping the rock permanently black and shiny. Basalt is highly porous, and cutting marks from the quarry formed ridges into which mosses will grow. At night, subtle floodlighting shows the wall to spectacular effect.

As housing developments continue to spread outwards in all European cities, the desire for a home with a garden becomes increasingly heartfelt. The demand for better, more beautifully designed

The Dutch architectural practice of Atelier Kempe Thill was among the winners of the Europan 2000 competition with their design for four glass-clad apartment blocks for the city of Rotterdam, a project on which they collaborated with UK-based environmental designer and landscape architect Luke Engleback. Computer-generated images show the balance achieved between urban architectural references and allusions to the natural landscape.

Following the design philosophy that plants are part of the mechanism of a building, atrium gardens in the centre of each block will be filled with trees to help moderate the climate and clean the air.

gardens, reflecting advances in technology, ecology and resource management as well as horticulture, is also very evident today.

Improvements in building methods, design and materials are the theme of a design competition run by Europan, the European Federation for New Architecture, established in 1988. Originally a French scheme set up to help young architects by offering them opportunities to realize their ideas, it now represents twenty-one countries and organizes regular competitions.

One of the winners of the spring 2000 Europan competition, which called for interdisciplinary collaboration between architecture, landscape architecture and urban planning, was the Rotterdam-based architectural design team of **André Kempe** and **Oliver Thill**. Their entry explores the aims that characterize today's housing schemes in answer to the popular need to combine city living with references to the natural world.

Atelier Kempe Thill's design unites the seemingly contradictory aims of this ideal in a project for residential units with large-windowed façades that, on one side, look onto a lively urban street scene and, on the other, face a large atrium – a winter garden courtyard – shared by all the apartments.

The four-block housing development is to be built on a 2.3-hectare site in Kop van Zuid-Noordzijde, Rotterdam. It will comprise 330 flats, each of a depth of a mere five metres from the outside city view to the internal courtyard window. Each apartment will have floor-to-ceiling windows that fully open to form a terrace overlooking a woodland garden, which is to be planted with a variety of mature indigenous trees and a few more exotic species. The internal walls of the buildings will thus form a transparent casing around an atrium garden at the centre of each apartment block.

For the planting scheme, Atelier Kempe Thill collaborated with UK-based environmental designer

and landscape architect Luke Engleback, who envisages the planting of trees such as silver birch, whose elegant white trunks and airy foliage will light the inner courtyard. Their leaves are also fine enough to filter dust from the open roof, helping to clean the air in accordance with the design philosophy that plants are part of the mechanism of a building and can contribute to its function as well as its beauty.

Open to the sky in warmer weather and covered with a light polycarbonate and steel roof in the cooler months, the atrium garden will provide shade in summer and allow light to penetrate into the interior of the buildings in winter. The design aims at a balance between the need for proximity to urban culture and the alliance with the countryside, and in this responds to the demands of twenty-first century living.

In Barcelona, Spanish architect **Oscar Tusquets Blanca** designed and built his own house, Villa Andrea, in 1992. He named it after his daughter and also as a tribute to the great Renaissance architect Andrea Palladio. Following in the traditions of Greco-Roman architecture, one of his great passions, he designed the house in classical style, with two dramatic columns on the south façade, a perfect reproduction in scale of the columns of the Parthenon.

The ground floor of the villa, which looks onto the garden, is Tusquets Blanca's family home, and the upper two storeys, which have a view of the northern part of the city, form his studio.

The Catalonian villa of architect Oscar Tusquets Blanca overlooks the garden which he designed with landscape architect Bet Figueras. Built in a similar fashion to the communal reservoirs for washing clothes which are still a frequent sight in Spanish country villages, a long black granite pool forms its central feature, bordered by citrus trees and parterres filled with flowering plants and vegetables. The pool deepens, rising above the vegetation as the terraces descend so that the water level remains constant.

The garden was designed with Spanish landscape architect **Bet Figueras** and has a confidence and monumentality to match the architecture of the house. It is largely designed around the beautiful trees that Figueras sourced from around Europe: evergreen oaks *(Quercus ilex)*, Italian cypress trees *(Cupressus sempervirens)*, the Italian stone pine *(Pinus pinea)* and the Judas tree *(Cercis siliquastrum)*. Mulberries *(Morus platanifolia)* combine with plane trees *(Platanus x acerifolia)* and cork oaks *(Quercus suber)* to create a dense screen around the edges of the garden, with apricots *(Prunus armeniaca)* adding colour in spring and summer.

The trees are arranged around a long, rectangular swimming-pool which mirrors the colonnaded façade of the villa, effectively doubling the height of the portico in the reflected image. The garden is seventeen metres square, the exact imprint of the house plan, and is designed as a cross between a Roman garden, classically proportioned and planted with flowering plants and vegetables, and an Arab garden, filled with water and fragrance and closed to the outside world.

Tusquets Blanca laid out the swimming-pool (lined in black polyester and surrounded by black granite) on strong architectonic lines along the central axis of the garden, of which it forms the main feature. The land falls away from the house towards the south, where the garden is terraced, and the depth of the pool increases as the terraces descend

in order that the water level should remain constant, with the result that the pool rises dramatically above the surrounding vegetation. In this it draws on the tradition of Catalonian villages, which often have a raised reservoir for washing clothes. The impressive Canary Island date palm *(Phœnix canariensis),* with its large, drooping leaves, contributes to the pool's architectural impact.

On either side of the long pool are a fruit orchard and kitchen garden planted with orange, lemon, lime and tangerine trees and a variety of vegetables, the exceptional climate of Barcelona helping the fruit and vegetable seasons to stretch practically all the year round, excepting a dormant month around February. The air of southern exoticism and luxuriance is further enhanced by a large *Ficus carica* which bends low enough over the water to allow figs to be reached from the pool.

The monumental colonnaded façade of the villa, a tribute to Palladio, makes a dramatic reflected image, doubling its height in the rectangular pool that extends in an axial line from the entrance.

The brief in 1999 for the designers of this small Cambridge garden – British landscape architect Cleve West and sculptor Johnny Woodford – was to devise a space that answered the needs of all the members of a young family. Their solution combined a child-like vitality and imagination with a sophisticated use of repeated patterns and colours. A five-pointed star marked out in granite cobbles makes a feature of the floor area and doubles as a fountain.

A scalloped black-painted wooden fence with large silver polka dots provides a backdrop for three slightly tilted, clipped Photinia x fraseri *'Red Robin' trees, each domed head cupped by a dip in the fence.*

British landscape architect **Cleve West** and sculptor **Johnny Woodford** collaborated on the small back garden – only seven-metres square – of a terraced house in Cambridge, England, where the challenge was to create a space safe enough for a toddler to play in yet sufficiently imaginative and vibrant to appeal to adults. The solution was to introduce a water feature and a number of ingenious and child-like graphic shapes based on a sophisticated use of patterning.

A large, five-pointed star of vivid, sky-blue-painted concrete edged with granite cobbles was placed at the centre of the plan to form a shallow, bubbling fountain; water from the tips of the star gently falls into the central point before it is recycled.

The painted concrete is part of a dramatic scheme of colour that brightens the entire space. Circles of purple-black grass *(Ophiopogon planiscapus* 'Nigrescens'), the canary yellow of the side walls of the garden and the silver and black rocking seat, designed by Woodford, in a sun-trap corner by the fountain, all fill the garden with bright, bold colour. The design is young and exciting and its style blends naturally with the interiors of the house.

The theme of curves and circles is carried through in the carefully spaced, round-clipped *Buxus sempervirens* and allium with pom-pom flowers, which fill the border flowerbed, contrasting details being provided by the rigid, sword-like leaves of yucca plants in pots.

More curvaceous shapes are used in the scalloped wooden fence which marks the back boundary of the garden. Painted black with large silver polka dots, its dramatic outline creates a pattern that visually dominates the garden, successfully detracting from all that is outside and beyond the fence. Three *Photinia x fraseri* 'Red Robin' trees, clipped into tight balls on long, thin trunks, are spaced equally, though jauntily tilted, in front of the back fence, their spherical heads appearing to be cupped in the scallops of the fence line and to mirror its polka-dot patterning.

Such repeated patterning focuses the eye so that it is distracted from non-repetitive elements and features outside the garden and sees only the patterns. This theory was applied in the now legendary parody of the parterre, the 'Bagel Garden' in Boston, designed by American landscape architect Martha Schwartz in 1979 (illustrated on page 44).

Expanding the concept of indoor/outdoor living space, Swiss architects **Pierre** and **Barbara Zoelly** designed a garden at Zollikon, near Zurich, in 1982 whose principal function is to provide peace and privacy. It is divided into three distinct sections: an enclosed courtyard entirely occupied by a shallow, rectangular pool in front of the main rooms of the house (sliding doors in the dining-room lead directly on to it); a terrace walkway with a trellis of wisteria overlooking a sharp escarpment down to Lake Zurich; and the steep bank itself, which is covered in wild grasses and flowers and has been left largely untouched, falling away to a fringe of mature trees at the boundary.

The entrance gate into the courtyard garden leads directly to a line of stepping-stones that curve across the pool to a solid wooden exit gate in the wall on the far side of the water. This extraordinary pathway across the wall-to-wall water is the only way to negotiate this section of the garden and is more of an artistic feature than a regularly used path.

Two angular abstract sculptures by Peter Haechler, placed to follow the curve of the stepping-stones towards the gate, hover at water level. They are designed to rotate in the breeze and to cast heavy reflections both in the water and in the windows of the house façade. As the inside of the house is predominantly decorated in sombre colours, the window glass takes on a mirror-like quality which accentuates the apparent size of the pool and also reflects any visitor who peers into the black interior.

The idea of self-examination and contemplation in this part of the garden is clearly evident, with no escape from your own image thrown back by the

Pierre and Barbara Zoelly's design for a garden near Zurich is based on contrasts of light and shade and a series of mirror images. It focuses on an enclosed shallow pool directly in front of the main rooms of the house, where clouds of wisteria flowers overhang a steel pergola and light up the water with fallen petals.

Two abstract sculptures by Swiss sculptor Peter Haechler, reflected in the water and the windows of the house, form the central feature of the pool. The water fills the entire courtyard space and can be crossed only by means of stepping stones.

black abyss of the water or the glass; even the front door is designed with a mirror instead of solid wood or a window in order to reflect the visitor and not reveal the occupant. The owners are both psychiatrists, and the garden, as well as providing a setting for relaxation, seems to invite contemplation, investigation and analysis; the dark pool is perhaps a metaphor for the complexities of the mind.

The mysterious, otherworldly air of the courtyard is enhanced by the delicate racemes and intoxicating scent of *Wisteria sinensis* and *W. sinensis* 'Alba', which climb unchecked over a double-columned steel pergola, forming a canopy that stretches into the water parallel to the house.

Next to the pool, on the edge of the water, is a small, twisted crab apple tree whose spring blossom and russet autumn tones add colour to this section of the garden. A rectangular block of glass bricks, like a piece of modern sculpture, stands beside it at sitting height; it is in fact the ceiling light of the underground bathroom, designed by Zoelly to light up the garden at night. The skylight is surrounded by lavender which can be seen from the living-room of the house.

A long larch bench shuts this area off from the rest of the garden and also affords a view westwards over Lake Zurich. Behind the house, the open expanse of the wild garden, tumbling down the steep slope to the boundary, offers the greatest possible contrast to the concentrated sense of highly controlled design and introspection that prevails in the garden proper.

In Denmark, all aspects of design are intrinsically linked to the landscape, and have a visual clarity and simplicity that is independent of fashion and style. This means that they also adopt a direct, uncomplicated approach to the functional demands of contemporary garden design.

Carl Theodor Sørensen (1893–1979) was one of Denmark's greatest twentieth-century landscape architects who, in 1948, designed a series of allotment gardens at Naerum, north of Copenhagen. Now a Landmark Site, it consists of a series of oval, hedged plots scattered across the landscape in a way that follows the undulations of the land and appears to flow with them naturally. His aim was simple: to combine the traditional function of an allotment with a new aesthetic dimension. The plots are all set at different angles, and each one, measuring twenty-five metres by fifteen, is enclosed by a high, clipped beech hedge with no hedges shared or touching. The flowing spaces between the compartments consist of neatly clipped lawns used for recreational purposes and access. An ingenious slant on a traditional concept, the design is pure, coherent and beautiful as well as effective.

One of Denmark's key twentieth-century landscape architects was Carl Theodor Sørensen, whose 1948 design for the Naerum Tract Gardens near Copenhagen now has the protected status of a Landmark Site. Repeating a simple oval shape outlined with beech hedging across the whole allotment area, Sørensen created a remarkable sense of space and movement.

Sørensen's stylistic imprint can be seen in the high, curved, beech hedging enclosing the garden near Copenhagen, which he designed for his daughter in 1967. The spatial balance created by the positioning and shape of plants was of paramount importance to his work.

Cobblestones line the circular hollow added in 1979 to form an entrance to the basement of the house and provide a sheltered suntrap. Low planting clads part of the sloping perimeter curve.

Sørensen introduced similar movement into the hedging design he devised for the garden of his daughter, landscape architect Sonja Poll, near Copenhagen in 1967. Located in a leafy suburban street, the garden is enclosed by two-metre-high beech hedging in a wide arc that frames the back of the house and a sweeping expanse of lawn. The design's freedom of movement and curving form are complemented by the arch of an old, elegantly tilted apple tree, which casts long shadows, especially in winter, when the sun is permanently low in the Danish sky.

The basement of the house is exposed on the south side, where a large scoop of earth was removed to create an outside entrance at the lower level. Added by Sørensen shortly before his death in 1979, the hollow is lined with cobblestones and its sloping banks are partially covered with a variety of low-growing plants. In front of the glass doors to the basement a circular terrace makes a pleasantly sheltered suntrap and seating area.

The curves of the terrace are echoed by the outer hedge and by the small, circular, island flowerbeds in the wide lawn, reminiscent of the patches created by grazing cows in a meadow. Each roundel is planted with a single species: rose, iris, Japanese anemone and tall grasses.

The garden feels like a small section of an enormous labyrinth, its high hedges only breaking to allow a narrow opening between one area and another. Quiet and controlled in character, this garden offers a marked contrast to a more informal and spontaneous garden hidden behind and sandwiched between an outer row of hedging. Here there is room for experimentation and for vegetables, flowers and fruit trees to grow with few restraints, protected from the harsh winds.

In a way, this garden is the reverse of the allotments of Naerum, where vegetables and flowers

Varieties of bamboo and sheet-steel containers on wheels are the two principal elements of this ingenious and versatile design by Uta Zorzi for an internal patio garden at Senigallia on the Adriatic coast of Italy (1997). An overhead awning and side screens diffuse the strong sunlight.

remain on the inside of the hedge. By dividing the garden with high barriers as he has, Sørensen has ensured that the overall space fulfils a number of functions, and that different activities can take place within it undisturbed.

Ingenuity of design adapted to both location and function can be seen in a garden in Senigallia, on the Adriatic coast of Italy. Here, an internal first-floor patio measuring just five metres by ten has been turned into an infinitely flexible garden by means of a series of plant containers on wheels, each one filled with a variety of bamboo.

The work of Rome-based landscape architect **Uta Zorzi**, the design plays with a range of simple geometric shapes in the form of scored sheet-steel containers which can be grouped either in the centre of the patio to create an island of planting or in any permutation to suit changes in light, mood or function. A rectangular wooden bench provides a seating space and a pool cools the atmosphere with the sound of gently falling water from a low fountain.

Seven different varieties of bamboo were selected to provide year-round greenery while at the same time keeping the scheme simple. Subtle variations in texture, leaf shape and shade of green give the design added interest, enhanced by the contrasting heights of the containers. A large white awning hangs over the whole patio to diffuse the bright sun and reflect ground-level spotlights on to the bamboo leaves at night.

The small Paris courtyard garden of designer Philippe Niez uses every available space and surface to create an oasis of soft colour and greenery. Woven willow panels from the Loire provide climbing frames for plants and a backcloth for a plaster bas relief of a cupid. Height and texture are achieved by ferns, bamboos and several varieties of clematis and balanced by spheres of clipped box which frame the entrance door.

French landscape designer **Philippe Niez**'s fourteen-square-metre courtyard garden, in the heart of the 11th *arrondissement* in Paris, is quiet and secluded, hidden from the main boulevard by a small cobbled side street that leads to a row of terraced houses.

Created in 1988, it is an intimate garden that was planned both as an external entrance hall and as an extension to the living space of the south-facing, open-plan house. The building dates from the turn of the twentieth century, and its style is modest compared with the imposing, uniform façades of the main boulevards of Paris. The surrounding walls of the neighbouring houses tower over the courtyard, and the formation of a screen that would mask these buildings and create a garden oasis was a top priority.

Throwing aside the logic that restrained planting, using a few select architectural specimens, creates an illusion of space in a small area, Niez filled his garden with climbers, bamboos and a giant palm. His concern was to emphasize the vertical, and he was encouraged in this by the fascinating climbing patterns of two *Clematis armandii,* which he first planted in pots and then transferred to the ground. In a small space, the habits and details of plants become the focus of attention and, in this case, the intricate convolutions of the clematis became a feature of the garden. The clematis are never pruned but left to climb where they wish.

On one of the neighbouring party walls Niez hung tiles made of chestnut wood and the other three

walls he masked with willow fencing. An artisan from Tourain on the River Loire, an area renowned for its willow-weaving tradition, was commissioned to make a series of woven panels one-and-a-half metres high, each one surrounded by a wooden frame. The willow was chosen for its neutral colour and soft, natural appearance to camouflage the harsh horizontal and vertical lines of the buildings, and also for its open texture which is perfect for supporting climbing plants.

Against the house, the woven panels are placed above an eighty-centimetre-high pea-green wooden facing that flanks the glass patio entrance doors of the building. In the opposite corner, a small exit to the fire stairwell and service entrance is disguised behind more willow fencing. The original crazy paving in the garden was retained, and planting is confined predominantly to the edges of the garden, using climbers to create the desired sense of privacy.

Tall and stately bamboo, *Semiarundinaria fastuosa,* is grown for its thick glossy culms in three areas: one by the southern entrance, where the vanilla-scented *Clematis armandii* uses it as a climbing frame, another in the north-west corner, where it is planted with *Clematis* 'Royal Velours', and the third directly opposite the main living-room patio doors, where the purple and violet flowers of *Clematis* 'Vyvyan Pennell' intertwine with the tall canes. Behind this latter clump, a fragrant *Clematis armandii* 'Apple Blossom' scrambles up the woven willow fencing, displaying a vivid profusion of white flowers that gradually turn pink through the summer and make a delicate addition to the view from the house. Between the two clumps of bamboo the flowers of *Camellia sasanqua* 'Cornish Snow' add a late-autumn splash of colour against dark oval leaves.

Ranged along the willow-clad eastern wall are four large rush-covered planters: in three of them are black bamboo *(Phyllostachys nigra)*, with its shiny, slender, black culms, and in the fourth is a tree fern *(Dicksonia antarctica),* which makes a dramatic impact both from inside the house and from the entrance as it is positioned opposite the gateway.

A structural element is provided by two box shrubs *(Buxus sempervirens),* planted on either side of the house entrance, each about sixty centimetres in height and clipped into an egg shape. The box on the east side is surrounded by the evergreen ground-cover ivy *Hedera helix* 'Glacier', which edges the paving, and by the soft, feathery-leaved shield fern *Polystichum setiferum* (Acutilobum Group), planted with *Helleborus x orientalis;* mind-your-own-business *(Soleirolia soleirolii)* clusters around the striking yellow-and-purple-spotted flowers of the Turk's cap lily *(Lilium pyrenaicum)*.

Complementing the blend of exotic and familiar planting are a small, mosaic-topped iron table and chairs, a Moroccan lantern and a plaster moulded bas relief of a cupid which serves as the garden's mascot. Each piece was chosen to match the courtyard's scale and colouring and to enhance its peaceful atmosphere – a rare commodity in the centre of Paris.

In the Five Element garden in Portugal, designed by Maurizio Russo, a large zinc platform represents Metal and a white stone wall the White Tiger; the line of the wall, rising from the ground to a height of two-and-a-half metres, suggests the tension in a tiger's spine prior to a jump.

Rebuilt with artificial rock modelled on the marine sedimentary rock of the fallen cliff face, Russo's cliff, one hundred metres long, represents the image of the Red Phoenix and the element of Fire. Zinc grid steps form a bench that stretches along the headland for thirty metres, overlooking a magnificent view of the ocean. Placed in accordance with the Japanese principles of Sakuteiki and fuzei, it catches the strong winds off the Atlantic.

In the northern corner of the garden is a metal sheet inscribed with Chinese calligraphic strokes representing the legendary Jumping Fish, which symbolizes strength and endurance. Water flows down the face of the metal into the pool below.

Italian sculptor and landscape architect **Maurizio Russo** began the Five Element Garden in the Algarve in Portugal in 1997. To compensate for an area of the existing garden that was lost when a cliff edge collapsed, he was commissioned to lay out a new garden on a three-hectare plot of land adjoining the property. To both Russo and the owners, the orientation, shape and natural ecosystem of the land demanded a sensitive approach and the minimum of intervention. He turned for inspiration to the twelfth-century Japanese philosophy of Sakuteiki, which is based on the belief that a landscape should express *fuzei*, where *fu* represents wind and *zei* sentiment.

The garden is used periodically for Tai-Chi workshops, and this ancient Chinese art of movement is closely connected with the philosophy of geomantic orientation in which the four points of the compass, together with the central point between them, correspond both to the five fundamental elements of Fire, Water, Metal, Wood and Earth and also to specific colours and animals. This powerful symbolic system became the main reference for the project and established the orientation of the whole composition. Russo also incorporated his love of calligraphy in his design, using the four strong ink strokes forming the Chinese character for 'heart' as indicators and markers across the garden.

The western corner of the garden represents the White Tiger and the element of Metal while the eastern point relates to the image of the Blue Dragon and the element of Wood. Here, the remains of an old retaining wall suggested the line for a long, serpentine dry-stone wall built of local rocks to express the twisting, undulating dance of the dragon.

In the northern corner, representing the Black Tortoise and Water, shade cast by the contorted branches of a pine tree and screens of canes cools the water that bubbles up from underground. Framed by giant granite stones, the water overflows down a metal surface inscribed with the calligraphy strokes of the legendary Jumping Fish, which symbolizes strength and endurance. The drainage system – covered by a small zinc grid pierced by aquatic grasses – creates a vortex in the centre of the pool.

The restored cliff lies at the southern point of the garden. Rebuilt with new artificial rock modelled on

the existing marine sedimentary rock, it is inspired by the image of the Red Phoenix and its element of Fire. The one-hundred-metre cliff catches the wind – or *fu* – whose energy is measured by temporary installations of flags and chimes. Two zinc-grid steps thirty metres long look out over a dramatic view of the ocean.

A clearing in a natural cane grove, which bisects the site from north to south, has become the geomantic heart of the garden, representing Earth and the colour Yellow. An existing *Pisticia lentiscus* marks the central point and the focus of the whole design. It is the perfect location for the practice of Tai-Chi, a bed of fine white sand making a natural floor and a large floating tent providing protection from the sun.

Another lifestyle design which takes meditative Chinese philosophy as its theme is a garden at Salmannsdorf, Vienna, where Austrian landscape architect **Maria Auböck** of **Studio Auböck & Kárász** created a meditation terrace in the remains of a bomb crater. Inspired by the topography of the site, Auböck designed a curved form suggesting the ancient Chinese yin and yang symbols of harmony. In Chinese philosophy, the universe is run according to a single belief system, the Tao, which is divided into the two opposite and complementary principles of yin and yang. Yin is the passive female aspect of the universe, associated with earth, darkness, coldness and the moon. The opposite symbol is yang, the active male aspect of the universe, linked with heaven, heat, light and the sun. All change in the universe can be explained by the workings of yin and yang and, as the symbol suggests, harmony is reached when both sides are in complete accord.

Such a contemplative philosophy fits well with a garden that aims to create a perfect balance between landscape and design. To achieve it,

A bomb crater near Vienna offered a site for this garden (1993–97) inspired by the Chinese Tao philosophy and its complementary principles of yin and yang. Two interlocking shapes represent the symbols, the yin side consisting of a limestone terrace and a marble-topped table and low stone wall, the yang side a wetland garden of pebbles and water-loving plants.

Auböck divided the circular, fifty-square-metre space of the bomb crater into two connecting, curved teardrop shapes representing the two symbols: the yin side takes the form of a local limestone terrace with a raised, round table of granite slabs, its top a circle of highly polished Indian marble; the yang side consists of a sunken water basin planted with yellow *Iris pseudacorus,* decorative, spiky-leafed water soldier *(Stratiotes aloides)* and the creeping perennial herb mare's tail *(Hippuris vulgaris).*

Old oak railway sleepers reinforce the circular wall of the hollow, which is vividly furnished in autumn with the brilliant colours of Boston ivy *(Parthenocissus tricuspidata* 'Veitchii'). The clearly defined design of this area emphasizes the sculptural quality of the slopes of the crater valley, and its sense of focus and order contrasts strikingly with the plan of the wilder garden beyond. A variety of perennials and a weeping willow *(Salix alba* 'Tristis') adorn the terrace, while an orchard of ancient apple trees rises towards the mass of beech trees in the distant Viennese Forest.

Steep banks frame the hollow, the yang side backed by a wall of railway sleepers, its vertical lines repeated in the granite base of the table.

British landscape architects **Bowles** and **Wyer**, based in Hertfordshire, incorporated an adaptation of Chinese thinking into their design for an enclosed basement garden in the heart of London. Made for a client interested in *Feng Shui* (literally meaning Wind and Water), it follows in essence the ancient Chinese art of placing or arranging buildings or sites auspiciously, a belief system which has gained a firm hold in the West in recent years. Laid out in 1996, the site is ten metres long and varies in width from three to seven metres; it is designed to be viewed from the ground-floor living rooms overlooking the garden at the back of the house.

Led by John Wyer's researches, the design is inspired by various aspects of Chinese culture. He introduced lacquer red, an auspicious colour denoting happiness, on an intruding corner wall of the garden and for details in the scheme. Light colours, bright metal and plants have been used to enliven gloomy, north-facing aspects of the garden, though no narrow, pointed leaves have been used as these signify disruption.

Water, representing wealth according to Feng Shui principles, flows towards the house – a sign of good fortune for the occupants – from a circular bowl which extends into a long, narrow pool cut in the concrete and Portland stone paving.

The shape of this bowl is repeated in the spherical heads of *Prunus lusitanica* planted along the sides of the garden and in a row running the length of it. The trees are set out in square beds edged with stainless steel and surrounded by river-washed marble pebbles, their clipped, dark green mop-heads contrasting with the linear graphics of the garden and its light-coloured floor. Clipped yew hedging forms a wide spread of evergreen on the back wall.

This London basement garden, designed to be seen from the ground floor living rooms overlooking it at the back of the house, is based on the principles of Feng Shui, its graphic pool pointing towards the house in accordance with the belief that, if its flow is correctly directed, water brings wealth and good fortune to the occupants. The back wall, painted a lacquer red, a colour denoting happiness, makes a striking contrast with the white paving and clipped green heads of Prunus lusitanica.

Overlooking the chapels and surrounding woodland, a grove of mature elm trees encircles a low wall crowning the knoll near the entrance to the Woodland Cemetery at Enskede, Sweden.

Many of the innovative ideas currently finding their way into garden design have been inspired by recently created urban and park designs. The Scandinavian philosophy towards the natural landscape is, as it has always been, open and embracing: rather that the wild should come into the garden than that the garden should attempt to tame the wild. Emulating the surrounding landscape, interfering as little as possible with natural ways of growth and harmonizing design with nature remains the basis of the Scandinavian ethic.

In Sweden, associations with the landscape are bound up with notions of freedom and accessibility – with ancient and commonly held rights to roam – and a deeply rooted appreciation of the natural landscape is part of the national character. In contrast to the gardening traditions of Denmark, England and Belgium, which regard the boundary as a necessary feature for reasons of history and climate, in Sweden clear-cut distinctions between gardens and the landscape have never been regarded as either necessary or established. This is as much a psychological perception as an accepted fact, and the notion of respect for what is already there, distilling its essence rather than imposing design upon it, is a fundamental precept.

It is a rare talent to be able to work within these parameters and produce designs which are both sensitive and well organized architecturally. One of the most imaginative and innovative landscape projects to accomplish this is the Woodland Cemetery in Enskede, south of Stockholm, which continues, nearly a century after its inception, to be regarded as profoundly influential both in Sweden and abroad. Hence its inclusion here; it cannot perhaps be regarded as contemporary in terms of date, but its design is seminal and therefore a vital thread in the fabric of modern design.

In 1915 **Gunnar Asplund** and **Sigurd Lewerentz** won an international architecture competition to design an extension to the existing burial ground. The plans for the cemetery developed over the ensuing twenty years, sparking much debate and public interest. The final design is sparse, clear and light, with the spatial qualities recognizable as characteristically Swedish. It turned away from traditional concepts of ordered graves in an enclosed space to create a woodland setting that reflects in its atmosphere and spirit something of the mystery surrounding life and death.

The entrance to the cemetery is in a wide open space near the edge of the forest, where a pathway

leads to a chapel and crematorium, both structures of secondary importance to the forest itself. The land sweeps up and away from the buildings to a knoll topped by a close-knit group of elms surrounding a low stone wall, its simplicity enhancing the serenity of the site. Paving set in a broken, disjointed pattern flows towards the knoll as a reminder of the vicissitudes of life. A network of narrow pathways criss-crosses the forest, providing access to graves set in the grass under the trees where light and shadow can play on them. There is no geometrical order or regimentation in the setting of the headstones, and the place is not depressing but welcoming, imbued with the Swedish belief in the landscape as a great power and ultimate healer. A tribute to the success of the design is the number of visitors who come here not just as mourners but to reminisce, contemplate or simply to enjoy the landscape.

Looking up towards the knoll from the chapel at Enskede, the power of the award-winning design is in its simplicity and sense of serene detachment from the world.

It was at Vinterviken in 1865 that the Swedish chemist and explosives expert Alfred Nobel first produced a relatively safe and manageable form of nitroglycerine, which he called dynamite, and from here that his explosives were exported worldwide. Next to the old sulphuric acid factory, now a sculpture gallery, is a grassed area laid with bands of cobbles in wide concentric curves marking the site of the buildings that once housed the community of workers.

Stockholm is surrounded by a great archipelago of over ten thousand islands. To the west is Vinterviken, or Winter Bay, an isolated and beautiful bay on the shore of Lake Mälaren. Once part of a seasonal transportation route that crossed the frozen waters of the bay and then continued into the centre of the capital, this inlet was also the place where Alfred Nobel (1833–96) invented dynamite and established his first company, Nitroglycerine Aktiebolaget. The manufacture of nitroglycerine on an industrial scale started here as early as 1865, and for over fifty years the Vinterviken factory was to deliver Nobel explosives all over the world. The site was well located for such industry, surrounded by high hills for protection in case of accidents and by water for transportation.

Long abandoned, it was not until the 1990s that the peninsula and the old sulphuric acid factory received attention. On the initiative of the Swedish Sculptors' Association the factory was renovated in 1988 to become a sculpture gallery. The reconditioned red-brick listed building, the Sculpturens Hus or House of Sculpture now exhibits items and information related to the former industrial activities at Vinterviken and also holds exhibitions of local and international sculpture.

Following the Swedish tradition regarding the sensitive treatment of landscape, the history and beauty of the natural surroundings were key elements in the design of a park for the site by landscape architect **Thorbjörn Andersson** and Stockholm-based **FFNS Architects**. This meant that the

A landing stage, constructed of Siberian larch, extends from the woodland to the water's edge so that visitors can reach Vinterviken by boat from Stockholm along the sea route that once linked it with the capital.

Stina Ekman's Mountain Cathedral, *a sculpture of impressive proportions and imagery, consists of a narrow shaft cut from the natural rock on the site to signify the force of a dynamite explosion. It serves as a memorial to Nobel and to the workers killed in accidents at the nitroglycerine factory in the course of its fifty-year history.*

design process placed as much emphasis on the importance of existing elements on the site that were to be left untouched as on those that were to be introduced.

In some respects the park and its regard for nature are a reaction against the Modernist Movement, which held that the new was to be worshipped over and above the established, the old and the traditional, and that there was little to be learned from the past. The contemporary tendency in Sweden's landscape design is once again to reflect on and care for the past, regarding Modernist arguments as closed. For Andersson, the lesson from the Modernist era is that traditions and culture are too important to be ignored.

Three aspects of the project were significant to him in his design strategy: the history of the site as one of the principle cradles of Swedish industry; the natural beauty and biodiversity of the area, together with its farming traditions, which he reflected in a plan for horticultural allotments; and the conversion of the factory building to a gallery where the artwork could spill over into the adjacent meadow and woodlands, now a public park. His aim was to impart an upsurge of energy to the whole area while respecting its original character.

At the eastern entrance to the park, a huge cathedral-like parking area was created under a flyover, thus clearing cars from the main site. A walkway was laid out to lead down to the water through the garden allotments, and another walk continues through mature woodland and a meadow area to the end of the peninsular and an unparalleled view over the calm waters of Lake Mälaren.

The two-and-a-half-hectare meadow, its sweeping curves accentuated by surrounding trees, was originally the site of buildings housing a community of workers from the dynamite factory. Its focus is a shallow bowl edged with fan-shaped cobbled strips at the point where the valley meets the water. In the open meadow a dozen white-barked Himalayan birch *(Betula utilis* 'Doorenbos') stand elegantly erect next to the gnarled trunks of fifty-year-old domestic apple trees, a legacy of the old community site. The area between the meadow and the water was partially cleared to open a view to the bay.

A sculpture by Stina Ekman, *Mountain Cathedral,* was cut from the sheer cliff face that rises from the edge of the pathway leading down to the water as a tribute both to the workers who lost their lives using dynamite and to the discoveries of Nobel. It explores the idea of impact and explosion, and takes the form of a shaft running from the cliff top to the ground between two vertical rock faces, opening as a crack at the top and widening to about two metres at the bottom, as if the shaft has been blown apart. It is a subtle work and a powerful statement of remembrance.

Andersson's sympathetic treatment of the woodland was based on respect for the trees already there and the addition of indigenous planting along the walkway, such as the spring-flowering *Anemone nemorosa* and fragrant, pale yellow *Primula veris* near the edge of the wood, with expanses of lily-of-the-valley *(Convallaria majalis)* deeper into the trees. Pine, hazel and mountain ash were left untouched but areas of undergrowth were cleared to allow unobstructed views of magnificent ancient oaks and to let flowering plants spread through the woodland to the end of the peninsular.

A main form of transport to the park is the regular tourist ferry between the City Hall in the centre of Stockholm and one of Sweden's main attractions, the palace of Drottningholm. The ferry now stops at a boat-landing integrated into the edge of the woodland. Constructed from broad planks of Siberian larch, whose natural properties make it well adapted to withstand wet conditions, its design is a testament to simplicity and to the use of natural materials.

The epitome of the city park whose references are strictly urban, Parc de la Villette, designed by Bernard Tschumi, is laid out on an axis which leads the eye through its green spaces to embrace a view of the chimneys and factories of Paris's northern industrial suburbs.

The park is scattered with red-painted follies, such as this geometric skeleton like the shell of a half-finished building, intended as comments on the cultural fragmentation of the modern age.

In France, the ideology of the twenty-first-century park is the antithesis of the Swedish ideal: its inspiration is the urban fabric of the city. Parc de la Villette, in the suburbs of northern Paris, was the result of a design competition in 1988 won by Swiss architect **Bernard Tschumi**, who took down the barriers between the green and the built environment and used urban technology and culture to blend city and park. Tschumi rejected all notions of tradition based on the model nineteenth-century park, where the green area was divorced from the city, as in Butte de Chaumont in Paris and New York's Central Park. Their emphasis was on isolation and seclusion, the idea of the park as refuge from the city, while Parc de la Villette wholeheartedly embraces the city itself.

Following the eighteenth-century tradition of incorporating references to literature and poetry in the garden, Tschumi invited writers and intellectuals to submit literary texts and critiques relating to the park, and the many writings about the project helped to stimulate the interest and celebrity that subsequently surrounded it.

With its north-to-south axis deliberately tilted to one side to upset perceived notions of order, the park consists largely of open grass fields dotted with large red follies; adopting an academic approach, it presents a cinematic sequence of structures that explore theories of the fragmentation created by Post-Modern culture. It is questionable how much of this ideology is absorbed by those who regularly use the park, but, as such projects should not be judged solely on rhetoric but on daily population figures, Parc de la Villette is a success.

Concrete blocks suspended from poles like swings at a fairground, at the Parc Mollet de Vallés in Barcelona, are Enric Miralles's vigorous response to the spread of urban graffiti, his objective being to disarm its perpetrators by demonstrating that it has become an accepted part of establishment culture.

Modern urban behaviour is also having a detectable influence on contemporary landscape architecture. Painted graffiti in cities is now so prevalent that Spanish architect and urban designer **Enric Miralles** (1955–2000) decided to accept rather than fight this urban affliction in his design for the Parc Mollet de Vallés in Barcelona. Its success was contingent upon the public's acceptance that graffiti is part of the fabric in which we live, that it is an expression of modern culture and that it can be incorporated constructively into modern design.

Bringing the city into the park, and thus extending the landscape into the city, was the aim of Miralles' project, which is one of a series of parks laid out in Barcelona in the 1980s in response to a modern demand for public spaces that offer a dynamic reflection of society. Inspired by the dream-like, surreal floating objects, animals and people in the paintings of Marc Chagall, Miralles constructed eight-metre-high, three-dimensional concrete blocks suspended over the landscaped park and supported by piers. Each block is a shape derived from graffiti scrawl and represents the name of a place near the park. The abstract forms are not legible as words, and they have little of the aggression of the scrawls that gave rise to them, but they do have a similar larger-than-life vitality, and Miralles hoped that this very quality would undermine the anti-social energy of the graffiti artists and act as a deterrent to a fresh onslaught of paint-daubing in the park.

Architecture and the Landscape

The boundaries between architecture and landscaping have narrowed in recent years to the point where two new design styles are emerging that incorporate both disciplines and are accepted by both: on the one hand, the application of organic solutions to architecture and, on the other, of architectural solutions to landscaping. The former is in the vanguard of a modern architectural design ethos while the latter is drawing welcome critical attention to the whole field of landscape design.

No longer seen as opposites, the natural and the built environments have formed a new relationship, working together to develop a joint strategy for the treatment of land in relation to architecture. The value of the landscape as a complementary element in all construction ventures is now almost universally recognized, and the result is the introduction of a complex configuration of organic and inorganic elements into new architectural design.

Throughout the early twentieth century, Modernist architecture regarded the importance of scientific and technological developments as paramount and largely turned its back on issues concerning the landscape, while garden design remained focused on horticultural prowess and restoration. This left few opportunities or incentives for mutual experimentation based on ecological precepts.

There were, however, brilliant and forward-thinking designers and architects whose work was an exception to this general rule. American architect Frank Lloyd Wright was the principal early proponent of the integration of the built and the natural environment, and to this day his work influences international design.

Late in his career, Wright fused Modernist Abstraction from 1920s Europe with the ideals of nineteenth-century American design, which expressed itself through more naturalistic shapes and a greater ecological awareness. His vision followed the simple principle that man and nature should be able to co-exist, and he aimed to combine what to most architects then appeared incompatible, to unite landscape and architecture, form and function, engineering and ecology in a single, harmonious design strategy.

Architects Grimshaw and Partners designed the interlinking geodesic domes of the Eden Project, near St Austell in Cornwall, as an ecologically sound covering for the world's largest plant enclosure. Based on the research of American designer and inventor Richard Buckminster Fuller, the domes are made of flat, hexagonal sections in a recyclable material called ETFE foil. A futuristic version of the classic English glasshouse, and completed in 2001, the design, is a triumph of the integration of architecture and landscape.

The Garden of Rest at the Brion Cemetery, near San Vito d'Altivole, Treviso, in northern Italy is widely regarded as an icon of modern architecture and landscaping. The work of two of Italy's most highly regarded designers, the garden was laid out in 1973 by architect Carlo Scarpa, who created its abstract sculptural forms, and planted by Pietro Porcinai.

His most famous house, designed for Edgar and Liliane Kaufmann, Falling Water, at Bear Run in Pennsylvania, was designed in 1936. Wright studied the natural pattern of rock ledges above a waterfall on the site and cantilevered the house over the river in a series of concrete mantels anchored to masonry walls. The house stands nine metres above the rock ledge, the horizontal lines of its low rooftops and terraces overhanging the falls. The genius of the architecture is in its harmony with the surrounding natural elements: even the walls and structures within the building were designed as extensions of the outside world.

However, circumstances conspired against the adoption of Wright's design philosophy on a wide scale. The need for mass prefabricated housing, the fascination with the machine-produced form, and the development of the skyscraper by architects such as Ludwig Mies van der Rohe and others, led the Modernist Movement to triumph for over half a century over what was seen as green architecture.

But today building ideas are undergoing a revolution in relation to the environment, as Wright had foreseen. As in garden and landscape design, architecture is based increasingly on rules of geography, topography and the existing features of the site. Conquering nature makes little sense, and there is in any case limited scope for the architect who places a building on a pedestal and disregards the surrounding landscape.

A seminal influence on architects and landscape designers for over sixty years, Frank Lloyd Wright's Falling Water at Bear Run, Pennsylvania, projects nine metres out over the river in a series of concrete mantels anchored to masonry walls. The result of a detailed study of the natural rock formations of the woodland site, these mantels borrow their horizontal form from the natural rock slabs beneath them while the vertical sections of the building merge into the surrounding trees.

Constructed of glass and galvanized steel, one projecting external corner of the building, housing the main living rooms, is visible from outside and continues the upper line of the rock ravine into which the building is wedged, almost like a primitive cave dwelling yet startlingly modern in design.

An architect's model of the Manoir d'Angoussart in Belgium and its nine-hectare site shows the extraordinary originality and scale of Emilio Ambasz's 1977 design. The house is largely underground, with geometric skylights and an internal courtyard augmenting the light into the interior supplied by the only outward-facing windows. Beneath the pyramid and long strip of glass to the left are the exercise facilities and swimming pool, while the approach to the house is via the central sloping ramp.

According to the philosophy of New York-based Argentinean architect and designer **Emilio Ambasz**, the ground removed to make the foundations of a building should be replaced by an equal measure of earth and additional planting; this can take a variety of forms, including the incorporation of planting areas on roofs and walls. As well as being a sound ecological maxim, in practice this policy is aesthetically, functionally and holistically more effective than most of the traditional building practices still in use today.

Ambasz's architecture embraces the connection with nature that mainstream design until recently chose to ignore. His work is striking in its unfamiliarity, offering unexpected encounters between ancient traditions and high technology. We are not used to buildings being camouflaged by the landscape and moulded to the topography of the site, and Ambasz's work therefore has the power to surprise as well as excite.

He began to adopt his revolutionary style of design in the 1970s, producing work on a monumental scale, with a fluidity and compositional skill of awe-inspiring originality. Akin to the Land Art of 1960s America, the idea of moving and remodelling the land is not a new one, but Ambasz's work is thoroughly modern in its application and vision. It is ergonomic architecture combined with ecological design, and it has gradually inspired a profound change in design techniques and thought patterns as well as an appreciation of the potential for architecture and landscape design to work together.

High skies and low, flat land are the characteristics of the Belgian landscape, and in 1977, on a nine-hectare site in Bierges, Ambasz designed the Manoir d'Angoussart, a complex, state-of-the-art construction in which the house and surrounding land were conceived as a single, indivisible entity.

Built in a south-facing ravine at one end of a four-hectare plane, the house is effectively buried in the ground so that, from the road 250 metres away, it is barely visible. The roof line is a continuation of the surrounding landscape, protruding geometric shapes being the only indication of the building's existence. The charm of the site is enhanced by the changes of level in the landscape, which help to camouflage the architecture as well as introducing movement and variety. The shared aim of owner and designer was to create a natural garden on the site, once part of a large estate surrounding a château, and to preserve existing features of the landscape wherever possible. Where plants were added, indigenous varieties were chosen.

The entrance to the house is via a gently sloping ramp. A moiré-patterned galvanized steel grill, supporting a trellis with window glazing behind, is in essence the façade of the house, which is low-lying in compliance with local building codes that restricted the height of the structure to a maximum of four meters. Forming a right-angle between the walls of the ravine is a two-storey glass projection that allows light into the central core of the house, where the main living and dining rooms, children's playrooms and other areas used principally during the day are located. The bedrooms overlook an inner courtyard in the centre of the house. A double-glazed pyramid-shaped skylight allows natural light into the swimming-pool and indoor exercise facilities.

Thanks to Belgium's moderate climate and the insulation properties of the surrounding earth, the house needs neither air-conditioning nor heating, except for seldom used electric heaters in the living rooms. Freestanding façades of double lattice-work covered with ivy ensure that every structural element of the building is completely immersed in the landscape.

Taking the view that it is a privilege for the country house to occupy beautiful natural surroundings, the London-based company of **Farjadi Farjadi Architects** adopts the design philosophy that architecture must complement the landscape and not oppose it. From the outset, the key concept in their design for a private house in the Ribble Valley, northern England, was to blend the building – which won an open design competition in 1977 – with the landscape. (The design was also one of twenty-five projects – by an impressive list of international architects – chosen by the Museum of Modern Art in New York to be exhibited at The Un-Private House exhibition in 1999.)

The brief for the house was to design five hundred square metres of accommodation to meet the needs of parents with children from previous marriages. Sima and Homa Farjadi designed a two-storey building consisting of a main house linked by a closed walkway to an annex, giving a sense of autonomy and privacy to both children and parents.

The building sits low in the landscape on an isolated site in several hectares of woodland and garden, the land dropping away dramatically below the house. The large roof unites the two sections of the building, forming a canopy at a lower level over the walkway and parking area and making a single undulating line that follows the slope of the valley. Made of wooden decking, the roof serves as a belvedere with views to the open countryside.

The Iranian-born architects wanted to relate their design for the house to the traditions of the Persian pavilion, where watercourses and pools are used to divide internal spaces and form essential features of the architectural structure. The building is intersected at three key junctures to create different spatial effects: at the meeting point of terraces, a lily pond and courtyard, in the covered walkway between the two houses and in the internal division of a two-storey hallway. The pond and courtyard form an intersection that cuts from the back ground-floor level of the house, near the main entrance, through to the front façade, which, as a result of the sharp downward slope of the hillside, is at first-floor level.

The most unusual and distinctive feature of the design is the cladding used on all vertical planes of the building; rather than traditional materials such as weatherboarding, tiles or slates being used for the walls and sheaves of thatch confined to the roof, here water-reed thatch is used on the external walls, acting as an insulating skin that blends harmoniously with the surrounding countryside. It serves not only as a camouflage but also as an embellishment to the house, adding a soft, organic texture to the outside in contrast to the sleek modern lines of the interior.

In order to design a private house that flowed with the contours of its Lancashire hillside site, Farjadi Farjadi Architects built a long, low structure in two linked but separate sections that follows the line of the valley. An organic layer of water-reed thatch covering all the external walls helps to retain internal heat and also to camouflage the building's simple, angular lines.

Villangomez, on the Spanish island of Ibiza, was designed in 1987/1990 as a simple, open-plan house that relates easily and naturally to its Mediterranean setting. The lines of the bright, whitewashed exterior are broken by overlapping sectional walls, allowing free circulation within the internal spaces of the house and creating entrances as well as views into the woodland at various points around the building.

An internal courtyard, where a few original pine trees and a newly planted lemon cast shadows on the tiled terracotta floor, enhances the sense of a seamless flow of space between the landscape and the house.

In Santa Eulàlia on the island of Ibiza, close to the shore in a mature pine wood, a single-storey house has been perfectly adapted to the natural topography of the site. Barcelona architects **José Antonio Martínez Lapeña**, **Elías Torres Tur**, **Salvador Roig** and **Xavier Pallejà** designed the whitewashed Villangomez as a single, continuous, open-plan living space which appears to flow uninterruptedly into the garden and surrounding wood. The homogeneity of the design is further emphasized by the use of simple, traditional building materials – brick and white plaster – typical of the Mediterranean.

A variety of spatial effects is created by the positioning of interior walls, some coherently joined to form rooms and others juxtaposed or overlapping to allow openings for views and indirect entrances. This complex system of screens is augmented by slatted wooden panels, adjustable in the interests of privacy and to provide shade from the intense summer sunlight.

Internally the rooms are linked by a series of patios and connecting spaces, the largest courtyard open to the sky, its terracotta floor tiles laid around already existing pine trees. Unhindered by boundaries, the trees seem to be as much a part of the interior as they are of the woods that frame the house. The courtyard garden is simply a fragment of the landscape, filled with the colours and light of the Mediterranean.

Like the previous examples, Villangomez highlights the currently prevailing trend towards integrating architecture into the landscape, while the following design investigates the potential of architectural solutions to landscaping itself, using building forms to provide part of the garden's essential structure.

The free shape of the pool is bordered on one side by water-loving plants such as iris and nymphaea and on the other by a lawn with mature deciduous trees. A clipped evergreen hedge divides the swimming pool and modern conservatory from a wing of the eighteenth-century villa.

At Villa Servadio Italian designer Pietro Porcinai created a garden that helped to revolutionize Italian gardening style, and at the same time demonstrated his remarkable talent for uniting architecture with the natural environment. One of his most inventive concepts here was the double pool: a swimming-pool, partially enclosed by the new conservatory, is divided only by means of wooden walkways from an ornamental pond that flows in a wide sweep across the garden, giving an entirely new treatment to the traditional Italian water feature.

Pietro Porcinai (1910–86), viewed by many as the master of modern Italian garden design, succeeded in breathing new life into the traditional Italian garden, adapting its ideals to a wider and more modern environment. He was designing at a time when the ecological movement in America was beginning to gain momentum, but in Italy the value of architectural form was still paramount and the focus largely on restoration. Against this backdrop, his experimental ideas were seen as revolutionary. A prolific artist and designer in many spheres, Porcinai is as much remembered for his ingenious planting schemes as he is for his talent in linking garden and villa.

On the hills above Perugia in central Italy, Villa Servadio is one of the most important of Porcinai's portfolio of garden designs. Created in 1970, it creates the perfect setting for the eighteenth-century house and Renaissance tower, and blends effortlessly with the typically Umbrian landscape. The garden was designed in three distinct areas connected by meandering pathways, seamless planting and the adaptation of existing contours.

One of Porcinai's most outstanding inspirations in the garden was the movement of earth subtly to alter the structural layout. The earth moved from around the fifteenth-century ivy-clad tower at the southernmost point of the garden was used to create a sweeping open space which visually and physically

links the front of the main house and the tower without the need of a path. A line of holly *(Ilex aquifolium)* emphasizes the gentle slope of the new contour.

The second section of the garden, the belvedere, is an adaptation of a traditional Italian feature, adopted here by Porcinai to take full advantage of the magnificent view, looking east to the ridges and slopes of the Apennines and their sprinkling of medieval Umbrian villages. The cypresses, vineyards, orchards and olive groves that clothe the hillsides show that, although methods may have changed, agriculture has remained much as it was in medieval times. A path of stepping stones in the grass leads to the belvedere, marked along the way by earthenware oil jars and ancient olive trees that link the garden with the landscape.

Central Italy's climate allows citrus trees to grow well as long as they are protected in winter, and here they are sheltered enough to thrive, underplanted with yellow-flowered santolina and scented lavender. Enclosing a tennis court and hiding it from the main garden is a continuous hedge of evergreen holm oak *(Quercus ilex)*, clipped into large scallops and rising to a peak at each corner of the rectangle in a style distinctive of Porcinai.

The third area, linking the north-west part of the garden with the house, is perhaps the most unusual feature of the whole design: an adjoining swimming-pool and ornamental pond. Long associated with the Italian garden, the idea of a water feature was given an entirely new treatment here. To one side of the slatted boardwalk which separates the two is the rectangular swimming-pool, partially enclosed by the modern conservatory attached to the house, while to the other side the free shape of the pond, replete with water lilies, aquatic plants and wildlife, curves languidly down the garden, accompanied by ornamental grasses and iris and flanked by a lawn overlooking the valley.

Designing the architectural detailing for the area linking house and garden, traditionally the province of an architect, was of great importance to Porcinai. Between the conservatory extension and the garden is an electrically operated glass and metal sliding wall, spanning the width of the building and dividing the swimming-pool so that the internal section of it can be enjoyed even on the coldest of days in a garden room bright with plants. As a result, the heart of the house and the centre of social activity for the family became the point at which garden and living space integrate. While light reflects off the swimming-pool into the extension of the house, the view of the garden from inside is elongated by the long expanse of water.

Akin to the landscape architecture ideas of California in the 1950s, which responded to the demand for outdoor living space, Porcinai's design was a new departure for the Italian garden. It created a paradigm for future designers, who adopted the concept of incorporating architectural features into garden design in a new way, creating modern recreational spaces which blend stylishly and naturally with the surrounding landscape.

Antique oil jars and ancient olive trees line the route marked out in stepping stones that leads the belvedere. In the past, country people of the region depended on olive oil not only for cooking but also for lighting, and used its waste products for fuel and fertilizer. They still regard it as a staple of life.

An even more radical design idea was developed by Italian architect **Gae Auli Aulenti** for the garden of the Villa Pucci, near Empoli in Tuscany. Standing high on a hill and surrounded by woodland, the imposing fourteenth-century villa rises through three-storeys to a typically Tuscan loggia, its white-plastered walls pierced by symmetrical windows framed in *pietra serena,* a local grey sandstone. It has been the home of the Pucci family since it was first built, as a small feudal fortification dominating the surrounding territory.

In 1971 Aulenti was commissioned to restructure completely the established traditional garden of formal flowerbeds and fountains, dating from the early part of the twentieth century, and, in its place, to devise a scheme more suited to the villa and its setting.

Based on a strict geometric rationale, corresponding perfectly to the austerity of the architecture, the linear simplicity of Aulenti's design shows an immense confidence and restraint. The entire garden was laid out as a lawn, cut into a series of shallow grass steps which stretch across the full width of the space, following the natural slope of the land and descending in a majestic sweep from the terrace at the front of the villa towards the woodland below the garden.

Contrasting with the deep grass treads, the risers are sharply defined in pre-cast concrete, graphically highlighting the slope like contour lines on a map, and rhythmically breaking the expanse of green with long, light grey bands that link the steps visually with the stone detailing of the villa façade. The architectural layout of the garden provides a pedestal for the building as well as seeming to anchor it firmly to the land.

The treads vary in depth from front to back, though in the flight leading from the front of the villa they are uniformly deeper than in those to the side, where they lead to a swimming-pool hidden among trees. Interrupting the otherwise unbroken horizontal lines across the garden, the steps are deeply indented at the sides, creating corners which are marked at intervals by large terracotta pots containing orange and lemon trees; one or two established trees have been left in place in the lawn further away from the villa.

The proportions, harmony and balance of Aulenti's design are the epitome of the classical ideal, yet its minimalist understatement succeeded in transforming the Italian garden and launching it into the modern age. In its use of a repeated linear form, it is reminiscent of works by American artist Frank Stella, which used coloured concentric squares to create an illusion of space. The perfect homogeneity of the garden and villa conveys an almost mystical sense of purity and calm.

Gae Auli Aulenti produced a design for the Tuscan garden of the Villa Pucci which balances superbly the austere lines and classical proportions of the fourteenth-century palazzo. The composition consists simply of shallow grass steps edged in concrete that range across the full width of the garden like a monumental plinth.

The Master's Villa at Cascina Albera, near Cremona, northern Italy, is a striking example of the fusion of a late seventeenth-century villa, a modern architectural renovation and a contemporary garden. In the early 1990s, Milan architect Maurizio Camillo Sala up-dated the villa while landscape designer **Anna Maria Scaravella** created a garden where, according to historical documents, no garden had previously existed. Their work is wholly complementary: the architecture of the house is as important to the garden and surrounding landscape as the design of the garden is to the house.

While retaining the original character of the building, the architect introduced a number of modern elements in his remodelling of the entrance doorways, fenestration and interior of the villa.

The recessed central section of the north façade and its symmetrical wings are mirrored on that side of the garden in a long, narrow pool which extends from the terrace around the house, cutting through the lawn in a straight axial line. Making a further link between house and garden, the stone used on the building also borders the pool.

Two large terracotta pots containing clipped bay trees mark the entrance doorway in a long-established Italian fashion. The planting is deliberately simple in this area to emphasize the linearity of the pool. *Populus nigra italica,* planted on the northern boundary of the garden in a zig-zag pattern, draw the eye to the countryside beyond, where the same elegant poplars, a traditional feature along the waterways of the Lombardy Plain, punctuate the view.

Just as Maurizio Sala subtly modernized the classical features of the late seventeenth-century Master's Villa, so Anna Maria Scaravella's design for the garden gives a contemporary treatment to a traditional Italian concept. Complementing the architecture of the north front of the house, she laid out a long, rectangular pool on an axial line corresponding precisely with the recess in the façade of the building, further linking the pool to the villa by using the same stone to edge it was used on the house. To the right can be seen part of the grassed bank Scaravella created to break the flat expanses of lawn and shape the western side of the garden.

Beverly Pepper's sculpture Cel Caigut *in the Parc de l'Estació del Nord, Barcelona, which inspired Scaravella's earth-moving operation at the Master's Villa.*

Weathered brick lines the walls of a sunken rotunda planted with lavender, rosemary and a Jupiter tree by the western entrance to the house.

A more elaborate, formal garden of clipped shrubs and sculptured hedging complements the ornate eastern entrance façade and main driveway. The planting scheme on the west side is also intricate but more contemporary in style.

In laying out the curved earth rampart that moulds the overall shape of the western section of the garden, Scaravella was inspired by an earth mound sculpture, *Cel Caigut* (Fallen Sky, 1986) in the Parc de l'Estació del Nord, Barcelona, by abstract sculptor Beverly Pepper. Clad in blue ceramics, Pepper's mound seems to rise out of the earth to a peak and then fall back and disappear into the ground. Like most of her work, the mound was influenced by forms derived from the natural world. The rampart rises to an elevated platform that contrasts with the flat expanse of lawn below it and incorporates part of an old red-brick wall, left as a historical note that endorses the continuity between villa and garden.

The same weathered brick is used in conjunction with concrete to make the concentric walls of a sunken rotunda near the western doorway. A pink-flowering Jupiter tree *(Lagerstroemia indica)* is planted off-centre in the inner circle and surrounded by clipped, fragrant *Lavandula spica* and *Rosmarinus officinalis*. Here, the placing of the tree, and the curves of the rotunda and the planting scheme around it, create movement and perspectives which act as a foil to the symmetry of the more formal areas of the garden and the architecture of the villa itself.

A small, hidden garden in Amsterdam, a simple rectangle like many others behind the terraced houses that front the city's canals, is lengthened and lit by the addition of a lead-lined water tank in a design by Dutch landscape architect Michael van Gessel (1999). The width of the pool is the same as that of the doorway in the garden façade, its simplicity of outline complementing the tall windows in the lower floors of the house and its only ornament a scattering of water lilies. The land slopes gently upwards from the house to the back of the garden and, in order to keep the water level constant, the pool has been raised about half a metre above the ground outside the garden entrance and sunk at the far end so that its top is flush with the paving of the terrace. Flanking the pool and screening neighbouring buildings are two long borders planted with herbaceous perennials, shrubs and a few mature trees, including a larch which stretches graceful limbs across the water.

Architect Oscar Tusquets Blanca and landscape architect Bet Figueras collaborated on complex designs for the renovation of a classical villa and its large hillside garden near Gerona. The north façade, showing the addition of the two symmetrical cube extensions, one of which contains an open staircase to the upper floor of the villa, the other a room with a low, horizontal window onto the terrace. A Japanese-style gravel garden to the right of the central rill is planted with low shrubs set amongst boulders.

The ground-level window of the glass extension cube added by Tusquets Blanca to the north face of the house looks out on to the bands of ochre-coloured concrete terracing, the colonnade and the long, straight rill punctuated by steps of falling water which create a wholly contemporary context for the fifteenth-century villa.

The Italian Renaissance architect Leon Battista Alberti (1404–72) cited the importance of placing a house on a hill with a wide perspective, and of establishing a protected garden that served as an extension of the house and a link between the building and the landscape beyond, creating an architectonic continuity that united man with nature. His theory could be said to encapsulate twenty-first-century ideals in landscape architecture.

Following these principles over six centuries later, a work of enormous dimensions has been laid out high on a twenty-eight-hectare hillside overlooking Gerona, north of Barcelona. The house and gardens, designed by Spanish architect **Oscar Tusquets Blanca** and landscape architect **Bet Figueras** respectively, are a statement in monumental structural design.

The villa is perfectly located on a south-facing slope looking towards the sea and protected by hills, which give it a mild micro-climate. Behind the property, the agricultural landscape is dotted with Italian cypresses *(Cupressus sempervirens)* and stone pines *(Pinus pinea)*, now practically native to the area, and evergreen oaks *(Quercus ilex)*.

The commission was to redesign the fifteenth-century villa, which had undergone a succession of extension works, and the challenge was to do so successfully within the limits imposed by the building's Historical Heritage status. Work began in 1997, the solution to the problem being to retain the original proportions and features of the stucco façade,

with corners and window frames in natural granite, and to gut and rebuild the inside.

Taking the spectacular views of the farmland, forest and sea as inspiration, Tusquets and Figueras segmented the garden into different areas, varying the character of each one according to its orientation in the traditional Italian Renaissance way. The entire garden is a series of modern interpretations of classical architectural features – columns, sweeping stairways, defining axes, waterways and a labyrinth – united in a highly stylized contemporary design.

The south garden is formal, with clipped hedging and two seventy-five-year-old Canary Island date palms *(Phœnix canariensis),* which stand as sentinels before the main façade of the house. A beautiful entrance canopy, sculpted into the gentle curves of a wave, enhances the symmetry of the architectural details.

Along one side of this southern section of the garden a line of clipped Italian cypresses creates a uniform six-metre architectural feature which also complements the regularity of the house. Six large evergreen oaks *(Quercus ilex),* pruned into a box-like canopy, cover a large part of the lawn and stand out dramatically against the azure sea in the distance.

A concrete terrace, stained yellow-ochre to match the house, flows away down the slope of the garden between two retaining walls, its line following the main axis towards the sea, and is continued by two flights of steps, presenting mirror images of each other, with a square platform between them. Below the terrace is a series of rectangular compartments edged with yew *(Taxus baccata)* and filled with tree germander *(Teucrium fruticans);* an evergreen perennial with oval, silvery-grey leaves that are somewhat aromatic, it has blue, tubular, double-lipped flowers at intervals throughout the year and acts as a perfect contrast to the dark yew. From this parterre the view spreads out towards the sea over a sunken maze planted with mature two-and-a-half-metre yew trees.

For the north façade Tusquets designed two cube extensions, one containing an open staircase, the other a sunken interior room, giving a view of the garden from a totally new perspective through a narrow horizontal window at ground level.

At the top of the slope running down towards these extensions, a single fountain jet breaks the surface of a shallow pool enclosed by a semicircle of English oaks *(Quercus robur).* Water channels surround a series of long platforms of ochre-coloured concrete, built parallel to the façade and divided by a straight, stepped rill. On the right is an area laid out in Japanese style with rocks and low-growing shrubs in a sea of gravel.

One of the most spectacular features of the whole design is the two-storey colonnade to the east side of the house, which consists of square, two-metre-high columns that pierce a split-level walkway from the terrace. Passing by a series of pools, this walkway crosses a bridge to a guesthouse, where more evergreen oaks contrast with a large swathe of white-flowering agapanthus. The bold, geometric columns and angled pools are placed for maximum dramatic impact, and their effect is further heightened by variations in texture and colour, the yellow sandstone columns silhouetted sharply against the wooden decking walkway and the water. The colonnade culminates in a single-width arched bridge with steel rails, under which a pool extends to form a grotto. Another water feature, an infinity pool, stretches directly south and visually flows out to the sea, a few tall cypresses punctuating the clear blue view in the middle distance and providing an upright frame to the edge of the pool.

Away from the house, the garden is softer and less architectonic. To the east, the entrance driveway curves past terraces planted like a prairie with steel-blue needle tufts of *Festuca glauca* and *Pennisetum clandestinum* in long strips that emphasize the scale and contours of the landscape. A hill to the north is yet to be planted with the dense forest of trees intended for it: evergreen oaks, the magnificent strawberry tree *(Arbutus unedo)* and cork oaks *(Quercus suber).*

Following the traditional Spanish idea of enclosing a garden, a wall runs along the perimeter of the property. Built in prefabricated concrete, it is made up of repeat-pattern, overlapping half-circles, each segment bedded at a different angle to its neighbour. This construction allows it to mould itself to undulations in the land as well as to curves in the boundary line, so that it seems to move naturally and fluently, animal-like, across the landscape.

Looking south, the view is spectacular: in the foreground an infinity pool and stepped terracing fall away from the villa below the main entrance, framed on one side by pines and evergreen oaks and on the other by a sculptural group of cypresses. The banded terracing of the garden echoes the strips of agricultural land in the valley below.

A two-storey decking walkway supported by rectangular sandstone columns makes a dramatic feature on the north-east side, between the villa and the terraced pools, forming a bridge over the entrance to a grotto and leading to separate guest rooms. A bank of white agapanthus overhung by evergreen oaks flanks the upper colonnade.

Slight variations distinguish the split-level gardens of two adjoining houses designed by the Raderschall partnership in Zurich. Concrete slabs matching the building and set into a gravel surround are used for both terraces, and clumps of unclipped box mark the outer edges of strip-like pools running parallel to each house in a clean, uncluttered layout. In one garden, a rectangular abstract work in the form of paving tiles by Ulrich Rückriem contrasts with a tall, upright sculpture by Gottfried Honegger. The back wall flames red in autumn with fan-trained Parthenocissus tricuspidata *'Veitchii'.*

In a Zurich suburb garden Swiss landscape architects **Raderschall Landschaftsarchitekten** have used a limited range of materials and plants to create a design based on bold but simple architectural graphics. Inspirational in its apparently effortless blending of landscape and architecture, it is a stylish response to the desire for a retreat from over-crowded and overly complicated lives.

Set in the beautiful, albeit stark, space around two adjoining houses built of concrete, steel and glass by architect Philipp Albers in 1999, the design in fact incorporates two separate gardens – one for each house – that complement each other in style and layout. They are effectively extensions of the building façade, mirroring in their geometrical layouts the balance of the inset fenestration and columns, and of the balconies which act as solar screening for the large, floor-to-ceiling windows.

The building stands on the highest part of the site, with a garage below at road level, and the logical landscaping solution was to terrace the land and

A long, narrow plunge pool occupies the lower level of the terrace, backed by a massive concrete wall that forms the boundary of the upper garden. The linear aspect of the design is emphasized by a concrete-strip promenade and wooden decking running the length of the pool.

incorporate the roof of the garage into the garden design. There is an economy of line in the architecture which is followed through in the landscaping – clean, linear shapes in concrete and gravel creating well-defined contrasts between mass and void. Exposed areas of concrete set off the patina of raw, untreated, rusty steel, while the graphic outlines of steps up from the garage to the terrace and sun lounge area above are punctuated by swathes of greenery in an understated yet highly effective planting scheme.

A sturdy concrete wall forms the backdrop to a long, rectangular plunge pool on a lower level, and provides a perfect foil for the water and the high bamboo trough that helps to screen it from neighbouring gardens. The detailing of this wall, with its exposed aggregate, is emphasized by symmetrically spaced concrete anchor points, and its continuity of line as it steps down to the promenade below, accentuates the horizontality of the whole design.

Gravel and concrete slabs immediately surround the building, the slabs tightly spaced near the walls – which are covered with climbers – and wider set with gravel inlays further away. In addition to the plunge pool, each house has a long, narrow water feature of its own running parallel to the terrace: a flat steel reflecting channel in one garden, complete with small bubbling jet; a deeper, darker channel in the other.

Clumps of box are strategically placed at each end of the pools to accentuate their length. Rings of rusted steel, one metre in diameter, form a circle for plume poppy *(Macleaya cordata)*, with its prolific creamy-white flower plumes, and purple-silver arching grass *(Miscanthus sinensis* 'Gracillimus'), which rises from the gravel like a fountain. The combined scheme for the two gardens is an imaginative fusion of geometry and abstract pattern, highlighting the plants by the discriminating choice of hard materials.

Major advances in load-bearing techniques in recent years have led to some close collaborations between architects and landscape designers in the development of rooftop gardens.

Designed in 1997 by Paris landscape architect **Laure Quoniam** for artist and illustrator Jean-Paul Goude, a roof garden was built as an architectural structure to span the tops of two apartment blocks built directly in front of Goude's own house. The need to screen these new buildings from the house led to the creation of a three-level garden, the first level extending an existing garden, the second creating a planted area around a studio above the new buildings and the third a rooftop garden on the highest level atop the new studio. The result is an oasis of foliage in the midst of Paris with panoramic views over the city, extraordinary both for its location and for the imaginative way in which it solves what appeared to be an insurmountable problem.

The façade of the original house, covered in clinging Virginia creeper, was the inspiration for the colour palette of the new garden at the front: largely green and white for the spring and summer months, turning to dramatic fiery reds in the autumn. Six *Cornus controversa* 'Variegata' are planted on the east side of the garden and one on the west, their purple-red autumn colours again complementing the creeper. An existing *Gleditzia triacanthos* and two creamy-white-flowered *Sophora japonica* 'Pendula' add height to the garden.

The white spring blossom and spectacular autumn colours of *Amelanchier canadensis* mix with the tall, elegant foliage of clumps of *Nandina domestica*, planted on either side of a curved path. The sulphur-yellow flowers of fifteen *Hamamelis mollis* 'Pallida' provide winter colour, underplanted with ground cover anemones and the tiny white spires of *Cimicifuga cahurica* and *Tiarella cordifolia*. Ivy covers

Only advanced engineering techniques made it possible to build a three-level Paris rooftop garden which spans the tops of two apartment blocks built in front of a private house. Designed by landscape architect Laure Quoniam for Jean-Paul Goude in 1997, the garden consists of an extension to the existing garden onto the new roof, an annexed studio space on top of the apartment buildings and a rooftop garden above that.

A pebbled pathway leads to a long flight of steps up to Goude's glass and steel studio, which is almost hidden in a shroud of greenery.

Cast concrete railings enclose the topmost garden which gives a spectacular view over Paris. In early summer the air is heavy with the scent of wisteria which overhangs white rhododendrons and white-flowering broom.

the ground on both sides of the garden, while Russian vine *(Polygonum baldschuanicum)* climbs the west wall and violet-blue *Wisteria floribunda* 'Macrobotrys' and white *Clematis montana* the east.

The overall effect is lush and jungle-like, as dense in its planting as any ground-level garden, and it is only the view that reminds you that it is in fact metres from the ground in the heart of the city.

The curves of a meandering, milk-white pebbled pathway and white stone steps lead to the studio, a modern structure of glass and steel, in the central part of the garden. *Wisteria sinensis* 'Alba' climbs on its west face and two blue-green weeping larches *(Larix kaempferi* 'Pendula') and a weeping blue cedar *(Cedrus atlantica* 'Glauca Pendula'), particularly remarkable in such a location, provide a darker contrast to the north. Specimens of white-flowering *Rhododendron* 'Palestrina' grow together with a mass of white-flowering broom *(Cytisus x praecox* 'Albus') and *Jasminum nudiflorum* on the south wall.

The view is even more spectacular from the top level roof garden, a narrow, rectangular site above the new studio. Sheltered by cast concrete walls and railings, masked by rampant climbers – *Polygonum baldschuanicum* and *Clematis montana* – it is planted with two *Cedrus atlantica* 'Glauca Pendula', white rhododendrons, white broom and a carpet of white-flowering tree heather *(Erica arborea* 'Alpina') mixed with *Euphorbia characias*.

Like a crow's nest, this is the perfect viewpoint over Paris, a testament to modern technology and its ingenious application but, more than that, to the vision of its designers. It demonstrates superbly the symbiotic relationship that has developed in recent years between architects and landscape designers and the imaginative and exciting work that can result from their collaboration.

The Vertical Garden

Using the wall of a building as a vertical planting screen, the façade of the contemporary theatre, the Theaterhaus Gessnerallee in Zürich, was seeded with grass embedded in clay by British artists Heather Ackroyd and Dan Harvey in 1993. The tactile green pelt, moulded firmly to the contours of the building, was intended to question assumptions about the distinctions between architecture and nature.

The glass façade of a house in Hamburg was turned into a remarkable high-rise greenhouse in 1996 by landscape architects wes and Partner, who created a wall of greenery on every level.

Given that space for building houses is now in such short supply, gardens are at risk of shrinking or disappearing completely from cities and suburbs unless imaginative ways can be found of incorporating them into the planning and structure of buildings. Designers and architects are having to review the whole concept of a garden and find new ways of creating it, and the constraints imposed by lack of space are therefore, paradoxically, having some stimulating consequences. Where a ground-level garden is not an option, designers are coming up with dramatic and brilliantly inventive proposals for gardens laid out on vertical planes and in spaces never previously regarded as the province of plants.

The vertical garden can be separated into three main types: one whose planting scheme is laid out on a vertical plane rather than in a traditional horizontal layout, one where tall trees establish the vertical line and, lastly, one whose vertical walls serve as either a visual backcloth or a physical support structure for plants.

Planting on a Vertical Plane

According to French botanist and scientist **Patrick Blanc**, a wall represents a means of extending the planting area of the garden in a new direction. As a member of France's esteemed Centre National de la Recherche Scientifique, Blanc has carried out research into tropical rain forests all over the world and has realized how extraordinarily adaptable plants are to the most inhospitable living conditions. In tropical forests, where trees vie for sunlight, they grow as tall as possible and their leaves form a dense canopy overhead. Underneath, smaller plants adapt to the shade and grow in every available crevice, their tenacious root systems searching out the required nutrients and water, even if they have to parasitize other plants to find it.

After careful study of tropical habitats, and experimentation with feeding materials, Blanc translated the scientific principles of the rain forest to a garden setting. His system is based on hydroponics, where plants grow without soil in an inert medium,

fed on a solution of all the elements necessary for growth. Since plants living in these conditions do not need to compete with each other for nutrients, more can be grown in a smaller area.

The concept of the hanging garden is an ancient one, and the idea of growing plants on walls and terraces, or, on a more modest scale, using window boxes and baskets to decorate garden walls, is far from new. But on the scale which Blanc conceived, creating a total wall of trees, flowers and shrubs, it is revolutionary and opens up a whole new range of possibilities for planting where space is limited.

Blanc applied this system in his own garden at Créteil, south-east of Paris; consisting of a sixty-square-metre courtyard in front of the house, it is enclosed on two sides by walls four-and-a-half metres high with a longer boundary wall at the end. The space is typical of a small urban garden, in shadow for much of the day from the buildings and walls around it. However, by expanding this small area skywards and covering the vertical surfaces in plants, Blanc has created a garden that is awe-inspiring in its luxuriance. Like a green nest, foliage fills the space from floor level to above head height in a mass of texture and colour.

To create a planting screen, Blanc places small, young plants into pockets cut in a stiff polyamide felt just thirteen millimetres thick. Their intertwining root systems add strength to the felt, which is backed by a thin sheet of PVC to protect both them and the wall. Adjusted to the weather and

French botanist and scientist Patrick Blanc has created a series of vertical gardens based on the growing patterns of tropical rain forests and the principles of hydroponics, in which plants grow without soil and are fed instead with a nutrient solution that supplies them with all their needs.

In his small garden south-east of Paris, Blanc has created walls of colour, with sun-seeking plants forming the higher canopy and ferns, corydalis, Azara serrata, saxifrage and Iris japonica thriving on the lower, damper levels.

Blanc's luxuriant green tapestry was originally created for an exhibition called Être Nature at the Fondation Cartier in Paris in 1998, when it was mirrored by a temporary interior plant screen, and has since become a permanent feature over the entrance to the gallery.

At the 1994 garden festival of Chaumont-sur-Loire, Blanc unveiled his Murs Végétaux, three-dimensional freestanding walls of plants placed in shallow pools of water that was recycled to feed them.

orientation of each site, a watering system regularly drips a classic mixture of diluted nutrients through the felt to feed the plants.

Mirroring the natural formations found in the tropical rain forest, the plants near to the top of the wall are sun-seeking larger shrubs and climbers that form a canopy over the lower planting. Profuse clusters of buddleia hang in long plumes all through the summer, together with the tiny, starry flowers of spiraea. Varieties of willow and fig give height and depth, with forsythia, berberis and erysimum adding texture and colour in different seasons.

Nearer to the bottom of the wall below this canopy, a shaded, damper area offers ideal conditions for varieties of fern, corydalis, rounded clusters of sweetly scented *Azara serrata,* cushion rosettes of saxifrage and groups of white-flowering *Iris japonica.* Mosses and lichens sprout in moist spaces close to the ground, forming a uniform green carpet, so dense that weeds hardly ever appear.

In 1994, at the third garden festival at Chaumont-sur-Loire in France, an annual showcase for innovative ideas in garden and landscape design, Blanc's *Murs Végétaux* were unveiled to the public for the first time. These high, planted screens were created as freestanding features with their base in a shallow trough of water that was recycled to feed the plants. The screens supported a wide range of familiar garden plants as well as some exotic species and made a magnificently impressive three-dimensional display.

Visitors to the festival were surprised to see a garden literally from a new perspective, to have their eye taken upwards to plants growing above their heads rather than down to ground level. The appeal of the design lay in its highly tactile and fragrant planting scheme, the fact that no soil was required and that the trough could double as a goldfish pool. Testing the concept to its greatest ever height to date, Blanc completed a garden wall thirty metres high in a Parisian hotel courtyard near the Champs Elysées in 2001.

For an exhibition called *Être Nature,* which effectively spanned the borderline between nature and art, Blanc created a vertical garden at the Fondation Cartier in Paris in 1998. Initially it consisted of two screens, planted in a way similar to his *Murs Végétaux,* separated only by the wall of the building, a permanent screen of hardy plants outside backed by a temporary, tropical one inside. The outside screen remains; sheltered and protected from the weather by its location, it hovers above the entrance to the Foundation, making a visual link with the greenery of the trees along the boulevard in front of the building. It also complements the 'Theatrum Botanicum', the botanical garden designed by Lothar Baumgarten at the back of the Foundation (discussed on page 55).

Part wild garden, part art canvas, Blanc's hanging screen is like a three-dimensional Henri Rousseau painting – vivid, luxuriant and surreal. All that is missing is a benevolent tiger to push back a lush leaf.

The same luxuriance is a feature of the garden designed by landscape architects **WES and Partner** for a private house in Hamburg. The prize-winning building, the work of architects Hachtmann + Pütz, is a radical departure from traditional architecture in that it is constructed effectively as a showcase for plants.

An outer glass wall the full height of the house stands less than two metres away from the main façade, also constructed largely of glass in a framework of steel, and is linked to the building by steel poles and metal grid terraces on each floor. Like a tall, shallow greenhouse filled with plants, the multi-storey garden occupies the space between the outer and inner glass walls, filtering light into the interior of the house through a screen of foliage, and presenting a haze of greenery filling the front of the building from top to bottom when seen from the street outside.

The terraces provide sheltered walkways running the full width of the building on each floor. Fast-climbing *Wisteria sinensis* and evergreen orange-yellow honeysuckle *(Lonicera henryi)* give a sense of height internally by climbing up the structural supports of the walkways and through the small gaps between the vertical sheets of glass in the external wall. Although not designed as an ecological garden per se, the plants do moderate temperatures inside the house and help to keep the atmosphere fresh and invigorating.

The ground plan of the Hamburg building, showing the narrow space between the two glass walls of the external façade in which WES and Partner have created a vertical screen of greenery.

Walkways provide access to external terraces in the glass and steel building designed by Hachtmann + Pütz, and light is filtered into the interior through a dense screen of planting which helps to keep the atmosphere cool and clean.

West 8's prototype design in 2000 for a suburban garden in Utrecht puts forward ideas that confound all the long-established traditions associated with suburban plots. Here, standing on an artificial mound, is an extraordinary rectangular frame thirty metres high and decked on every level with potted Juniperus virginiana 'Glauca' trees.

In a design that seeks to isolate the garden from its surroundings, Dutch landscape architect **Adriaan Geuze** explores the idea of a contemporary *hortus conclusus,* a protected paradise enclosed on all sides, which makes references to nature but does not set out to imitate it. The design is abstract enough for the mind to make connections to the natural world but not to register specific associations.

West 8, Geuze's Rotterdam-based landscape architecture and urban design firm, created a proposal for a garden at Houten, a densely populated suburb of Utrecht, as one of twenty to be displayed on a seven-and-a-half-hectare park completed in 2002. Although never built, it is extraordinary in many respects, but particularly as a prototype garden in a new housing development. Just as the bathroom suite or the colour of the façade can be chosen from a numbered selection to customize the house, so too the garden can be selected from one of the showcases.

This is in no way the traditional suburban garden of fencing, lawn and flowerbeds; instead it examines the shifting ground between illusion and reality. Elevated on a three-metre artificial earth mound, a rectangular frame soars thirty metres high, its structure suggesting that one could climb it for the view from the top but in fact there is no way up. A series of evenly spaced horizontal platforms are adorned with rows of potted *Juniperus virginiana* 'Glauca' trees of similar height, colour and spacing, and each level of the tower is lined with red-flowering pelargoniums. At the top is a large, golden object not unlike a large potato that disguises the watering system for the plants below. From the bottom, one's view is tunnelled through the layers of planting to a glimpse of sky, like looking up an exotic, flower-lined lift shaft.

The choice of plants on the tower is a clear and perhaps ironic reference to the typical suburban garden, with its evergreens and pelargoniums, and used in this incongruous, dreamlike context their very familiarity causes some slight unease. Even the ground area inside the tower, where a terrace surrounds a sunken pool, seems in some way to be illusory. It has all the essential romantic elements of a garden pond with water lilies *(Nymphaea* 'James Bryden') and frogs, but one senses that it too may be an ironic reference to the suburban garden. The design is in any case a thoroughly modern and ingenious solution to the problem of space and it offers a welcome, irreverent alternative to the hackneyed themes that have perhaps been around for too long.

Edouard François' 'Sprouting Building', an apartment block at Montpellier, where plants were embedded in the actual fabric of the façades to create a form of organic architecture that blends with the natural surroundings. The building was constructed using gabions, stainless steel mesh baskets filled with stones, which were lodged in grooved panels in the outer walls. Over a thousand plants were then plugged into the gaps between the stones by a team of abseilors.

A vertical screen designed by British artist Judy Wiseman for a courtyard wall in a private garden in England, and densely planted with the silvery, sword-like, evergreen perennial Astelia chatamica (2001).

The interior of the frame is lined with horizontal platforms uniformly planted with red-flowering pelargoniums. At ground level a walkway surrounds a sunken pool filled with water lilies and frogs.

The potential of the vertical garden is further demonstrated in a design for the façade of a residential building in France by **Edouard François**. Completed in 2000, it juxtaposes urban architecture with natural materials – stone, wood, metal and plants – in a powerful and unusual alliance. The Château Le Lez, a sixty-four-apartment, seven-floor building on the wooded bank of the River Lez in Montpellier, is now known as the 'Sprouting Building' because its garden covers much of its outer walls.

The façades of the building were constructed from gabions, large stainless steel mesh baskets filled with stones, like those traditionally used to stabilize riverbanks – a reference to the vernacular methods used here in the past. These were incorporated into prefabricated, grooved panels that formed the main structural framework of the walls.

Initially, a mixture of fertilizer and earth impregnated with plant seeds was sprayed across the entire surface of the outer walls in the hope that this growing medium would lodge between the large stones and hold the sprouting seedlings in place. However, the stones proved too widely spaced to sustain the small plants and larger specimens were subsequently hand-plugged into the walls by a team of abseilors, creating an organic skin on the vertical faces of the building. An automatic irrigation system regularly feeds the plants. As they grow, their colours and textures will increasingly enliven the façades, and the apartment balconies will take on the aspect of private tree houses, providing the residents with greater privacy and a sheltered open-air living space.

The Use of Trees

Tall, upright tree trunks create an immediate impression of strength, elegance and timelessness, and these qualities have been brilliantly achieved in a landscape design at Camorino, southern Switzerland, by means of the simple addition of trees.

On a flat, grassed area of 1500 square metres, landscape architect **Paolo Bürgi** planted a hundred specimens of the Lombardy poplar *(Populus nigra italica)*, evenly spaced in a spiral pattern. The spiral form holds a deep-rooted significance for us on many conscious and subconscious levels, and our response to it is instinctive as well as aesthetic. It represents growth and order in the natural world and occurs in a wide variety of animal and plant structures: the swirl of wind currents, for example, and the formation of a waterspout, the unfolding leaf of a fern and the intricate construction of an ammonite are all based on the same perfect, coherent, logical structure.

The absolute simplicity of Bürgi's concept gives the spiral at Camorino an added potency. Culminating in a simple, circular, paved area under a vaulted cathedral of greenery, the nucleus of the design is the still centre of the garden, where power and energy are most highly concentrated. The tall, slender shapes of the trees cast deep shadows on the grass as light filters through them, like the spokes of a wheel that moves round with the sun.

The poplars at Camorino clearly form a man-made plantation, yet the structure and spatial integrity of the design are so closely connected to nature that it captures brilliantly the *genius loci*, the true spirit that inhabits each place.

Landscape architect Paolo Bürgi planted one hundred Lombardy poplars (Populus nigra italica) in a simple spiral extending over a wide expanse of grass on the Piano di Magadino, in Ticino in southern Switzerland, in 1985. The dark, horizontal shadows of the trees, interspersed with bands of sunlight, balance their vertical outlines and enhance the linear clarity of the design.

The slim silver trunks of birch trees fill the garden of a square of apartment buildings in Paris designed by Italian architect Renzo Piano. Evenly spaced in straight rows like a traditional plantation, they are densely underplanted with clipped evergreen honeysuckle. Paving in brick and concrete forms a series of intersecting paths across the square and perfectly echoes both the deep terracotta tones of the building and the grid lines of its banded, geometric façade. This classically simple garden is the work of landscape architects Michel Desvigne and Christine Dalnoky.

Trees are also the principal feature of a Paris garden designed by French landscape architects **Michel Desvigne** and **Christine Dalnoky** between 1989 and 1992. Hidden from the main street by a narrow entrance, the large sunken garden is enclosed by apartment buildings designed by the celebrated Italian architect Renzo Piano, which it complements with great style and restraint.

Flights of steps lead down to the garden from the apartment blocks on each side of the square. The tall, slim trunks of silver birch trees planted in a regular formation give the design a vertical emphasis, their white bark reflecting the banding that encases the rectangular windows of the buildings. Beneath the trees, the low-growing shrubby honeysuckle *Lonicera nitida* spreads a dense, neatly trimmed carpet, forming blocks of evergreen planting intersected by pathways. Paved in terracotta tiles with concrete banding, the floor of the garden forms a grid pattern that almost precisely replicates the geometric format of Piano's façades.

In winter, the light, upward-sweeping branches of the trees allow a view through to the buildings while in summer a green haze of delicate foliage hovers above the garden and gives it shade.

A similar sense of seclusion is achieved in a different way by sinking a garden to below street level at the Fondation Louis-Jeantet building in Geneva. Paris-based landscape architects **Henri Bava**, **Olivier Philippe** and **Michel Hoessler** of **Agence TER** and architects **J.M. Anzevui**, **N. Deville** and **J.M. Landecy** of **Agence Domino** won a design competition in 1993 to create a new garden for an early twentieth-century Palladian-style villa.

Intrigued by the relationship between building, ground space and urban setting, the designers considered how best to integrate the architecture of the Foundation with a new garden on a site where space was extremely limited. The solution was to sink part of the raised piazza in front of the villa to street level, creating a well with a terrace walkway around it, and to lay out the garden in this sunken courtyard.

Two square-cornered horseshoes, interlocking though not connecting, form the retaining walls of the courtyard, their angular outlines marked by dark rills, whose water circulates around the perimeter of the terrace above the garden and falls in a cascade to the floor below, the noise of the waterfall drowning out the sounds of the city. The upper floors of the building give a bird's-eye-view of the garden while the walkway is level with the tops of the trees and offers glimpses of the courtyard through the foliage.

The sunken garden is filled with randomly planted *Prunus sargentii*, whose sugar-pink spring flowers stretch like a carpet in front of the villa; as the petals fall, the carpet reforms as a swathe of faded pink on the courtyard floor.

The retaining walls of the garden are constructed of plain concrete, relieved by a regular pattern of indented circles made in the casting process, which forms a contrast to the ornate façade of the villa and a simple backdrop to the foliage of the cherry trees. Long slabs of black slate, interspersed with thick bands of pearlwort (sagina), flow across the courtyard floor like logs jammed in a green river.

The design works as successfully at night, when spotlights throw the shadows of branches onto the walls of the courtyard, as during the day, when the garden seems isolated from the outside world with a view only of the trees and sky overhead. From inside, the emphasis of the design is purely vertical.

Agence TER and Agence Domino devised an ingenious solution to a space problem at the Fondation Louis-Jeantet in Geneva by creating a well in the piazza that extends from the building at first-floor level.

From inside the courtyard, the emphasis of the planting is purely vertical, with a view only upwards through the branches. At night the trees are lit from beneath.

The upper floors of the building have a bird's-eye view of the cherry trees (Prunus sargentii) that turn the garden sugar-pink in spring and shades of deep red and copper when the leaves turn in the autumn.

Dominique Perrault transplanted mature pine trees from Normandy to create an enclosed garden like a deep green forest for the new French National Library in Paris, thus completing his architectural plan for the prestigious building opened in 1996. The garden can be seen from the reading rooms ranged round the outside and from the tall glass towers at each corner.

Again, tall trees are the principal feature of the garden of the Bibliothèque Nationale de France, The French National Library, which is a high-technology building on the River Seine in Paris, officially opened in 1996.

Seven years earlier, in 1989, architect **Dominique Perrault** had won the competition to design this prestigious and coveted project, commissioned by François Mitterrand, which would provide an appropriate home for the much-expanded national archive and book collection. His solution was a simple and elegant design comprising four tall, glass corner towers linked by a stepped plinth which creates a somewhat barren wooden esplanade around a sunken, rectangular garden. Nearly half the entire collection of the library is now stored in these towers, with the remaining volumes and rare books kept in storerooms beneath the plinths; the public spaces and reading rooms are ranged round the interior garden.

Occupying a space of two-and-a-half hectares, the garden is open to the sky and is composed of nearly 120 fully mature pine trees that were successfully transplanted from Normandy. This pristine forest, while closed to visitors, offers a prospect conducive to concentrated reading and meditation – an image of the landscape which answers a profound need in a city environment for a reminder of the natural world – its appeal heightened perhaps by its inaccessibility.

Opposite: *Like a monumental white wall, this abstract bas relief, one of a series by sculptor and artist Ben Nicholson, reflects light onto the water of the rectangular lily pond designed in 1980 by British landscape architect Geoffrey Jellicoe for the gardens at Sutton Place in southern England.*

Luis Barragán used a startling palette of pinks and yellows to animate the walls he designed for his scenographic landscaping compositions. Mexican by birth, he travelled extensively in France and Spain in the 1920s and still exercises a powerful influence on garden designers throughout western Europe today. Water as well as colour was a recurring theme in his work and here, at the San Cristobal estate outside Mexico City, which he laid out in the late 1960s, a pool and the wall it reflects are the principal features of his design, the vivid magenta contrasting brilliantly with the azure blue water and sky.

The Vertical Wall

The vertical wall is no longer regarded by architects and designers simply as a structural necessity or a barrier. It is now being required to fulfil a wider potential, as a feature which serves both a functional and an aesthetic role in a garden. Aside from addressing the contemporary problem of shortage of space, it can serve not only as a climbing frame or backdrop for plants but also as a design feature in its own right, one that affects atmosphere and perspective, introduces colour or decoration and links the garden to the architecture of a building and the landscape beyond.

The rigorous simplicity of the work of Le Corbusier, the influence of Islamic architecture from Spain and the ideas of the Mexican Minimalist architect and designer **Luis Barragán**, are cited by many of today's landscape architects as inspiring them to expand their perceptions of the wall and use it in a much broader context than before.

Barragán trained as an engineer and was a self-taught architect who, in the 1920s, travelled extensively in France and Spain and, in 1931, attended Le Corbusier's lectures in Paris. In his landscape architecture he used the wall as a key design element in the form of pure planes of stucco, adobe, timber or even water, often painting hard materials in a range of dazzling pinks, yellows and magentas perfectly suited to the bright sunlight of Mexico and a refreshing departure from the Modernist use of glass and cast concrete.

His compositional elements, and particularly his walls of colour, were intended to draw viewers into his designs so completely that the outside world ceased to exist and they were conscious only of the effect of the colour itself. In a garden setting, these walls serve as modern icons to promote contemplation or a mood of serenity, to stimulate the imagination or simply to provide a canvas for the shadows of trees to play across the coloured surface.

Often high and placed to frame a view or take the eye into a more distant perspective, the walls give his gardens the look of a stage set, their structural impact combining with dramatic water features such as troughs, aqueducts, flowing channels, waterfalls and pools. The stone surface of a wall acts as the perfect foil for the reflective properties of water and therefore offers it the ideal background. Barragán's use of water was a reference to his childhood on a Mexican ranch, where the land was dry and water precious.

Known as 'The Twelve Apostles', this stately circle of clipped yews enclosed by a red brick wall was designed by landscape architect Paul Deroose for a private garden in Belgium. A flight of steps curves up round the outside of the perimeter wall to a platform which gives a view over the ring of trees and the traditional garden beyond.

In a classically beautiful garden in Belgium, a ring of twelve yew trees *(Taxus baccata)* enclosed in a circular wall dominates a design by landscape architect **Paul Deroose**. Known as 'The Twelve Apostles', it is an intriguing folly in the midst of an otherwise traditional garden of roses, perennial borders and clipped hedging. The space contained within the wall is twenty-four metres in diameter and the red-brick wall itself, with red pointing, is two-and-a-half metres high, making a bold sweep of colour in the orderly, clipped lawn and accentuating dramatically the vertical aspect of the garden. The wall is punctuated by three doorways and one window, and a flight of steps on its eastern side curves up to a platform giving a bird's-eye view over the rest of the garden.

The curved wall, reminiscent of the Wailing Wall in Jerusalem, has the ability to prolong sound and create echoes, properties which add to the atmosphere of the space inside it and its sense of detachment from the rest of the garden.

The yew trees stand evenly spaced and of uniform height, each clipped from ground level into the shape of a bullet. They will be allowed to grow to three metres – not much more than their present height – so that from outside the wall a ring of green domes can be seen topping the earth-red brick. They have an air of gravitas, like Church dignitaries gathered in solemn debate in a chapter house.

The potential of the wall is further explored in the sculptural work of **Richard Serra,** whose industrial steel sheets, bisecting the landscape, caused much controversy in the art world of the 1960s. They have continued to be a source both of debate and inspiration ever since.

Serra's *Spin Out* is an arrangement of three Acier Cor-Ten steel walls intersecting an opening in the woods at the Kröller-Müller Art Museum at Otterlo in the Netherlands. Cor-ten steel is part of a group known as 'weathering' steels because they provide better resistance to atmospheric corrosion than plain carbon steel; for this reason it was not long before they found their way into the garden. In Serra's designs the sheer weight and incongruity of the industrial metal provides a powerful contrast to the natural environment in which he used it.

Richard Serra's Spin Out *(1972–3) comprises a series of linear steel sculptures set at right-angles to the pathway through an area of woodland at the Kröller-Müller Art Museum at Otterlo in the Netherlands.*

Interlocking steel plate and concrete walls create variations of space and height in a garden designed in 1991 by Weber and Saurer near Solothurn in Switzerland. The steel acquires a patina of bright, striated colour as it weathers, enhanced here by sprays of the tall bamboo Fargesia murieliae.

A concrete terrace runs the width of the garden, with steps leading down to a swimming-pool bordered by long grass and ox-eye daisies. A series of overhead wires creates a framework for a dense canopy of climbing plants over a walkway running in front of the walls.

In a similar vein, landscape architects **Luzius Saurer** and **Toni Weber** used industrial steel in a suburban garden at Solothurn, Switzerland, erecting a series of steel plate walls as a backcloth to the planting scheme and a screen to shut out neighbouring gardens. Here, the concept of the wall is given an even more contemporary interpretation, but the principal emphasis of the garden is again its vertical line.

The properties of the steel are such that time and atmospheric conditions play an important role in the ageing process: it takes on a patina of vivid rusty shades once it is exposed to sun and rain and acquires a velvety, eroded texture, giving it a timeless quality.

A concrete wall, covered in Virginia creeper, slightly out of line with and marginally higher than the steel walls, leaves a gap between the angled planes for clumps of tall bamboo *(Fargesia murieliae)*, its narrow, pale green culms softening the hard edges and adding height. Together these walls also form the backdrop to a concrete terrace running the width of the garden. They are largely hidden from view from the house by an arched pergola supporting a number of climbing plants on overhead wires running parallel to the walls. Around the terrace, *Anemone japonica,* the lemon-yellow flowers of the day lily (*Hemerocallis lilioasphodelus*) and tall, eye-catching spires of yellow *Ligularia przewalskii* add splashes of colour against the steel, with a ground cover of *Epimedium x rubrum*.

Four wide steps lead down to a swimming-pool and a long border of wild flowers and grasses that flank it to one side of the house. The walls and windows of the building itself are swathed in the heavy branches and delicate lilac racemes of a large climbing wisteria.

Moto Terreno Solare *by Italian sculptor Arnaldo Pomodoro is the principal feature of a garden designed by Ermanno Casasco at Marsala in Sicily between 1989 and 1994. The planting scheme, with its luxuriant displays of date palms, citrus trees, yuccas and jacaranda, enhances the surreal atmosphere of this theatrical landscape.*

Pomodoro's monumental sculpture, ninety metres long by nine metres high, is built of yellow volcanic tufa native to Sicily, its central section rising from a shallow pool that reflects its dramatically fractured surface.

At Marsala in Sicily, sculptor Arnaldo Pomodoro's 'Moto Terreno Solare' (Movement of Earth and Sun), created for the Minoa Symposium, comprises a wall of truly vast dimensions. Nine metres high and ninety metres long, it is made of yellow volcanic tufa native to Sicily and derives its language of expression from its provenance. A textured relief of cracks and broken planes, it rises from a pool of clear, shallow water filled with pebbles like a piece of vertical landscape architecture.

The surrounding garden, designed by Milan-based landscape architect **Ermanno Casasco**, is made up of an undulating series of man-made hills, mounds, ditches, trenches and valleys, planted with literally hundreds of different species. Desert plants used around the sculpture create an exotic, surreal atmosphere, the huge fronds of date palms *(Phœnix canariensis* and *P. dactylifera)* almost like sculptures in themselves. Glossy-leafed *Citrus limon, C. aurantium,* architectural *Yucca rostrata* and *Ficus benjamina* grow among beds of rare cacti with strongly scented *Jasminum azoricum* and *J. polyanthum.*

The strawberry tree *(Arbutus unedo)* and the evergreen carob from the Middle East *(Ceratonia siliqua)* mix with jacaranda, its vivid, lilac-blue clusters of trumpet-shaped blossoms appearing in spring and later carpeting the ground with a haze of blue.

A collection of palms – European fan palm *(Chamaerops humilis)* and the king and queen sago palms *(Cycas revoluta* and *C. circinalis)* – are planted around meandering paths that climb over the hills and mounds, providing a soft undulating backdrop to the monumental structure of Pomodoro's wall.

A place where everything seems much larger than life, this artificial landscape laid out under the dazzling Sicilian sun is used for wedding ceremonies and banquets, and its glamorous, fantasy atmosphere seems perfectly suited to its function.

In Milan, a single vertical wall of a tall, narrow courtyard was transformed in 2000 into a remarkable organic garden made of sculptured earth and water. Designed by **Maurizio Russo** and landscape architects **Studio AP &G**, it is flanked by a red-brick wall eleven metres high and a plate glass wall; facing it, four metres away, is the fenestrated back wall of the owner's house, which was converted from a 1900s warehouse.

The post-industrial character of the building and the new architectural conversion into a modern living space work brilliantly together to create a setting for the textures and materials of the sculpture. The film 'Stalker', by director Andrej Tarkovsky, in which an abandoned industrial site becomes the scene of mysterious events, was its principal source of inspiration. The enclosed space of the shaft-like courtyard gives it a feeling of inviolable isolation, both from internal and external viewpoints.

Near enough to view every detail from the house, the sculpture wall – executed by Neapolitan artist

A tall, narrow, internal shaft, enclosed by buildings and with little natural light, offered the only available space for a garden in Milan, where a single wall was transformed in a design by Maurizio Russo into a remarkable sculpture of earth, water and planting. At night it is brilliantly lit with spotlights from below.

A waterfall trickles gently down the wall from the top, connecting the different strata and keeping their colours and details alive.

The falling water is recycled through the pool at the foot of the shaft, where a zinc grid is planted with ivy, ferns and bamboo, their leaves permanently moist from a spray of fine mist.

Lucia Ausilio – abstractly represents a geological slice through the earth seen in cross-section. As if a giant spade has dug deep into the ground, revealing layer upon layer of history in the different stratifications, it is a narrative commentary on the land on which the house was built and a reflection of both the history of the region and of human intervention in the landscape.

Subtly coloured bands of earth differentiate the strata, each one containing artefacts to denote its historical significance. Roots protrude from clay-coloured ground in one layer, petrified twigs in another, pieces of broken ceramics refer to a heritage of craftsmanship, while floating bottles and old cans are embedded in the earth as a reference to more recent times. Pebbles from the river are mixed with yellow and white boulders and roughened chunks of travertine marble, one of Italy's oldest and most valued building materials.

Water constantly runs down the wall, like a thread connecting the different strata and bringing their colours to life, and sprinklers on the side walls spray it with a constant mist which fills the air with an atmospheric vapour.

The earth wall hides electric cables and the watering system for the ground-floor garden. Although the shaft is open to the sky, little light penetrates to the base of the courtyard. Here, bamboo *(Phyllostachys aurea)* grows in graceful, yellow-brown clumps, its slender shoots accentuating the verticality of the well, with ferns and ivies planted in a zinc grid fed by the continuously recycled water.

The design makes such brilliant use of the very limited and awkward space available that it seems to make a virtue of the problems it had to overcome. The result, combining botanical and sculpture garden, makes no distinction between the concepts of art in the garden and the garden as a work of art. Here they are mutually complementary and homogeneous.

Leaping the Fence

Although the idea of borrowing the landscape, exploiting the natural beauty of the surroundings to the best possible advantage, is centuries old, today's designers are interpreting the concept in new and original ways.

Prior to the Renaissance the Western garden ideal was equated with the Hortus conclusus, an enclosed garden which had clear boundaries to protect it from the hostile environment beyond. With the emergence of Italian villa gardens the relationship between buildings, gardens and the landscape became one of the fundamental questions of garden design. As the world outside the garden was increasingly perceived as 'landscape' with its own aesthetic qualities, it became, at least visually, an element in their design.

In the oriental world, the concept of a garden with no artificial boundaries to mark it off from the unknown world beyond stretches back far longer, to the teachings of Confucius (550–478 BC) and the doctrines of Taoism and Buddhism. These ancient philosophies were based on spiritual values that regarded boundaries – of the garden as well as the mind – as restricting the spirit and the imagination. Gardens were for meditation, for contemplation and for the reading of spiritually uplifting poetry in highly stylized surroundings. For the spirit and ideas to flow, boundaries had to be established in accordance with the ancient Chinese metaphysical science of geomancy and balanced with the forces of yin and yang.

The traditional Chinese garden has a long and intimate association with the landscape, drawing twisted trees and fantastic rock formations into the design so that they form as much a part of the garden as its ornamental gateways, pavilions and bridges. Inextricably linked with the traditions of calligraphy, literature and art, the Chinese garden borrowed freely both from the landscape itself and from stylized representations of it, particularly from the *Shan Shui* genre of paintings depicting high mountains and swirling waters which were made famous by Sung Dynasty scrolls.

Japanese gardens also incorporated the distant landscape into their designs. The Ryoanji Temple Garden in Kyoto (see page 50), now a UNESCO World Cultural Heritage Site, is perhaps the best known of its type: characterized by highly controlled and stylized forms representing trees, mountains and other features of the natural landscape, it is laid out over an expanse of rock and sand and enclosed by an outer wall, its elements purely symbolic, an idealized, conceptualized representation of the land-

Ornamental grasses at Eygalières, in southern France, form a natural transition from the controlled planting of the garden, designed by Alain David Idoux, to an open field of wild flowers and agricultural land that merges with the distant mountains of the Luberon to the south-west.

scape beyond. In recent years the Japanese concepts of abstracting from the landscape and of metaphorically extending the garden to the horizon have both exerted a significant influence on landscape architecture in the West.

Although their aims and aspirations were in almost every other respect quite different, the formal French gardens of the 1600s did have something in common with the traditional Japanese garden: their long, straight axes were intended to suggest that they continued into infinity, not just as far as the neighbouring field, and their schemes were undoubtedly symbolic in meaning and stylized in their use of natural forms.

It was as a reaction to such rigidity and control that this same idea, of extending the view as far as the eye could see, reappeared in the landscape gardens of eighteenth-century England. In 1780 the English writer, philosopher and landscape critic Horace Walpole (1717–97) made his now famous quip, 'He leapt the fence and saw that all nature was a garden'. This statement encapsulates the ideal of incorporating the landscape – that most beautiful of natural gardens – into the design of the garden itself so that the two become one. It was to this end, of course, that the ha-ha was devised (see pages 56–8), and it is a principle to which this book frequently refers because it informs so many aspects of landscape architecture today.

In the twentieth century, when European landscape design was toying with Modernism, British landscape architect and urban planner Christopher Tunnard returned to the principles of ancient philosophy in his essays *The Garden in the Modern Landscape,* published in the *Architectural Review* in 1938, declaring that the new landscape was the garden without boundaries. It is a principle followed with great style by a number of garden designers and landscape architects today.

From an education in classical philosophy, Spanish designer **Fernando Caruncho** views the garden, as did the ancient Greeks, as one of the purest expressions of truth and life. Applying this concept to design, he regards not only the site but also the landscape surrounding it as essential references and sources of inspiration.

At Mas de les Voltes in Catalonia, Fernando Caruncho laid out a remarkable garden planted largely with wheat, a traditional Mediterranean arable crop, which runs uninterruptedly into the farmland around it.

Like a vast parterre, the tracts of wheat, laid out symmetrically and intersected by long, straight, grass-covered paths, are framed by olives and tall, slender cypresses.

The land is ploughed and re-seeded and the crop harvested every year as it is in the fields around the property, ensuring a regular cycle of change in the garden that mirrors the farming seasons.

To the east of the house four square carp pools divided by paths in a cross formation mirror a line of tall Italian cypresses and a bank of thickly planted shrubs and trees.

His design for the garden at the Mas de les Voltes in Catalonia, Spain, completed in 1995, comprises a triumvirate of ideas that are all closely linked to the traditions of the land: firstly, by integrating the garden physically into the landscape; secondly, by referring to the traditional agriculture of the area in its planting scheme; thirdly, by making clear connections with the passing of time and the seasons.

A formal arrangement of large tracts of wheat, a crop cultivated around the Mediterranean since ancient times, lies on a gentle, south-facing slope away from the house, visually extending the garden to the neighbouring arable fields and the distant agricultural landscape. Laurel *(Laurus nobilis)*, olives *(Olea europaea)* and tall, slender Italian cypress *(Cupressus sempervirens)* are set in a geometric formation around the wheat squares, forming a symmetrical layout divided by pathways like a vast parterre. A forest of bay trees to the south-east of the property acts as a protective and aromatic barrier.

In reflecting the changing of the seasons, just as the arable landscape does, the cycle of growth in the wheat parterre is a microcosm of the farming calendar: newly seeded earth furrows come alive with emerald green shoots in spring, then turn gold as the crop ripens and finally to a haze of palest yellow ochre in summer before it is harvested. The play of light on the wheat in all seasons of the year is a key element in the design.

Wide, sweeping lawns, punctuated by the twisted trunks of ancient olives trees, line the approach to the house. A large, circular pool abuts the end of the main axis of the garden to the south, while four square carp pools set in the traditional layout of the paradise garden – a central cross of intersecting walkways – are surrounded by low terraces of *Vitis vinifera* to the east. Fruit trees and a number of different varieties of rose, together with climbing ivy and the fragrant, evergreen *Trachelospermum jasminoides*, create a link between garden and countryside.

In the ancient indigenous forest on the western boundary, statuesque evergreen oaks *(Quercus ilex)* and English oaks *(Quercus robur)* grow alongside the strawberry tree *(Arbutus unedo)*, whose small, pendulous, honey-scented clusters of white blooms appear in late autumn with bright, orange-red strawberry-like fruits. A long line of bamboo *(Phyllostachys aurea)* meets the corner of the forest on the eastern boundary, giving the garden both protection and privacy.

Caruncho's design draws its ideas not only from Catalonia's agricultural history but also from Spain's Moorish traditions, and from the gardens of the Italian Renaissance and classic French formalism, where symmetry and perspective were key elements.

Despite its rural setting, there is little pastoral about the garden; its highly stylized geometrical plan is far removed from thoughts of a bucolic idyll or agricultural toil. Instead it blends seamlessly with its surroundings through its brilliant modern interpretation of the classical rules of design.

In Denmark, agricultural crops have again been used in a highly original scheme for a large-scale garden project designed by Danish landscape architect **Stig L. Andersson**. Berrypark Enghaverne in Danstrup, North Zealand, is a ten-hectare site on the edge of Lake Esrum, in a remote moraine territory of ridges and mounds moulded by centuries of agriculture. A few isolated houses and mature, statuesque trees are scattered across its surface among the rocks and debris carried down and deposited at the margin of a glacier. Tracts of protected forest where wildlife flourishes, lakes, streams, ancient burial mounds and long, winding roads make up this bleak landscape in which thoughts of a traditional garden seem entirely alien.

Undaunted by the inhospitable site, however, Andersson has succeeded in creating a remarkable garden using indigenous plants and grasses and a variety of berry-bearing shrubs. Completed in autumn 2001, it is laid out in what appears to be a haphazard arrangement similar in principal to Action Art, where an artist throws paint on to a canvas to see how colours interact and what random images emerge. Like berries tossed into the wind and left to fall freely to the ground, eleven separate clumps of garden lie scattered across a cornfield, each around nine hundred square metres in size and surrounded with hedging or locally sourced stone walling. The perimeter plants or wall act as part structure, part protective barrier, and, depending on the planting within the enclosure, vary in height from one to one-and-a-half metres. Each enclosure is planted with a single variety of shrub, specifically chosen to contrast with plants in neighbouring compartments.

At the north corner of the site the broad crowns of English oaks spread over the highest part of the undulating garden, in front of a ravine heavily planted with different varieties of willow, some grown for their buds and catkins like *Salix daphnoides*,

In the bleak, open country of northern Denmark, landscape architect Stig L. Andersson completed the basic structure for a garden at the end of 2001 which uses a variety of indigenous plants to link it to its surroundings. The Berrypark Garden consists principally of eleven enclosures, each one containing a different type of berry-bearing shrub, set out like islands in the fields adjoining the house.

The symmetrical, upswept branches of a hornbeam make a characteristic silhouette against a winter sky.

A typical feature of the moraine landscape are the small dew ponds lying in the natural depressions created at the end of the Ice Age by retreating glaciers.

A ground plan of the site, showing the house in the lower right-hand corner and the berry enclosures and ponds scattered over the ten-hectare site to the west and north.

From the house, the land falls away across a wide expanse of ploughed-up winter wheat fields to a kidney-shaped enclosure planted with an assortment of fruit trees and berry-bearing shrubs.

S. elaeagnus subsp. *angustifolia, S. purpurea* 'Nana' and *S. viminalis*. Groupings of berry bushes continue here too with cherry trees encircling two clumps of black currants, plums framing gooseberry bushes and a patch of strawberries enclosed by Swedish whitebeam *(Sorbus intermedia)*, its white spring flowers and large, shiny, red autumn berries a complementary foil to the summer fruit.

On the opposite bank of the ravine is an irregularly rounded clump of raspberries surrounded by a thicket of hazel. Two parallel avenues of evergreen conifers, *Thuja occidentalis*, flank a serpentine wall made up of boulders collected from the site and marked by a clump of bramble bushes enclosed by hybrid larch *(Larix x eurolepis)*, which make a beautiful splash of colour in the autumn. Two wetter areas are planted with *Salix alba* and *S. alba* var. 'Sericea'.

The house, a rethinking of the local vernacular farmhouse laid out around a courtyard, was designed and built by Danish architect Dorthe Mandrup Poulsen in 2001. It stands at the southern end of the site, the areas closest to it devoted to a flower garden planted with gladiolus, protected by hornbeam *(Carpinus betulus)*, and a vegetable and herb garden hedged in with beech *(Fagus sylvatica)*, where old varieties of cabbage, potatoes and root crops are grown. The compost heap is also masked by a beech hedge. Protective rows of hazel are planted on one side of the house and a curved beech hedge shields it from the road on the other.

The berry crop, grown for both commercial and private consumption, continues the local tradition of agricultural expertise into a new era of production, and also helps to maintain the established character of the landscape. An essential feature of the design is the actual siting of the berry enclosures – like small islands floating in the cornfields – which allows the garden to become literally a part of its surroundings, with views extending to Lake Esrum and the fields, forests and farmhouses in the distance.

An old almond tree stands at the start of a low wall laid out by Alain David Idoux in a simple spiral pattern in the meadow to the south-west of the house. Built of irregularly shaped, white Baux de Provence stones, it is punctuated at regular intervals by new, young almonds planted along its internal curve.

A wide fan of lavender plants, spaced to allow for maximum growth in the traditional Provençal fashion, radiates across the stony red earth at Eygalières. A vertical stone marks the point at which the lines converge at the farthest extremity of the garden.

In Eygalières, in the Luberon region of southern France, is a garden designed by the landscape architect **Alain David Idoux** (1949–97) that appears to embrace the very edges of the Alpilles mountain range which extends across the view from south to west. The eight-hectare garden surrounds a traditional low-built *mas,* or farmhouse, dating from 1664, and is laid out in a series of different sections, each one leading fluently into the next.

The entrance pathway from the parking area is lined with irises, wormwood *(Artemisia absinthium),* Russian sage *(Perovskia atriplicifolia)* and *Pittosporum tobira.* Surrounding the house is a large sweep of lawn, long and angular against the soft landscape and dotted with oak, olive and cypress trees. The planting is denser near to the house, where tightly clipped hedges and shrubs form an undulating mass of greens, greys and silvers. Vernacular Provençal plants such as rosemary, santolina, sage and broom *(genista* and *cytisus)* – chosen for their reliability to survive in the hot and arid climate with little irrigation – are clipped into uncustomary rounded shapes.

To the south-east, balls of lavender, spaced according to the traditional horticultural method to allow for maximum growth, are set in lines that fan out from the furthest corner of the garden. At the point where the lines converge, a simple erect stone, one that might have been turned up during ploughing in a neighbouring field, stands in an opening between hedging and stonework. Traditionally used to mark the start of a pathway or the crossing point of roads, here the upright stone serves as the metaphorical point of connection between the modern garden and the agricultural heritage of the land.

To the south-west of the lawn, an area of ornamental grasses forms the transition from controlled planting close to the house to a wilder open plain of grass and wild flowers that fades into the distant hills. Following the curves of a perfect spiral, a wall less than half a metre high and built of irregularly shaped pieces of Baux de Provence stone winds its way across this area like the symbol of some primeval cult, significant but arcane. The start of the spiral is marked by an old, gnarled almond tree and the curves along its length by new, young trees.

In its simple elegance the wall is a work of art which serves both as a fitting memorial to Idoux – this was the last garden he designed before his early death – and as a testament to his creative genius and respect for the natural landscape.

The same sense of place and harmony with nature has been achieved over the years at West Mill by the owners Andrew and Briony Lawson and their family. In a remote, sublimely beautiful valley in Devon, south-west England, it is a garden which relates with extreme sensitivity to its surroundings.

The old stone mill house, dating from the thirteenth century, lies low in the valley with its water wheel in a fast-running stream that flows into the sea below the garden. Its setting is spectacular but raw winds that sweep up from the shore make it inhospitable to all but the most hardy of plants. The steep banks around the house are covered in tough grasses and shrubs, with goat willow *(Salix caprea)* and blackthorn *(Prunus spinosa)* – its spiny twigs covered in masses of small white flowers in early spring – bent almost horizontal by the gales.

Reached by a steep, shingled pathway bordered with grazed grass and the tusks of low-lying plants, the mill is encircled by a rounded, south-facing terrace paved in local stone, which visually links all the elements of the low-built house and its outbuildings with the valley and the curving shoreline. This part of the garden was created over a number of years by the family and a group of designers, craftsmen and artists, who incorporated serendipitous finds such as fishing nets, nautical ropes and whalebones into its design and defined its perimeter with a skeletal fence of weather-beaten driftwood.

An east-facing section of the garden was created in 1995 by **Dan Pearson**, whose skill in integrating British planting philosophies with contemporary design has placed him in the front rank of the present generation of landscape architects. Captivated by the intrinsic beauty of the area, he established a new planting scheme that blends perfectly with the natural flora, accented here and there with splashes of colour to draw the eye and mark the seasons. Spring-flowering pussy willow (S*alix daphnoides* 'Violet Willow') is planted with *S. chermesina* and *S. alba* 'Britzensis', which provide structure in the winter and a shimmering haze of foliage in the summer. For contrast, tangles of the bright, shiny branches of sea buckthorn *(Hippophae rhamnoides)* are set against *Elaeagnus angustifolia* 'Quicksilver' and the dark elder *(Sambucus* 'Guincho Purple'), whose foliage turns from green to purple-black in the autumn. For height and texture there are foxgloves *(Digitalis ferruginea)*, the feathery plumes of *Calamagrostis arundinacea,* the white rosebay willowherb *(Epilobium angustifolium* var. album) and the late-flowering cream and coral-pink spears of *Kniphofia* 'Jenny Bloom'.

Nearer to the house, curving mosaic pathways of coloured pebbles laid out on nautical themes are combined with plants chosen to withstand the winds and the harsh, salt-filled air. Dense clusters of *Phlomis fruticosa,* seathrift *(Armeria maritima)*, *Echinacea purpurea* 'White Swan' and rock rose *(Helianthemum nummularium)* are grouped with mint, thyme, white clover and clusters of tiny violet-blue *Verbena bonariensis.* The paper-like petals of the Californian poppy *(Romneya coulteri)* and the

Terraces and steps link the different levels of the garden at West Mill, Devon. The sensitive scheme for the eastern section, designed in 1995 by Dan Pearson, introduces only hardy cultivated plants that blend easily with indigenous varieties, and will survive the salt-laden gales along the headland.

Driftwood from the beach makes a rail for the steps that curve up round the house, whose whitewashed walls provide a backdrop for a haze of summer colour, including Digitalis ferruginea, Knautia macedonica *and the tiny violet-blue flowers of* Verbena bonariensis.

From the hills above West Mill no garden is evident, simply a spectacularly beautiful river valley running down to the wild Devon coast, the slopes lit up in late spring by the yellow flowers of gorse.

slender annual *Eschscholtzia californica* 'Cream Beauty' flutter in the wind near the house, where, in springtime, the grass is scattered with a profusion of daffodils and narcissus.

Artificiality or sophistication would have been incongruous at West Mill and a detraction from the beauty of the landscape. To enhance its setting, the planting had to be kept simple and to blend with the wild flowers that belong naturally on this elemental stretch of coastline. The result is a perfect interaction between nature and design.

This colourful and eccentric garden, on a beach near Dungeness in southern England, mirrors the individuality and artistic eye of its creator, the late Derek Jarman. A vivid splash of red valerian makes a striking contrast to the black weatherboarding of the cottage.

At the back of the house, Jarman made sculptures from the flotsam and jetsam – old spanners, driftwood and lengths of rusty chain – that he found washed up along the shoreline. Islands of self-heal (Prunella vulgaris), sage and arabis are scattered across the shingle in a garden that has no formal design but leaves self-seeding plants to establish its balance and structure.

Another remarkable English garden with a coastal location was created by painter, theatre designer and film maker **Derek Jarman** (1942–94). On the bleak, shingle-strewn stretch of beach and sand dune surrounding his house at Dungeness, Kent, Jarman created a garden that he wrote about and filmed.

Prospect Cottage, its view stretching over the sea to the far horizon, is a black-painted, wood-built fisherman's cottage that Jarman bought in 1987. Nearby are other cottages, none of whose gardens have visible boundaries, and a basic road connecting them. Behind the houses the imposing blocks of the Dungeness nuclear power station loom threateningly over the landscape. The juxtaposition of Jarman's quaintly rustic cottage and this ugly symbol of the modern world would seem surreal were it not that his garden is infinitely more so.

Using what grew there naturally and supplementing it with features of his own, Jarman created an inimitably personal garden. The front part consists of sparse, spiky vegetation scattered over a mixture of shingle and stones while the rear garden is a collection of driftwood, curiously twisted iron and other *objets trouvés*, strewn with clumps of arabis, sage, yucca and artichoke.

Interspersed with these cultivated plants are drifts of indigenous wild flowers such as seakale, sedum, sky-blue cornflowers, marigolds and valerian, which thrive in this tough environment. A curious mix of seaside smells blends with the aromatic scents of santolina, comfrey, rue and other herbs. Pebbles from the shore make patterns for pathways, flints outline the planting beds and mounds of shingle have been built up to protect the garden from leeward damp.

Flotsam and jetsam provide the main functional and aesthetic aspects of the garden, serving to prop up plants, define spaces and demonstrate the innate beauty of form, colour and texture that Jarman believed can be seen as much in a piece of driftwood or discarded junk as in a priceless work of art. He treated the shingle beach as a canvas on which to express his highly developed painterly instincts, using the light and the weather as well as existing features of the site as his sources of inspiration.

It is as hard to separate the garden from its surroundings as it is to distance the character and personality of Jarman from the garden. His films were frequently revisionist in tone, interpreting history from his own viewpoint and in his own often controversial style. Equally, while his garden is the antithesis of the traditional English landscape garden, it is at the same time his version of the concept. It reflects the spirit of the place in the light of his own particular vision, which he himself identified in some of the poetry that he wrote at Prospect Cottage.

Ugly modern elements, such as the power station at Dungeness, can sometimes provide the motivation to design a garden that will distract from its immediate surroundings while nonetheless capturing the atmosphere and character of its location. The garden at Oud Aa lies at the junction of two intersecting roads in a flat, densely populated area between Amsterdam and Rotterdam. Although these major cities are no more than sixty kilometres apart, over half the population of the country is squeezed into them; in the area between them, known as the 'Green Heart' of Holland, land is at a premium. The garden therefore presented a challenge in that it was important to create an illusion of space as well as privacy, to open the garden out to incorporate the natural attractions of the site while shielding it from traffic and other intrusive elements.

The Oud Aa garden was designed in 1999 by Dutch landscape architect **Paul van Beek** and its main features are two key components in the Dutch landscape: sky and water. On the side farthest from the roads the property is bounded by dykes and the River Aa, and it was the sharp incisions made by these waterways through the flat landscape, and the wide, open sky that most interested van Beek.

At the centre of the rectangular garden is a southeast-facing house designed by Dutch architect Jaco de Visser. A striking modern building constructed of wood, steel, glass, copper and concrete, it has a simple façade with a cladding of western red cedar covering its upper storey. Like a coat of armour, a shield of copper, which has already acquired a beautiful powder-green patina, curves in one continuous line over the roof and down the wall at the back of the house. The architecture is simple and striking, with strong geometric lines that complement the flat, green landscape.

Dykes have been dug around the circumference of the garden and straight across its centre, effectively as tributaries of the River Aa, creating a large oval plane bisected by an axial line. The house stands on a platform on this central axis, its main entrance driveway made of crushed mussel-shell shingle in iridescent shades of blue and grey which mirror the vast expanse of sky. Gnarled old poplars to the south-west provide shelter and act as a screen between the garden and neighbouring properties and the road.

In tune with the lines of the long, arched roof of the house, curved steel bridges span the axial waterway which runs past the building and on towards the western side of the garden. Here, the hybrid black poplar *(Populus x canadensis* 'Marilandica') enjoys a watery habitat while, on the island created by a U-shaped dyke to the north, varieties of crab apple and ornamental pear are overhung by the domed crowns of walnut trees. Earth banks, built up along the dykes to protect the garden from flooding, have been planted with wild grasses such as *Phragmites australis, Carex riparia* and *Typha latifolia,* leading the eye into the wider view of the landscape beyond.

In the lawn in front of the house a large depression has been dug for a triangular pool; filled with flowering water plants, it is softened around the edges by reeds, perennials and ferns, including *Ligularia dentata* 'Othello' and *Osmunda regalis*. This is the only part of the garden where ornamental plants form part of the scheme. Elsewhere, the planting has been kept as natural as possible in order to encourage native species to thrive and in turn to entice wildlife to settle.

Van Beek has made a garden that captures the essential nature and atmosphere of this flat, watery landscape by establishing only boundaries that are natural, vernacular features of the area – part of its history and agricultural traditions – and that give it its sense of space and isolation.

Water is the principal feature of the flat landscape around Oud Aa, in the 'Green Heart' of Holland, and, in addition to the dykes that surround the garden, a large pond has been created in front of the house, providing the perfect habitat for a wide assortment of reeds, grasses and other water-loving plants such as Osmunda regalis *and* Ligularia dentata *'Othello'.*

Arched steel bridges beside an ancient willow span the dykes that run past the back of the house, dividing the garden and forming an island of ornamental fruit trees.

An aerial view of Oud Aa shows the intricate pattern of waterways that enclose and bisect the garden. To the left is the group of ancient poplars which line the approach to the house and help to screen the road.

Completely immersed in its surroundings – in a landscape of a dramatically different character – is an island garden in Italy's southern Tyrrhenian Sea, where steep, rocky slopes, azure water and a vast expanse of sky make a spectacular setting. The garden was designed in 1990 by British landscape architect **Clare Littlewood**, who is based near Pavia, northern Italy.

Filicudi (its ancient name of Phoenicusa refers to its fern-covered slopes) is one of the smallest of the Aeolian Islands off the north coast of Sicily; roughly oval in shape, with a short neck extending to a south-eastern promontory, it covers just nine-and-a-half square kilometres. A combination of fertile soil, produced by the eruptions of six volcanic cones which formed the island, and the abundance of coral, sponges and fish in the seas around it, attracted settlers intermittently throughout its long history. The Greeks and later inhabitants began the work of terracing the slopes into a series of grand stairways that, from the sea, give the island a distinctive, striped appearance. The coastline is indented by narrow inlets, deep green grottoes and fantastical rock formations.

The garden at La Guardia, meaning look-out point, lies in the south-east corner of the island, and its site was chosen for its seclusion, its height above the sea and its beautiful day and night-time views across to the north coast of Sicily and Mount Etna. It was created from scratch around a seventeenth-century house that, after years of neglect and dereliction, had been restored in 1978. The natural sandy soil of the site had largely disappeared in the process of restoration, leaving a recycled rubble base for the terrace that Littlewood could not easily replace since the remoteness of the location virtually prohibited the transportation of new materials. In any case, the

On the terrace that overlooks the Filicudi coast is a large millstone, one of two unearthed on the site in the course of building work, which is raised as a table in the centre of an eight-pointed star, an image inspired by the clear night skies of the southern Mediterranean. The benches around two sides of the terrace are decorated with hand-made local tiles.

The spectacular expanse of sea and sky and the ancient traditions of the island were the principal reference points in Clare Littlewood's design at Filicudi. A path descends tortuously to the coastline far below the garden, the zigzag pattern marked out in pebbles as a reference to the days not long ago when donkeys and mules were the only means of transport.

extraordinary qualities of the stone found around the site, which she used in combination with local tiles, produced a terrace that appears to have emerged naturally from its volcanic base. Perched high on the edge of a cliff just a short distance from the house, it is a five-sided polygon, its longest side just under five metres in length, with a large millstone, one of two unearthed on the site, at its centre. The stone is raised as a table above an irregular, eight-pointed star marked out in the paving with pebbles, which serves as a sort of triangulation point – orientating the house and garden to landmarks on both sea and coast; it also looks up to the stars and links the terrace symbolically to the immense galactic display in the night sky.

Facing out to sea from the terrace are two benches set into the walls and backed by pelargoniums whose nutmeg fragrance fills the air. The seats of these benches are inlaid with locally handmade, nineteenth-century tiles in light blue and white with touches of rust-red, evenly spaced in groups of four, which were presented to Littlewood by one of the builders. Opposite the path from the terrace a smaller millstone is elevated on a retaining wall.

The pebble line decoration around the star is also used to form a zigzag pattern in the pathway leading to the terrace from the house, the zigzag a reminder of the intricate network of mule tracks that once covered the island (there is still only one stretch of proper road). From the terrace this pathway, paved in huge local stone slabs – some of them colossal – and bordered in places by small, flat rocks covered in orange lichen, follows a tortuous descent to the port far below. It branches off in one direction to a fifth-century BC prehistoric village and, in another, to a beautiful rocky beach at Le Punte, from where Littlewood collected the pebbles for her terrace.

Scorching summer days and long periods of drought limit planting to indigenous Mediterranean species that comply with Littlewood's number one landscape design rule: they must be capable of withstanding local conditions without the need for irrigation. In this respect, as well as in its use of vernacular materials for structure and landscaping, the garden is an integral part of its setting, cleverly exploiting the natural advantages of the site while respecting the character and traditions of the island.

Jutting out from the crown of a hill near Piacenza, the belvedere of the modern house, transformed by architect Cini Boeri from an old stable block, looks out over a wide expanse of open agricultural land. The garden was laid out by Elena Balsari Berrone and Chiara Curami Balsari of Milan, who collaborated with the architect in the design of a dramatic white cloth sail to cover an open-air dining area near the house.

Another Italian garden that takes full advantage of its location and its views stands on the summit of a hill overlooking the open agricultural countryside of Piacenza in Emilia Romagna, northern-central Italy. Here, an old brick stable block with five hectares of rough rural land was transformed into a country house by Italian architect Cini Boeri in 1993. She added a large new wooden building to the existing structure and connected the old part to the new by means of a fenestrated overhead walkway.

The result is a long, thin, two-storey structure jutting out over the valley north-westwards, with a belvedere at the prow of the building whose height accentuates the verticality of the slim façade. The horizontal line of the gently pitched roof follows the slope of the land, while the long side walls of the building are punctuated by rectangular windows.

Given the dramatic site and the bold, geometric style of the architecture, Milanese landscape designers **Elena Balsari Berrone** and **Chiara Curami Balsari** wanted to devise a plan for the garden that involved the minimum of intervention. Their aim was to make it practical for its owners to use and enjoy while maintaining its essential links with the landscape of the region.

The site had one large existing tree, a century-old mulberry, its rough, ingrained trunk leaning at such an angle that it needs a brick support to help it stay upright. To enhance the mulberry, to provide an attractive place to sit, and also to emphasize the curve of the entrance drive, concentric semicircular rows of rectangular stone slabs set flush with the grass are arranged around the trunk of the tree, the rows progressively lengthening towards the outside edge of the curve. The drive is lined on both sides with a hedge of hazel *(Corylus avellana)* that sweeps east towards the house; on the far side of the mulberry is an orchard of figs, apples and pomegranate trees and a vegetable plot, which camouflages the parking area to the south-west.

A linear pathway parallel to the south-west side of the house, and bordered by aromatic rosemary, runs from the mulberry tree and on past the main entrance to give access to steps down a bank to a paved area below the front of the house. Here, an English oak *(Quercus robur)* and a Japanese maple *(Acer palmatum* 'Osakazuki') draw the eye in autumn when they make a brilliant splash of red. To the north, a steep slope of evergreen yellow-flowering plants such as St John's wort, rock rose and Spanish broom *(Spartium junceum)*, with its rush-like green stems, blend with phillyrea to merge into the distant view of established woodland. At the foot of the valley, red maples *(Acer rubrum)*, scarlet oaks *(Quercus coccinea)* and the Persian Ironwood tree *(Parrotia persica)* make a spectacular autumn show of vivid oranges and reds intermingled with the yellow, felt-backed leaves of the silver lime *(Tilia tomentosa)*.

On the south-west boundary a dense curtain of colour is provided by rugosa roses such as the light-pink 'Frau Dagmar Hastrup', mixed with the purple-red 'Scabrosa' and the fragrant primrose-yellow shrub rose 'Frühlingsgold'. The rest of the land on the slopes away from the garden is clothed in wild

grass, which is left to grow tall, the wind rippling through it, until it turns to pale gold in midsummer, like the crops in the fields on the far side of the valley.

A flowerbed next to the house on the north side is brightened by a seasonal progression of yellow-flowering plants, starting with the tiny, golden-yellow buds of the Cornelian cherry *(Cornus mas)* in early spring, then the butter-yellow flowers of *Forsythia suspensa* a month or so later, followed in late autumn by the sulphur-yellow clusters of the Chinese witch hazel *(Hamamelis mollis* 'Pallida'); lastly, in midwinter, when almost everything is dormant, come the welcome yellow, bell-shaped blooms of wintersweet *(Chimonanthus praecox)*. The yellow theme is taken up again in the south-west section of the property by *Kerria japonica,* planted here with *Viburnum tinus,* lavender and rosemary.

In order to provide shade near the house for an outside eating area, which is exposed to the full heat of the summer sun, the landscape designers collaborated with the architect to create a large, triangular white cloth sail to cover the table and seating space. Anchored at two corners by angled poles and, at the third, pinned to the ground, the cloth is stretched into a sweeping curve – like a huge white bird alighting on the grass. Casting deep pools of shadow, which make shifting, abstract shapes on the ground, it is an eye-catching feature of both the garden and the landscape, its silhouette standing out in sharp relief against the valley below.

Seen from the south-west, the house and garden blend effortlessly with the surrounding landscape.

Paving stones were laid in concentric semicircles in the grass around the leaning trunk of an ancient mulberry – the only existing feature on the land when the house was built – both to draw the eye to the tree and to create a visual link with the curving entrance drive.

The roof of a wooden pergola reproduces the grid pattern of Jürgen Weidinger's 2000 design for a garden at Bad Saarow, its format replicated by the shadows on the matrix of concrete paths.

A plan of the large rectangular garden shows its clear links with the abstract, grid-like paintings by Piet Mondrian which inspired it.

A more abstract interpretation of the relationship between garden and landscape is to be seen at the old spa town of Bad Saarow, one hour south-east of Berlin. Set in the midst of an old pine wood is a turn-of-the-twentieth-century house, its red-brick painted façade symmetrically set with large square windows that look out over a rectangular garden. The natural connection between the existing *Pinus sylvestris* in the garden and those in the wood beyond was a key element in the design devised by Berlin landscape architect **Jürgen Weidinger**, assisted by Anselm Bohley. The layout is based on the regular matrix of a woodland plantation.

For Weidinger, the tall, straight trunks that allow light to pour down in shafts onto the ground were reminiscent of the powerful compositional grid lines used by Piet Mondrian, a leading member of the Dutch avant-garde movement known as De Stijl. Founded in 1917 by a group of painters, sculptors, poets, designers and architects, the movement (and the journal of the same name) promoted the philosophical and mathematical principles of Neo-Platonism, and sought to achieve balance and harmony not only in life and society but also in art and design. It had a profound influence on the development of twentieth-century art, from architecture to painting and from product design to landscape architecture. Mondrian replaced traditional illusionist devices used in painting, such as heightened perspective, with colour and line – black grids on white backgrounds filled with rectangles of colour – which followed both the structural rhythms of nature and the sense of proportional balance that characterized classical Greek and Renaissance architecture.

This notion of equilibrium is reproduced in the garden at Bad Saarow. Lying behind Lake Scharmützelsee and the spa area of the town, the garden covers 1,200 square metres and has trees on two sides, with a neighbouring house and a small road on the other two. The area in front of the house is divided by paths forming a cross, and each rectangle is then further divided by irregularly laid pathways of roughly set concrete, some decorated with inlaid seashells. The sandy ground here allows pines to grow well and the lawn and pathways are carpeted with pine needles.

Shrubs have been planted to screen the garden from its neighbours but with enough space between them to allow light to pass and views to remain open so that its links through the trees to the landscape are retained. *Berberis stenophylla, Lonicera tellmaniana* and bright-berried pyracantha mix with yew and evergreen viburnum, while a variety of colourful rhododendrons and sweet-scented azaleas accentuate the woodland atmosphere which pervades the site. A pergola at the end of the garden, backed by tall pines, allows a view along the length of the property to the house and repeats overhead the distinctive grid patterning of the paving beneath it.

Throughout the garden Weidinger has made the most of the play of light and shade through the trees, allowing their contrasts to dominate his design and give it its essential sense of balance. Just as this chiaroscuro effect imitates the light and shade in the pine woods, so cross-currents flow back and forth between the grid lines of garden and woodland.

A garden for the top of an apartment block built in the 1950s was designed by **Raderschall Landschaftsarchitekten** in 1998 to incorporate its own very different horizons – the Zurich skyline.

The design takes the contemporary view that a garden should be regarded as an extension of the living space of a house. Given that this is a Swiss rooftop garden, it had to take account of extremes of weather: a traditional garden of grass and flowering plants was clearly not the ideal solution. In any case, it was more interesting to draw the city into the design rather than shut it out with screens of greenery.

Natural stone slabs cover the base of the terrace, which extends for twenty-four metres from the doorway leading onto it from the penthouse; a forty-five-degree dog-leg at the end is highlighted by a container-grown *Amelanchier lamarkii,* which makes a delicate display of white flowers in spring and a fiery glow in the autumn, when its leaves turn a rich red against a dark gravel surround.

The first part of the garden is flanked by two rows of chrome-nickel steel planters, square ones on the south-east side and lower, rectangular ones on the opposite side. The planting in each container consists of evergreen and deciduous shrubs and perennials, which produce a vivid combination of blue, orange and white flowers in summer, when the roof garden is most in use. *Cistus laurifolius* mix with aromatic white-blossomed *Choisya ternata* and rock rose (*Helianthemum* 'Ben Heckla'); violet *Campanula poscharskyana* 'Stella', *Caryopteris x clandonensis* 'Heavenly Blue' and 'Kew Blue' blend with *Lavandula* 'Hidcote Blue' and pale-blue flax *(Linum perenne)*; and a strong contrast is provided by vermilion *Potentilla fruticosa* 'Red Ace' and fiery orange *Crocosmia x crocosmiiflora.*

Despite the seemingly artless profusion of flowers that overspill the planters by midsummer, the garden has no pretensions to be natural. Indeed, its structural elements are designed as a visual continuation of the urban roofscape.

A pergola consisting of eight upright, curved-topped steel poles, which reach up from the planters to support an almost invisible system of cables, half spans the terrace and breaks the horizontality of the skyline. Brilliant autumn-colouring Boston ivy (*Parthenocissus tricuspidata* 'Veitschii') and *Wisteria floribunda* 'Longissima Alba' are beginning to climb up the poles and along the wires to create an arbour whose shade will keep this part of the garden pleasantly cool in summer.

Five large terracotta pots planted with clipped balls of box mark the end of a long, shallow reflecting pool, whose outlines repeat the shape of the planters and extend the view along the terrace in the direction of the urban skyline.

A stylish and practical design for an exposed rooftop terrace in Zurich was devised by Roland and Sibylle Aubort Raderschall to relate the garden to the urban skyline. Square steel tubs planted with an assortment of shrubs and perennials are ranged in facing rows across the pale stone floor.

A steel pergola whose upright poles are linked to horizontal overhead wires supports wisteria and Boston ivy and in time will give shade over the open-air living area at one end of the terrace.

The art of garden design can often consist of using scale, perspective and planting to create an effect based entirely on illusion. Here, in a suburban area of Zurich, Eduard Neuenschwander laid out a rocky woodland pool with rhododendrons, ornamental grasses and water-loving plants to suggest an infinity of space and an entirely natural landscape setting; in reality the garden is bounded by a road and neighbouring properties and the entire concept is a brilliantly imaginative piece of artifice.

In terms of the aims of its design, another Swiss roof garden, started in the 1980s – this time in a suburban area near Zurich – is at the opposite end of the spectrum to the Raderschall urban roofscape garden. In order to create the illusion of a natural landscape stretching as far as the eye can see, Swiss architect **Eduard Neuenschwander** designed in this unlikely setting a woodland garden with a pool banked by massive rocks that at its furthest and most inaccessible point appears to continue into infinity.

In reality, however, the whole design is based on the power of suggestion, and it is only the steep natural gradient of the land that allows the garden to appear boundless. It is actually laid out on the roof of a garage with a soil base of thirty centimetres; the pond is a mere fifty centimetres deep, and the view from the end of the garden overlooks the road below and the rooftops of this densely populated suburb. The garden's connection to the landscape is purely imaginary. As its perimeter is higher than that of the next-door gardens, the neighbours' neat hedges and mown lawns cannot be seen, and the simulation of unlimited space therefore appears entirely convincing.

Formative years spent at Alvar Aalto's design studios in Finland shaped Neuenschwander's philosophy that all things relate to nature. For Aalto, one of the most significant aspects of architectural design was its link to the natural world, and he demonstrated his understanding of these links in his adept handling of materials, light and space to create designs based on pure organic forms. For Neuenschwander, even in a wholly artificial and contrived design, such as this suburban garden, it was important to maintain these essential connections.

Planting is deliberately simple around the pond. At the back, wild *Rhododendron impeditum, R. ferrugineum, R. catawbiense, R. repens* and *R. Luteum* form a dense backcloth for a number of water-loving plants that thrive here in the boggy conditions: the reddish-purple *Lythrum salicaria,* marsh marigold *(Caltha palustris),* rushes (typha and juncus) and spires of white-flowered *Sagittaria sagittifolia;* on the edge of the water are yellow *Iris pseudacorus* and varieties of nymphaea.

Large slabs of natural granite encircle the back of the pond, the gaps between them planted with thick vegetation and a flurry of flowering plants, overhung by the gnarled trunk of a Scots pine *(Pinus sylvestris).* Thyme and lavender add fragrance to the air, with dense clusters of *Achillea tomentosa* and spires of flowering *Asphodeline lutea* adding dashes of colour to the varying shades of green. The height of the foxgloves and *Verbascum grandiflora* is balanced by the small, bright pink blooms of *Dianthus deltoides* and *D. carthusianorum.*

The garden is a masterful evocation of nature in a setting where only imagination, design skills and engineering confidence could conspire to create it. Neuenschwander demonstrates that almost any illusion can be achieved in a garden, and that spectacular effects can be produced merely by implication if the designer has vision enough to see beyond the constraints of the location.

Jeff Koon's Puppy *(1992), a sculpture made of earth, wood and steel dominates the piazza outside the Guggenheim Museum in Bilbao, towering over the impressive new building designed by Frank Gehry. It plays on preconceptions related to proportion and scale both in its figurative representation and in its cladding of seventy thousand pansies.*

THE PLANTING REVOLUTION

Plants are likely always to remain one of the fundamental elements of any garden design. Despite the modern tendency to incorporate more architectural features and hard surfaces than in the past, and to design low-maintenance schemes that sometimes push plants to one side, a garden, at least in the minds of most people, is above all a collection of flowers, shrubs and trees.

The challenge presented by the horticultural aspects of landscape architecture today demands that designers have a comprehensive range of horticultural skills. They must have a sufficient knowledge of plants and their requirements to be able to experiment with the ways in which they are grown and displayed in the garden, and to use their characteristics to best advantage. They must also have a creative eye for grouping colours, shapes and textures to create contrasts or harmonies. And they must have the imagination to produce original, fresh ideas that follow the tenets of good design while respecting the ecological balance of the site. It is a tall order.

In almost every country in Europe the names of a number of historical figures in the world of horticulture live on as a result of their research and experimental work or through the gardens they created. Many plants now honour their contributions by carrying their names.

The increase in the varieties of plants available throughout Europe since the 1980s is owed in part to improved standards of growing and in part to an increase in the exchange of knowledge and expertise worldwide, but it is also the result of keen competition between the better professional nurseries.

A few decades ago plants were not traded on such an international scale as they are today; nurseries tended to operate locally or at least within their own country's borders. To transport plants on a big scale from one country to another was unrealistically complicated and costly, with no guarantees for their survival. Nowadays, the situation is different, thanks to improved communications, better transport facilities and a network of nurseries, some of international repute, which can send any number of specimens, including fully mature trees, across the continent to order.

As already demonstrated, books, magazines, the Internet, television programmes and flower shows have all boosted an interest in plants. Even the popular demand for eye-catching floral arrangements – for homes, hotels, offices, conference centres – has played a part by encouraging experimentation in original ways of displaying them, to the point that the boundaries between floristry and art installations are no longer always easy to define.

A series of wild flower gardens and meadows were created in 1987 at Sticky Wicket near Dorset, southern England, by Peter and Pam Lewis with the aim of encouraging indigenous species of wild flowers to spread and thrive as they once did throughout the countryside. Among the May-flowering varieties pictured here is yellow rattle (Rhinanthus minor), *a parasite on grass and an asset therefore in preventing strong rye grasses from overpowering more delicate plants; mixed with it are ox-eye daisies* (Leucanthemum vulgare), *creeping clover* (Trifolium pratense) *and varieties of plantago.*

Landscape designer Stephen Woodhams uses contrast to display the individual characteristics of Trachycarpus fortunei *and* Senecio cineraria *'White Diamond' by planting them together in galvanized steel tubs in his London garden. Blue up-lighters shine through an aluminium grid floor, and mirrors behind the planters visually enlarge the space by reflecting climbers on the opposite wall.*

In his atelier in St Niklaas, Belgium, Daniël Ost crosses boundaries between art, garden design and floristry in his use of plants as raw materials for works of art, twisting and bending them into dazzling displays of colour and texture, some on the scale of outdoor installations.

Begun in 1987, Beth Chatto's gravel garden near Colchester is a remarkable testament to her ideology based simply on providing plants with the conditions that suit them best. Despite the dryness of the region, her borders thrive, and her planting schemes illustrate her artistry as well as her plantsmanship: in the top picture a perfect balance can be seen in the arrangement of shrubs and perennials such as the elegant reed grass Calamagrostis X acutiflora *'Karl Foerster' and the delicate frond of common fennel (*Foeniculum vulgare*), which together form a backdrop for the vivid* Agapanthus campanulatus *'Cobalt Blue'.*

Spires of verbascum *and* allium *rise above clumps of* Yucca gloriosa, *whose outlines are softened by drifts of* Stipa tenuissima *in this island bed surrounded by winding gravel paths.*

The same response can be seen in the recent movement towards organic and home-grown vegetables and fruit as a reaction against mass-produced foodstuffs and the over-use of chemicals on the land. The threat to native wild flowers posed by intensive farming has given rise to a much greater awareness of their beauty and value: areas of wilderness are now conserved rather than cleared; weeds are recognized as wild flowers rather than eradicated. Concern about the state of the planet has lead to a much more ecological style of gardening, acknowledging the importance of putting back into the land at least as much as we take out.

Stimulating all these developments and simultaneously responding to them is a public ever keener to garden.

British weavers Judy and David Drew mastered the art of creating long, curving woven willow fencing at their garden in Vil'aines les Rochers in France, begun in 1992. An exceptionally sturdy natural screen, it makes an ideal climbing frame for plants and an effective alternative to ubiquitous cedar-wood trellising. The Drew team first exhibited the fencing at the garden festival at Chaumont-sur-Loïre in 1995 and thus helped to inspire a new generation of willow weavers.

East Anglia is one of the driest areas of England and, for over forty years, horticulturalist **Beth Chatto** collected weather data at her garden and nursery at Elmstead Market, near Colchester, that revealed that summers are warming up, rainfall is decreasing and winters are becoming milder: her empirical evidence showed that, for decades at least, weather patterns have been changing.

She responded by laying out a gravel garden, which she believed would cope with a future of increased heat and drought, and applied to it her extensive knowledge of plants and their habitats. For twenty-five years, the area now occupied by the gravel garden was a car park measuring just over a third of a hectare. The soil consisted of seven metres of raw sand and gravel deposited by melting glaciers over five hundred thousand years ago. To prepare the ground, this compacted mixture was broken up and fed with a mulch of compost, well-rotted manure and bonfire waste in order to give the plants the best start. A carpet of gravel was added to keep in moisture, and six beds were laid out between winding gravel pathways.

Living in such an arid area with poor soil forced Chatto to accept drought as a way of life and to introduce plants that grew naturally in a similar environment.

She had been fascinated by the origins of plants ever since an early visit to Switzerland with her husband when she first saw alpine plants in their native habitat. Further trips overseas for plant hunting and research were a revelation in showing her how plant associations varied according to conditions such as aspect, soil and rainfall.

Her late husband, Andrew Chatto, was a fruit grower who conducted a life-long study of the

habitats of garden plants and was a major influence on her own experiments. His research work during the 1930s and '40s, although it was not then labelled ecological, demonstrated a concern for the environment which Beth Chatto undoubtedly shares. She believes that establishing an ecological balance in her gardens is paramount, and that understanding the conditions in which a plant grows naturally will give it the best chance of survival. She takes a holistic approach, planting primarily according to the needs of the plants and not allowing purely aesthetic considerations, and they remain vitally important, to take precedence.

By following this principle, she has created a magnificent and enormously varied garden at Elmstead Market that is not only a victory over the conditions of the site but one that will continue to prosper even if hose-pipe bans are permanently enforced or the soil is not fed for years to come. The plants are healthy, happy and self-sufficient.

Her list of basic plants for the gravel garden is extensive, increasing annually as new experimentation bears fruit. Larger shrubs, such as the arching barberry *(Berberis x ottawensis* 'Superba'), with reddish-purple leaves, yellow flowers in late spring and red fruits in autumn, is grown alongside spring-flowering *Amelanchier lamarckii,* whose young leaves are coppery-pink, turning vivid red in autumn when its purple-black fruits appear. The hot pink, butterfly-like flowers of *Gaura lindheimeri* 'Siskiyou Pink' contrast with the primrose-yellow flowers of the evergreen alpine shrub *Helianthemum* 'Wisley Primrose' and *Bergenia* 'Admiral'.

Plants with spear-like flowers, such as the pale lavender *Phlomis tuberosa* 'Amazone' and violet-blue Russian sage (*Perovskia atriplicifolia* 'Blue Spire'), with its finely cut, aromatic, silver-grey leaves, grow with *Agapanthus campanulatus* and the creamy-apricot *Diascia barberae* 'Blackthorn Apricot'. Good foils for the smaller plants are the feathery reed grass *Calamagrostis x acutiflora* 'Karl Foerster' and Mexican feather grass *Stipa tenuissima,* which catches the breeze like fine-textured silk. Ground-cover winter creeper *Euonymus fortunei* 'Emerald 'n Gold' grows around fleshy-leaved *Sedum telephium* 'Matrona' and cushion spurge (*Euphorbia polychroma),* while the more delicate chives *(Allium schoenoprasum)* and wormwood *(Artemisia absinthium* 'Lambrook Mist'), with its shimmering grey foliage and tiny grey flowers, are planted in drifts with pale pink *Sedum populifolium.*

Scale and grouping form the aesthetic guidelines of Chatto's layouts. She uses her extensive vocabulary to establish schemes that take all aspects of the plants – height, shape, colour, texture and ground-cover potential – into consideration, moving the plants around in their pots until she has achieved a composition that satisfies her.

The gravel garden is a testament to Beth Chatto's ideology. Its sense of aptness, achieved largely because the plants appear so perfectly at home in their environment, recalls the words of Alexander Pope in his epistle to Richard Boyle, Earl of Burlington, published in 1731: 'Consult the genius of the place in all; That tells the waters or to rise, or fall.'

A walled garden attached to a modern house near Gerona is the setting for a wild flower experiment by Teresa Galí, in which indigenous plants are encouraged to establish themselves and spread with as little help or interference as possible.

In the traditional Spanish garden water plays a key role in irrigation, acoustics and temperature control, and the only structural features in Galí's garden are two watering systems, one a slow drip-pipe, the other a series of mobile copper sprinklers.

An award-winning garden in an arid area north of Barcelona, designed by Spanish landscape architect **Teresa Galí** in 1999, combines ecological concerns with understated design. The garden occupies a courtyard attached to a single-storey modern house at Púbol, Gerona, its space defined by the architects Luís Jubert and Eugènia Santacana as part of the design for the house.

There were no preconceived ideas or criteria for the garden – the intention was simply to develop it over time, accepting natural processes of growth and change. Time was the essential element in understanding what would grow well and where, in establishing how long a plant would take to reach full maturity and in dictating when a human hand should intervene.

The creation of the garden paid due attention to all the initial stages, from the preparation of the soil to the propagation of the plants. These processes, so often treated hastily in the rush to achieve rapid results, were studied with great delight by Galí and the owner of the garden, Jordi Cantarell; time and effort spent in this way became an integral part of their forward planning.

Laying out the garden began with the planting of an upper terrace area. Among the first plants to go in were a dwarf pomegranate *(Punica granatum)*, with its bright orange-scarlet flowers, the purple-spiked butterfly bush *(Buddleia davidii)*, starry-flowered spiraea, Japanese privet *(Ligustrum japonica)*, white-blossomed common hawthorn *(Crataegus monogyna)*, dog rose *(Rosa canina)*, *Cornus sanguinea*, *Viburnum tinus* and tiny, pink-flowered *Tamarix gallica*.

In the lower part of the garden, wild flowers and grasses spread rapidly from seeds: tiny-leaved fat hen *(Chenopodium album)*, perennial rocket *(Diplotaxis erucoides)*, the pinkish-purple fumitory *(Fumaria officinalis)*, shepherd's purse *(Capsella bursa-pastoris)*, sowthistle *(Sonchus vulgare)*, common groundsel *(Senecio vulgare)* and the rose-purple creeping thistle *(Cirsium arvense)*, with ground-cover of *Xantium strumarium*.

In the traditional Spanish garden, water plays a key role in irrigation, acoustics and temperature control, and, aside from the plants, the only features in Galí's design were two watering systems, one a slow drip-pipe, the other a series of five mobile sprinklers on one-metre-high copper nozzles. In response to intermittent irrigation, more indigenous plants spontaneously appeared. Against the white, angular walls of the house, the garden gradually became a dense green screen of vegetation – wildflowers, grasses and a few shrubs all blending in an unplanned and unpredictable mix. Some of the stronger plants, such as *Xantium strumarium* and chenopodium, were weeded out to ensure that the survival of the fittest did not mean delicate varieties were overcome – and also to allow room for more surprises, such as the haze of white umbelliferae that emerged towards the end of summer.

In 2000, during the garden's second summer, the decision was taken not to water the garden, but instead to allow the plants to parch under the strong Spanish sun and see what survived. As the September rains began to fall, most of them reappeared, the grasses sprouting new shoots from below. After an autumn mulch and a rigorous pruning session, the garden was left to overwinter and returned revitalized the following spring.

The ideal behind the project was to create a metaphor for freedom, to allow spontaneity and the laws of nature to rule the garden, to expect the unexpected. Its greatest joy is the discovery of self-seeded treasures brought in by the wind that then establish themselves and, in turn, spread their own seeds far beyond the garden, extending the idea that everything is in a constant state of transition.

In a garden Galí designed for Spanish architect Joan Roig, a similar theme is explored. Annually, on the architect's birthday, each guest at a party in the garden is given seeds and bulbs and, like a party game, everyone chooses where to plant their allocation. In this way, the garden also draws in Roig's friends and family as participants and introduces a further element of chance. With more planted every year, it will become an increasingly complex and exciting mix of accident, surprise and natural evolution.

North of Copenhagen, by contrast, is a garden designed by Danish landscape architect **Henrik Pøhlsgaard**, on a site chosen specifically for its established, mature trees, emblems of permanence in a garden where the passage of time is marked slowly, by seasonal changes and regeneration.

Pøhlsgaard began the garden in 1983, on a plot of land just seven hundred metres from the sea on the north coast of Sjaelland, one of Denmark's three main islands. In the north-west corner of the garden, seven old poplars stand like tall sentinels, their leaves rustling at the slightest stirring of the wind, with cherry, spruce and other trees creating a natural woodland habitat for wildlife. The wooden house, which he designed and built in 1985, stands centrally between this wooded area and a more structured section of the garden, where trees were cleared and a long gravel strip was laid to form the backbone of the design.

Pøhlsgaard's philosophy was to impose few restrictions on the plants that established themselves in the garden, and to waste no time attempting to grow others that had no wish to be there. Plants freely seed and scatter over the ground, disarmingly appearing in new unplanned positions every year.

On the borders of the garden, narrow spikes of white-centred, bright blue *Veronica chamaedrys* grow alongside tall foxgloves and creeping bellflowers *(Campanula rapunculoides)*, whose pendant blue bells hang through the summer months. Clover *(Trifolium hybridum)*, glossy yellow celandine *(Ranunculus ficaria)* and delicate lilac-white drifts of lady's smock *(Cardamine pratensis)* cover the lawn in front of the house in spring, to be followed by yellow-centred, white-petalled ox-eye daisies *(Chrysanthemum leucanthemum)* and smaller common daisies *(Bellis perennis)*. By midsummer the lawn has become a tall meadow and is then cut back so that the grass can revive, turning a vivid green again in the autumn.

The only artificial elements are the gravel strip

The policy that Danish designer Henrik Pøhlsgaard applies in his garden to the north of Copenhagen is to control nature with the lightest of touches. Aside from a gravel strip down the middle of the garden, the only artificial feature is a striking azure-blue wall, where a single, perfectly positioned evening primrose has self-seeded.

like a runway down the centre of the garden and a striking rectangular, azure-blue wall four metres wide and just over two metres high. Its paint, though fading, is still a bright, vibrant blue, especially effective when it catches the light of the setting sun as the colours of the plants begin to soften. The wall acts as a powerful force to unite the different elements of the design, its linearity and strong colour introducing an element of order into this almost wild, understated garden.

To the side of the gravel dainty, spurred flowers of *Aquilegia vulgaris* hang over a group of button-like tansy *(Tanacetum vulgare)* and carpets of forget-me-nots *(Myosotis scorpioides)*. To the south, a mass of spurred, pink-flowered *Impatiens glandulifera* (known as touch-me-not because the seed capsule pops open at the slightest touch) casts dark shadows across the wall in the late afternoon. The spontaneous arrival of a single evening primrose *(Oenothera biennis)*, perfectly positioned to one side of the wall – its yellow blooms opening at twilight and lasting until dawn – is the sort of accident of nature that Pøhlsgaard welcomes and leaves well alone.

At the centre of the exploratory work of French landscape architect **Gilles Clément** is the thesis that a garden is a complex resource that cannot be isolated from its immediate setting or its wider landscape environment. Like Teresa Galí and Henrik Pøhlsgaard, both of whom demonstrate their fascination with time and its influence on a garden's development, Clément views the garden and its landscape in the wider context of the evolution of the planet itself.

He regards the garden in the way that he regards the Earth, as a place whose ecological balance and integrity must be maintained. To this end, he seeks to preserve natural habitats and reintroduce indigenous plants so that native birds, animals and insects follow. Such habitat gardens are, in his view, essential to our planet's future. Just as nature does not define itself within a boundary, nor should the garden, and Clément is in the forefront of a movement towards more natural gardens, fields sown with wild flowers or land left to return to a natural state. With the growing realization that the ecology of the Earth is fragile has come an awareness that by establishing rules to manage it sustainably we can contribute at least to its survival rather than its demise. The same principles apply to a garden.

Taking this precept as his motivation, Clément developed the concept of the wild garden, or 'Jardin en Mouvement' (the garden in motion), which is a system based on allowing wild flowers and grasses to 'move' around the garden, seeding spontaneously

and leaving spaces in areas not inhabited by plants, in other words wherever those spaces occur naturally. The structure of the garden should emerge as a consequence of the self-seeding plants and wildlife determining the logical pathways across it rather than as a result of imposing a formal design. He is concerned with relationships in the landscape that are part of the overall balance of nature, not just those created for the sake of aesthetics.

His own garden at La Vallée, Creuse, in central France, partly destroyed then replanted following the raging storms that swept the country in 1999, is an experiment intended to produce the antithesis of the classical French garden. Rejecting formal axes, sweeping vistas and geometrical lines, Clément's planting style is free and simple, largely left to the ways of nature.

His garden, seven thousand metres square and surrounded by fields and a five-hectare forest, epitomizes the new genre of natural habitat garden that he aims to promote. His choice of plants, often influenced by ecological factors, includes many that other gardeners reject on grounds of their unconventional looks or unsociable habits, such as excessive growth or intrusiveness; to Clément this gives them distinction and therefore more appeal. Giant hogweed (Heracleum mantegazzianum), with its stout, dark reddish-purple stems, spotted leaf stalks and vast compound leaves, grows three metres tall. Dramatic and invasive, it takes a brave designer to introduce it in a garden, but at La Vallée it is totally at home. He uses giant rhubarb (Gunnera manicata), which reaches a height of over two metres, and the umbrella plant (Peltiphyllum) to add more architectural structure, and, for colour as well as height, giant thistles such as Onopordon acanthium, O. arabicum and the pin-cushion-like flowers of cirsium, hollyhocks (Althea rosea), gentian-blue Anchusa italica, the very invasive rosebay willowherb (Epilobium angustifolium), foxgloves (Digitalis purpurea), helianthus and artichoke thistle (Cynara cardunculus).

More exotic species, such as the flowering fern (Osmunda regalis) and the castor oil plant (Ricinus communis), with its startling, crimson-spiked flowers, are combined with swathes of white- and purple-flowered clary sage (Salvia sclarea), evening primrose (Oenothera biennis), plume poppy (Macleaya cordata) in cream, white and pink, Acanthus mollis, with its large, ornamental leaves, and Ligularia clivorum, with toothed leaves and golden flowers. Lilies, delphiniums and hostas, such as H. sieboldiana, are scattered among the larger plants to produce groupings that appear entirely natural and spontaneous.

Clément has also applied his planting skills to the dense urban fabric of Paris, where he contributed to the plan of a new park on the fourteen-hectare site of the old Citroën car assembly plant on the banks of the River Seine. The park is the result of a competition in 1985 for a design which incorporated natural and artificial elements, architecture and movement. There were two winners and the plan of the park combines ideas from both. The Parc André Citroën was opened to the public in 1992.

Clément and architect Patrick Berger designed the part to the north – the 'Jardin Blanc', two large and six small greenhouses, a 'garden in motion' and a series of theme gardens, 'Jardins Sériels'. French landscape architect Alain Provost and architects Jean-Paul Viguier and Jean-François Jodry designed the southern area – the 'Jardin Noir' with its large central lawn, the geometrically arranged 'Jardin des Metamorphoses', a canal and grottos. An unobtrusive diagonal pathway running north-west to south-east marks the dividing line between the two sections.

Dominating the central part of the park are the two impressive greenhouses of the 'Jardin Blanc', divided by a granite terrace punctuated by ground-level water shoots and bordered by clipped, columnar magnolias. Next to them is the vast lawn of the 'Jardin Noir', which opens onto the river bank. Water, in the shape of fountains and waterfalls, sculpture pools and a canal, plays an integral role in the park, just as it has always done in the formal French garden. Similarly, the splendours of the past are acknowledged in the vistas, enhanced by the rhythm of regularly spaced trees and hedges, which run parallel to the diagonal pathway on a single axis.

In his own garden at Creuse in central France, Gilles Clément allows the seeds of wild flowers and grasses that arrive on the wind to grow where they land, and in contrast to any formal design process, visitors and wildlife determine paths and crossing points. A sloping rock bank cut naturally into terraces makes the perfect habitat for plants that need good drainage and can survive well with little soil. A range of grasses, creeping plants and perennials, including foxgloves, have populated the crevices between the rocks.

Wild shrubs, such as elder (Sambucus nigra), mix with planted trees and perennials throughout the garden.

The orange theme garden is one of a series of six designed by Clément for the Parc André Citroën in Paris. The vistas are enhanced by the rhythm of repetition, the borders on either side of the pathway creating a pattern of sinuous curves along the banks.

Contrasting with the sophistication of the southern part of the park, which is ordered and geometric, the 'garden in motion' is an open prairie. Here, flowers normally associated with fallow land – corn poppies, clover, foxgloves, campions, dandelions and other wild flowers – seed themselves and spread freely. In this urban setting, amidst functional modern buildings, the overall effect is startlingly unexpected.

The six intimate 'Jardins Sériels', designed to stimulate the senses, are each laid out on different perspective lines and with different iconographic references, their plants selected for their fragrance and colours. Among them are gardens based on a silver and an orange theme.

The silver garden is intended to be viewed from a balcony and its foliage plants refer to the metal silver and its associations with the moon. The silvery willow-leafed pear *(Pyrus salicifolia* 'Pendula'), which bears delicate white flowers in the spring, grows along the length of the garden together with *Salix purpurea* 'Nana', whose beautiful silver-blue foliage complements its wiry purplish stems. Evergreen yew *(Taxus baccata)* acts as a foil for the pale silvers of pearly, everlasting *Anaphalis margaritacea,* *Artemisia absinthium*, silver sage *(Salvia argentea)* and *Verbascum bombyciferum.* Creeping willow *(Salix repens)* and silver-white *Santolina neapolitana* mingle with the needle-like leaves of *Euphorbia niciciana.* Blue oat grass *(Avena sempervirens)* forms a ground cover and the tendrils of convolvulus make a climbing frame of the walls behind the trees.

The orange garden is seen from a straight central pathway bordered by pebble banks deeply indented by the meandering outline of beds along the walls. Its planting alludes to colour or word associations on an orange theme. Azaleas 'Flame', *A.* 'Orange Beauty' and *A.* 'Wilhelm III' form a blaze of fiery colour in the spring. *Rosa chinensis* 'Mutabilis', the butterfly rose, produces a kaleidoscope of colours from orange buds to yellow blooms, darkening with age through shades of orange, rich pink and finally deep crimson. The chatterbox orchid *(Epipactis gigantea)*, *Kniphofia galpinii* and *Iris germanica* 'Orange' are backed by *Clematis orientalis* 'Orange Peel', which adds height and texture. Peruvian lilies (alstromerias) grow in bunches like cut flowers in varying shades of orange, and *Lilium* 'Pirate' sends out stunning, bright orange flowers against green foliage.

Sunk below street level in the Parc de la Villette, Alexandre Chemetoff's 'Jardin des Bambous', despite its location in the centre of Paris, is a luxuriant oasis densely planted with some forty species of bamboo.

In the last few years, planting in parks and urban spaces as well as private gardens has shown a marked tendency to include areas devoted to more natural planting. At the Parc de la Villette in Paris, the red-painted steel follies designed by Swiss architect Bernard Tschumi in 1982 are a clear reference to the park's urban setting, but the 'Jardin des Bambous', with its collection of some forty species of bamboo, has a distinctly informal air. Designed by French landscape architect **Alexandre Chemetoff**, with **Madeleine Renan** and artists **Daniel Buren** and **Bernard Leitner**, it occupies a strip of land 120 metres in length beside a long, straight route that is crossed by an overhead footbridge linking upper sections of the park. It is a sunken oasis of tranquillity within the vast lawns of the highly frequented urban park, its vertical bamboo canes topped by a haze of bright green leaves that effectively expand the horizons of the garden.

In 1990 artist Érik Samakh created 'Grenouilles Electroniques', a sound installation for the bamboo garden that adds another dimension to the setting. Using a simple piece of audio equipment, Samakh plays recorded frog-croaking noises through a small amplifier, enhancing the semi-tropical atmosphere already created by the moist air and rustling bamboo canes.

On completion of the garden, and on publication of subsequent widespread articles devoted to it, this design sparked a renewed interested in bamboo. A sudden flurry of designs appeared in which it featured, and – despite the propensity of some varieties to shoot off uncontrollably in all directions – bamboo acquired a new popularity in the contemporary garden.

Ross Palmer's design for this north London garden draws on his New Zealand origins for much of its inspiration and atmosphere. A steel mesh staircase provides access to it from the back of the house, the long, arching rails ending in circular wheels based on the Koro, the Maori symbol for everlasting life. The theatricality of the concept is heightened by the architectural foliage of plants native to New Zealand – Phormium tenax, Cordyline australis, Dicksonia antarctica *and* Polypodium vulgare.

In urban areas, where space is restricted, plants with a beautiful, distinctive silhouette, unusual foliage or striking, exotic flowers provide a garden with a focal point and a compositional structure. The fact that such plants tend to be tender is not necessarily a problem in that the climate in most European cities is relatively temperate and gardens often sheltered enough to create a microclimate. The designs of London-based New Zealand landscape architect **Ross Palmer** exemplify this theory in using exotic plants that thrive in the temperate climate of the city. Having studied new methods of transplantation and the re-habituation of plants, he combines his skills as a horticulturalist with a keen interest in experimenting with organic materials.

Rejecting all constraints imposed by notions of the traditional English garden, Palmer's designs have a sense of humour and quirkiness that contrasts strikingly with the neighbouring gardens of more conventional urban London. New Zealand plants seem theatrical in such a setting and, to eyes accustomed to the subtle palette of flora in the northern hemisphere, the colours he uses are startling. Flowers, leaves and stems are often impressive in all respects – in terms of texture, shape and dimensions as well as colour – and, when grouped together in a small space and juxtaposed with more common European species, the result is spectacular.

For a terraced house in Maida Vale, northwest London, he designed a walled garden for a space eleven metres by five-and-a-half metres at the back of the building. The level of the garden is one floor below the main ground floor entrance at the front of the house, and access to it is provided by an arching, black-painted steel stairway, also designed by Palmer, with open steel mesh steps that sweeps round into the centre of the garden. The sculptured steel wheels, like thread wound sparingly around a ball, which form the ends of the railings, were inspired by the Koro, a Maori symbol for everlasting life. The open treads allow a view through to the garden from above so that the stairway is fully integrated into the overall design.

To give the garden privacy, Palmer heightened the existing walls with untreated mild steel mesh to a height of three-and-a-half metres. Two stainless steel cables stretch from these walls to the side of the house. One strand supports a rampant Russian vine *(Polygonum baldschuanicum)* which in summer forms a lofty canopy projecting from the house, despite drastic spring pruning. *Muehlenbeckia complexa,* which bears clusters of tiny flowers on twiggy stems, is slowly making its way along the second cable from the house, while another New Zealand native, *Clematis paniculata,* with pure white flowers and yellow stamens, climbs the fencing.

The ground is decked in reclaimed iroko wood, cut to surround the rich mix of lush New Zealand native plants and English perennials. To heighten the drama, Palmer put in a number of *Phormium tenax,* known as New Zealand flax, which shoots out greyish-green sword-like leaves up to three metres long. Other striking New Zealand plants are the tree fern *Dicksonia* antarctica and *Cordyline australis,* whose erect, rough grey trunk sends up branches culminating in a spiky mass of long, stiff leaves. The hardy evergreen fern *Polypodium vulgare* mixes well with the more delicate *Adiantum venustum,* white-flowered *Hydrangea arborescens* 'Annabelle', *H. aspera* 'Macrophylla' and the lemon-scented, white-blossomed *Magnolia denudata.*

The effect of Palmer's planting scheme, with its exuberant display of year-round greenery and colour, is one of almost jungle-like exoticism and luxuriance, rare to encounter in a small London garden.

The perennial planting border was once the domain of a number of designers and horticulturalists whose names have become almost synonymous with the traditional English flower garden: the great Gertrude Jekyll (1843–1932), whose collaborations with Edwin Lutyens produced some of the finest gardens in the country; Vita Sackville-West (1892–1962) whose series of 'garden rooms' at Sissinghurst is world famous; and, more recently, Christopher Lloyd who created the magnificent borders of Great Dixter. Despite the labour-intensiveness of large mixed borders, their popularity, after a period of decline, is returning. Over the last decades, the design and study of new and contemporary perennial planting ideas became a major influence in northern Europe. The perennial appeal was sparked by increased research into flower species worldwide, better access and understanding through modern communications and a greater number of specialised nurseries. Coupling these influences with the move towards a more natural garden habitat, away from the garden of ornament, a new planting style is born.

An advocate of this revival is Dutch nursery owner and garden designer **Piet Oudolf**, who began his own garden in Hummelo, Holland, in 1982. Oudolf was influenced by the work of German nurseryman Karl Foerster on perennial flowers and grasses uncorrupted by hybridization, and became interested himself in creating mixed perennial borders. Over the years he experimented with the positioning of plants in the garden in order to create a good skeletal structure and points of interest throughout the year.

Perennials have a tendency to produce a blaze of colour in the summer and little or nothing in the winter, but Oudolf set out to challenge that: to introduce interest by means of strategic spacing and grouping of plants so that even in dormant months the dynamics of the design are still effective. Architectural evergreen foliage, seed heads and stems continue to have an intrinsic beauty even after flowering, and indeed are often enhanced by frost or snow. *Achillea filipendulina* hybrids, *Aster umbellatus*, gillenia, tall *Lavatera cachemiriana* and vernonia, the bold, textured leaves of rodgersia, rudbeckia, *Stachys monieri* and most grasses create fascinating shapes and forms well beyond the autumn.

Oudolf arranges plants not so that they compete with their neighbours but so that they complement each other and make for a natural composition. The positioning of each specimen follows his design doctrine that knowledge of a plant's characteristics is essential in order to place it to best advantage, and to combine it in the most imaginative and attractive way with other plants. Sometimes it works by trial and error, occasionally by chance, but the results are spectacular all the year round.

The formula he follows in planting any border is gradually to build up layers of colour and texture throughout the bed until he has achieved the desired effect, always bearing in mind the qualities that each plant will contribute at different times of the year. In his own garden, the borders are set against finely clipped, undulating yew and beech hedges. Beginning his planting scheme for one, he first placed at the back the tall, upright *Phlox paniculata* 'Lavendelwolke', complemented by the fluffy clusters of tubular pinkish *Eupatorium purpureum* 'Atropurpureum' and the mass of pink blooms of *Filipendula rubra*. The dull crimson, oblong flowers of *Sanguisorba officinalis* and the aromatic foliage and showy heads of bergamot *(Monarda)* formed the next bank of colour, followed by *Lythrum* 'Blush', whose pinkish wands stand out against *Calamagrostis brachytricha* and the fern-like foliage of achillea; nearer the front are the bold, star-like whorls of *Astrantia* 'Claret' and the five-petalled pink blooms

In 1982, at Hummelo in Holland, Piet Oudolf has established a nursery and private garden that are changing the way we view perennial plants. Through his detailed studies of plant forms he has acquired a remarkable ability to combine different species in such a way that their characteristics are seen to best advantage, demonstrating that seed heads and stems can contribute as much to a perennial border in winter as flowers in summer.

Layers of undulating clipped yew hedges form overlapping screens like the wings of a stage set at Oudolf's Hummelo garden, with isolated columns of yew guiding the flow of grass around islands of Stachys byzantina *'Big Ears' and groups of mixed shrubs.*

Owned and created by Nicole de Vésian, this garden in Provence is the perfect memorial to a designer whose imagination and sensitivity found full expression here. Her talent for treating native plants in new ways is one of its most distinctive features, but it is also exceptional for its delicate fusion of soft greys and greens in tiers of planting that carry the eye from the garden to the wooded slopes of the valley.

of *Saponaria x lempergii* 'Max Frei'.

Oudolf chooses colours as an artist selects from a palette and combines them in a new and bold manner, yet with a subtle eye for harmony; his painterly compositions also show a fine sense of balance and attention to detail. Above all they display his knowledge and love of plants. His priority is always the plants themselves and all they have to offer – an approach which may seem obvious but, handled with his subtlety and skill, is startlingly successful.

In the heart of the Vaucluse department of Provence is a terraced garden on the outskirts of the village of Bonnieux which looks out over a magnificent forest to the distant Luberon mountains. In 1986 fashion designer and landscape architect **Nicole de Vésian** (1916–97) began a garden which has matured into a celebration of Provence expressed in her own unique artistic style. The garden is a reflection both of de Vésian's rare sense of composition and of the history and heritage of the area, combining the best of French style with one of the finest of French landscapes.

Her idea of Provence was not the glamorous, rich playground associated with the coast of south-west France but the arid peasant landscape of the interior.

In order to establish links with the past, de Vésian liked to re-invent old items found in and around the site, and the garden, which she designed from scratch, incorporates a number of local finds: stone

An iron gate next to the house leads to a lower terrace where an old grinding stone found on the site has been placed on a wall against a screen of vigorously climbing plants. The leitmotif of the garden is the clipped shrubs whose stylized sculptural outlines give it rhythm and continuity.

Lavender, rosemary, honeysuckle, silver germander, Santolina chamaecyparissus and Sempervivum blend with lichen-covered paving and ancient stone artefacts on a terrace overhung by coniferous trees. In the distance can be seen the mountains of the Luberon to the south-west of the house.

troughs now filled with varieties of sempervivum, stone carvings or broken statues displayed on cast iron rods and fitted in niches in the rough-cut stone walls around the garden.

The house stands on the highest part of the garden, with the best of the views to the south-west. Massed planting by the kitchen terrace forms a dense, low hedge, a mixture of rosemary, honeysuckle, lavender and an abundance of white *Convolvulus cneorum*. Nearby, a low bank of tightly clipped plants makes an undulating plateau, blending lavender with rosemary, the evergreen silver-grey leaves of *Teucrium fruticans* and the distinctive blue-grey of *Santolina chamaecyparissus*. Dark-green, shiny, aromatic *Myrtus communis* forms a tall, narrow passageway behind.

Plants indigenous to the area are combined in ways not always associated with their species: imaginative groupings of tightly clipped plants form waves of greens and greys throughout the garden, a theme which became de Vésian's signature motif. This delicate palette is accented here and there with shades of lilac from *Iris unguicularis*, which flowers from October through to the spring, yellow from the climbers *Rosa* 'Mermaid' and the vigorous evergreen, double-flowered *R. banksiae* 'Lutea', and splashes of white from *R.* 'Iceberg'.

To the north-west of the house nestles the old village water tank, converted into a deep, square pool. A gnarled old quince tree separates the pool from a discrete showering area enclosed by the butterfly bush *Buddleia davidii* 'Black Knight' and *B. davidii* 'White Cloud', accompanied by the vigorous, scented, single pink flowers of *Rosa* 'Kew Rambler'. Near the water, the planting is freer, with clumps of silver, oval-leaved salvia and sun roses (cistus), which grow happily around the whole garden, lighting up areas of darker foliage. The paving sweeps around little pockets and islands of plants to culminate in a round terrace overlooking the valley.

On this lower terrace, reached by a small flight of steps with intricately detailed wrought-iron railings, lavender is grown in rows in the local fashion and also in a geometric arrangement with four clipped rosemary bushes planted in the form of a cross. Here, vines grow up the sun-drenched walls of the garden and into archways and niches built by de Vésian to add architectural interest and texture, especially important in the winter months.

A variety of paving techniques and materials

define the different areas of the garden; a path made from railway sleepers winds back towards the top terrace and links up with another grouping of trees and shrubs clipped into rounded, flowing shapes. The repetition of these distinctive outlines gives movement to the whole design and also serves as its leitmotif. Benches are scattered at strategic points throughout the garden, enticing the visitor to sit and soak up the atmosphere and the magically beautiful views of foreground plants and distant forested hills.

Just as de Vésian used indigenous plants to shape her garden, so too did the great Brazilian architect, painter, stage- and garden designer **Roberto Burle Marx**. He had a deep knowledge of South American plants, and his ability to use them as a painting medium to produce works of abstract art has become legendary. He succeeded uniquely in bringing the exotic and eye-catching plants of his native country into the modern garden.

In 1936, Le Corbusier collaborated with a group of Brazilian architects to design a high-rise building for the Ministry of Education and Health in Rio de Janeiro, and the roof terrace – an arrangement of free-flowing forms – was designed by Burle Marx at the start of his brilliant and influential career. Although his garden projects were confined to his own country, he became one of the most internationally renowned figures in landscape architecture of the twentieth century, and no book on contemporary garden design would be complete without him.

His nursery and plant collection was comprised almost entirely of species indigenous to Brazil, with only an occasional hybrid. Focusing primarily on tropical evergreens, he used plants such as glossy-leaved philodendrons, the bold and showy bromeliads, anthuriums with their striking red, pink or white sail-like flowers, palms, orchids and bougainvillea, which is native to Brazil. Whether using specimens individually for their architectural structure or in larger groups to create dazzlingly effective patterns of colour and texture, his planting schemes were dramatic, often consisting of free-flowing curves like the strokes of a paintbrush or the crescent shape of a Brazilian beach.

According to British landscape architect Geoffrey Jellicoe, who was his contemporary and an influential figure in Europe, Burle Marx was the first designer to

Roberto Burle Marx's work caught the attention of designers throughout Europe in the 1940s and '50s and still exerts a powerful influence today.

Above left and opposite: At the Carmago Garden (1955/88) in Theresopolis, Brazil, Burle Marx planted the silvery-plumed native South American Cortaderia selloana as a contrast to the woodland trees cladding the steep hillside behind. A stepped cascade takes the eye down a steeply sloping bank, and leads to an expanse of lawn planted with groups of trees and shrubs.

Centre and right: In Burle Marx's own garden, near Rio de Janeiro, a path through a water garden follows the lines of the natural landscape and complements the leaves of the water lilies on either side of it. Lush bromeliads and other native South American species clad the walls of Burle Marx's villa.

apply the principles of abstract art to the landscape and, in doing so, to raise garden design to a status that paralleled the Modern Art Movement in Europe. A French Renaissance-style château with a formal garden and parkland and a Victorian Rococo-style aviary, Waddesdon Manor near Aylesbury, southern England, was built in 1874–89 by Baron Ferdinand de Rothschild and is now the home of his vast collection of eighteenth-century French art. To give the gardens a modern aspect and a sense of renewal, American artist **John Hubbard** was invited to design a new garden for the summer of 2000. This was the first of five annual events in which a major artist is commissioned to create a garden and to mount a simultaneous exhibition of his or her work in the White Drawing Room of the manor.

Hubbard's design used computer-aided techniques to adapt an original watercolour scheme for the garden into a series of rectangles like carpet tiles, each tile representing a particular part of the design. This layout was then passed on to a nursery in Cornwall which planted up trays with seedlings of the relevant species. The pre-rooted specimens were subsequently taken out of their trays intact in a pre-established order and planted in a prepared bed on site. This specialized technique eliminated the need for each seedling to be transplanted individually and laboriously from its growing medium to the final bed.

The tiles are planted as long, undulating strips to follow Hubbard's original design, and from afar the effect is of solid blocks of colour laid out in a tapestry of wide, sweeping shapes against a backdrop of formal, clipped yew hedging. Fresh green rosettes of *Sedum pachyclados* and the powdered, silver-grey, fleshy leaves of *S. spathulifolium* 'Cape Blanco' contrast with mounds of grey-green cerastium and golden mossy cushions of *Sagina subulata* var. *glabrata* 'Aurea'. The dense matt foliage of *Arabis ferdinandi-coburgi* stands out against blue-green *Sempervivum calcareum* and powder-blue *Senecio viravira*. Two beds – one curved, one straight – use the same species but in different arrangements. In total over fifty thousand specimens were planted.

Hubbard's use of the latest technology and planting methods made this an essentially modern as well as a strikingly effective design. It also, importantly, updated the image of the bedding plant: no longer can it be regarded simply as a roundabout reservation filler; it has acquired a new status as a respectable component of the contemporary garden.

In 2001 a new garden, the work of fashion designer **Oscar de la Renta,** was laid out at Waddesdon, also based on a colourful arrangement of carpet beds, using plants such as ajuga, alternanthera, aptenia, echeveria and sedum with more unusual specimens such as *Deschampsia flexuosa* 'Tatra Gold', *Festuca* 'Elijah Blue' and *Iresene Brilliantissima*.

Computer-aided techniques were employed to create the slabs of colour that make up the tapestry-like weave of grasses and flowering plants in this 2001 design for a garden at Waddesdon Manor by Oscar de la Renta.

The new parterre laid out by Guido Hager in the Rechberggarten in Zurich, opened to the public in 1992, follows the original plan of the eighteenth-century garden on the site, with its orangery and four rectangular beds, while horticulturalist Nicole Newmark introduced an exuberant and entirely contemporary planting scheme which is redesigned annually.

A modern parterre in a public park in Zurich also exemplifies an innovative approach to planting. Designed by Swiss landscape architect **Guido Hager** and Zurich-based horticulturalist **Nicole Newmark**, the walled Rechberggarten is a reconstruction of an eighteenth-century garden on the site.

After carrying out research into the history of the park, Hager decided to retain the principal elements of the original garden plan: he arranged four rectangular beds twenty-eight metres long on either side of a central axis leading to a Baroque fountain, along the lines of the eighteenth-century layout, but he also incorporated elements which give his design a contemporary feel. He had no wish to restore the garden in its entirety to its original state; rather he wanted to retain its essence while at the same time giving it new life.

Nicole Newmark created the planting schemes for the beds, reminiscent of traditional flower-beds in eighteenth-century parks but interpreted in a new and imaginative way. In each of the beds, 240 specimens of each plant are randomly arranged, avoiding any preordained pattern, simply with the aim of achieving a mass of vivid colour. The planting pattern remains the same, but the colour scheme and thus the mixture of plants is redesigned annually.

For the summer of 1997, she designed a particularly spectacular arrangement of fiery oranges and yellows relieved by white. Tall, rich gold, black-centred *Rudbeckia hirta* 'Marmalade', scattered with the smaller flowers of white snapdragons (*Antirrhinum* 'Sprite'), were planted with bright orange and yellow *Calendula officinalis* 'Fiesta Gitana', matched for intensity of colour by the bold, golden-orange *Chrysanthemum* 'Goldball' and *C.* 'Mischung'. For continuous ground cover throughout the season, *Zinnia angustifolia* 'Star Orange' and 'Star White' provided a profusion of showy, dahlia-like flowers in oranges and whites. The yellows and deep oranges of the French marigold (*Tagetes patula*) provided a dazzling show all summer long and into the autumn, accompanied by the white *Nicotiana* 'Domino', with its profuse clusters of tubular, five-petalled flowers.

Seen from a distance, the borders seem to vibrate and shimmer with a haze of colour that lights up the garden.

Like the work of other designers in this chapter, the collaboration of Hager and Newmark demonstrates that plants make a fundamentally important contribution to garden design, not just in terms of their individual and collective beauty or other attributes but also because they can inject new life into the whole concept of landscape architecture and influence its development.

Art and the Garden

English designer Kate Pritchard used chestnut and bramble twigs to make spherical frames like loosely wound balls of string up to three metres in diameter, for a landscape location at the garden festival of Chaumont-sur-Loire in 2000. Their simple shape and natural materials blended with the setting both as environmental sculpture and as a frame for climbing plants.

Italian sculptor Nanni Valentini and landscape architect Ermanno Casasco collaborated to produce a brilliant alliance of art and design in this garden in Piedmont, northern Italy, completed in 1985, where a free-flowing planting scheme is perfectly complemented by a naturalistic sculpture. The circular leaves of nymphaea and the outline of the pond itself inspired the textured, plate-like sculpture which appears to be floating on the surface of the water.

In recent years artists working in a range of different disciplines have been collaborating with landscape architects throughout Europe, to their mutual benefit, to produce some brilliant – if sometimes controversial – new work. Strategically placed in the right outside location, art works can acquire an added dimension and at the same time contribute a new aspect to the landscape. They can add depth and perspective to a garden, highlight nuances not previously evident and radically affect its atmosphere, style and character.

As a practice, combining art with the landscape goes back centuries and covers two related but independent themes: firstly, the aesthetic value of art works in an open-air setting and, secondly, the potential of the garden or landscape itself to serve as a creative medium. This chapter explores the first concept while the following chapter examines the second.

Sculpture used as an ornamental feature in a garden can be traced back to Roman times, when statues of deities were placed in sacred groves and figures of emperors and military heroes arrayed in the grounds of country villas in every corner of the empire. Ever since, representations of gods and humans, flora and fauna have been translated into fountains, pillars and a myriad other forms to adorn the properties of the rich and powerful. In the Italian Renaissance, and later in other parts of Europe, sculpture played an important role in the decoration of grand parks and gardens, and it is no surprise to see figurative or representational works in such a context. In the past, however, they were generally intended to blend in with their setting or to provide a focal point; nowadays, the aim is often not merely to please but to create a context for modern art that will surprise, stimulate, provoke and excite. Simply to adorn the scenery is no longer the sole objective; rather it is to integrate art with the landscape so that one enhances the other.

This aim affects fundamentally the expression of the artist's ideas, particularly in terms of scale and choice of materials. An artist producing a work for a garden setting clearly views the creative process

The six-hectare park at Terrasson-Lavilledieu in the Dordogne, south-west France, designed by Kathryn Gustafson and Philippe Marchand in 1995, incorporates an area of oak woodland underplanted with rhododendrons. Reminiscent of land artist Michael Singer's First Glade Ritual series in the late 1970s, where thin bamboo strips were twined around trees, here a single continuous length of gold tape runs a metre off the ground through the woodland, winding between the trees with no visible means of support, its curves accentuated by shafts of sunlight between the trees.

quite differently from the way he or she would approach it in making a piece for indoor display, and draws heavily on the design of the site for inspiration. Similarly, landscape architects are tending increasingly to create gardens in which works of art play an important part and are finding a new stimulus in the input provided by the work of established contemporary painters and sculptors.

Works of art can be appreciated more fully and by a wider audience in an appropriate three-dimensional context such as a public park or garden, and in the course of the twentieth century a number of parks and other landscape settings have been devised specifically for the purpose of displaying modern sculpture. One such is the sculpture park attached to the Kröller-Müller Museum in the National Park De Hoge Veluwe, at Otterlo in the Netherlands, whose collection includes Sol LeWitt's six-sided tower and a copy of a tree in bronze entitled *Faggio di Otterlo* (Otterlo beech) by Giuseppe Penone. Another example is the Yorkshire Sculpture Park at West Bretton in northern England, where the work of international artists is exhibited in the 105-hectare garden and park of the Palladian house. A third is the Louisiana Museum in Humlebaek, Denmark, designed by landscape architects Vibeke Holscher and Lea Norgaard, where the sculpture displayed includes works by Jean Arp, Max Bill, Alexander Calder and Henry Moore. Arguably, such sculpture parks are simply open-air extensions of the museum's exhibition space, but they can be much more than that. Site-specific sculpture, where an artwork is created with a particular location in mind, has given the sculpture park a new aspect.

An example of this is the Gori Collection at the Fattoria di Celle, Pistoia, in northern Tuscany, which is unique to Italy as the only collection of works intended specifically for an outdoor location. It is not a display of sculpture in an open-air gallery but a range of over sixty permanent environmental art installations which are an integral part of their landscape setting.

A latter-day patron of artistic talent, Giuliano Gori unveiled his collection in 1982. Framed by trees on a wooded Tuscan hillside, the Fattoria, a villa farmhouse dating from the seventeenth century, houses a number of the exhibits – its entrance signposted by a monumental arched sculpture in red iron by Alberto Burro – but site-specific pieces are displayed outside. The gardens are laid out partly in the style of eighteenth-century English parkland, with specimen trees, meandering pathways, waterfalls and grottoes, and partly as terraced olive groves. Designed to appear natural, the landscape is in fact wholly artificial: its contours have been adapted and show the sculptures to greatest advantage, drawing attention to a particular work by creating a focal point at the end of a vista, in much the same way as earlier gardens drew the eye to a fountain or folly.

Artists known for their sympathetic approach to issues connected with the landscape were asked to execute a work for a chosen location on the site, each piece related in some way to the land or to an aspect of the local architectural environment. Among them are Sol LeWitt, Dani Karavan, Richard Long, Ian Hamilton Finlay, Alice Aycock, Luciano Fabro, Michelangelo Pistoletto, Robert Morris, Anne and Patrick Poirier, Magdalena Abakanowicz and Richard Serra; a phalanx of different cultural and artistic backgrounds. The whole parkland is mapped out as a tour of the collection, with the art pieces as landmarks; the visitor is free to wander through shady woodland, sit by a stream or admire an open view, and to see works by some of the world's most talented sculptors and artists in an ideal context. The sheer size and complexity of some of the pieces can undoubtedly be appreciated more fully here than in an indoor exhibition space and it is a unique experience to be immersed in an environment in which art and the landscape work in such perfect harmony.

Land artist **Richard Long** complements a low-key circular earthwork in the park with a green stone circle exhibited in the indoor gallery. *Celle Sculture* by **Mauro Staccioli** stands on a wooded hill in the park. A thin, elegant, gravity-defying triangle of concrete, it seems to be energetically climbing the hill, drawing the eye deeper into the woodland glade. The site was chosen for its natural opening between the trees, which allowed the sculpture to be built without removing any vegetation and at the same time to enhance the beautiful natural vault among the holm oaks to which its long lines appear to point. Despite its size and strong, linear aspect, Staccioli's sculpture is not hostile, threatening or obtrusive; indeed, its simple, slightly unbalanced form allows it to blend effortlessly with the natural forms of the landscape while subtly altering perceptions of the height and space around it.

Dani Karavan's Linea 1.2.3, *a white concrete strip like a searchlight, bisects the mown grass in the parkland at the Fattoria di Celle and travels on into the adjoining woodland, interrupted only by the presence of a tree in its path, whose dark, vertical line is made more dramatic by the bright horizontal band.*

Using a similar concept of the bisection of space and taking a cue from the genius of space, **Dani Karavan**'s *Linea 1.2.3* consists of strips of concrete laid along the ground to make a straight, continuous, narrow band dividing an area of lawn. Like a clear shaft of light striking the ground, the strong, white line is dramatic and arresting against the green grass. It follows its directional route undeflected by the presence of a mature tree standing in its path, and leads the eye across the lawn into a woodland thicket. In relation to the tree, the effect is disconcertingly surreal in that the concrete band appears to pass underneath it, suggesting that the tree is balancing precariously on the line like a tightrope walker. In common with other pieces at Celle, one of the most impressive aspects of the work is that it generates a powerful dynamic energy between the landscape setting and the sculpture itself.

Among the most famous pieces at the Fattoria di Celle is **Robert Morris**'s powerful work, *The Labyrinth,* a sculptural maze which occupies an open, sloping area in a grove of trees. Rising majestically to above head height, solid and austere, its polished green and white marble recalls the splendid cathedrals of Pistoia, Pisa and other cities nearby, its linearity perfectly contrasting with the verticality

Robert Morris's The Labyrinth, *set in an open, sloping grove, is a rectangular construction of polished green-and-white marble, the same material as was used to build many of the splendid cathedrals of the nearby Tuscan towns. Inside, the sharply angled walls, about two metres high, form a maze of tight, narrow passageways leading to the central point.*

The idyllic setting for Catharsis, *in a meadow enclosed by wooded hills at Celle, was chosen specifically by Polish artist Magdalena Abakanowicz to heighten the poignancy of the work; inspired by the suffering of Poles under the Nazi and Communist regimes, thirty-three hollow bronze figures stand in rows like prisoners at a roll call.*

of the surrounding trees. The entrance to the maze is at the farthest point from the track and leads to a complex, claustrophobic interior. The route through the labyrinth twists and turns between sharply angled walls to a small, confined central point, like a high stone cell, the only open space being the sky above. The massive, monumental quality of the work accentuates this sense of entrapment so that inside one feels hardly able to breathe, and it is with a sense of release that one escapes from this vertical prison, appreciating even more the openness and beauty of the surroundings.

Japanese sculptor **Aiko Miyawaki**'s *Utsurohi* is a study in the definition of space using fluid lines of tensile steel cable stretched across an open area of landscape. Following the Zen philosophy that nothing is immutable or constant, Miyawaki's work focuses on the changes and transformations that govern the cycles of nature. Looping and intersecting in a series of sinuous curves and arcs, these cables correspond to the irregular, curving outlines of the landscape, reflecting changes in the light and atmosphere and picking up vibrations from natural sound waves. They thus demonstrate that every aspect of life is subject to transformation and to the influence of forces beyond the world around it.

Catharsis by surrealist Polish artist **Magdalena Abakanowicz,** which joined the Celle collection in 1985, is a prominent and compelling work comprising a group of thirty-three hollow, abstract, standing figures. Made of bronze, they are set out in rows so that the viewer must walk amongst the figures to examine them and is therefore drawn into close contact with them. The surface of each one is moulded like an organic, protective shell over a concave interior whose texture resembles mummified skin. The work may be understood simply as a metaphor for the isolation that is a feature of the human condition, but Abakanowicz's sculptures also represent something more specific. They stand for the mute endurance of dehumanized victims of the repression and cruelty imposed first by the Nazis and then by the Communist regime of Poland, where she grew up. She chose their pastoral setting, in a meadow beside the woodland at Celle, for its incongruity with the subject matter, an irony which gives the work an added power.

An extensive programme of exhibitions and performances takes place annually at the Fattoria, some of them linked with the collection, some held in an open theatre designed by the internationally renowned American sculptor **Beverly Pepper,** who lives and works in Umbria. The forms and forces of the natural world influence Pepper's abstract work, and her *Spazio Teatro Celle,* inspired by the classical oppositions of void and solid, is an example of her remarkable capacity to unite the three-dimensional aspects of contemporary sculpture and landscape architecture. Two columnar forms stand like slim sentinels in front of the theatre, which is laid out on a circular ground plan divided into three equal sections: a flat, open performance space occupying a third of the circle is enclosed at the back by two grass-covered earth ramps rising behind the stage towards the centre of the circle. A narrow opening between these ramps, on a straight axial line with the columns, reveals a glimpse of the woodland beyond. The walls of the ramps are retained by slabs of heavy-duty cast iron, which is used here as a physical and metaphorical means of fusing the modern architecture of the theatre with its natural earth walls. The columns have clear connotations with Renaissance and Baroque monuments and their vertical lines are beautifully balanced by the horizontal emphasis of the ramps.

Coinciding with the tenth anniversary of the opening of the park to the public, Pepper's theatre was inaugurated in June 1992 with the premier of a musical piece – *L'ora alata* (The winged hour) by Daniele Lombardi; inspired by and commissioned specially for the venue and the occasion, it was accompanied by a dance performance choreographed by Antonella Agati. Among the theatrical, dance and musical pieces performed here recently were a percussion concert, played on instruments designed by four contemporary artists, and an interpretation of a Japanese tea ceremony.

The integration of art and the landscape was also the subject of a recent project in the Burgundy

A window in the château of Barbirey-sur-Ouche provided the location for Le Jeu du Jardin (1996) by Bernard Lassus. Transparency images of drawings depicting architectural features were set against a view through the window, inviting visitors to consider the ways in which such additions to a garden alter its character and the relationships between elements within it over time.

Érik Samakh designed an extensive bamboo framework over a section of the lake at Barbirey-sur-Ouche for his Trompe l'Oreille (1998), a sound installation devised to transmit the croaking of frogs and thereby attract frogs to the site. In time reeds and rushes will become established beneath the framework and provide a habitat that will encourage the frogs to settle permanently.

Two tall, columnar forms stand side by side in front of Beverly Pepper's Spazio Teatro Celle, marking the axial line that runs through the centre of the circular space. The arena is closed at the back and sides by grass-covered banks of earth, a narrow opening between them lining up with the columns and allowing a view through to the trees that frame the site.

region of France. In 1996 Grand Public, an independent group of French curators, including landscape architect Laurence Vanpoulle, invited five artists to create a site-specific installation for the eight-hectare garden park of the château of Barbirey-sur-Ouche. Entitled 'Artists in the Garden', this unique venture, under the patronage of the owner of the property, Roland Garaudet, spanned a period of five years, from 1996 to 2000. Each of the artists – Bernard Lassus, Jean-Nöel Buatois, Érik Samakh, Jacques Vieille and Jochen Gerz – chose a location for their work with a view to creating a series of temporary and permanent exhibits that interact with each other and with the landscape.

For the first year, landscape architect, artist and designer **Bernard Lassus** produced Le Jeu du Jardin,

Château de Barbirey-sur-Ouche. This temporary work investigated the theme of transformation and development in a garden over time. On the windows of a room in the château he placed transparency images of historical drawings representing architectural features from other locations, which could be seen from inside the building against a view of the Barbirey garden today. The game that Lassus invited the viewer to play was to imagine the ways in which such additions and alterations affect the character of a place and change the relationships between its various features and aspects over time. It challenged normal perceptions of a garden that tend naturally to focus on the present, without considering its past or imagining its future, and its originality stimulated interest in the project as a whole.

In 1997 artist **Jean-Nöel Buatois** created *La Chevelure de Bérénice,* a collection of meticulously arranged mother-of-pearl buttons set on stalks, like translucent mushrooms. Nestling on the ground of the belvedere, a look-out mound open to the sky but concealed by the trees of the park, the shiny mother-of-pearl catches the light and draws attention to the composition; below the line of sight and half-hidden by moss and fallen leaves, it might otherwise be overlooked. By the simple device of designing and placing his work so discreetly that we have to stop in our tracks to observe it, Buatois invites us to share his sense of joy in the neglected details of the natural world.

French sound artist **Érik Samakh** uses technology to broaden our aural awareness and question our perception of natural sound. His *Trompe l'Oreille,* created for Barbirey in 1998, is an installation similar in concept to his *Grenouilles Electroniques* for the Bamboo Garden of the Parc de la Villette in Paris (see page 178). The aim of his work is to transmit recorded sounds which will attract wildlife and, over time, encourage them to stay so that ultimately the recorded sounds are replaced by natural ones.

Having studied the ecological balance of his chosen lakeside location at Barbirey, Samakh designed a large bamboo frame over the water as overhead protection from predators in a secluded area of reeds and wild grasses. He then set up his ultra-minimalist, ecologically friendly sound installation and played a series of tape-recorded frog noises. Frogs responded, attracted by the repertoire of croaks and the well-defended habitat, and began to colonize the lake. Eventually the bamboo frame will collapse, but by then the grasses will have been encouraged to grow up and thicken, allowing the frog colonies a chance to become established and live on largely undisturbed.

This ecological auditorium is not immediately understandable as art; rather it seems to be delicately balanced between technology and science, but its dynamics are remarkably effective in consisting of a series of actions and reactions which heighten both our perception of sound and our appreciation of the site itself.

Focusing on points of particular interest and beauty, five benches designed for the 1999 project were placed strategically through the park by French artist **Jacques Vieille,** known for his striking gallery and outdoor installations. Each bench is set on two low, boulder-like concrete blocks and placed slightly off the beaten track from the obvious route around the parkland – one at the back of a disused quarry surrounded by undergrowth and sheer, rugged walls of stone, another in a hidden corner beside a slow-running stream – and each one is sited in such a way that it offers a choice of different views.

The tops of the benches are highly decorative, the surface of the concrete incised with a network of hundreds of tiny lines in a single colour, like a coded plan or the map of some secret location. These designs accentuate the idea of mystery and potential discovery that is already suggested by the placing of the benches in unfrequented areas of the park, drawing the visitor to explore beyond what is immediately apparent and to view what is evident from another perspective.

The final collaborator, German video artist and sculptor **Jochen Gerz,** involved the whole village of Barbirey in a project devised for the year 2000. It was based on the organization of an artistic and highly imaginative ceremony involving all the inhabitants of the village and surrounding areas, at which the park would be renamed after a living person of merit connected to the community. A celebratory feast was held at which produce grown in the château *potager* was served. The ceremony has become an annual event and is set to gather momentum in future years.

Jacques Vieille's work for the penultimate year of the project at Barbirey-sur-Ouche consisted of five highly-coloured benches placed in out-of-the-way locations around the park and gardens, inviting visitors to observe aspects of the surroundings from a different visual perspective. Projecting like a jetty over the river that runs through the park, this one is set at an angle to the bank in such a way that the far end is surrounded by water and gives a view downstream under the trees.

Deities (1998), a group of ceramic heads by Patricia Volk, arranged on the ground beneath Acer palmatum *trees, is one of the striking sculptural exhibits at the open-air Hannah Peschar Art Gallery in Surrey, southern England. The park was designed by New Zealand landscape architect Anthony Paul as a series of woodland water gardens with flowing streams, ponds and planting expertly laid out to complement the sculpture.*

The landscape is the motivating force behind many of the site-specific pieces produced by Swiss artist **Paul Wiedmer,** who lives and works in a secluded valley near the village of Civitella d'Agliano, in the most northerly reaches of Lazio, central Italy. The four-acre site is both a botanic garden and an open-air arena for sculpture, where a collection of works by Wiedmer and other invited artists are exhibited.

Called La Serpara, meaning place of snakes, it is shrouded in the greenery that extends along the hills above the River Chiaro, a tributary of the Tiber. It offers a perfect habitat for Wiedmer's collection of thirteen species of rare bamboo, each one planted in a location that shows its distinctive characteristics to advantage and offers a safe haven at night for roosting birds. *Phyllostachys bambusoides* 'Castillonis', with its banded green and sand-coloured stems, complements black bamboo *(Phyllostachys nigra),* introduced into Europe from China in 1827, and *P. edulis,* which grows up to twenty-five metres high, its feathery tops catching the slightest breeze.

Wiedmer's sculpture celebrates the biodiversity and history of the landscape and explores some of its more dynamic and elemental aspects, searching for a new understanding of the old parables of the land. He uses iron and its age-old association with fire as a reference to the inhabitants of this region in prehistoric times, and draws inspiration from the art of the Etruscans who settled here in about 750 BC and left traces of their civilization throughout the area.

At the entrance to the garden an iron sculpture of a tree throws long, searching limbs into the air, and when the gates are opened flames triggered by hidden sensors roar up through the branches as a dramatic if somewhat alarming welcome. Similarly, torches of gas and flame, activated inadvertently by people passing through the garden, light up iron sculptures that stand prominently against the thick vegetation of the valley.

The central part of the garden is occupied by a flat field planted with vivid green alfalfa *(Medicago sativa)* and bisected by a pergola decked with climbing kiwi plants *(Actinidia chinensis).* On one side of this field is an installation scale model of a helicopter landing pad complete with lights. Installed in 1998 by Swiss artist **Res Ingold,** the helicopter port is the base of a fictional company, Ingold Airlines. On the basis that the greater the exposure of the brand name, the more accepted it becomes, the artist promoted and marketed the airline as if it were a real company in order to investigate the nature and power of perception.

On the other side of this field, overlooking the river, is another work by Wiedmer, *Temple of Iron,* an architectonic sculpture consisting of twenty-one iron columns set in three rows, resembling the columns of a Greek temple. A flat, sheet-iron roof hovers over the columns and, when viewed from underneath, reveals a battery of gun-shot holes through which the light shines like a constellation of stars. Heavy iron-mesh chimneys at the corners of the roof emit short spasmodic bursts of fire. There is something disconcerting yet simulta-

An alliance of the basic elements of iron and fire make up this work by Swiss artist and sculptor Paul Wiedmer at the entrance to his home and studio at La Serpara in northern Lazio. Flames ignited by concealed sensors flare up suddenly and dramatically to light the branches of the iron tree at the arrival of a visitor.

Wiedmer's Temple of Iron, an architectonic installation of twenty-one iron columns, is surmounted by chimneys that burst unexpectedly into flame at the triggering of a sensor, the roaring torches lighting up the sky in a remarkable display of noise and energy.

neously compulsive about fire in such a verdant and tranquil setting, and the flames and the noise provoke mixed reactions from visitors.

Each year one or two artists are invited to visit the valley and find an inspirational place for which to make a new sculpture or installation. In the year 2000 German installation artist **Wilhelm Koch** created a permanent work consisting of a series of lawnmowers placed among the massive volcanic tufa rocks of a grotto by the river. Perched and angled above head height as though on display in a showroom, their coloured blades and upright handles stand out startlingly in the soft shade of the trees. Koch uses electrical and mechanical appliances to provoke public comment on human intervention and the use of resources to replace everyday manual tasks: the shaping of society by the culture of the appliance. His perplexing placement of objects against incongruous backdrops investigates their intrinsic and aesthetic value. At the festival of Pentecost the gates of La Serpara are opened to the villagers and other guests for a celebratory feast and a review of the year's work, and when Koch was resident he invited the villagers to create mown grass patterns and compete in slalom races with their lawnmowers at La Serpara.

In 1997 Italian sculptor **Attilio Pierelli** produced an installation for La Serpara which studied the power of reflection in the landscape through the use of carefully sited stainless steel mirror sculptures. Two large, curved screens of metal, one placed slightly out of alignment with the other, were set up not merely with the purpose of observing their reflective properties but also with a specific and wider aim: to question the way we see and interpret the world by throwing back to us distorted images of the surrounding trees and vegetation, the sky and indeed ourselves. Two large stones at the base of the mirrors give an impression of kneeling figures studying their reflections and seeing other figures looking back; the work is called *'Ancient Conversation'*.

The two stainless steel screens that make up Attilio Pierelli's installation Ancient Conversation *(1997), at Paul Wiedmer's La Serpara, throw back a range of distorted images like a beautiful abstract painting of the surrounding landscape in order to question our interpretation of what we see around us.*

The Millesgården, an open-air sculpture gallery and garden created by Carl Milles on Lidingö Island near Stockholm at the turn of the twentieth century, is a perfect representation of the theatricality and artistic flair that made his international name. Angels and cupids blowing trumpets stand precariously perched on tall, slender columns ranged across the terrace near the house, while figures of gods and heroes line the walls of the classical Italianate garden.

The prolific Swedish sculptor **Carl Milles** (1875–1955) used a more artistically contrived and formal setting in which to display his work. On Lidingö Island, near Stockholm in Sweden, he began the creation of a garden at the turn of the twentieth century that he continued to work on throughout his life and that is now an open-air museum. Impressive though it is in itself, the garden was specifically intended as a context in which to display his own art work, mostly consisting of sculpted bronze figures.

Set against a spectacular backdrop of Lake Värtan and the mountains behind it, the Millesgården is laid out in an Italianate style of open terraces and flights of wide stone steps flanked by pillars and classical urns. The upper terraces and stairways are softened by an array of plants, and in summer the urns spill over with flowers. Clipped hedging and tall trees give height and security around the villa, which was designed to house some of Milles's work and also his large collection of Romanesque artefacts.

His reputation was based largely on the many monumental fountains he created in Sweden and the United States (where he spent much of his working life), which demonstrate a distinctive and often humorous vitality. Here, large figurative fountains, some grotesquely fusing representations of classical and Nordic figures such as tritons and goblins, are placed at strategic points around the garden. The terrace immediately outside the house is left to the display of dramatic bronze sculptures, feats of great artistic daring largely inspired by the work of Gianlorenzo Bernini (1598–1680) and Auguste Rodin (1840–1917). Full-sized human figures and god-like images, mythical creatures and angels playing flutes, trumpets and panpipes, torsos combining classical, mythological and religious references all stand mounted on an array of tall pillars, plinths and pedestals, many high above the viewer's head.

The garden and its sculpture collection are a perfect example of art and the landscape working together to their mutual advantage: the garden is enlivened and dramaticized by the sculptures and they in turn appear even more arresting in their classically traditional setting.

'Art Transpennine 98', an exhibition extending from Liverpool to Hull along the Pennine Way in northern England, included the work of fifty contemporary visual artists, among them American artist **Mark Dion,** who created a permanent work combining garden design and sculpture.

Dion is internationally acclaimed for his art works relating to ecological issues, the theme of most of his pieces being the ephemeral nature of the world we live in, the threats to its delicate balance and man's role in its preservation.

In a walled orchard next to the Storey Gallery in Lancaster, *The Tasting Garden* relates to the planting there of varieties of fruit tree that were once common in the north of England but are now rapidly declining. Navigation around the art work is via a network of four winding pathways like branches, each representing one major fruit variety of plum, pear, apple and cherry from the north of England, while offshoots from these paths lead to twenty-one newly planted specimens of rare varieties, each one marked by a larger-than-life-size bronze sculpture by Robert Williams depicting its fruit. Dion's art work is both an interpretation of a contemporary garden and a reflection on mass agricultural practices obliterating native species. The garden also highlights human control of what will grow where by juxtaposing the trees with a diminutive stone hut representing the arboriculturist's work shed.

Mark Dion laid out The Tasting Garden, *a permanent exhibit in the walled orchard of the Storey Gallery in Lancaster, as a comment on the varieties of once common fruit that are fast disappearing from cultivation. It consists of a network of intersecting paths leading to specimens of newly planted rare fruit trees, each one marked by a small, white-painted column topped like a finial by a bronze sculpture, the work of Robert Williams, depicting its fruit.*

At the Giardino dei Tarocchi in Tuscany, Niki de Saint Phalle created a world of her own invention inhabited by an array of fantastical beings inspired by the images of the Tarot card pack. Here, the Queen, clad in a blaze of colourful ceramic mosaics, a small red crown perched on her mane of blue hair, imperiously surveys the panoramic view to the coast.

The Giardino dei Tarocchi, or Tarot Garden, occupies a natural amphitheatre at Capalbio in the Tuscan Maremma region of central Italy. Just half a mile from the Tuscany-Lazio border, once the frontier between the Grand Duchy of Tuscany and the Papal States, the villa stands on a gently sloping hillside about fifteen kilometres from the sea, overlooking the brackish marshlands of the coastal plain. An area of scrubland adjoining the traditional villa garden was set aside in 1979 for the work of French artist **Niki de Saint Phalle,** (1930–2002). It is now the stage for a series of dazzlingly inventive figurative sculptures, reminiscent in their scale and surrealism of the monstrous creatures that inhabit the *sacro bosco* of the sixteenth-century Villa Orsini at Bomarzo, in Lazio.

In Renaissance gardens, symbolism, narrative and iconography played an enormously important role in expressing complex artistic and intellectual ideas. Here, Saint Phalle has used the symbols of the Major Arcana of the Tarot card pack – the Magician, the Queen, Justice, the Sun, the Castle, the High Priestess, the Angel of Temperance – as well as dragons, sorcerers and magicians of her own invention, to represent figures in an enchanted garden that appeared to her once in a dream. Their strange fantastical shapes loom up from the ground and tower over the landscape, each one decked in glinting mosaics and encrusted with a coat of jewels like a carapace. Made up on steel frames by Swiss kinetic artist Jean Tinguely (1925–91), the figures were sprayed with concrete before being given their overlays of brilliant colour and decoration by Saint Phalle.

The Magician stands perched above a cascade of water and a shallow, circular pool; from his torso of marine-blue Murano glass emerges a head of mosaic mirrors and brightly-coloured ceramics that extends into a waving hand. The Queen, with flowing blue hair, a small red crown and multi-coloured patterned breasts (a distinctive feature of Saint Phalle's female figures), overlooks the panoramic view to the coast. A bird-like animal, a many-headed serpent and the scarlet Rocket are placed along the path to the Tower. The Castle appears as a broken angular structure with a black metal sculpture by Tinguely representing a thunderbolt striking its top.

Existing cork oaks, holm oaks and olive trees were left to grow up between the figures and are beginning to envelope them so that it is now even harder to distinguish art from nature or fantasy from reality. The sheer size and exuberance of the Tarot Garden is exciting in itself, and no indoor space could come close to the effectiveness of its Capalbio setting, where undulations of the land and twists in the paths contribute to the drama of Saint Phalle's magical world.

The sinuously curving outline of an indefinable creature – half dragon, half sea monster – with a sucker-like mouth and gleaming, scaly skin, emerges from a section of brilliantly colourful walling patterned with inlaid glass and ceramics.

A chequerboard pattern makes a striking feature of this arch set into a wall of mosaics. Beyond it a paved terrace leads to a series of grottoes, their outer walls roughly textured like an encrustation of barnacles.

Art and the Garden 207

'Glistening Amphibian Skin' aptly describes this design for one of the six interconnecting courtyard gardens at the corporate headquarters of a chemicals company in Basle, completed in 1993. The textured, black rubber floor, irregularly patterned with yellow pads, suggests reptilian markings, and the luxuriant planting and fine mist that pervades the garden conjures up a swamp-like tropical habitat.

Surrealism also features in the unlikely setting of a corporate garden for a Swiss pharmaceutical company outside Basle, designed by Swiss landscape architect **Samuel Eigenheer** and sculptor **Franz Pösinger.** The theme of their collaboration, time and travel, is carried through a series of six individual courtyards running the length of the long, thin building.

The first garden is a conventional white, gravelled area with a blue-tiled fountain and terracotta pots filled with lemon trees and laurel at the south entrance to the building. The garden doubles as a reception room in summer and acts as an introduction to the other, more imaginative and unconventional courtyards which lie beyond.

The second is occupied by a large pool, and the only way to cross the water is by pulling hard on ropes that slowly move a stone raft from one side to the other. The next is the aptly named 'Glistening Amphibian Skin' garden. Large, yellow footprints and round shapes like lily pads are marked out on the black rubber floor of the courtyard around beds of lush, green tropical plants, the patterns and colouring suggesting reptilian markings; fine jets of mist keep the 'skin' permanently glistening. The floor is scale-like in its texture, and undulating, so that walking on it creates the unsettling sensation that it is moving beneath one's feet.

The fourth courtyard plunges back in time into a primeval 'Stalagmite Garden' of ferns and mosses, with concrete-cast rock formations rising up from an underground lake system. Holes in the floor allow the constant stream of water running down the stalagmites to drip into the lake below, filling the enclosed courtyard space with its sound.

In the fifth courtyard, the 'Broken Intact World', the obstacles strewn in the path become even harder to negotiate: here the geological fault on which Basle lies is represented in a surreal exploration of the consequences of a crack emerging in the land beneath the city. Built up in layers of concrete, a cross-section through a wide crack in the ground reveals the stratification of the earth below: stone capitals and fragments of sculpture lie at the

base level, related to the Roman occupation of the region; iron machinery, symbolic of the industrial age, occupies the next layer up, and on the top level are brightly coloured, over-sized medicinal pills to link the scene with the products of the company and therefore with the present day. Vividly painted garden gnomes with smiling faces are grouped all over the surface on either side of the crack, some sunk into the concrete, perhaps as an ironic statement on corporate identity.

The sixth courtyard is 'A Forest of Mirrors', with silver birch trees, evergreen shrubs and glimpses of the sky reflected in a series of tall mirrors set at different angles around the garden. The whole space is filled with a confusing array of images, multiplied and thrown back onto tilted planes and surfaces and creating a sense of disorientation that seems to be accentuated by the intoxicating smell of the wisteria that climbs up the high walls overlooking the courtyards.

Employees of the company are given the choice of steering a hazardous course through the courtyards, open to the sky and the elements, or of approaching their offices by means of the more conventional indoor route. This may be a self-indulgent piece of work, but its combination of kitsch and irreverent humour provides a welcome change from the usual, unimaginative corporate garden settings.

Ferns, mosses and concrete-cast pillars of calcified rock fill the fourth courtyard, the 'Stalagmite Garden', where water is constantly recycled through an underground lake.

Since a garden aims to be much more than simply a receptacle for art, a piece of sculpture or an installation, however beautiful, must always be able to contribute something significant to the alliance. This principle is reflected in a garden near Waregem and Ronse, in Belgium, where landscape architects **Jean-François Van den Abeele** and **Els Huigens** of the Ghent-based company Fris in het Landschap drew up an original design for a project combining Land Art and sculpture. On the only piece of rising ground for miles around, the garden has a panoramic view over the valley of the River Schelde and the flat, somewhat bleak expanses of the Flanders countryside. It is laid out on the 2.6-hectare site of a disused loam pit, which lies a little distance from the house, with an old windmill overlooking it from the crown of the hill. Drawing on the history of the site for their inspiration, Van den Abeele and Huigens converted the loam pit into a shallow amphitheatre with a series of grass steps, like the cuts made by the loam diggers in the past, radiating out in concentric circles across its surface. Completed in 1996, it forms

An old windmill and an amphitheatre transformed from a disused loam pit dominate the design of this Belgian garden, above the valley of the River Schelde in Flanders. The concentric rings radiating out across the shallow bowl are sharply defined, the wide grass treads of the steps edged in light-coloured concrete to link them with the white-painted windmill.

To the left of the mill, the dark shape of Fernando Botero's sculpted bronze bird stands out in silhouette against an expanse of open sky, its comfortably bulbous outlines characteristic of his monumental figurative sculptures. From the highest point of the site, it looks out over the flat expanses of the distant view.

the central focus of the design and serves as a lookout stage over the landscape, although its practical use is perhaps less important than its visual impact.

The old stone windmill towers over the scene, its four stark sails, now turning purely for aesthetic reasons, making a picturesque silhouette against the vast expanse of sky. Beside it stands a bronze sculpture two-and-a-half metres high of a monumental, magisterial, voluptuously rounded bird, wittily depicted by Columbian artist Fernando Botero. Most of Botero's work takes the form of generously proportioned human and animal figures, attempting to impart sensuality on the object and exemplifying his belief that art should transcend reality. Poignantly juxtaposed to the redundant windmill, the bronze bird that will never fly royally presides over the landscape with great aplomb.

The transformation of the central feature of this Belgian garden from loam pit to amphitheatre in a contemporary form of Land Art leads into the following chapter, in which the land itself becomes the chief protagonist.

The Contemporary Garden as Art

Pre-historic earthworks and burial mounds, Greek and Roman amphitheatres and medieval military ramparts scattered throughout Europe demonstrate that man has been changing the natural contours of the landscape on a massive scale for millennia. We are therefore accustomed to the idea that the land can, to an extent at least, be adapted to our precise specifications. The first attempts to alter its contours for aesthetic purposes were relatively small-scale operations, designed to introduce variety into an otherwise featureless stretch of land around a house, to divert a river, build a mound to site a folly, or simply in order to be able to see beyond the garden wall. More ambitious earth-moving projects began to be seen in eighteenth-century England, notably in the work of Charles Bridgeman (1680–1738) at Claremont in Surrey, where a stepped grass amphitheatre was carved out of a hillside.

The concept of earth-moving in order to create works of land sculpture was developed in the late 1960s. Rather than using the land as a context in which to display works of art, this movement – known as Land Art – used the earth itself as the medium, moulding and adapting it into a form of sculpture. The ideas that characterized Land Art were largely influenced by Minimalism, when images were pared down to the barest of geometric forms, and it was also an expression of disenchantment with the technology of an increasingly industrialized culture.

Land Art turned its back on the confines of the gallery as an exhibition space and also on the notion of art being a collectible commodity. At a time of rising prosperity, when the desire to acquire a certain lifestyle, and the possessions to go with it, was rapidly spreading, prices at auction houses were hugely inflating the value of works of art, and part of Land Art's appeal lay in its non-collectability. It could not be regarded as an acquisition or treated as a saleable commodity. Its sheer scale meant that the only way of exhibiting it on gallery walls was through photography, and collectors could only keep works in the form of documentary records. Clearly this reduced its

Italian artist Gabriele Jardini views the transformations of his organic sculptures by time and weather as part of the creative process. Here, packed snow between two silver birch trees, is punched with holes to acquire an almost transparent lightness that unites the work with the landscape.

economic potential, but what little it had was, inevitably, exploited through film and photography, rather as was the case with other experimental post-war movements such as Body and Performance Art. In this way, ironically, it did to a degree become an artistic commodity, though its lack of real commercial value ultimately detracted from its success, exactly the opposite of what its exponents originally intended.

Land artists constructed works on a scale not seen since the Megalithic, Egyptian or pre-Columbian periods, often locating their works in open expanses of desert or in mountain ranges where they would have the maximum impact. This was energizing and beneficial in ecological as well as artistic terms in that it increased the flow of inspirational ideas based on environmental concepts, and stimulated artists to expand the horizons of their own thinking in this regard. Ecological sensitivity became a central issue, and a number of American artists, in particular, drew attention to environmental problems through their large-scale land projects. Among them were Michael Heizer, Nancy Holt, Walter De Maria, Richard Serra, James Turrell and Robert Smithson. Notable exponents of the Land Art movement in Europe include Richard Long and Carl Andre.

In turn, land artists introduced sculptors, painters and others, including landscape architects, to a new vocabulary of expression. By manipulating the landscape on a huge scale, they could radically alter perspectives as well as spatial awareness. The work of artists like American Mary Miss, for example, investigated the potential for heightening the perception of other landscapes than those immediately visible by means of introducing a false perspective and an enhanced sense of depth, work that clearly relates to many aspects of landscape architecture. Environmental artists such as Bavarian Nils-Udo, whose work establishes links between specific landscape sites, horticulture and art, remain a constant inspiration for contemporary landscape architects. Likewise, many of the controversial designs emerging from temporary garden shows and exhibitions, discussed in the final chapter, take their direction from these experimental interdisciplinary works.

Artists have always seen it as part of their role to act as commentators on contemporary social and political issues, and many are now working with landscape architects on the side of the environmentalists, demonstrating their concerns by promoting organic rather than man-made materials and engaging in a new wave of experimental work in response to the current crisis. They are as much engaged with the fundamental issue of space as they have always been, but they are helping to turn the tide of estrangement from nature by focusing attention on the fragility of the ecological balance and the scarcity of land as a resource.

Land Art has progressed into a more popular and accessible genre in recent years, and, though the corpus of contemporary work relating to landscape architecture remains sparse, ideas keep flowing and some exciting results are emerging. They separate into two main groups: firstly, art works created through the physical displacement of earth and, secondly, those made from organic materials that form part of the actual fabric of the land; this latter section leads into a discussion of the areas in which organic art overlaps with garden design in indoor gallery and exhibition spaces.

The third part of this chapter examines the ways in which the landscape, always a source of inspiration for poets and philosophers as well as artists, is influencing the revival of an ancient tradition in which literary quotations and elegiac texts in the form of sculptural inscriptions are incorporated into the fabric of a garden.

Michael Heizer's Double Negative *(1969) at Morman Mesa, Overton, Nevada, involved the displacement of a massive quantity of sandstone and rhyolite, a fine-grained igneous rock formed by the rapid cooling of lava, measuring 457.2 x 15.2 x 9.1 metres and weighing 243,900 tonnes. This is one of a series of Land Art works carried out by Heizer in the Nevada desert, using compacted earth, volcanic rock and reinforced concrete on a formidable scale.*

An open-air art exhibition, 'Secret Gardens – 2', was held in 2000 in the gardens of Trinity Hospital, Greenwich, south London, with the aim of displaying site-specific works on the subject of environmental change as reflected in gardens and the landscape. Selected by the curator of the show, Theresa Bergne, the works included Griet Dobbel's statue Birdseed Madonna*; moulded from a stone figure of the Virgin on a plinth, it is made from birdseed and was destined to be gradually pecked away by birds in order to highlight the contrast between the permanence of stone and the ephemeral nature of organic materials.*

The Contemporary Garden as Art 215

Changing the Contours

Like the Land Art works of the 1960s, an earth sculpture in Hampshire, southern England, specially commissioned for its location, was created by artist **Veronique Maria** in 1998 with the aim of demonstrating the potential of the land itself to serve as a medium. Its setting is a traditional English garden, designed by Jill Billington and Barbara Hunt, of clipped yew hedges and flower borders enclosed by a stately, curved brick wall.

Maria's work takes the form of a grass-covered mound of earth thirteen metres wide and three metres high, standing alone on the far bank of a river that divides the garden from adjoining woodland. On the slope facing the fast-flowing water that gushes out below a weir, the earth has been scooped out just below the summit of the mound to form a crater-like indentation. This circular hollow is lined with a heavy, woven rope that coils from the centre and spirals up to the brim of the hollow and flows down its bank to the edge of the weir towards the water.

One of Maria's main sources of influence was American artist James Turrell's *Roden Crater*, which is among the most remarkable pieces of Land Art ever

Reminiscent of the work of James Turrell in Arizona, the ash-coloured, crater-like hollow near the top of the mound, which itself resembles a volcanic cone, transmits a strong sense of the latent power of the Earth's forces, a sense that is heightened by the fast-moving waters of the river that borders the mound.

A view from the inside of Veronique Maria's earth mound in Hampshire, set against a background of the traditional house and garden, shows the intricacy of the woven rope lining that fills the circular hollow.

created in terms of scale, location and artistic commitment. Begun in 1979, it is an on-going project sited in a dormant volcanic crater in Arizona which Turrell is adapting into a combined observation centre and art installation: from the crater visitors can contemplate the universe as well as the geological and topographical features of some four hundred other volcanic cones in the surrounding area. Turrell's aim was as ambitious as his project: to explore the relationship between man and the cosmos, between the Earth and the visible galaxies and between life on this planet and the geological evidence of its origins.

Maria follows through this idea of using the powerful image of a volcanic crater to represent the forces of nature and to serve as a metaphorical link between our planet and its primeval beginnings, the rope-filled hollow reminiscent of a cocoon or receptacle for an embryonic form of life. By siting the mound beside a fast-running river, she accentuates the tension and almost tangible energy generated by the image.

Early morning sun casts deep shadows across Kim Wilkie's 'Archimedes Spiral' (1997), a light covering of snow accentuating the curves and subtle changes of level that define its shallow banks. The outermost ring leads through an opening in a farm fence to form a long, sweeping arc across a neighbouring field. The skeletal outline of a hornbeam perfectly balances the scale of the spiral, whose central point, below the level of the surrounding land, is marked by a freestanding sculpture by Simon Thomas.

A scale diagram shows Wilkie's plan for the garden and adjoining field, a long S-bend linking the two spirals, one close to the house and outbuildings, the other climbing to the top of a distant mound, illustrated in the inset photograph.

Landscape architect **Kim Wilkie**'s art work for his own English garden, also in Hampshire, is in a quite different conceptual vein though based on a similarly radical use of the land. The 'Archimedes Spiral' consists of banks of earth laid out over a wide, grass-covered tract of ground that incorporates the area beside the house, a nearby meadow and part of the more distant landscape of woodlands and fields. Archimedes (287–212 BC), Greek mathematician and engineer, was the inventor of the so-called Archimedes' Screw, a cylindrical device containing a spiral screw for the purpose of raising water. Wilkie has translated Archimedes' ideas about the movement, time and space of the spiral into an earth sculpture with beautifully sweeping, gentle lines.

The central point of the spiral, which lies in a shallow depression slightly below the level of the ground near the house, is marked by a sculpture by Simon Thomas, the focus for the concentric circular banks unwinding around it. The spiral climbs out of the innermost rings to rise flush with the surface and extends into a long, arching arm across the field. There it turns back on itself and wraps around a conical mound of earth, forming another series of concentric curves that ascend in a pathway to the summit, the grass on the ramp kept short by grazing sheep. This raised spiral is effectively the inverted form of the sunken spiral in the land by the house.

The subtleties and complexities of the design are infinite, since different perspective views, weather conditions and effects of light and shade on the various levels of the land alter the apparent dimensions and scale of the work. The spiral as a symbol of growth has a power to which we respond instinctively, and as an aesthetic form its regularity has an almost hypnotic perfection that Wilkie has exploited with great sensitivity and confidence.

Architect and theorist **Charles Jencks** and his late wife, Chinese scholar and artist **Maggie Keswick**, took the curving form to even more ambitious lengths in their garden in Dumfriesshire, Scotland, begun in 1990, where dramatic feats of earth-moving were required to bring about a garden that in its scale almost matches the work of some of the early North American land artists. However, rather than using the land as a means of establishing a new approach to art, Jencks and Keswick sought to shape a garden in accordance with *Feng Shui*, the ancient Chinese form of geomancy, and the Taoist philosophies relating to a landscape energised with *qi* – the life breath of the mountains.

The 'Garden of Cosmic Speculation' explores the connections between art, science, philosophy and the land, searching for answers to complex cosmological questions concerning the energies that govern the forces of life. It takes its inspiration also from the principles of the mathematical Chaos Theory – used to calculate irregular and unpredictable stress resulting, for example, from wave action – and combined these concepts with theories of astrophysics and cosmogony (the study of the origin and evolution of the universe). A scientific study of different wave formations resulted in Jencks' and Keswick's use of banks of earth laid in long, repeated curves that flow across a large part of the twelve-hectare garden. Placed at strategic points are ten iron gates, their design based on the soliton, a non-linear wave which maintains its smooth, raised form rather than widening and dispersing in the usual way, behaviour that is also characteristic of waves of energy in atomic physics. Circular moon gates and windows were often used in ancient Chinese gardens to frame a distant view and, following the principles

The Garden of Cosmic Speculation, like a landscape from another world in its theatricality and superhuman scale, extends along a valley completely enclosed by woodland in a remote corner of Dumfriesshire, southern Scotland. The view from the 'Snake Mound' towards the stepped pyramid of the 'Snail Mound' shows the sculptural outlines of artificial banks cut into terraces that enclose two interlocking lakes, one serpentine, one kidney-shaped, divided by a narrow spit of land; a longer, narrower arc of water accentuates the concave line of the bank sweeping away to the right.

Charles Jencks's plan shows the wide curves of the earth banks, based on intersecting wave formations, of the 'Giant Dragon Ha-ha', incorporating the 'Symmetry Break Terrace' and the 'Black Hole Terrace'. Changes of level, seen in the photograph above, denote the three principal stages in the evolution of the universe – energy, matter and life; a yew hedge, in the lower left-hand corner of the plan, rises from the base of the ha-ha to curl round the house, denoting the final transition into consciousness.

The 'Symmetry Break Terrace', part of the complex system of walls and terraces that makes up the 'Giant Dragon Ha-ha', comprises a pointed oval shape laid with strips of grass and gravel in an optically confusing series of linear patterns.

of Taoism, thereby draw it into the foreground scenery. Here, that practice is applied not only in the use of gates but also in the sweeping banks of earth that echo the rounded shapes of the rolling Scottish hills, visually extending the garden into the wider landscape.

The huge area covered by the garden is divided into a number of different sections of earth sculpture and water, each one based on an independent but related philosophical concept. Perhaps the most awe-inspiring is the series of monumental stepped mounds and curving lakes to the east of the house. A giant construction called the 'Snail Mound' dominates the whole area. Clean cut and perfectly symmetrical like a ziggurat, it is fifteen metres high and designed with two cleverly interlacing spiral pathways that meet at the summit, one that rises, another that descends. It towers over the wide expanses of two linked lakes and another large earth bank sculpture, the 'Snake Mound'. These two grass-covered mounds, their edges chiselled to perfection to accentuate their sinuous coils, appear to be pushing up and out of the lakes like articulated water creatures.

Terraces made up of a complex arrangement of intersecting walls and hedging to the north-west of the garden, based on interpretations of the Big Bang theory, repeat the soliton wave pattern, in this case using two waves passing through each other to create their serpentine outlines. The 'Giant Dragon Ha-ha' – built on two different levels, its walls made from two types of local stone, snakes around the circumference of the 'Black Hole Terrace', whose central lozenge shape is made up of a chequerboard of green plastic grass and aluminium sheeting. Representing the gravitational distortion of space and time in the vicinity of a black hole as well as the petaphysical aspects, the terrace becomes increasingly twisted and elongated as though metamorphosing from one form of life to another. The ha-ha extends beyond it to embrace the 'Symmetry Break Terrace', laid in long strips of pebbles and grass in optically distorted patterns like a piece of Op Art. The straight lines become warped as they pass through the first three stages, or jumps as Jencks describes them, representing the formation of the universe: energy, matter and life. A yew hedge, an extension of the lower wall, rises to the upper level and wraps itself around the house above the terraces, signifying the final jump into consciousness.

In Belgium, landscape architect **Paul Deroose** has created a piece of Land Art that dominates Vaubannerie in Aalbeke and is, in all respects, a surprisingly modern departure from the classical Belgian garden of clipped hedges and ordered planting. Resembling the ramparts of a castle or military bunker, the long banks of earth, softened by their gently sloping sides and covering of grass, are set at right angles to one another around a sunken lawn on the north side of the site. Closed on the south and east by low buildings and on the west by the house, the garden is bordered to the north by this low-lying barrier, which is broken only by a narrow gap where a path, also flanked by grass-covered banks, leads into adjoining woodland. A formal plantation of mature poplar trees, the wood is kept free of undergrowth so that its grid-like formation of tall, straight trunks, contrasting with the horizontality of the banks, can be clearly seen from the garden.

At Aalbeke in Belgium, the straight trunks of a plantation of mature poplar trees contrasts with the horizontal emphasis in Paul Deroose's garden, where low, angular, grassed mounds like ramparts replace the traditional hedge as barriers to mark off the garden from the surrounding landscape. An opening between the mounds allows access and an open view from the garden to the woodland.

The most celebrated example of Robert Smithson's works, Spiral Jetty (1970), at the Great Salt Lake, Utah, achieved cult status on account of its ephemeral nature as well as the striking beauty of its form. Made of an accumulation of rocks, earth and salt crystals, it was destined to be eroded and eventually destroyed by the effects of time and the elements.

Richard Long's A Line in England, Yorkshire, 1977, is made up of boulders fallen from a hillside and laid in a straight line, leading the eye to a cleft in the hills ahead. Long's objective was to draw attention to the natural landscape by imposing on it an artificial element, which acquires an authenticity only in his photographic images of the site.

A startlingly dramatic night-time image is created simply by a line of light projected across an expanse of Icelandic hills by Magdalena Jetelova in Iceland Project, 1992; in setting up a dynamic between the landscape and human intervention, it recalls the work of Richard Long and the land artists of the United States.

Organic Art

The second area in which the natural environment takes centre stage is concerned with art works that use organic materials, and indeed the fabric of the landscape itself, as their creative material. More than any other art forms, works created from organic constituents are by their very nature subject to natural obsolescence as a result of erosion by weather and time. This very interaction can often be a source of enrichment, however, enhancing patina or texture and adding an unpredictability that contributes an added dimension.

For this reason, not all Land Art works were intended to last. American experimental artist **Robert Smithson** (1938–73) used the natural processes of time and erosion to create his most famous work *Spiral Jetty* (1970) at the Great Salt Lake in Utah. Partly because of its ephemeral nature, it achieved cult status, with visitors flocking to see the accumulation of rocks, earth and salt crystals that made up the spiral and that would soon be destroyed by the elements. It was Smithson's intention that nature should play its part in the life of the work since it would thus acquire greater complexity.

Artists in Europe had, for obvious reasons, few opportunities to develop works on the scale of North American models, and as a result they adopted a different approach to the concept of Land Art, taking existing land formations as their subject matter and using natural materials – stone, earth and plants – to construct art works rather than shifting huge tracts of land. As an experience of landscape, these materials were part of a universal vocabulary. This tended to make their projects more accessible and more influential in a broader context since the materials they used could be adapted more readily to landscape architecture and garden design.

The Contemporary Garden as Art 223

Since the 1960s, self-styled environmental artists Christo and Jeanne-Claude have defined the contours of the land – buildings and bridges and, most famously, expanses of landscape and stretches of coastline – with woven fabric not associated in colour, texture or location with the site. Running Fence *was an art work of heavy woven white nylon panels hung from steel cables between 2,050 steel poles, five-and-a-half metres high and stretching over thirty nine kilometres across the counties of Sonoma and Marin in California. Started in 1972 and completed in September 1976, the work drew attention to aspects of the landscape by imposing on them an unexpected, artificial element. Funded entirely by the artists, it remained in place for just fourteen days before the materials were removed and recycled. In that time however, the scale of the project and the remarkable beauty of the finished work brought it worldwide attention.*

Richard Long's *A Line in England, Yorkshire 1977*, was made up of rock fallen from a crumbling cliff face and laid in a straight axial line along a valley. Long often documented his projects with written texts, maps and photographs, and here, bisecting the photographic image, the effect of the line is simple but immensely powerful, heightening the perspective view to the sharp gully between two mountainsides. While artificially created lines were used in the past for aesthetic purposes, to impose formal structure on a garden, for artists such as Long, the point of the line was purely conceptual. Its importance to Long was that it was the only feature of the site that had involved human intervention, that its existence was contrived and artificial, yet in the photographic image, and in the imprint of that image on our mind's eye, it takes on the guise of authenticity. Long was interested in the distinction between the two types of reality. The disequilibria between the passage of time at the place, and the action and the longevity of the act in the photographic image create the narrative of Long's work.

Neo-land artist **Andy Goldsworthy,** who works around the world but mainly in his native Scotland, regards the action of time and the weather as essential features of his projects and the transience of his images as part of their artistic purpose. He uses all manner of natural elements – rock formations, trails of autumn leaves pinned to the ground or floating on a pond – to focus on the beauty of organic forms. Laboriously constructed over many hours – or even days if ideal weather conditions are slow to materialize – his art works mainly consist of highly stylized sculptures that are born of the landscape to which they are destined to return. They are rapidly absorbed by the earth once time and the elements have eroded or destroyed them, and their survival as works of art relies solely on the photographic images that Goldsworthy makes of them, circulating them to a wider audience through printed material, films or exhibitions.

This series of three works demonstrates Gabriele Jardini's meticulous care and inventiveness in the use of ephemeral organic materials to dress the trunks of poplar trees in Lombardy woodland. In the first, he applied a layer of mud to the bark of a tree and covered it with a thick, soft coat of the seeds of the wild dandelion (Gerenzano, spring 1997); in the second, the jewel-like red berries of the rowan tree were pinned to the bark with thorns (Gerenzano, summer 1997); in the third he used chestnut leaves, rolled and fixed with thorns to form striations of brilliant green against the dark trunk (Appino Gentile, winter 1999). As Jardini's documentary photographs show, the trees looked as exotic as tribal dancers in full regalia in their woodland setting.

Italian land artist and photographer **Gabriele Jardini**, based in Lombardy, has studied and recorded organic forms on film and video since the early 1980s, with the aim of highlighting a certain object or phenomenon in relation to its surroundings. Like Goldsworthy, his work does not have the invasive approach to the landscape that is often a characteristic of Land Art; rather, he establishes a subtle creative dialogue between art and the natural environment.

Using materials from the landscape or garden, he makes extraordinarily delicate and imaginative sculptures and installations which are in themselves marvels of construction. The works are as diverse as the materials used. Their textures and colours transform trees into emblematic representations of the interaction of nature and art: a collection of elliptical leaves encircles a tree trunk, the top and underside of the leaf forming contrasting bands of light and dark; another tree is hung with garlands of red berries, the ripe fruits decorating the bark like jewellery. With infinite patience and care, Jardini aligns hundreds of reed stems between the intersecting branches of a tree or weaves slender hazel branches into a hanging basket that will be transformed into a white nest when it fills with snow.

The action of the elements – sudden rain, snow or frost, for example – can damage or destroy these ephemeral artefacts in a matter of moments, but again Jardini views this as a feature of the creative process, just as living plants are subjected to damage by weather and time. Accepting its transient nature, Jardini carefully registers the work photographically, from its conception to its eventual extinction, to communicate the beauty of the experience. His locations are carefully chosen to interact with the art works and contribute to their effect. Returning year after year to certain places, Jardini repeats the same processes in order to register seasonal changes and the effects of time on the environment.

Using a range of living plants from Asia, Africa and Europe, British artist Marc Quinn created Garden 2000, *an experiment in cryogenics. Arranged in a steel-framed glass tank of silicone oil and frozen at –20° C, the plants will retain the freshness of their present condition indefinitely.*

The concept of gardens as a source of artistic inspiration is giving rise to a variety of new mediums, both in gallery spaces and outside. In 2000, the Museum of Modern Art in Oxford held an exhibition entitled 'Enclosed and Enchanted', which showed the work of ten contemporary artists on the relationship between nature, architecture and the man-made landscape of the garden. Mounted by Kerry Brougher, Director of the Museum, and Michael Tarantino, independent curator, the exhibition included photography, film, painting, sculpture and installation art, and addressed the subject of the natural world through works made specifically for man-made spaces such as a gallery.

The artists deliberately opposed the garden's conventionally accepted romantic associations with Arcadia and sought instead to shed a new light on its constituent materials. German artist **Wolfgang Laib**'s *Pollen from Pine* consisted of a rectangle on the floor of the gallery made entirely from pine pollen laid out like a Minimalist painting of a single block of luminous colour. By placing the pollen in a contrived geometric arrangement in an indoor exhibition space, detaching it from its normal environmental associations, Laib sought to explore the relationship between man and nature by bringing the essence of the natural world inside.

Italian artist **Giuseppe Penone**'s work questioned the accepted distinctions between art and nature in his naturalistic bronze tree trunks placed in terracotta pots. British sculptor **Antony Gormley** recalled the mythical associations of the Garden of Eden with *Fruit,* a massive cast-iron apple suspended from the ceiling of the gallery, where it confounded all thoughts of paradise and temptation. Artist **Diana Thater,** based in Los Angeles, explored the connection between visual perception and modern technology in *Oo Fifi,* a video film of Claude Monet's garden at Giverny, France, which she separated into screens of red, blue and green. Superimposing them slightly out of synch resulted in a series of technically manipulated, impressionistic images quite different from the pictorially familiar garden of Monet's paintings.

The use of ephemeral organic materials in art in the landscape was the principal theme of the first of a series of exhibitions held at the Salisbury Festival in southern England in 1999. Organized by Theresa Bergne, the festival's creative producer, it was entitled 'Secret Gardens'. Intrigued by the idea that art displayed in an outside location could persuade people to view the landscape in a different way, Bergne invited a number of artists to produce work using organic materials and to show it in the open landscape arena of the Wiltshire countryside.

In *Blasted Oak,* British artists **Heather Ackroyd** and **Dan Harvey** studied the natural processes of life, growth and death characteristic of a living organism, exploring the way in which a form of life can be returned to a dead organism and, in the process, transform it. A magnificent but long-dead oak tree in the grounds of Wilton House, near Salisbury, was temporarily surrounded by scaffolding platforms and a liberal distribution of grass seed applied in a clay mixture to the surface of all its branches. Even using such a commonplace plant as grass, the skeletal structure of the oak acquired a living, vivid green mantle which gave it a semblance of the vigour it had

Pollen from Pine by Wolfgang Laib was exhibited first at the Installation Carré d'Art at the Musée d'Art Contemporain de Nîmes in 1999 and again at the exhibition 'Enclosed and Enchanted' at the Oxford Museum of Modern Art in 2000. A rectangle measuring 320 by 360 centimetres, it makes a block of pure, luminous colour like an abstract painting.

once had. An eloquent dialogue was established between the organic and the ethereal within the landscape. The grass continued to thrive for a month and was then allowed to follow the natural pattern of death and decay (see illustration on page 48).

In *Contour,* artist **Tania Kovatz** also explored ideas of transformation and renewal but from a different viewpoint, which involved intervention in the actual topography of her chosen site, a field of grasses and wild flowers occupying the floor of a secluded valley near Salisbury. Following the seasonal agricultural cycle, the earth was ploughed up and seeded in the spring, in this case with oat seed, the crop sprouted and grew, ripened in the summer and was harvested.

The work served as an exploration into the way agricultural practices condition the landscape by changing its contours, removing many of the indigenous plants from the countryside and restoring life to the land in a modified form. It also drew attention to seasonal patterns and regeneration since agriculture artificially accentuates the normal cycles of life. The stubble was ploughed back into the soil after harvesting and the land – re-seeded with wild flowers, including seeds collected from the banks of the valley – was returned to its natural state.

Like Smithson and Long, Kovatz established a dynamic between a specific site and her own artistic perception of it, and this union of art and the landscape remains a constant inspiration in contemporary garden design.

THE WRITTEN WORD

The history of garden-related literature goes back to the earliest cultures of both East and West, and its romance and serenity have always been seen as conducive to expressions of love in its most elevated forms. An idealized Arcadian landscape, itself a projection of thoughts and ideas, was the proper setting for the study of uplifting poetry, philosophy and worthy literary tracts, a source of spiritual edification and enlightenment, and although we may look for more straightforward pleasure from gardens today, the tradition nonetheless continues. Its most recent manifestation can be seen in the increasingly widespread arts and literary festivals throughout Europe that use gardens as a stage for poetry readings and the performing arts.

Gardener and poet Alice Oswald wrote a series of odes for the Salisbury Festival of 1999 inspired by the

For the Salisbury Festival in 1999 Tania Kovats created Contour, *sowing a wide ribbon of blue oat seed along the floor of a Salisbury valley, both as a study in organic renewal and as a comment on the transformation of the natural contours of the land through agriculture.*

A garden of literary, philosophical and artistic references on many levels, Ian Hamilton Finlay's 'Little Sparta' uses cryptic symbols and elegiac texts to make connections with the landscapes of antiquity. Inscribed 'To Apollo', 'His Music', 'His Missiles', 'His Muses', the house overlooks a slim column crowned with a warship in the lily pond.

beautiful seventeenth-century gardens of Heale House, with their fishponds, rose borders and traditional ornamental Japanese tea-house. The poems were published as a booklet and two of them also featured as forms of installation art: Oswald taped 'A Noh Ballad', an evocative poem about the spirit of a kingfisher, and concealed the recording equipment in a well in the centre of the garden like a piece of art or a fabulous flower. The recording made visitors pause to reflect, imagine and listen, creating the quintessential poetic garden. A line from another poem, 'The River' – `carries the moon carries the sun but keeps nothing', was inscribed on a long, narrow stone which was placed in the river running by the garden as a physical link with the poem that celebrates it.

The alliance between literature and the landscape is also receiving an injection of new life from contemporary writers whose subject is gardens, or who use gardens as a context for written inscriptions, taking texts either from their own writings or those of other authors.

Visual sensitivity and a love of words formed the artistic foundations of Ian Hamilton Finlay's work in the garden of his old stone farmhouse at Stonypath, Dunsyre, in the Pentland Hills of Scotland. He was widely known as a writer of plays, short stories and poetry before he began to concentrate on the relationship between words and images which has occupied him ever since. In the 1960s he became known as a leading member of the Concrete Poetry movement, using words to evoke an image or convey a cryptic message in a way which was open to a variety of interpretations and responses.

Beginning in 1967, Hamilton Finlay transformed

Under a brooding sky that casts dark shadows over the landscape, the portentous message, 'The Present Order is the Disorder of the Future' seems to take on a deeper significance in relation to the present state of the world: the words are taken from the French revolutionary Louis-Antoine Léon de Saint-Just, whose name is inscribed beneath them.

his 1.6-hectare site into a modern conception of a classical garden, which he called 'Little Sparta', placing sculptures and stone inscriptions in the landscape that made carefully chosen references to the classics. He sought to bridge the gap between the classical landscape traditions of the eighteenth and nineteenth centuries and Minimalist art of the 1960s, and also to revitalize the ideas expounded by such luminaries as Alexander Pope and the poet and designer William Shenstone, who devoted much of his life to creating his own sublime version of Arcadia in his garden at Leasowes in the English Midlands.

Hamilton Finlay's garden is a medium for the expression of new concepts in literary and political thinking, and many of its allusions are intended to revive intellectual interest in the history of the world. Recollections of past civilizations pervade the garden, evoking fallen empires and lost worlds through an array of pastoral references and elegiac texts. The phrase 'See Poussin/Hear Lorrain', inscribed by sculptor John Andrew on a stone tablet, invites the viewer to contemplate the landscape in the way that Nicolas Poussin and Claude Lorrain portrayed Elysian antiquity. Another inscription, 'Picturesque', attached to a rustic stake at the edge of the duck pond, makes an ironic commentary on painterly interpretations of Arcadian perfection.

The texts and symbols that fill the garden achieve ironic poignancy through the disparities between words and image. They are sometimes confusing, always enigmatic and thought-provoking, in the great tradition of the classical eighteenth-century English garden, but Little Sparta is also entertaining on a variety of levels. This is not a classic or neo-classic garden. It is a landscape of provocation and it makes an important contribution to the interdisciplinary development of contemporary design.

Placed on the ground beside a woodland walkway is a resin and gold-leaf sculpted head by Ian Hamilton Finlay and Alexander Stoddart (1988) with the words 'Apollon Terroriste' engraved across the forehead.

Swiss landscape architect Dieter Kienast (1945–98) linked current developments in the visual arts and media with literature, philosophy and music in his designs for the landscape, believing that a reliance on tradition would hold back the progress of landscape architecture as an accepted form of modern art. He held the view that the design of contemporary gardens and parks should represent the past but also, importantly, look to the future if it was to continue to evolve.

Kienast was concerned with the use of the written word in the form of sculpture rather than as a simple inscription. In a garden that he began at Uetliberg, Zurich, in 1989 he experimented with this idea by expressing his perception of the garden both visually and literally in the form of a balustrade spelling out in large concrete letters the words 'Et in arcadia ego'. A long stretch of water leads the eye from the main part of the garden in a sweeping vista to the balustrade, which is the main focus of the design. Since it stands at the boundary of the garden, on the edge of the adjoining forest, the phrase questions whether Kienast perceived Arcadia as being inside the garden, where nature is tamed and confined, or outside, where it is free and unbounded.

Taken from the fifth of Virgil's ten pastoral poems, the *Eclogues,* the Latin phrase can be translated either as 'I too am in Arcadia', referring to Arcadia as an idealized landscape inviting spiritual communion with nature, or as 'Even Death is in Arcadia', suggesting that death is present even in paradise or utopia. The text became well known through two paintings by Nicolas Poussin dated around 1626 and 1630, each something of an artistic cipher, in which groups of shepherds in idyllic landscape settings are shown gazing at the inscription 'Et In Arcadia Ego' on a sarcophagus.

Kienast also planned to play with texts in his own Zurich garden by using the words of the performing artist and singer Laurie Anderson, 'Paradise is where you are right now', as a mounted inscription. His early death prevented him from carrying out his intention, but his widow, Erika Kienast, has done so on his behalf: the text, inscribed in blue lettering on clear perspex, hangs on the boundary wall of the garden as a fitting epitaph to the designer.

A fitting memorial to Swiss landscape architect Dieter Kienast was erected in his own Zurich garden by his widow after his death: 'Paradise is where you are right now', from a song by Laurie Anderson.

Kienast believed that garden design should be receptive to influences from a range of artistic disciplines if it is to evolve as an independent art form. In his plan for a garden at Uetliberg, Zurich, the words 'Et in arcadia ego' from Virgil's fifth Eclogue are inscribed along a balustrade on the woodland boundary, forming the focal point of a lake that dominates the design.

On the ground, 'The Text Garden', designed by Janet Hodgson and Anna Douglas, in Calderstones Park, Liverpool, has the formal appearance of a parterre, in marked contrast to the neglected city park it has replaced.

Only an aerial view of the garden clearly reveals the layout of the work. The letter shapes in yew and box hedging set in a gravel surround spell out the common names of four wild flowers.

In a lighter vein, 'The Text Garden', created by **Janet Hodgson** and **Anna Douglas** in Calderstones Park, Liverpool, northern England, illustrates a more directly accessible and visual approach to the use of texts in the garden. Part of the 'Art Transpennine 98' exhibition (see page 202), it was laid out in a corner of an old city park once overrun with wild flowers and grasses. It is based on a formal design of letter shapes in yew and box hedging, surrounded by an expanse of gravel and enclosed on two sides by wild flower borders.

At ground level the texts are hard to decipher since the maze of hedging, a bit like an asymmetrical parterre, is only legible as words when circumnavigated or, like large-scale forms of Land Art, when seen from the air. The words in fact spell out the names of four flowers – forget-me-nots, lords-and-ladies, love-in-a-mist and lily of the valley – popular rather than botanical names since they are intended to conjure up images of romantic, old-fashioned gardens. The work contributes to the social history of the site by documenting the past as well as giving the park a new life that relates to its previous existence.

An ambitious proposal, begun in Germany in 1998 but never fully realized, aimed to create a mutually complementary union between nature and poetry through a project entitled 'Poetische Landschaft', planned by **Brigitte Labs-Ehlert** and Swiss architect **Peter Zumthor**. Ten international poets – Inger Christensen, Michael Donhauser, Amanda Aizpuriete, Peter Waterhouse, Yoko Tawada, Katrina Frostenson, Michael Hamburger, Thomas Kling, Cees Nooteboom and Gennadij Ajgi – were commissioned to write a piece inspired by a particular chosen site on a stretch of land in the Ostwestfalen-Lippe region. Simultaneously, though without any collaboration with the poets, Zumthor designed a site-specific architectural structure for each location.

The poets did not see the architectural plans and Zumthor did not read the poems, the objective being that the participants should respond independently to the landscape. The merits of this particular project cannot be properly judged, but the concept is a fascinating one: to be able to compare the responses of exponents of different artistic disciplines to the inspirational qualities of a single location has the potential to add appreciably to the repertoire of design ideas for the future.

FORUMS FOR THE FUTURE

'Les Petits Radeaux', designed by Berlin landscape architects Luc Monsigny, Axel Hermening, Martina Levin and Nicolai Levin, was sited between three old washhouses along a millrun at Dieue-sur-Meuse, near Verdun in north-east France, to link the work with the history of its location. Using recycled materials and drawings made by children, the red-painted rafts were hung with sails like washing on a line. It was produced for the 'Jardins…à suivre!' festival, which ran simultaneously in Lorraine and in the Luxembourg Ardennes in the summer of 2000.

Stainless-steel sheets, used to make a decorative form of fencing, were exhibited by French landscape architects Philippe Herlin and Daniel Jud at the tenth Chaumont festival in 2001. The steel was punched with a flowing, stencil-cut design of willow leaves, the shapes cut from the metal creating a mirror image of the design on the ground.

Visionary ideas, however outlandish or fantastical they may sometimes initially seem, are the material from which mainstream trends of the future develop. It should not be forgotten that the avant-garde's shock factor diminishes with time and that examples of revolutionary new ideas, whether artistic or technological, which met with hostility when they were first introduced, are now all around us. In the field of garden design this is equally true. Controversial new concepts should therefore be welcomed rather than rejected, as they often are, simply as exercises in self-promotion on the part of publicity-seeking designers. They may amount to no more than that; on the other hand they may contain the germ of an inspiration.

Temporary garden shows and exhibitions by their very nature encourage the innovative and the unexpected, and offer a forum for genuinely original concepts that might never otherwise progress beyond the drawing board or be seen by the general public. They also serve as market places where designers alert to the need to keep abreast of modern developments can pick up topical information, and they help to maintain a lively discourse between art, architecture and garden design. Sometimes the designs exhibited are not intended to be translated into concrete reality; rather like haute couture shows, they are exercises in flamboyance and experimentalist creativity from which ideas that are sound and workable will eventually be distilled.

Temporary shows focusing purely on contemporary design began to flourish in Europe in the 1990s, coinciding with a wider understanding and acceptance of modern art. They provide a platform for the designer to stretch his or her imagination and extend the boundaries of what is currently possible in terms of techniques and even public acceptance, not necessarily wishing to change the world of landscape architecture, but taking on a role in challenging the institution of that art form. Many such shows offer support to the whole arena of landscape architecture by providing funds for the testing of new materials and allowing designers far greater freedom and flexibility than they would be permitted in

As an experiment in modern construction techniques and materials, like the concrete trees of Mallet-Stevens and the Martels at the 1925 world exposition in Paris, Belgian landscape architect Luc Lampaert and interior designer Jean-Pierre Detaeye created 'The Concrete Garden' in 1994. It was devised as a temporary prototype project for small gardens in a suburban area near Ghent.

a privately funded permanent project. They therefore serve as launching pads for students and graduates seeking to establish themselves independently, and at the same time guarantee the participants an audience with an interest in their work.

Many of the most radical and influential ideas of recent years have emerged from World Expositions. In their year-long shows championing the best and most innovative projects from around the globe, they have a long tradition of generating seminal works in the fields of architecture and landscape design. The 1925 'Exposition des Arts Décoratifs et Industriels Modernes', held in Paris, showed garden designs that heralded the movement towards Modernism: Gabriel Guévrékian's triangular colour garden had a revolving glass sphere and water fountains and a minimal horticultural element, while architect Robert Mallet-Stevens and sculptors Jean and Joël Martel designed a garden with concrete trees. Regarded as innovative but shocking at the time, these ideas translated into widely accepted garden designs of the future.

At first sight, a modern garden can still be unnerving. We assume that a landscape or garden design will be readily comprehensible in a way that we would not expect from a painting. However, like the gardens of antiquity, with their complex iconography and classical references, contemporary gardens are often wrapped in layers of meaning; as we have seen, they can make allusions to arcane philosophies, artistic theories and religious principles, and many consequently require careful study before they can be fully understood.

In 1993, **Bernard Lassus,** who studied under the Cubist artist Fernand Léger (1881–1955), a champion of outdoor public art and a major influence in landscape architecture, created a temporary garden, 'Les Buissons Optiques', at Niort in the Poitou-Charentes region of France, which explored optical illusion in a way that many people found disconcerting and incomprehensible. Rows of flowers interspersed with painted boards and vertical mirrors played with the scale, perception and depth of the garden, twisting it into a distorted kaleidoscope of colours. Arguably, its ephemeral nature contributed to the controversy that surrounded it, but, in the years since its first unveiling, it has become a much-published icon of the contemporary garden. (see p. 262)

A brief tour of the most important exhibitions and temporary shows around Europe, as well as a few of the smaller, more experimental events, will demonstrate that garden design is flourishing and that many of the ideas currently circulating are set to become establishment features in the repertoire of landscape architecture of the future.

A balcony garden designed by Nina Thalinson for the Hedens Lustgård show in Göteborg, Sweden, in 2000. Thalinson's exhibit included a glass screen, a wooden sun lounger and a profusion of white sweet peas, ingeniously lit by fairy lights arranged like a cryptic code in a series of wall panels.

Christopher Bradley-Hole's gold-medal winning garden from the Chelsea Flower Show in 2000 was reconstructed at the Göteborg show. Its monolithic rocks reflected in a pool, with feathery planting softening the edges, looked particularly effective at night, when artificial lighting accentuated the colours and textures.

CHELSEA AND HAMPTON COURT

An important source of incentive and encouragement to garden designers and landscape architects is the prestigious awards that often accompany temporary garden festivals and exhibitions. A Gold Medal at the world-renowned Chelsea Flower Show, the annual London exhibition established in 1913 and organized by the Royal Horticultural Society, is one of the highest accolades given for exceptional achievement in horticulture and garden design; it also represents recognition that virtually guarantees publicity and international commissions to its winner for years to come.

Together with its sister show, the Hampton Court Palace Flower Show, Chelsea has experienced something of a metamorphosis in recent years. Until the 1990s both were regarded as showcases for plants displayed in traditional settings. Now all that has changed. New and innovative design ideas are rapidly becoming a feature of these time-honoured shows, and their positive public reception is encouraging greater experimentation.

In 1990 British landscape designer **Julie Toll** won the Gold Medal for her wild flower garden at Chelsea and stimulated a flurry of enthusiasm for its concept, in essence a natural habitat garden. It was not a new idea. Since the 1950s, Lawrence Hills, founder of the Henry Doubleday Research Association, and naturalist Miriam Rothschild, in her garden near Peterborough, Cambridgeshire, have advocated and grown wild flower preserves in order to save indigenous plant species and encourage wildlife. However, it was not until the unveiling of such a garden to a wide audience at Chelsea that its appeal was fully appreciated, an example of the power of publicity. From 1991 to 1996 Toll created a succession of gardens at Chelsea, including butterfly, forest and woodland gardens, which also received widespread accolades.

A similar phenomenon occurred in 1998, following British landscape architect **Mark Anthony Walker**'s Gold Medal win at Chelsea for his 'Water Meadow Garden'. His design created the illusion that the garden was laid out on the edge of a pond, with mature pollarded white willow *(Salix alba)* and a long plank walkway made of western yellow pine *(Pinus ponderosa)* cut into reed-like strips. The planting, which was informal in its arrangement and beautifully proportioned in relation to the space it occupied, included bullrushes *(Typha latifolia),* rushes *(Juncus effusus* and *J. inflexus),* common reeds *(Phragmites australis),* flag iris *(Iris pseudacorus)* and yellow iris *(I. sibirica),* mixed with buttercups, marsh marigolds and angelica. In the pond itself were water lilies, bog bean and water forget-me-nots.

The triumph of the garden lay in its apparent naturalness, a quality that impressed everyone who saw it. It did not seek to introduce a sea change in the course of contemporary design; it simply captured the spirit of the moment and encouraged a desire felt by many people to create a more ecologically friendly garden at home. In this it was a great success.

The 1996 Chelsea prize-winner by Julie Toll, 'Forest Garden', took the natural planting concept into a woodland clearing, which made a perfect setting for a mixture of wild and cultivated shade-loving plants. Her objective was to design a garden which would enhance the natural habitat of birds and insects and encourage the spread of both plants and wildlife throughout the forest.

Julie Toll's award-winning wild flower garden at Chelsea in 1990, sparked an enormous interest in natural gardening and a nostalgia for the countryside of fifty years ago. The plants seen here were once common corn camomile (Anthemis arvensis), *the common poppy* (Papaver rhoeas), *corn marigold* (Chrysanthemum segetum) *and the powder blue cornflower* (Centaurea cyanus).

Gold Medal winner at Chelsea in 1998 was Mark Anthony Walker's 'Water Meadow Garden', which captured the prevailing spirit of the moment in its design for an ecologically friendly garden, with pollarded white willows and a pine plank walkway bordered by water-loving plants and wild flowers.

At the Hampton Court show in 1996, British designer **Bonita Bulaitis** designed a strikingly imaginative garden with textured, cast concrete walls that created divisions across the site and curved around its extremities, pierced by horizontal rectangular openings filled with stained glass panels designed by Susan Bulaitis. The colours of the glass, enhanced by the sun shining through them, played around the curved walls, reflecting off the pools that formed an important element in the scheme and back on to the plants, thus uniting the design, and also incorporating in the garden materials normally associated with the interior of a house.

Grasses and perennials were used to soften the edges of the walls: feathery reed grasses (*Calamagrostis acutiflora* 'Karl Foerster' and *Stipa tenuissima*) and tussock grass (*Deschampsia cespitosa* 'Bronzeschleier') mixed with the blue needles of festuca and mounds of *Molinia caerulea,* while varieties of sedge grass were planted for height and texture. Colour from perennials – pinkish-purple *Allium sphaerocephalon,* lavender-blue *Verbena bonariensis* and pink heuchera – mingled with silvery artemisia to complement the stained glass.

Mirror-lined, cross-shaped water channels and cantilevered steps in serpentine formation made a dramatic sweep up towards a raised platform. Here, copper rods pierced the back wall of a sitting area to create an overhead framework for climbers on the wall above a wooden bench.

It was essentially a blueprint for an urban garden and, in much the same way as Bulaitis married modern design harmoniously with natural planting, a year later, in 1997, British architect and landscape designer **Christopher Bradley-Hole** designed a garden for the Chelsea Flower Show that cleverly combined classical with contemporary ideas. 'The Latin Garden' appeared at a time when the public was warming to modern innovations in landscape architecture and it had an extraordinary impact.

Mixing classical architectural detail and spatial awareness with modern materials, a streamlined framework of stone, steel and glass provided the structure for a Mediterranean-inspired planting scheme. The design incorporated a number of elements – timber flooring, white gravel on the flowerbeds, simple rectangular seating with walls used as divisions – that were easily translatable into a private garden setting, and it caught the crest of a wave of enthusiasm towards more imaginative garden design that was then sweeping through the British gardening public. It was voted 'Best Garden' at the show and helped to stimulate a greater openness in the minds of the show's organizers towards more cutting-edge garden designs in the future.

One of the first show gardens successfully to introduce the idea of using materials associated more with interior than exterior design was Bonita Bulaitis's garden at the Hampton Court show in 1996, which incorporated modern stained-glass window panels designed by Susan Bulaitis into its curving white walls.

Christopher Bradley-Hole's 'The Latin Garden' at Chelsea in 1997 integrated classical architectural detailing with modern materials and planting ideas, and helped to stimulate a wave of public interest in elements such as timber flooring, white gravel as a bedding surface and walls rather than hedges as a screening material, all features that have increased in popularity in the last five years.

'Cascade of Buckets' by French landscape architects Michel Desvigne and Christine Dalnoky, at the inaugural Chaumont Festival in 1992, consisted of two hundred and twenty-two identical galvanized buckets arranged systematically in six lines down a steep slope. Each one was fitted with a copper pipe that rested on the lip of the bucket below it, so that a cascade of water trickled slowly from one to the next, watering the mint plants spreading between them.

CHAUMONT-SUR-LOIRE

One of the most successful and prestigious of contemporary garden events is the 'Festival International des Jardins' at Chaumont-sur-Loire in France. The intention of its initiator and director, Jean-Paul Pigeat, was to establish a dynamic between the classic French landscape of the Loire and new, experimental approaches to the treatment of contemporary gardens.

The festival began in 1992, when such design luminaries as Emilio Ambasz, Fernando Caruncho, Michel Desvigne and Christine Dalnoky, James Wines and Hiroshi Teshigahara were invited to take part, and has grown significantly in popularity ever since. It is now regarded as an institution in the field of experimental garden design, attracting a wide range of talent from all over the world, though mainly from Europe, ranging from students to famous designers in a variety of artistic disciplines. A few honorary guests such as artists or noted landscape architects are still invited to contribute designs, and since 1993 an international jury has selected entries and judged the winners.

In addition to the festival, Pigeat also founded at Chaumont the 'Conservatoire International des Parcs, Jardins et du Paysage', an educational centre for horticulture and a welcome competitor to France's highly influential landscape design school at Versailles. Each year students from the Conservatoire design and build a number of show gardens for the festival.

Although these temporary gardens do make the public look anew at the landscape and its natural forms, they also pose the rhetorical question as to whether what is on display is really a garden. Do such projects promote experimentation for its own sake in the sense that, because the exhibition has a short lifespan, designers can afford to be not just controversial but unrealistic? It is difficult to gauge how much impact the Chaumont Festival has on the design of private gardens and how much time it will take for the proposals it puts forward to find their way into the domain of the popular garden.

There are, however, clear examples of design ideas from Chaumont that have been recognized immediately as important and influential. Unveiled in 1994, the vertical gardens of French botanist Patrick Blanc (see pages 125–7), won immediate acclaim, and a wall remains a permanent feature in the experimental garden next to the exhibition site. Another success was a woven wall of willow stems (illustrated page 173) created as a garden fence for Chaumont in 1995 by two British artists based in France, Judy and David Drew. Two years later widespread recognition also greeted German designer Peter Latz's 'Mist Garden', in which clouds of vapour enveloped the garden, heightening the sense of prehistory suggested by the main structural feature of the garden, a stack of white stone blocks curled around in a spiral like an ammonite.

The use of aluminium and zinc pots, elaborate and unusual water features, new materials for paving – including recycled, coloured glass pebbles – fabrics for the garden and different wall colours and treatments have also been aired for the first time at Chaumont and have subsequently found their way into private gardens.

The design team of New Zealander James Frazer and British landscape architect Tina-Louise Febrey created an atmosphere of exotic luxuriance on the theme 'Libre!' at Chaumont-sur-Loire in 2000 with their garden of native New Zealand shrubs and trees, largely unknown in Europe. Reclaimed iroko, oak, elm and jarra wood were used to create a rustic, zigzag walkway and fencing through its jungle-like forest of plants.

Argentinean artist Liliana Motta's 'Water Saver Garden' at the 1998 Chaumont Garden Festival demonstrated an ingenious irrigation system using plastic water bottles hung on long poles like downpipes to conserve rain water.

'Réflection dans une flaque d'eau', designed by artist Serge Mansau, was shown at the Chaumont 2000 festival dedicated to the theme *'Mosaiculture'*. His series of boat-shaped planters were fixed over a pool on almost invisible rods as if floating on the water, and densely packed with low-growing shrubs such as Euonymus fortunei *'Emerald Gaiety'*, Lonicera nitida *'Baggesen's Gold'* and Berberis thunbergii *'Bonanza Gold'*, their subtle palette of greens and golds set against the blue of the pool and enveloped in a soft mist, making a strikingly artistic composition.

Hanover Expo 2000

At the International Exposition in Barcelona in 1929 Ludwig Mies van der Rohe unveiled the German Pavilion, which remains a key showpiece of high Modernism. In the same spirit of radical innovation, the Dutch Pavilion at Hanover Expo 2000, whose overall theme embraced the trinity of 'Man, Nature and Technology', presented a template for future urban living. A prototype housing project was introduced by a team of designers led by **Winy Maas** from Dutch landscape architecture and urban planning group **MVRDV**.

The proposal was for an eight-floor building, forty metres high and topped with wind sails, covering a ground area of 150 by 60 metres. The plan for its living space reflected a variety of Dutch cultural concepts and traditions as well as concerns surrounding future population densities, pollution and the quality of life. Holland, like other highly populated European countries, is actively exploring the role of the environment in relation to building solutions for the future. Here, the living space was interspersed with a floor of trees, a greenhouse of tropical plants and areas of potted plants, forest and sand dune, with a water feature on the roof.

Building vertically to alleviate shortages of space has long been accepted as the architectural norm, but rarely has any attempt been made on this scale to incorporate gardens within the architecture in order to respond to the now widely understood need for living areas and green spaces to be combined. The design demonstrated that modern architectural and engineering technology can be modified to accommodate a wide variety of plants and other natural elements and that nature can be infinitely adaptable to the demands of new technology. The MVRDV project was an adventurous experiment in ecological design and it remains to be seen if its popularity will result in permanent housing solutions.

Alongside such stimulating concepts, the design of the park of Expo 2000 needed to be truly visionary in order to promote the role of landscape design in relation to architecture and urban planning. With his design team, Algerian-born landscape architect **Kamel Louafi,** based in Berlin, took up the challenge and produced a design of considerable flair and imagination for the seventy-hectare site, which stretched the length of the exposition and beyond.

His scheme consisted of a series of garden sections whose structure diminished in formality the further away from the main centre of Expo activities each was placed, thus reflecting a logical progression from the architectural to the natural environment.

Using the metaphor of a river as a source of life and a symbol of change, these 'Gardens of Transition' were laid out on either side of a meandering green corridor running the length of the park, and carried the theme through with allusions to the passage of time, transportation and communications, motion, transformation and development in the context of the new millennium. Borrowing from an eclectic range of sources and traditions, they took the form of a Moorish patio garden with a waterfall, a pavilion of illusion constructed of opaque glass, a tea house beside a bamboo garden and a dune pavilion in a desert setting.

The 'Gardens in Transition' formed the main section of the park and led into the Expo-Park South and an expanse of agricultural land where Louafi sited the least formal of his designs, a series of strikingly graphic images of scarecrows and rustic, white stone walls.

MVRDV's Dutch pavilion at Expo 2000 in Hanover consisted of a colourful assembly of landscape elements interspersed with living accommodation in an eight-floor building topped with wind sails. An ambitious project in both ecological and architectural terms, it aimed to answer the modern demand for high-rise urban dwellings that relate directly to the natural environment.

In direct contrast to the more formal gardens at Expo 2000, dry stone walls and a row of lanky scarecrows, striding over the crown of a field at the farthest extremity of the park, were designed by Kamel Louafi and his team as a reference to the agricultural land surrounding the site.

Each section of the overall design was marked by a different tree species, from the large-leafed lime (*Tilia platyphyllos*) around the Mediterranean garden to *Magnolia kobus* in the bamboo garden, the Himalayan birch (*Betula utilis*) in the dune garden and the maidenhair tree (*Ginkgo biloba*) in the agricultural parkland. A 'Black Garden', constructed of dark slate and stonework and planted with the Austrian pine (*Pinus nigra ssp. Nigra*), at the northern entrance to the exposition directed the eye along a central vista that culminated in a belvedere looking out over the rest of the park.

Ostensibly designed as an exhibition park, it is important to note that Louafi's vision formed a connection between the city of Hanover and nearby Laatzen by creating a landscape to become a park for the neighbourhood. The garden design evolved into business areas around the park in order to sustain the rejuvenation of the area once the Expo closed its gates to the public.

Events Around Europe

In 1993, Italian landscape architect Daniela Colafranceschi created a temporary open-air theatre garden at Fara in Sabina, seventy kilometres north-east of Rome, as part of the 'Laboratorio Internazionale Città Riflesse', an exhibition directed by architect Gianni Celestini. In collaboration with the town's theatre school, Colafranceschi devised an installation garden based on sound and illusion called 'Zefiro dall'Oriente' (Wind from the East).

Sited in an open area on the edge of the town, the garden took the form of a narrow, zigzag, grass-covered walkway, above ground level and on varying gradients, which also served as the performance space. A degree of verve and showmanship was required of the actors as they negotiated its steep, angled ramps and the forest of tall, thin, plastic tubes, arranged in a rectangular grid, that accompanied it along its abstract route. A length of pale blue ribbon was linked to a ring at the top of each pole and, when the wind blew, the movement of the ring produced a soft musical sound from the tubes.

A triennial cycle of exhibitions dedicated to exploring the relationships between urban culture, the garden and memory, called 'La Ville, Le Jardin, La Mémoire', ran from 1998 to 2000 at the Villa Medici, the home of the French Academy in Rome and the study centre for its Prix de Rome scholars. It was held in the villa itself, which is normally closed to the public, in its Renaissance gardens and in the ateliers of the artists-in-residence, which are located along the Aurelian Walls, forming a point of contact between the influences of the modern and the classical worlds. Some of the artists used the city of Rome as the inspiration for their exhibition projects. Although ecological awareness is greater now than ever before, local identities and cultural specificity are under threat from a number of aspects of technology and globalization, and the exhibitions sought to underline the issues that are hindering progress towards reconciliation between these various factors.

The three curators – Laurence Bossé, Carolyn Christov-Bakargiev and Hans Ulrich Obrist – were invited by Bruno Racine, the Director of the Academy, to choose a number of artists whose work was already internationally known in the field relevant to each exhibition. Transcending a purely aesthetic approach to gardens, 'Le Jardin' showed the work of thirty artists who, together with the artists-in-residence, had for many years taken part in an ongoing dialogue on the nature of gardens and the landscape and whose ideas currently represented a new approach to the garden and its place in future art and design. It also presented a virtual garden exhibition on the Internet, based on the theme of the global garden.

Swiss artist **Lucius Burckhardt** devised a walking tour through Rome, avoiding all the well-known monuments to reveal neglected aspects of the natural environment of the city, while Canadian **Janet Cardiff**'s 'Villa Medici Walk' invited visitors to go on an exploratory audio walk, complete with headsets, around the ancient villa gardens. Thought to be the site of the gardens of Lucullus, they were once adorned with magnificent statuary, and, although many of the finest pieces were removed to Florence centuries ago by the Medici Grand Dukes, they have nonetheless retained beautiful fountains, sarcophagi and fragments of classical ornament. They are also one of the very few gardens to have kept their original sixteenth-century layout, with its geometric parterres, its long, walled walk which catches the morning sun, its *bosco* of ilex trees and magnificent loggias from which to admire the gardens. Oscillating intriguingly between fiction and reality, the audio narration revealed hidden layers of history and meaning in the Renaissance design and demonstrated the debt contemporary garden designers owe to the traditions of the past.

A plan and elevation of Daniela Colafranceschi's temporary open-air theatre garden, 'Zefiro dell'Oriente', which was a feature of the summer festival at Fara in Sabina, Lazio, in 1993.

Raised walkways across an open square in front of the old town walls created a precarious, zigzag route for the actors, members of the local theatre school, who took part in a spectacle involving sound, colour and illusion.

Thomas Heatherwick's 'Hairy Sitooterie', one of the garden gazebos exhibited at Belsay Hall in the summer of 2000, derived its name from over five thousand one-metre-long ash batons protruding from the sides and top of the structure, giving it a softly spiky texture.

English Heritage, an organization dedicated to the preservation of England's historic sites and buildings, celebrated the Year of the Sculpture in 2000 in conjunction with two regional arts associations, Northern Arts and Northern Architecture. Twelve artists, architects and interior designers were commissioned to produce a work on the theme 'Sitooterie', a Scottish word for a place in which to sit outside (literally sit-out-erie). The idea was the brainchild of artist Judith King who masterminded the event. Each of the 'Sitooteries', three-and-a-half metres square, was a modern interpretation of the exedras, pavilions and summerhouses that have adorned the gardens of country houses for centuries. Aptly, they were shown throughout the summer at Belsay Hall in Northumberland, whose neo-classical architecture and twelve-hectare, historic gardens offered inspiration to the participants as well as an appropriate backdrop to the exhibits.

In a woodland area, London-based architecture group **FAT** (Fashion, Architecture, Taste) created a miniature Romanesque church, while designer **Julian Opie** constructed a graphic version of the 'Sitooterie', a sort of modern Greek temple in the form of a plastic bus shelter. Belsay Hall's arched ha-ha was the location for the tactile 'Hairy Sitooterie', designed by **Thomas Heatherwick;** based on a wooden cube construction, it took its name from over five thousand one-metre-long ash batons that protruded from its walls and top, giving it a spiky surface like a haircut *en brosse*.

In the quarry garden, artist **Tania Kovats** created the 'Rocky Love Seat', a simple, stark white cube split down the middle to reveal two sculpted rock seats set in a miniature landscape. Nearby, 'Enclosed Plane', by architects **Mosedale Gillatt** and product designers **Octo Design,** comprised five bright, annealed stainless-steel panels that unfolded like a magic box, disclosing two curved seats of American oak, a deckchair and a glazed wall; when not in use the panels folded up to reflect the surrounding landscape of the quarry. And London-based architect **Claudio Silvestrin** designed 'Millennium Hope' for Belsay's Pillar Hall, a stark, empty room where his unconventional indoor 'Sitooterie', a tribute to the building's original

architect, Sir Charles Monck, was equipped with a classic walnut table and benches.

The inaugural International Festival of Gardens at Westonbirt Arboretum in Gloucestershire, south-west England, was held throughout the summer of 2002. The first wholly contemporary garden show in Britain, it is set to become an annual event and an excellent showcase for the best and brightest of modern garden design.

The city of Lausanne in Switzerland organized two garden events, for the summers of 1997 and 2000, that transformed the cityscape. The aim of 'Lausanne Jardins', directed by Lorette Coen, was to illustrate the wide spectrum of art and design work currently contributing to the contemporary urban garden, and to attract public attention to the city itself and its environment. A number of complementary events ran alongside the garden festivals, designed particularly to broaden the appeal of the city's landscape architecture, and visitors, equipped with a map highlighting the gardens, were encouraged to explore Lausanne from a new perspective.

A number of well-known European landscape architects were invited to take part in the first event, while for the second a competition was launched to select the participants, all of them again European. The gardens they created lasted for the summer of each year and some remain as permanent features of the city. Scattered throughout Lausanne and its suburbs, several were sited in places where they would give new impetus to a run-down area. For 'Lausanne Jardins 1997' French landscape architect **Gilles Clément** transformed a stretch of embankment alongside the electric rail track between Lausanne and Ouchy into a rhythmic sequence of planting. Since his design was intended to outlive the summer and remain indefinitely, Clément added a number of new trees, including the white-barked West Himalayan birch *(Betula utilis* var. *jacquemontii)* and blue holly *(Ilex x meservae)*, to existing specimens of *Magnolia kobus, M. x soulangeana* and a large Japanese angelica tree *(Aralia elata)*. He also planted the enormous leathery-leaved giant hogweed *(Heracleum mantegazzianum)*, and, at the beginning and end of the embankment, clumps of bamboo *(Phyllostachys nidularia, P. aureosulcata* and *Sasa palmata)*. The grassed areas were scattered with wild flowers to create a prairie of colour – a 'Jardin en Mouvement' – accompanying the passage of the train through the landscape.

Also for 1997, Swiss interior designers **Sylvia Krenz** and **René Schmid,** in collaboration with horticulturalist **Pascal Cadosch,** devised a project whose simplicity would allow it to be set up in any neglected area of the inner city. Ceramic blue pots were sited at evenly spaced intervals down a stairway, accentuating the height of the steps and the length of the retaining wall beside them, and forming a descending line which continued, with the pots randomly spaced, along a main axial route through the area. The pots were identical, though planted with a different variety of aromatic, medicinal or edible plant, including chives *(Allium schoenoprasum)*, wormwood *(Artemisia absinthium)*, *Dryopteris erthyrosora* and the Japanese hop *(Humulus japonicus)*.

For 'Lausanne Jardins 2000', four different areas of historical interest – Flon, the hill of Montriond, Montbenon and the cemetery of Bois-de-Vaux – provided settings for a total of thirty gardens. These included an installation spanning two high-rise buildings, a camping garden with plants in small tents, a garden on the façade of a tall building and an arrangement of gnomes placed on rooftops and visible only through a telescope. Architects **Maria** and **Bernard Zurbuchen-Henz** devised a project titled 'L m'aime' (signifying 'Lausanne loves me'), in which a series of words and phrases related to the title – 'Un peu', 'Beaucoup', 'Passionnément', 'A la folie' and 'Pas du tout' – were spelled out in large letters ranged along the skyline and interwoven with climbing runner beans *(Phaseolus vulgaris)*, black-eyed susans *(Thunbergia alata)* and morning glory *(Ipomea purpurea)*.

While horticultural excellence is not their sole aim, the Lausanne garden festivals are serious and highly organized events which serve as a showcase for the creativity of Swiss and other European designers.

'L m'aime' ('L' for Lausanne), devised by Maria and Bernard Zurbuchen-Henz and team for Lausanne Jardins 2000, used climbing runner beans, morning glory and black-eyed susans on iron frameworks to spell out along the skyline in large letters 'Passionnement', 'Beaucoup', 'Un Peu' and other words qualifying the title of the work.

One of the most innovative and appealing ideas for Lausanne 2000 was 'Le Jardin Ferroviaire' by Swiss artist Jean Scheurer and team. Fourteen goods wagons filled with plants were attached to a passenger train that travelled around Switzerland all summer to promote the festival.

'Rasenstücke', Klaus Bortoluzzi's design for the 1997 Berlin 'Temporäre Gärten' festival, alluded to Dürer's famous watercolour depicting marshland grasses, Das Grosse Rasenstück, and to the relationship between nature and city life.

'Les Jardins en Plastic', a one-day installation consisting of small yellow plastic flags on metal poles, was created in 1996 by landscape architects Marc Pouzol and Céline Boquillon, and simultaneously marked a number of sites in central Berlin. Here it is seen in front of the monument in the courtyard of Baroque castle Schloss Charlottenburg. The project was the prototype for the Berlin Temporary Garden Festival which has been staged annually since 1997.

A similar promotional scheme is taking place in the fast-developing urban arena of Berlin, where a group of landscape architects is drawing attention to little-visited areas of the city by means of an annual temporary garden festival, the 'Temporäre Gärten'. Launched in 1997, the show has attracted a wide following of designers and visitors alike. It lasts just three days each summer, and the challenge to participants is to create a garden structure or display on a set theme that arrests the attention of passers-by and contributes in a stimulating, original way to its location.

The first festival, which coincided with the annual congress of German architects, was held in the Schlossplatz and adopted the theme 'Cultivating the View'. This idea was the joint brainchild of the Berlin and Brandenburg chapter of the Bund Deutscher Landschaftsarchitekten, the Landscape Institute of Germany, and Berlin-based landscape architects Daniel Sprenger and Marc Pouzol. The temporary garden installations included two hundred randomly scattered yellow stones, to be rearranged by passers-by; mini gardens in matchboxes; sunflower heads laid out in a grid on a square entitled 'Helianthus Erectus' by **Jens Henningsen;** and a piece of garden turf in a briefcase, designed by **Klaus Bortoluzzi** and titled 'Rasenstücke', perhaps alluding to Albrecht Dürer's famous sixteenth-century watercolour study of wild grasses, *Das grosse Rasenstück* (The Great Piece of Turf), and also an ironic commentary on the shrinking nature of gardens and the dominant contemporary influence of office life.

In the second year, the festival occupied the wide open space of Alexanderplatz, where twenty-five participants interpreted the theme 'The Search for a Place'. Original and provocative ideas ranged from a garden of inverted trees to a moveable garden in a shopping trolley. The 1999 theme was 'The Suburb in the City Centre' and its location Fisherman's Island, a jungle of tower-blocks built over the site of Berlin's medieval centre. Giant sunflowers scaled a tower-block wall as a comment on the satellite television dishes that have spread like a rash across the Berlin skyline. In '1000 Weisse Rosen' **Andrea Nicke** and **Gregor Zimmer** placed vases of white roses on a bridge as a symbolic link between the country garden filled with growing plants and the cut flowers of the city. There was a game of solitaire, a garden of plant pots on a grid with one open space in which to move a pot; viewers were encouraged to participate.

In 2000 the festival returned to Alexanderplatz with the theme 'Inter-Metropolitan', investigating the global spread of influences in art and design and including a drive-in garden. The festival of 2001 spanned Karl-Marx-Straße in Neukölln and was based on the theme 'A Desire for Opulence'.

The brevity of the Berlin festival is one of its attractions for a wide range of contributors – designers, architects, artists, urban planners and landscape architects, working alone or in partnerships – who can only afford a short interruption to their normal working lives. More is often contributed to the melting pot of ideas at such short-term temporary shows, therefore, than at their longer-running counterparts, and as a result they are frequently richer, livelier and more innovative. They generate an energy and spontaneity that is appealing in itself and that gives added impetus not just to the show but to the whole field of garden design. In 2001, Potsdam, south-west of Berlin, hosted the

Vertical information boards broke the horizontal emphasis of large areas of planting in Stefan Tischer's exhibition garden at the Bundesgartenschau in Potsdam in 2001.

A bed of foxgloves (Digitalis purpurea) at BUGA 2001.

Stefan Tischer's 'Garden of Perspective', in which a large pair of painted eyes stares back at the viewer. Red-and-white striped banners strung across the garden accentuates the width of the space and the predominant colour of the planting scheme.

A light-hearted look at the relationship of man, the garden and the elements, 'Regenspender', by Berlin-based landscape architects Büro Sprenger, was shown at the inaugural 1997 Berlin Temporary Gardens Festival.

'Bundesgartenschau' (BUGA), the Federal Garden Show; held every four years in a different location, it has now run for fifty years. The objective of the Potsdam show was to stimulate growth and investment in the city. The seventy-hectare site was broadly divided into four sections: a river site and an urban site (each of which was dedicated to a series of individual gardens), a park and an agricultural area. Hamburg-based landscape architect **Dirk Junker** and Berlin-based landscape architect **Stefan Tischer** designed the basic structure for a series of theme gardens within the park area, which are surrounded by hedges. Using a range of different layouts, themes and colour schemes in plans for twelve temporary gardens, both landscape architects showed the diversity of contemporary garden-design. These were set up in April and dismantled at the end of October 2001.

A four-hectare site designed by Tischer himself served as an exhibition space for over one hundred sustainable plants that are used in whole or in part in some practical way. Huge tracts of a single species were planted together, signposted by an image of the plant they represented, while another sign showed an image of the individual plant cell or component part that is used; for example, a swathe of sunflowers had an image of the seed from which sunflower oil is extracted.

Tischer also presented a prototype design for a suburban garden, where there is often length but little width. His aim in the 'Garden of Perspective' was to create a setting that distracted from the narrow-

ness of the space by introducing variety and drama in its use of structure and strong colour and by laying the garden out along meandering corridors of planting. The eye was thus drawn to particular features, such as an expanse of red *Salvia splendens* mixed with foxgloves, tall, spiked kniphofia and a bright clump of annual grasses rather than seeing the whole length of the garden at once. In an ironical twist on the idea of the garden being the subject of scrutiny by visitors, Tischer painted on a board, which he mounted above head height at the end of the garden, a large pair of eyes which appeared to be staring back at the viewer.

Peter Latz & Partner, produced a design for a sixteen-hectare site in the southern part of the Volkspark Bornstedter Feld, with cathedral-like groves of trees, a recreational area laid out in a spiral design and a large central meadow.

An interdisciplinary team composed of Swiss landscape architect **Stefan Rotzler** and Berlin-based artist **Otmar Sattel** won the competition for the agricultural section. In their proposal, the sixty-five-hectare site was divided into fields for grazing herds of cows, horses, pigs, sheep and goats, each species enclosed by a brightly coloured plastic fence. Bisecting the area was a central walkway defined by white fabric umbrellas like bath caps, one of which sheltered a video screen. The screen relayed live video footage directly from a camera fitted to the horns of the cows in order to show the scenery from a cow's perspective – a novel approach to information-gathering as a means of enhancing our awareness of the landscape.

Would such a concept as this, or, equally, some of those exhibited at the festival of Lausanne or at Belsay Park, translate to a permanent garden? Perhaps not in their original form, but they do influence and inspire a younger generation of landscape architects and designers, and provide a forum for experimentation not usually feasible outside the college classroom. There must be open-mindedness towards new, controversial concepts if garden design is not to stagnate, and, as scepticism gradually diminishes, perhaps it will be replaced by understanding and admiration. It takes time; as modern art becomes more understandable with familiarity, so modern gardens become more comprehensible the more we see of them. After all, 'Capability' Brown, on a mission to transform garden design in the eighteenth century, encountered understandable hostility as he destroyed established gardens and replaced them with idealized imitations of the natural landscape that we now regard as classics.

The art of garden design should be allowed to overturn as well as confirm traditional values. Admittedly, there is a barrier to our acceptance of some of these new ideas aside from the visual shock they sometimes cause: our notion of the garden as a haven of greenery and flowering plants, a paradise garden, is deeply embedded in our psyche. Can we relax in a space built of hard-edged plastic and steel and filled with concrete trees? It could be argued that if we do not feel good in a garden without plants, we shall reject high-tech modern elements out of hand as being too harsh and inhospitable and not give them a chance to prove themselves. Maybe greater acceptance is simply a question of time, or maybe such gardens push us to think more about the process of making a garden and what it does to the ecology of the site. Are some gardens more about anti-nature than they should be?

A final thought: which of these gardens will be the Versailles, Het Loo or Sissinghurst of the future and become a much-loved national treasure, one that for years to come will inspire as much admiration and give as much pleasure as they have done? Time will tell.

Set up to show the landscape from a cow's perspective, video cameras fitted to the horns of cows relayed live footage directly to screens under large umbrellas in this project conceived by landscape architect Stefan Rotzler and artist Otmar Sattel for the agricultural section of BUGA, Potsdam, in 2001. Their concept was unfortunately never turned into reality.

'Puffing Mosses' was designed by Swedish artists Thomas Nordström and Annika Oskarsson for a wild garden created by Julie Toll at the Rosendal Garden Festival in 1998. Masterminded by Swedish landscape architect Ulf Nordfjell, the festival took place in 1998 during Stockholm's year as City of Culture. The moss-covered rocks emitted puffs of steam at regular intervals, lighting up the pond and filling the air with vapour, which created the perfect atmospheric conditions for mosses to thrive.

Glossary

Acanthus mollis (bear's breech) 178
Acer (maple) 13
 palmatum 'Osakazuki' (Japanese ~) 163
 rubrum (red ~) 163
Achillea (yarrow) 182
 filipendulina (fern-leaf ~) 182
 tomentosa (woolly ~) 167
Aconitum wilsonii (wolfsbane) 66
Actinidia chinensis (kiwi plant) 200
Adiantum venustum (Himalayan or evergreen maidenhair) 181
Aesculus hippocastanum (horse chestnut) 68, 69
African lily, see Agapanthus
Agapanthus (African lily or lily of the nile) 118
 campanulatus (African blue lily) 174
 'Cobalt Blue' 172
Ageratum (flossflower) 45
Ajuga (bugle) 188
Akebia quinata 77
Alcea (hollyhock) 59
 rosea 71
 rugosa 63
Alchemilla mollis (lady's mantle) 68
alder, see Alnus glutinosa
alfalfa, see Medicago sativa
Allium (chives or garlic) 83, 172
 christophii 59
 hollandicum 59, 61
 schoenoprasum (chives) 174, 248
 sphaerocephalon 44, 240
 ursinum 63
almond tree, see Prunus dulcis
Alnus glutinosa (alder) 57, 58
Alpine moon daisy, see Leucanthemopsis alpina
Alstroemeria (lily) 179
Althea (hollyhock)
 rosea 178
Alternanthera 188
Amelanchier (serviceberry)
 canadensis 122
 lamarckii 166, 174
Amsonia tabernaemontana (blue star or blue dogbane) 66
Anaphalis (pearl everlasting)
 margaritacea 179
 triplinervis (three-veined everlasting) 20
Anchusa italica (Italian bugloss) 71, 178
Anemone (anemone) 61
 japonica (Japanese ~) 141
 nemorosa (wood ~) 99
Angelica archangelica (angelica) 239
Anthemis arvensis (corn camomile) 239
Anthurium (flamingo plant) 186
Antirrhinum 'Sprite' (snapdragon) 189
apple tree, see Malus domestica
apricot tree, see Prunus armeniaca
Aptenia (baby sun rose or heartleaf ice plant) 188
Aquilegia (columbine) 59
 alpina 61
 vulgaris 177
Arabis ferdinandi-coburgii (rockcress) 157, 188
Aralia elata (Japanese angelica tree) 248
Arbutus unedo (strawberry tree) 54, 55, 68, 118, 142, 149
Aristolochia macrophylla (pipevine) 78
Armeria maritima (seathrift) 155
arrowhead, see Sagittaria sagittifolia
Artemisia (artemisia or wormwood) 240
 absinthium 153, 179, 248
 'Lambrook Mist' 174
artichoke, see Cynara
artichoke thistle, see Cynara cardunculus
Arum maculatum (lords-and-ladies) 232
Asphodeline lutea (yellow asphodel or King's spear) 167
Astelia chatamica (silver spear) 131
Aster 66
 amellus 'Veilchenkönigin' 20
 umbellatus 182
Astrantia 'Claret' (great masterwort) 182
Atlas ceder, see Cedrus atlantica
autumn crocus, see Colchicum
Avena sempervirens (blue oat grass) 179
Azalea 165
 'Flame' 179
 'Orange Beauty' 179
 'Wilhelm III' 179
azalea, see also Rhododendron
Azara serrata 126, 127

baby sun rose, see Aptenia
bald cypress, see Taxodium distichum
balsam, see Impatiens

bamboo, see Fargesia murielae, Nandina domestica, Phyllostachys, Pleioblastus, Sasa palmata or tesselata, Semiarundinaria fastuosa
Baptisia australis (false indigo) 66
barberry, see Berberis
barber's twinspur, see Diascia barberae 'Blackthorn Apricot'
bay tree, see Laurus nobilis
bear's breech, see Acanthus mollis
beech, see Fagus
Bellis perennis (daisy) 177
bell flower, see Campanula
Berberis (barberry) 126
 stenophylla 165
 thunbergii 'Bonanza Gold' 243
 x ottawensis 'Superba' (arching ~) 174
bergamot plant, see Monarda
Bergenia 'Admiral' (bergenia) 174
betony, see Stachys
Betula (birch)
 utilis (Himalayan or Kashmir ~) 245
 'Doorenbos' 99
 'Jacquemontii' 248
 pendula (silver ~) 80, 132, 133, 209
bindweed, see Convolvulus
birch, see betula
bird cherry, see Prunus padus
black currant, see Ribes nigrum
black-eyed susan vine, see Thunbergia alata
blistercress, see Erysimum
blue dogbane, see Amsonia tabernaemontana
blue flax, see Linum perenne
blue mist shrub, see Caryopteris x clandonensis
blue oat grass, see Helictrotrichon, Avena sempervirens
blue spirea, see Caryopteris x clandonensis
blue star, see Amsonia tabernaemontana
bluebeard, see Caryopteris x clandonensis
bog bean, see Menyanthes trifoliata
Boston ivy, see Parthenocissus tricuspidata 'Veitchii'
Bougainvillea 186
box, see Buxus sempervirens
Bromeliad 186
broom, see Cystisus, Genista, Spartium
buckbean, see Menyanthes trifoliata
Buddleja davidii (butterfly bush) 175
 'Black Knight' 185
 'White Cloud' 185
bugbane, see Cimicifuga dahurica
bugle, see Ajuga
bugloss, see Anchusa azurea
bullrush, see Typha latifolia
burnet, see Sanguisorba
bush cinquefoil, see Potentilla fruticosa 'Red Ace'
bush germander, see Teucrium fruticans
butterfly bush, see Buddleja davidii
Buxus sempervirens (box) 61, 63, 64, 66, 77, 83, 89, 90, 121, 166, 233
 'Arborescens' 59

cabbage palm, see Cordyline australis
Calamagrostris (reed grass)
 x acutiflora 'Karl Foerster' 174, 240
 arundinacea 154
 brachytricha 182
Calendula officinalis 'Fiesta Gitana' (pot marigold) 157, 189
Californian poppy, see Eschscholtzia California, Romneya coulteri
Caltha palustris (marsh marigold) 167, 239
Camellia sasanqua 'Cornish Snow' (camellia) 90
Campanula (bell flower) 66
 lactiflora 68
 poscharskyana 'Stella' 166
 rapunculoides (creeping ~) 177
Canada thistle, see Cirsium avense
Capsella bursa-pastoris (shepherd's purse) 175
Cardamine pratensis (cuckoo flower or lady's smock or mildmaid) 177
Carex (sedge) 240
 riparia 158
carob tree, see Ceratonia siliqua
Carpinus betulus (hornbeam) 53, 57, 58, 61, 64, 150
Caryopteris x clandonensis (blue mist shrub, bluebeard, blue spirea)
 'Heavenly Blue' 166
 'Kew Blue' 166
Castanea sativa (sweet chestnut) 61
castor bean, see Ricinus communis
castor oil plant, see Ricinus communis
cattail, see Typha
Ceanothus x delilianus 'Gloire de Versailles' (French hybrid ceanothus) 68

cedar, see Cedrus atlantica, Thuja occidentalis
Cedrus atlantica (Atlas cedar)
 'Glauca Pendula' (weeping ~) 123
celandine, see Ranunculus ficaria
Centaurea cyanus (powder blue cornflower) 66, 157, 239
Cerastium (chickweed) 188
Ceratonia siliqua (St. John's bread or carob tree) 142
Cercis siliquastrum (Judas tree) 81
Chamaerops humilis (dwarf or European fan palm) 142
Chenopodium (goosefoot) 175
 album (fat hen or lamb's-quarters) 175
chestnut, see Castanea, Aesculus
chequered lily, see Fritillaria acmopetala meleagris
chickweed, see Cerastium
Chimonanthus praecox (wintersweet) 164
Chinese forsythia, see Forsythia suspensa
Chinese silvergrass, see Miscanthus sinensis
Chinese temple tree, see Ginkgo biloba
Chinese windmill palm, see Trachycarpus fortunei
chives, see Allium
Choisya ternata (Mexican orange or mock orange) 166
Chrysanthemum (daisy)
 'Goldball' 189
 'Mischung' 189
 leucanthemum (ox-eye daisy) 177
 segetum (corn marigold) 239
Cimicifuga dahurica (bugbane) 122
Cirsium (thistle) 178
 arvense (Canada ~) 175
Cistus (rock rose or sun rose) 185
 laurifolius 165
Citrus (citrus tree) 80, 110
 aurantium (sour orange tree) 142
 limon (lemon tree) 82, 107, 111, 142
 limonum (lime tree) 82
 reticulata (tangerine tree) 82
 sinensis (orange tree) 31, 82, 111
Clematis 61, 89
 'Vyvyan Pennell' 90
 armandii 52, 77, 89, 90
 'Apple Blossom' 90
 montana 123
 orientalis 'Orange Peel' 52, 179
 paniculata 181
 viticella 'Purpurea Plena Elegans' 68
 'Royal Velours' 90
clover, see Trifolium
cocklebur, see Xanthium strumarium
Colchicum (autumn crocus)
 tenorei 'The Giant' 68
columbine, see Aquilegia
comfrey, see Symphytum
common bean, see Phaseolus vulgaris
confederate jasmin, see Trachelospermum jasminoides
Convallaria majalis (lily-of-the-valley) 99, 233
Convolvulus (bindweed) 179
 cneorum (silverbush) 185
coral bells, see Heuchera
Cordyline australis (cabbage palm or Cornish palm) 181
corn camomile, see Anthemis arvensis
corn marigold, see Chrysanthemum segetum
Cornelian cherry, see Cornus mas
cornflower, see Centaurea cyanus
Cornish palm, see Cordyline australis
Cornus (dogwood) 61
 controversa 'Variegata' 122
 mas (Cornelian cherry) 163
 sanguinea 175
Corsican mint, see Mentha requienii
Corsican pearlwort, see Sagina subulata
Cortaderia selloana (pampas grass) 186
Corydalis 126
Corylus avellana (hazel or filbert) 57, 69, 99, 151, 163
cottonwood, see Populus
cowslip, see Primula veris
crab apple, see Malus sylvestris
Crambe maritima (seakale) 157
crape myrtle, see Lagerstroemia indica
Crataegus monogyna (hawthorn) 60, 61, 175
crimson cushion, see Knautia macedonica
Crocosmia x crocosmiiflora (montbretia) 166
Crocus 61
 chrysanthus 'Blue Pearl' 68
 tommasinianus (early ~) 57
cuckoo flower, see Cardamine pratensis
culver's root, see Veronica virginica
Cupressus sempervirens (Italian or true cypress) 81, 117, 118, 148, 149, 153

currant, see *Ribes*
Cycas circinalis (sago palm) 142
 revoluta (cycad palm or sago cycas or false sago palm) 142
cycad palm, see *Cycas revoluta*
Cydonia (quince tree) 59, 185
Cynara
 cardunculus (artichoke thistle) 178
 scolymus (globe artichoke) 157
cypress, see *Cupressus sempervirens, Taxodium distichum*
Cytisus (broom) 153
 x *praecox* 'Albus' 123

daffodil, see *Narcissus pseudonarcissus*
daisy, see *Bellis perennis, Chrysanthemum*
dandelion, see *Taraxacum officinale*
Darmera (umbrella plant) 178
 peltata 71
date palm, see *Phoenix*
day lily, see *Hemerocallis lilioasphodelus*
Delphinium (larkspur or staggerweed) 35, 178
Deschampsia (hair grass)
 flexuosa 'Tatra Gold' 188
 cespitosa 17
 'Bronzeschleier' (tussock grass) 240
Dianthus (pinks)
 barbatus (Sweet William) 59
 carthusianorum (clusterhead ~) 167
 deltoides (maiden ~) 14, 53, 167
Diascia barberae 'Blackthorn Apricot' (barber's twinspur) 174
Dicksonia antarctica (Tasmanian or soft tree fern) 90, 181
Digitalis (foxglove) 167, 177, 178, 179
 ferruginea 154
 purpurea 178, 251
Diplotaxis erucoides (white rocket) 175
dog rose, see *Rosa canina*
dogwood, see *Cornus*
Dryopteris erythrosora (Japanese shield fern) 248
dusty miller, see *Senecio cineraria* 'White Diamond'
dwarf palm, see *Chamaerops humilis*

Echeveria 188
Echinacea purpurea 'White Swan' (white coneflower) 155
Echinops ritro (globe thistle) 68
 'Veitch's Blue' 68
Elaeagnus angustifolia 'Quicksilver' (Russian olive) 154
elder, see *Sambucus*
elegans hosta, see *Hosta sieboldiana*
elegans plantain lily, see *Hosta sieboldiana*
elm, see *Ulmus*
Epilobium angustifolium 'Album' (white rosebay willowherb) 154, 178
Epimedium x rubrum (red barrenwort) 141
Epipactis gigantea (chatterbox orchid) 179
Erica arborea 'Alpina' (tree heather) 123
Eryngium (silver-blue sea holly) 35
Erysimum (blistercress or fairy wallflower) 126
Escallonia macrantha 54, 55
Eschscholtzia california (Californian poppy) 155
Eucomis bicolor (King's flower or pineapple lily) 63
Euonymus europaeus (European spindletree) 57
 forturei 'Emerald 'n Gold' 174
 'Emerald Gaiety' 243
Eupatorium purpureum 'Atropurpureum' (joe pye weed) 182
Euphorbia (spurge or milk barrel)
 characias 123
 'Lambrook Gold' 66
 niciciana 179
 polychroma 174
European beech, see *Fagus sylvatica*
European fan palm, see *Chamaerops humilis*
European spindletree, see *Euonymus europaeus*
evening primrose, see *Oenothera*
evergreen maidenhair, see *Adiantum venustum*
everlasting, see *Anaphalis*

Fagus (beech) 64, 86, 87, 182
 sylvatica (European beech) 61, 151
fairy wallflower, see *Erysimum*
Fallopia wallichii (Himalayan knotweed) 66
false dragonhead, see *Physostegia*
false indigo, see *Baptisia australis*
false sago palm, see *Cycas revoluta*
false Solomon's seal, see *Smilacina racemosa*
Fargesia murielae (bamboo) 141
fat hen, see *Chenopodium*
Fatsia japonica (Japanese aralia) 63
feather grass, see *Stipa*
fennel, see *Foeniculum vulgare*
fescue, see *Festuca*
Festuca (fescue) 240
 glauca (blue ~) 14, 53, 118
 'Elijah Blue' 188
Ficus benjamina (weeping fig) 142
 carica (common fig) 82, 126, 163

fig, see *Ficus benjamina*
fig buttercup, see *Ranunculus ficaria*
filbert, see *Corylus avellana*
Filipendula rubra (Queen of the Prairie) 182
firethorn, see *Pyracantha*
flame flower, see *Phlox paniculata* 'Lavendelwolke'
flamingo plant, see *Anthurium*
flossflower, see *Ageratum*
flowering tobacco, see *Nicotiana* 'Domino'
foamflower, see *Tiarella cordifolia*
Foeniculum vulgare (fennel) 172
forget-me-not, see *Myosotis*
Forsythia suspensa (weeping forsythia) 126, 163
fountain grass, see *Pennisetum*
foxglove, see *Digitalis*
Fragaria vesca (strawberry) 151
fraser photinia, see *Photinia x fraseri* 'Red Robin'
French hybrid ceanothus, see *Ceanothus x delilianus* 'Gloire de Versailles'
French tamarisk, see *Tamarix gallica*
Fritillaria acmopetala (olive-flowered fritillary) 68
 meleagris (snake's-head ~, chequered lily, guinea-hen flower) 57
fritillary, see *Fritillaria*
Fumaria officinalis (fumitory) 175
fumitory, see *Fumaria officinalis*

Galanthus nivalis (snowdrop) 57, 63
goosefoot, see *Chrysanthemum*
Gaura lindheimeri 'Siskiyou Pink' (pink gaura or wand flower) 174
Genista (broom) 153
Geranium
 magnificum 66
 pratense 'Mrs Kendall Clark' (meadow cranesbill) 68
germander, see *Teucrium*
giant hogweed, see *Heracleum mantegazzianum*
giant rhubarb, see *Gunnera manicata*
Gillenia 182
Ginkgo biloba (maidenhair tree, Japanese or Chinese temple tree) 62, 245
Gladiolus (sword lily) 151
Gleditsia triacanthos (honeylocust) 122
globe artichoke, see *Cynara scolymus*
globe thistle, see *Echinops ritro*
gooseberry, see *Ribes uva-crispa*
goosefoot, see *Chenopodium*
gorse, see *Ulex europaeus*
grapevine, see *Vitis vinifera*
great masterwort, see *Astrantia* 'Claret'
guinea-hen flower, see *Fritillaria acmopetala meleagris*
Gunnera manicata (giant rhubarb) 71, 178

hairgrass, see *Deschampsia*
Hamamelis (witchhazel)
 mollis 'Pallida' (Chinese ~) 122, 164
 x *intermedia* 'Diane' 68
hawthorn, see *Crataegus monogyna*
hazel, see *Corylus avellana*
heartleaf ice plant, see *Aptenia*
heath pearlwort, see *Sagina subulata*
Hedera helix (ivy) 11, 13, 68, 122, 145, 149
 'Glacier' 90
Helianthemum (sun rose or rock rose) 163
 'Ben Heckla' 166
 'Wisley Primrose' 174
 nummularium 154
Helianthus (sunflower) 178, 251
Helictrotrichon (blue oat grass) 179
hellebore, see *Helleborus*
Helleborus (hellebore)
 torquatus 63
 x *orientalis* (lenten rose) 90
Hemerocallis lilioasphodelus (day lily) 141
Heracleum mantegazzianum (giant hogweed) 178, 248
Heuchera (coral bells) 240
Himalayan balsam, see *Impatiens glandulifera*
Himalayan birch, see *Betula utilis*
Himalayan knotweed, see *Fallopia wallichii*
Himalayan maidenhair, see *Adiantum venustum*
Hippophae rhamnoides (sea buckthorn) 154
Hippuris vulgaris (mare's tail) 93
holly, see *Ilex*
hollyhock, see *Alcea, Althea*
honeylocust, see *Gleditsia triacanthos*
honeysuckle, see *Lonicera*
hop, see *Humulus*
hornbeam, see *Carpinus betulus*
horse chestnut, see *Aesculus hippocastanum*
Hosta sieboldiana (elegans hosta or elegans plantain lily) 178
houseleek, see *Sempervivum*
Humulus japonicus (Japanese hop) 248
Hydrangea
 arborescens 'Annabelle' (smooth or wild ~) 181

 aspera 'Macrophylla' (rough-leaved ~) 181
Hypericum (St. John's wort)
 perforatum (perforate ~) 163

Ilex (holly) 145
 aquifolium 57, 63
 meserveae 'Blue Prince' 63
 x *meserveae* 248
Impatiens glandulifera (Indian or Himalayan balsam or touch-me-not) 177
Indian balsam, see *Impatiens glandulifera*
Ipomoea purpurea (morning glory) 248
Iresene brilliantissima 188
Iris 34, 153
 germanica 'Orange' (bearded ~) 179
 japonica (Japanese ~) 126, 127
 pseudacorus (yellow or flag ~) 66, 93, 167, 239
 sibirica (Siberian ~) 66, 239
 unguicularis (winter or Algerian ~) 185
ironweed, see *Vernonia*
ivy, see *Hedera helix*

Jacaranda brasiliana (palisander tree) 142
Japanese anemone, see *Anemone*
Japanese angelica tree, see *Aralia elata*
Japanese aralia, see *Fatsia japonica*
Japanese hops, see *Humulus japonicus*
Japanese maple, see *Acer palmatum*
Japanese mock orange, see *Pittosporum tobira*
Japanese nut tree, see *Gingko biloba*
Japanese pagoda tree, see *Sophora japonica*
Japanese rose, see *Kerria japonica*
Japanese shield fern, see *Dryopteris erythrosora*
Japanese temple tree, see *Ginkgo biloba*
jasmin, see *Jasminum*
Jasminum (jasmin)
 azoricum 142
 nudiflorum (winter ~) 123
 polyanthum (pink or winter ~) 142
Jerusalem sage, see *Phlomis*
joe pye weed, see *Eupatorium purpureum*
Judas tree, see *Cercis siliquastrum*
Juncus (rush) 167
 effusus (soft ~) 239
 inflexus (hard ~) 239
Juniperus virginiana 'Glauca' (silver eastern red cedar) 130

Kerria japonica (Japanese rose or kerria rose) 164
kerria rose, see *Kerria japonica*
King's flower, see *Eucomis bicolor*
King's spear, see *Asphodeline lutea*
kiwi fruit, see *Actinidia chinensis*
Knautia macedonica (crimson cushion or red pincushion flower) 154
Kniphofia (red hot poker)
 'Jenny Bloom' 154
 galpinii 179

lady's mantle, see *Alchemilla mollis*
lady's smock, see *Cardamine pratensis*
Lagerstroemia indica (crape myrtle) 113
lamb's ear, see *Stachys byzantina*
lamb's-quarters, see *Chenopodium*
larch, see *Larix*
Larix (larch)
 kaempferi 'Pendula' (Japanese ~) 123
 x *eurolepis* (European ~) 151
larkspur, see *Delphinium*
laurel, see *Laurus nobilis*
laurel tree, see *Laurus nobilis, Prunus laurocerasus*
Laurus nobilis (bay or laurel tree) 54, 112, 149
Lavandula (lavender) 58, 85, 153, 164, 167, 185
 angustifolia 167
 'Hidcote Blue' 166
 officinalis 61, 63
 spica 113
Lavatera cachemiriana (tree mallow) 182
lavender, see *Lavandula*
lavender cotton, see *Santolina*
laurustinus, see *Viburnum tinus*
lemon tree, see *Citrus limon*
lenten rose, see *Helleborus x orientalis*
leopard plant, see *Ligularia*
Leucanthemopsis alpina (Alpine moon daisy) 66
Leucanthemum vulgare, see also *Chrysantemum leucanthemum* (ox-eye daisy) 170
Leucojum aestivum (summer snowflake) 57, 68
lichen, see *Lichenes*
Lichenes (lichen) 127, 161
Ligularia (leopard plant)
 clivorum 178
 dentata 'Othello' 158
 przewalskii 141
Ligustrum (privet)

japonicum (Japanese ~) 175
　ovalifolium (California ~) 57
　vulgare 'Atrovirens' 51
Lilium (lily) 35, 178
　'Pirate' 179
　pyrenaicum (Pyrenean or Turk's cap ~) 90
　regale (regal ~) 17
lily, see *Alstroemeria, Lilium*
lily of the nile, see *Agapanthus*
lily of the valley, see *Convallaria majalis*
lime tree, see *Citrus limonum, Tilia platyphyllos*
linden tree, see *Tilia*
Linum perenne (pale-blue flax) 166
Lonicera (honeysuckle) 185
　henryi 52, 128
　nitida (box ~) 132, 133
　　'Baggesen's Gold' 243
　tellmanniana 165
loosestrife, see *Lythrum*
lords-and-ladies, see *Arum maculatum*
love-in-a-mist, see *Nigella damascena*
lucerne, see *Medicago sativa*
Lythrum (loosestrife)
　salicaria 167
　　'Blush' 182

Macleaya cordata (plume poppy) 69, 121, 178
Magnolia 178
　denudata 181
　kobus 245, 248
　x *soulangeana* 248
maidenhair tree, see *Ginkgo biloba*
maidenhair vine, see *Muehlenbeckia complexa*
Malus
　domestica (apple tree) 50, 57, 61, 93, 163, 204
　sylvestris (crab apple tree) 85
mandarine tree, see *Citrus reticulata*
maple, see *Acer*
marsh marigold, see *Caltha palustris*
mare's tail, see *Hippuris vulgaris*
marigold, see *Tagetes patula*
marjoram, see *Origanum*
marsh marigold, see *Caltha palustris*
Matilija poppy, see *Romneya coulteri*
meadow cranesbill, see *Geranium pratense* 'Mrs Kendall Clark'
Medicago sativa (lucerne, alfalfa) 200
Mentha aquatica (water mint) 241
Mentha requienii (Corsican mint) 154
Menyanthes trifoliata (buck bean or bog bean) 239
Mexican orange, see *Choisya ternata*
milk barrel, see *Euphorbia*
milkmaid, see *Cardamine pratensis*
mind-your-own-business, see *Soleirolia soleirolii*
mint, see *Mentha*
Miscanthus sinensis (Chinese silvergrass) 52
　'Gracillimus' 121
mock orange, see *Choisya ternata*
mock privet, see *Phillyrea*
Molinia caerulea (purple moorgrass) 240
Monarda (bergamot plant) 182
montbretia, see *Crocosmia x crocosmiiflora*
morning glory, see *Ipomoea purpurea*
Morus (mulberry tree) 164
　platanifolia (mulberry umbrella) 81
mountain ash, see *Sorbus*
Muehlenbeckia complexa (maidenhair vine) 181
mulberry tree, see *Morus*
mulberry umbrella, see *Morus platanifolia*
mullein, see *Verbascum*
Myosotis (forget-me-not) 233
　scorpioides (water ~) 177, 239
myrtle, see *Myrtus communis*
Myrtus communis (myrtle) 58, 185

Nandina domestica (heavenly bamboo) 122
Narcissus pseudonarcissus (daffodil) 57
New Zealand flax, see *Phormium tenax*
Nicotiana 'Domino' (flowering tobacco) 189
Nigella damascena (love-in-a-mist) 233
Nymphaea (water lily) 106, 110, 115, 136, 167, 186, 191, 239
　'James Brydon' 130, 131

oak, see *Quercus*
obedient plant, see *Physostegia*
Oenothera (evening primrose) 176, 177
　biennis 221
Olea europaea (olive tree) 31, 110, 145, 148, 149, 153, 193, 206
olive tree, see *Olea europaea*
olive-flowered fritillary, see *Fritillaria acmopetala*
Onopordon (thistle)
　acanthium (cotton or woolly ~) 71, 178
　arabicum (Arabian ~) 71, 178
Ophiopogon planiscapus 'Niger' (purple-black grass) 83
orange tree, see *Citrus sinensis*

orchid, see *Orchidaceae*
Orchidaceae (orchid) 186
oregano, see *Origanum*
Origanum (marjoram or oregano) 59
osier, see *Salix viminalis*
Osmunda regalis (royal fern) 158, 178
ox-eye daisy, see *Chrysanthemum leucanthemum, Leucanthemum vulgare*

Paeonia lactiflora (white peony) 35
palisander tree, see *Jacaranda brasiliana*
palm, see *Cycas*
Panicum virgatum (switchgrass) 52
Papaver (poppy) 157, 179
　rhoeas 28, 239
Parrotia persica (Persian ironwood) 163
Parthenocissus (Virginia creeper) 122, 141
　quinquefolia 63
　tricuspidata 'Veitchii' (Boston ivy) 93, 120, 166
pear tree, see *Pyrus*
pearl everlasting, see *Anaphalis*
Pelargonium 131
Peltiphyllum 178
　peltata (umbrella plant) 71
Pennisetum (fountain grass)
　alopecuroides 52
　clandestinum 118
peony, see *Paeonia lactiflora*
perennial flax, see *Linum perenne*
Perovskia atriplicifolia (Russian sage) 153
　'Blue Spire' 20, 174
Persian ironwood, see *Parrotia persica*
Petasites (sweet coltsfoot)
　japonicus 'Giganteus' (Japanese ~) 66
Phaseolus vulgaris (common runner bean) 248
Phillyrea (mock privet) 163
Philodendron 186
Phlomis (Jerusalem sage)
　fruticosa 154
　tuberosa 'Amazone' 174
Phlox paniculata 'Lavendelwolke' (flame flower) 182
Phoenix (date palm)
　canariensis (Canary Island ~) 82, 118, 142
　dactylifera 142
Phormium tenax (New Zealand flax) 181
Photinia x fraseri 'Red Robin' (red top photinia or fraser photinia) 83
Phragmites australis (reed) 158, 239
Phyllostachys (bamboo)
　aurea (golden ~) 54, 145, 149
　aureosulcata 248
　　'Spectabilis' 70
　bambusoides 'Castillonis' 200
　edulis 200
　nidularia 248
　nigra (black ~) 90, 200
Physostegia (false dragonhead or obedient plant) 66
Picea (spruce) 176
pineapple lily, see *Eucomis bicolor*
pine tree, see *Pinus*
pinks, see *Dianthus*
Pinus (pine tree) 73, 91, 99, 107, 136, 165
　nigra nigra (Austrian ~) 245
　pinea (stone ~) 81, 117, 118
　ponderosa (western yellow ~) 239
　sylvestris (Scotch or Scots ~) 165, 167
pipevine, see *Aristolochia macrophylla*
Pittosporum tobira (Japanese mock orange) 153
plane tree, see *Platanus x acerifolia*
Plantago (plantain) 170
plantain, see *Plantago*
Platanus x acerifolia (plane tree) 64, 81
Pleioblastus variegatus (bamboo) 70
plum tree, see *Prunus domestica*
plume poppy, see *Macleaya cordata*
Polygonatum multiflorum (Solomon's seal) 69
Polygonum baldschuanicum (Russian vine) 123, 181
Polypodium vulgare (polybody) 181
polybody, see *Polypodium vulgare*
Polystichum setiferum (soft shield fern) 90
pomegranate tree, see *Punica granatum*
poplar, see *Populus*
poppy, see *Papaver*
Populus (poplar or cottonwood) 176, 222, 224
　nigra 'Italica' (black or Lombardy ~) 112, 132
　x *canescens* 'Marilandica' (black ~) 158
Portugal laurel, see *Prunus lusitanica*
Potentilla fruticosa 'Red Ace' (Red Ace bush cinquefoil) 166
pot marigold, see *Calendula officinalis* 'Fiesta Gitana'
primerose, see *primula*
Primula (primrose)
　japonica 'Alba' (Japanese ~) 63
　veris (cowslip) 99
privet, see *Ligustrum*

Prunella vulgaris (self-heal) 157
Prunus 57
　armeniaca (apricot tree) 81
　avium (wild cherry) 57, 151, 204
　domestica (plum tree) 57, 151, 204
　dulcis (almond tree) 153
　laurocerasus (laurel tree) 55
　lusitanica (Portugal laurel) 94
　padus (bird cherry) 57
　sargentii (sargent cherry) 134, 176
　spinosa (blackthorn) 154
Punica granatum (pomegranate tree) 163, 175
purple moorgrass, see *Molinia caerulea*
purple-black grass, see *Ophiopogon planiscapus* 'Niger'
Pyracantha (firethorn) 165
Pyrus (pear tree) 158, 204
　communis 57, 62
　salicifolia 'Pendula' (weeping willowleaf ~) 179

Queen of the Prairie, see *Filipendula rubra*
Quercus (oak) 99, 153, 206
　coccinea (scarlet ~) 163
　ilex (holm or evergreen ~) 55, 81, 117, 118, 149, 193, 206
　robur (English or pedunculate ~) 57, 58, 118, 149, 150, 163
　suber (cork ~) 81, 118, 206
quince tree, see *Cydonia*

ragwort, see *Senecio*
Ranunculus ficaria (fig buttercup or lesser celandine) 63, 177
raspberry, see *Rubus idaeus*
Red Ace bush cinquefoil, see *Potentilla fruticosa* 'Red Ace'
red barrenwort, see *Epimedium x rubrum*
red currant, see *Ribes rubrum*
red hot poker, see *Kniphofia*
red pincushion flower, see *Knautia macedonia*
red top photinia, see *Photinia x fraseri* 'Red Robin'
reed, see *Phragmites australis*
reed grass, see *Calamagrostris*
Rhinanthus minor (little yellow-rattle) 170
Rhododendron (rhododendron, azalea) 165, 179, 193
　'Palestrina' (azalea) 123
　catawbiense 167
　ferrugineum 167
　impeditum (azalea or dwarf azalea) 167
　luteum (Pontic or yellow azalea) 167
　repens 167
Ribes (currant) 150, 151
　nigrum (black ~) 151
　rubrum (red ~) 151
　uva-crispa (gooseberry) 151
Ricinus communis (castor bean or castor oil plant) 178
rockcress, see *Arabis ferdinandi-coburgii*
rock rose, see *Cistus, Helianthemum*
Rodgersia 182
Romneya coulteri (Californian poppy) 154
Rosa (rose) 35, 61, 149
　'Aloha' 52
　'Cardinal de Richelieu' 59
　'De Rescht' 59
　'Dublin Bay' 69
　'Félicité et Perpétue' 63
　'Francis E. Lester' 52
　'Graham Thomas' 59
　'Iceberg' 185
　'Kew Rambler' 185
　'Madame Alfred Carrière' 52
　'Madame Pierre Oger' 59
　'Mermaid' 52, 54, 55, 185
　'New Dawn' 52
　'Phyllis Bide' 52
　bansiae 'Lutea' 185
　canina (dog rose, wild rose) 175
　centifolia 'Muscosa' 59
　chinesis 'Mutabilis' (butterfly rose) 179
　gallica
　　officinalis 'Versicolor' 59
　rugosa
　　'Frau Dagmar Hastrup' 163
　　'Scabrosa' 163
　　'Frühlingsgold' 163
rose, see *Rosa*
Rosmarinus (rosemary) 59, 153, 163, 164, 185
　officinalis 63, 113
rosemary, see *Rosmarinus*
rowan ash, see *Sorbus*
royal fern, see *Osmunda regalis*
Rubus idaeus (raspberry) 151
Rudbeckia 182
　hirta 'Marmalade' 189
rue, see *Ruta graveolens, Thalictrum*
rush, see *Juncus*
Russian sage, see *Perovskia atriplicifolia*
Russian olive, see *Elaeagnus angustifolia*

Russian vine, see *Polygonum baldschuanicum*
Ruta graveolens (rue) 157

sage, see *salvia*
sago cycas, see *Cycas revoluta*
Sagina subulata (Corsican or heath pearlwort) 77, 78
 'Aurea' 188
Sagittaria sagittifolia (arrowhead) 167
sago palm, see *Cycas circinalis*
Saharan pink, see *Stachys monnieri*
Salix (willow) 61, 126
 alba (white ~) 151, 239
 'Britzensis' 154
 'Sericea' (silver ~) 151
 'Tristis' (weeping ~) 93
 caprea (goat ~) 57, 58, 154
 chermesina 154
 daphnoides (violet ~) 150
 'Violet Willow' (pussy willow) 154
 elaeagnus angustifolia 151
 purpurea 'Nana' 151, 179
 repens (creeping ~) 179
 viminalis (osier) 151
Salvia (sage) 153, 157
 argentea (silver ~) 179, 185
 nemerosa 63
 sclarea (clary or muscatel ~) 71, 178
Sambucus (elder)
 nigra (black ~) 178
 'Guincho Purple' 154
Sanguisorba (burnet)
 armena 66
 minor (salad or small ~) 14, 53
 officinalis (great ~) 182
Santolina (lavender cotton) 153, 157
 chamaecyparissus 185
 neopolitana 179
Saponaria (soapwort)
 ocymoides 14, 53
 x *lempergii* 'Max Frei' 183
sargent cherry, see *Prunus sargentii*
Sasa palmata (bamboo) 70, 248
 tesselcta 70
saxifrage, see *Saxifraga*
Saxifraga (saxifrage) 126, 127
Scilla campanulata (Spanish bluebell or wood hyacinth) 59
Scutellaria incana (skullcap) 66
switchgrass, see *Panicum virgatum*
sea buckthorn, see *Hippophae rhamnoides*
sea holly, see *Eryngium*
seakale, see *Crambe maritima*
seathrift, see *Armeria maritima*
sedge, see *Carex*
Sedum (stonecrop) 157, 188
 acre (common or biting ~) 53
 album (white ~) 53
 pachyclados 188
 populifolium 174
 rupestre (reflexed ~) 53
 spathulifolium 'Cape Blanco' 188
 telephium 'Matrona' (autumn ~) 174
self-heal, see *Prunella vulgaris*
Semiarundinaria fastuosa (narihira or temple bamboo) 90
Sempervivum (houseleek) 63, 185
 calcareum 188
Senecio (ragwort)
 cineraria 'White Diamond' (dusty miller) 170
 viravira 188
 vulgare 175
serviceberry, see *Amelanchier*
shepherd's purse, see *Capsella bursa-pastoris*
shield fern, see *Dryopteris erythrosora, Polystichum setiferum*
shrubby germander, see *Teucrium fruticans*
silver spear, see *Astelia chatamica*
silverbush, see *Convolvulus cneorum*
skullcap, see *Scutellaria incana*
sloe, see *Prunus spinosa*
Smilacina racemosa (false Solomon's seal) 63
snake's-head fritillary, see *Fritillaria acmopetala meleagris*
snapdragon, see *Antirrhinum* 'Sprite'
snowball, see *Viburnum opulus*
snowberry, see *Symphoricarpos albus*
snowdrop, see *Galanthus nivalis*
soapwort, see *Saponaria*
soft shield fern, see *Polystichum setiferum*
soft tree fern, see *Dicksonia antarctica*
Soleirolia soleirolii (mind-your-own-business) 90
Solomon's seal, see *Polygonatum multiflorum*
Sonchus vulgare (sowthistle) 175
Sophora japonica (Japanese pagoda tree) 63
 'Pendula' 122
Sorbus (rowan or mountain ash) 99
 aucuparia 225
 intermedia (Swedish whitebeam) 151

sour orange tree, see *Citrus aurantium*
sowthistle, see *Sonchus vulgare*
Spanish broom, see *Spartium junceum*
Spanish dagger, see *Yucca gloriosa*
Spanish bluebell, see *Scilla campanulata*
Spartium junceum (Spanish broom) 163
spearwort, see *Ranunculus flammula*
spear grass, see *Stipa calamagrostis*
speedwell, see *Veronica*
Spiraea (spirea) 127, 175
spirea, see *Spiraea*
spruce, see *Picea*
spurge, see *Euphorbia*
Stachys (betony)
 byzantina (wooly ~ or lamb's ears) 54
 'Big Ears' (giant lamb's ears) 182
 monnieri (common ~ or Saharan pink) 182
staggerweed, see *Delphinium*
star jasmin, see *Trachelospermum jasminoides*
Stipa (feather grass)
 arundinacea 154
 calamagrostis (spear grass) 20
 tenuissima (Mexican ~) 44, 172, 174, 240
stonecrop, see *Sedum*
Stratiotes aloides (water soldier) 93
strawberry, see *Fragaria vesca*
strawberry tree, see *Arbutus unedo*
stream orchid, see *Epipactis gigantea*
St. John's bread tree, see *Ceratonia siliqua*
St. John's wort, see *Hypericum*
summer snowflake, see *Leucojum aestivum*
sunflower, see *Helianthus*
sunrose, see *Helianthemum*
Swedish whitebeam, see *Sorbus intermedia*
sweet chestnut, see *Castanea sativa*
sweet coltsfoot, see *Petasites*
Sweet William, see *Dianthus barbatus*
sword lily, see *Gladiolus*
Symphoricarpos albus (snowberry) 57
Symphytum 'Hidcote Blue' (comfrey) 66, 157

Tagetes patula (French marigold) 189
tamarisk, see *Tamarix*
Tamarix gallica (French tamarisk) 175
Tanacetum vulgare (tansy) 177
tansy, see *Tanacetum vulgare*
Taraxacum officinale (dandelion) 179, 224
Tasmanian fern, see *Dicksonia antarctica*
Taxodium distichum (bald cypress) 53
Taxus (yew tree) 64, 66, 165, 216, 221, 233
 baccata 66, 94, 118, 140, 179
Teucrium fruticans (tree germander) 118, 185
Thalictrum (rue) 66
thistle, see *Cirsium, Onopordon*
Thuja occidentalis (white cedar) 151
Thunbergia alata (black-eyed susan) 248
thyme, see *Thymus*
Thymus (thyme) 154, 167
Tiarella cordifolia (foamflower) 122
Tilia (linden or lime tree) 64
 argentea or *tomentosa* (silver ~) 163
 platyphyllos (large-leafed ~) 245
touch-me-not, see *Impatiens glandulifera*
Trachelospermum jasminoides (star or confederate jasmin) 54, 55, 62, 149
Trachycarpus fortunei (Chinese windmill palm) 170
tree heath, see *Erica arborea* 'Alpina'
tree mallow, see *Lavatera cachemiriana*
Trifolium (clover) 29, 179
 hybridum (alsike ~) 177
 pratense (creeping ~) 170
 repens (white ~) 154
tulip, see *Tulipa*
Tulipa (tulip) 31, 61
tussock grass, see *Deschampsia cespitosa* 'Bronzeschleier'
Typha (cattail) 167
 latifolia (broadleaf ~ or bullrush) 158, 239

Ulex europaeus (gorse) 155
Ulmus glabra 'Pendula' (weeping Scotch elm) 96
umbrella plant, see *Darmera, Peltiphyllum*
upright verbena, see *Verbena bonariensis*

valerian, see *Valeriana officinalis*
Valeriana officinalis (valerian) 157
Verbascum (mullein) 44, 167, 172
 bombyciferum (giant silver ~) 179
Verbena bonariensis (verbena-on-a-stick or upright ~) 154, 157, 240
verbena-on-a-stick, see *Verbena bonariensis*
Vernonia (ironweed) 66, 182
Veronica (speedwell)
 chamaedrys (germander ~) 176
 virginica (culver's root) 66

Viburnum 165
 opulus (snowball) 165
 tinus (laurustinus) 164, 175
vine, see *Vitis*
Virginia creeper, see *Parthenocissus*
Vitis (vine)
 'Brant' 52
 vinifera (grapevine) 149

wand flower, see *Gaura lindheimeri* 'Siskiyou Pink'
water lily, see *Nymphaea*
water mint, see *Mentha aquatica*
water soldier, see *Stratiotes aloides*
weeping fig, see *Ficus benjamina*
weeping forsythia, see *Forsythia suspensa*
weeping Scotch elm, see *Ulmus glabra* 'Pendula'
weeping willow, see *Salix alba* 'Tristis'
white cedar, see *Thuja occidentalis*
white coneflower, see *Echinacea purpurea* 'White Swan'
white fireweed, see *epilobium angustifolium* 'Album'
white rocket, see *Diplotaxis erucoides*
white willow, see *Salix alba*
whitebeam, see *Sorbus*
wild cherry, see *Prunus avium*
wild rose, see *Rosa canina*
willow, see *Salix*
wintersweet, see *Chimonanthus praecox*
wisteria 11, 141
 floribunda (Japanese ~)
 'Longissima Alba' 166
 'Macrobotrys' 123
 sinensis (Chinese ~) 54, 55, 62, 84, 85, 128
 'Alba' 84, 85, 123
witchhazel, see *Hamamelis*
wolfsbane, see *Aconitum wilsonii*
wood hyacinth, see *Scilla campanulata*
wormwood, see *Artemisia*

Xanthium strumarium (cocklebur) 175

yarrow, see *Achillea*
yellow asphodel, see *Asphodeline lutea*
yellow-rattle, see *Rhinanthus*
yew tree, see *Taxus*
Yucca 157
 gloriosa (Spanish dagger) 44, 172
 rostrata (beaked or big bend ~) 142

Zinnia angustifolia (narrowleaf zinnia)
 'Star Orange' 189
 'Star White' 189

Index

Aalto, Alvar 29, 33, 167
Aasen, Bjarne 45
Abakanowicz, Magdalena 193, 195, 196
Ackroyd, Heather 49, 125, 226
Agati, Antonella 196
Agence Domino 134
Agence In Situ 38
Agence TER 134
Aizpuriete, Amanda 233
Ajgi, Gennadij 233
Albers, Philipp 120-121
Alberti, Leon Battista 117
Alfonso XIII 33
Altherr, Jürg 44-45
Ambasz, Emilio 37, 105, 241
Ammann, Gustav 33, 34
Anastassiades, Michael 247
Andersen, Jeppe Aagaard 47
Anderson, Laurie 232
Andersson, Stig L. 47, 150-151
Andersson, Sven-Ingvar 47, 60-61
Andersson, Thorbjörn 44, 98-99
Andre, Carl 214
Andrew, John 231
Antononio, Marco 12
Anzevui, J.M. 143
Archimedes 219
Arp, Jean 193
Arriola, Andreu 41, 113
Asplund, Gunnar 32, 33, 95
Atelier Kempe Thill 79-80
Attiani, Gianna 12
Auböck, Maria 39, 92-93
Aubort Raderschall, Sibylle 43, 77, 120-121, 166
Aulenti, Gae 41, 111
Auricoste, Isabelle 14
Ausilio, Lucia 145
Aycock, Alice 193

Baines, Bridget 44
Baljon, Lodewijk 13, 43, 50, 70
Balsari Berrone, Elena 163-164
Banfi, Belgiojoso, Peressutti & Rogers 40
Banfi, Gianluigi 37
Barba, Rosa 42
Barragán, Luis 37, 139
Batlle, Enric 42
Baumgarten, Lothar 55, 56, 127
Bava, Henri 134
Becquillon, Céline 249
Belgiojoso, Lodovico 37
Benet, Jean-Pierre 52
Berger, Patrick 178
Bergne, Theresa 214, 226
Bernini, Gianlorenzo 203
Bettum, Ole 45
Bihr-de Salis, Jane 68
Bill, Max 193
Billington, Jill 216
Blaisse, Petra 73
Blanc, Patrick 125-127, 172, 241
Blom, Holger 33
Boeri, Cini 163
Bohley, Anselm 165
Bonnin, Alexandra 22
Boquillon, Céline 249
Bortoluzzi, Klaus 249
Bossé, Laurence 246
Botero, Fernando 41, 211
Botta, Mario 40
Bowles, Edward A. 94
Bowles and Wyer Landscape Architects 94
Boyle, Richard, Earl of Burlington 174
Bradley-Hole, Christopher 43, 237, 240
Braque, Georges 31
Brett, Julia 13
Bridgeman, Charles 213
Brookes, John 37
Brougher, Kerry 226
Brown, Lancelot 'Capability' 17, 56, 148, 252
Brunier, Yves 14
Buatois, Jean-Nöel 197, 198
Bulaitis, Bonita 240
Bulaitis, Susan 240
Bund Deutscher Landschaftsarchitekten 249
Burckhardt, Lucius 246
Bureau B+B 42
Buren, Daniel 180
Bürgi, Paolo 39, 132

Buro B+B 43
Buro Mien Ruys 33-34
buro voor vrije ruimte 43, 51
Büro Kiefer 43
Büro Sprenger 251
Burle Marx, Roberto 37, 186
Burro, Alberto 193

Cadosch, Pascal 248
Caldeira Cabral, Francisco 42
Calder, Alexander 35, 193
Campioni, Giuliana 41
Cantarell, Jordi 175
Capecci, Roberto 12
Cardiff, Janet 246
Caruncho, Fernando 42, 54-55, 148-149, 241
Casasco, Ermanno, 25, 142, 191
Cejka, Andrea 39
Celestini, Gianni 246
Chagall, Marc 101
Chatto, Andrew 173
Chatto, Beth 43, 44, 172, 173-174
Chemetoff, Alexandre 38, 180
Chermayeff, Serge 35
Christensen, Inger 233
Christo 224
Christov-Bakargiev, Carolyn 246
Church, Thomas 14, 36, 73
Clément, Gilles 38, 71, 177-180, 248
Coen, Lorette 247
Colafranceschi, Daniela 246
Cominas, Manuel 42
Colvin, Brenda 37
Confucius 147
Cooper, Paul 11, 19, 74-75, 76
Corajoud, Michel 38
Cramer, Ernst 33, 37, 39
Crowe, Sylvia 37
Curami Balsari, Chiara 163-164

Dalnoky, Christine 38, 132, 133, 241
De Belder(-Kovacic), Jelena 42
de la Renta, Oscar 188
De Maria, Walter 19, 37, 214
de Meuron, Pierre 40
de Noailles, Charles and Marie-Laure 31
de Rothschild, Baron Ferdinand 188
de Saint Phalle, Niki 19, 205-206
Detaeye, Jean-Pierre 236
de Vésian, Nicole 183, 185-186
de Visser, Jaco 158
Delmulle, Frank 65
Deroose, Paul 140, 222
Descombes, Georges 40
Desvigne, Michel 38, 132, 133, 241
Deville, N. 134
Devriendt, Eli 57-58
Dezallier d'Argenville, Antoine Josèphe 56
Dhont, Erik 43, 62-63
Dion, Mark 204
Dobbels, Griet 214
Donhauser, Michael 233
dos Santos Cabral, Luis Manuel 42
Douglas, Anna 233
Drew, Judy and David 173, 241
DS landscape architects 43
du Gard Pasley, Anthony 37
Dujardin, Denis 65-66, 67

Eckbo, Garrett 14, 35, 36, 39, 45, 73
Eigenheer, Samuel 208-209
Ekman, Stina 99
Engleback, Luke 79, 80
Esteban Penelas, José Luis 31
Esteras Matín, Emilio 31

Fabro, Luciano 193
Farjadi, Sima and Homa 106
FARJADI FARJADI ARCHITECTS 106
FAT (Fashion, Architecture, Taste) 247
Febrey, Tina-Louise 242
Ferrara, Guido 41
FFNS Architects 98
Field Day 74
Figueras, Bet 42, 80, 81-82, 117
Finlay, Ian Hamilton 18, 19, 193, 229, 231
Fiol, Carmen 42, 113
Fish, Margery 36

Foerster, Karl 33, 182
Forestier, Jean-Claude Nicolas 33, 41
François, Edouard 131
Frazer, James 242
Freixes, Dani 42
Friberg, Per 40, 44, 45
Frostenson, Katarina 233
Fuksas, Massimiliano 41
Fuller, Richard Buckminster 103

Gabriel, Suzanne 17
Galí, Beth 42
Galí, Teresa 42, 175-177
Garaudet, Roland 197
Gaudí, Antoni 30
Gehry, Frank 169
Geoffroy-Dechaume, Guillaume 71
Gerz, Jochen 197, 198
Geuze, Adriaan 43, 130
Gillatt, Mosedale 247
Girot, Christophe 40
Glemme, Erik 33
Golby, Rupert 44
Goldsworthy, Andy 20, 224
Gora, Monika 45
Gori, Giuliano 193
Gormley, Antony 226
Goude, Jean-Paul 122
Grimshaw and Partners Architects 103
Gropius, Walter 28, 29, 35, 37, 40
Gross. Max. Landscape Architects 44
Guévrékian, Gabriel 31, 236
Gustafson, Kathryn 21, 40, 193

Hachtmann + Pütz Architekten 128
Haechler, Peter 84
Häfner/Jiménez Büro für Landschaftsarchitektur 43
Hager, Guido 40, 59, 189
Halprin, Lawrence 39, 45
Hamburger, Michael 233
Hammerbacher, Herta 33
Hansen, Richard 43
Hargreaves, George 47
Harvey, Dan 49, 125, 226
Heatherwick, Thomas 247
Heizer, Michael 37, 214
Henningsen, Jens 249
Henrich, Jordi 41
Hepworth, Barbara 37, 252
Hermening, Axel 235
Hermelin, Sven 33
Herlin, Philippe 235
Hero of Alexander 50
Herzog, Jacques 40
Hijink, Ben 11
Hills, Lawrence 239
Hoare, Henry 56
Hoare, Richard Colt 56
Hobhouse, Penelope 43
Hodgson, Janet 233
Hoessler, Michel 134
Hollein, Hans 39
Holscher, Vibeke 47, 193
Holt, Nancy 37, 214
Homer 49
Honegger, Gottfried 120
Hooftman, Eelco 44
Hotz, Theo 77
Howarth, Penny 74
Høyer, Steen 47
Hubbard, John 188
Huigens, Els 210
Hulterström, Kristina 17
Hunt, Barbara 216

Idoux, Alain David 147, 153
Ingold, Res 200
Inside Outside 73
Itten, Johannes 28, 33

Jäckel, Stefan 43
Jalbert, Emmanuel 38
Jardini, Gabriele 213, 224, 225
Jarman, Derek 157
Jeanne-Claude 224
Jeanneret, Charles-Edouard, see Le Corbusier
Jekyll, Gertrude 28, 34-35, 43, 182
Jellicoe, Geoffrey 34, 136, 186

Jellicoe, Susan 34
Jencks, Charles 19, 220-221
Jetelova, Magdalena 223
Jodry, Jean-François 178
Jubert, Luís 175
Jud, Daniel 235

Kandinsky, Vassily 28
Kárász, János 39
Kassler, Elizabeth 37
Kaufmann, Edgar and Liliane 104
Kempe, André 79
Kent, William 56, 148
Keswick, Maggie 220-221
Kienast, Dieter 39, 232
Kienast, Erika 232
Kiley, Dan 14, 35, 39, 45, 73
King, Judith 14
Kingdon-Ward, Frank 34
Klee, Paul 28
Kling, Jean 14, 52-53
Kling, Thomas 233
Knight, Stephanie 13
Koch, Wilhelm 202
Koolhaas, Rem 73
Koon, Jeff 169
Kovats, Tania 228, 247
Kratochwill, Sepp 39
Krenz, Sylvia 233
Kroll, Lucien 43

Labs-Ehlert, Brigitte 233
Laib, Wolfgang 226
Lampaert, Luc 236
Landecy, J.M. 134
Lange, Willy 33
Lassus, Bernard 197, 236
Latitude Nord 38
Latz, Peter 43, 59, 241, 252
Latz, Anneliese 59
Latz, Tilman 59
Lawson, Andrew and Briony 154
Le Corbusier 27, 29, 31, 33, 37, 40, 139, 186
Le Nôtre, André 17, 59, 71
Léger, Fernand 236
Legrain, Pierre-Emile 31
Leitner, Bernard 180
Leonardi, Cesare 41
Levin, Martina 235
Levin, Nicolaï 235
Lewerentz, Sigurd 32, 33, 95
Lewis, Peter and Pam 170
LeWitt, Sol 193
Lichtenstein, Roy 41
Lipchitz, Jacques 31
Littlewood, Clare 160-161
Lloyd, Christopher 43, 182
Louis XIV 51, 71
Lombardi, Daniele 196
Long, Richard 20, 37, 193, 214, 223-224, 228
López Hernández, Francisco 41
Lorrain, Claude 18, 56, 231
Louafi, Kamel 43, 244-245
Lutyens, Edwin 28, 34, 182

Maas, Winy 43, 244
Macklin, Jean 34
Mallet-Stevens, Robert 32, 236
Mansau, Serge 243
Marchand, Philippe 193
Maria, Veronique 216-217
Martel, Jean and Joël 32, 236
Martínez Lapeña, José Antonio 41, 42, 107
Matisse, Henri 252
Mattern, Hermann 33
McGarth, Raymon 35
McHarg, Ian 37, 45
Mecanoo 43
Michelangelo 90
Micke, Tobias 43
Mies van der Rohe, Ludwig 29, 40, 244
Milles, Carl 203
Miralles, Enric 42, 101
Miranda, Vincente 42
Miró, Joan 41
Miss, Mary 214
Mitterrand, François 136
Miyawaki, Aiko 195

Monck, Sir Charles 248
Mondrian, Piet 28, 165
Monet, Claude 226
Mongini, Daniela 12
Monsigny, Luc 235
Moore, Henry 35, 37, 47, 193
Morris, Robert 193, 194-195
Morris, William 28
Motta, Liliana 242
Muller, Camille 51
MVRDV 43, 244

Neuenschwander, Eduard 39, 167
Newmark, Nicole 59, 189
Nicholson, Ben 37, 136
Nicke, Andrea 249
Nicolas Grimshaw and Partners 103
Niez, Philippe 89-90
Nils-Udo 214
Noailles, Charles and Marie-Laure de 31, 33
Nobel, Alfred 98
Noguchi, Isamu 37, 39
Nooteboom Cees 233
Nordfjell, Ulf 17, 253
Nordström, Thomas 253
Norgaard, Lea 47, 193
Nouvel, Jean 55, 56
Nyeland Brandt, Gudmund 33

Obrist, Hans Ulrich 246
Octo Design 247
Office of Metropolitan Architecture (OMA) 14
Olmstead, Frederick Law 27
Oneto, Gilberto 41
Opie, Julian 246
Oskarsson, Annika 253
Ost, Daniël 170
Osty, Jacqueline 38
Oswald, Alice 18, 228-229
Oudolf, Piet 43, 182-183

Page, Russell 34
Palladio, Andrea 81
Pallejà, Xavier 107
Palmer, Ross 73, 181
Paul, Anthony 43, 198
Pearson, Dan 43, 154
Pechère, René 43
Penone, Giuseppe 193, 226
Pepper, Beverly 42, 112-113, 196, 197
Peressutti, Enrico 37
Perrault, Dominique 136
Peter Latz & Partner Landscape Architects 252
Philippe, Olivier 134
Piano, Renzo 132, 133
Picasso, Pablo 31, 252
Pichler, Walter 39
Pierelli, Attilio 22, 202
Pigeat, Jean-Paul 40, 241
Pistoletto, Michelangelo 193
Pizzetti, Ippolito 41
Pliny the Younger 50
Pøhlsgaard, Henrik 176-177
Poirier, Anne 193
Poirier, Richard 193
Poll, Sonja 87
Pomodoro, Arnaldo 142, 191
Pope, Alexander 174, 231
Porcinai, Pietro 41, 103, 109-110
Pösinger, Franz 208-209
Poulsen, Dorthe Mandrup 151
Poussin, Nicolas 18, 56-57, 231-232
Pouzol, Marc 249
Pritchard, Kate 191
Provost, Alain 38, 178

Quinn, Marc 226
Quoniam, Laure 122

Racine, Bruno 246
Raderschall, Roland 39, 77, 120-121, 166
Raderschall, Sibylle Aubort 39, 77, 166
Raderschall Landschaftsarchitekten 77, 120, 166
Rainer, Roland 40, 166
Renan, Madeleine 180
Robinson, Willam 34
Rodin, Auguste 203
Rodor, ORZ & Partners 11
Rogers, Ernesto Nathan 37
Roig, Joan 42, 176
Roig, Salvador 107
Romano, Giulio 62
Rose, James 35, 39, 45

Roth, Alfred 33
Rothschild, Miriam 239
Rotzler, Stefan 39, 252
Rousseau, Henri 127
Rückriem, Ulrich 120
Ruisanchez, Manuel 41
Russo, Maurizio 19, 90, 91-92, 142, 144-145
Ruys, Mien 33, 34

Sacconi, Annamaria 41
Sackville-West, Vita 182
Sælen, Arne 45
Saint-Just 231
Sala, Giovanni 41
Sala, Maurizio 112
Samakh, Érik 180, 197, 198
Santacana, Eugènia 175
Sarap-Quist, Tiina 45
Sasaki, Hideo 47
Sattel, Otmar 252
Saurer, Luzius 43, 141
Scaravella, Anna Maria 112-113
Scarpa, Carlo 41, 103
Scheurer, Jean 248
Schmid, René 248
Scholma, Anet 33
Schwartz, Martha 43-45, 83
Serra, Richard 140, 193, 214
Sgard, Martine 17
Shenstone, William 231
Shepheard, Peter 36
Silvestrin, Claudio 247
Simons, Tom 45
Singer, Michael 193
Sini, Rafaella 12
SITE 37
Smithson, Robert 19, 37, 140, 214, 223, 228
Soeters, Sjoerd 70
Sørensen, Carl Theodor 33, 47, 86-88
Soukop, Willi 35
Sousa da Camara, Manuel 42
Spagnulo, Pino 25
Sprenger, Daniel 249
Staals, Marlène 50
Staccioli, Mauro 193
Stagi, Franca 44
Steele, Fletcher 32
Steinitz, Carl 47
Stella, Frank 111
ST raum a. 43
Stoddard, Alexander 231
Studio AP & G 144-145
Studio Auböck & Kárász 92
Swanson, Neil 44

Tarantino, Michael 226
Tarkovsky, Andrej 144
Tarrasó, Olga 41
Tawada, Yoko 233
Terzic, Mario 39
Teshigahara, Hiroshi 241
Thalinson, Nina 236
Thater, Diana 226
Thill, Oliver 79
Thomas, Simon 219
Tibbalds TM2 25
Tinguely, Jean 205
Tischer, Stefan 43, 251-52
Toll, Julie 239, 253
Topotek 1 Ges. v. Landschaftsarchitekten mbH 43
Torres Tur, Elías 41, 42, 107
Tschumi, Bernard 38, 100, 180
Tunnard, Christopher 35, 148
Turrell, James 37, 214, 216-17
Tusquets Blanca, Oscar 42, 80– 82, 117-118

Vacherot, Lawrence 38
Valadier, Giuseppe 62
Valentini, Nanni 191
Vanpoulle, Laurence 197
van Beek, Paul 11, 43, 158
Van den Abeele, Jean-François 210
van Gessel, Michael 115
van Groeningen, Isabelle 44
Van Mol, Thomas 43
van Valkenburgh, Michael 47
Vaux, Calvert 27
Veldhoen, Hans 33
Vendrell, Xavier 41
Véra, André and Paul 31
Verey, Rosemary 36
Vergilius 231
Vermander, Chris(tian) 43, 51

Vexlard, Gilles 38
Vieille, Jacques 197, 198
Viguier, Jean-Paul 178
Volk, Patricia 198
von Schoenaich, Brita 43
von Spreckelsen, Johann Otto 71

Walker, Mark Anthony 43, 44, 239
Walker, Peter 47
Walpole, Horace 148
Walser, Urs 43
Waterhouse, Peter 233
Watkinson, Simon 247
Weber, Toni 43, 141
Weber + Saurer 141
Weidinger, Jürgen 43, 165
WES and Partner 125, 128
West 8 43, 73, 130
West, Cleve 83
Wiedmer, Paul 22, 200, 202
Weisse, Rosemarie 43
Wilkie, Kim 44, 218, 219
Williams, Robert 204
Wilson, Ernest 34
Wines, James 37, 241
Wirtz, Jacques 42, 43, 64
Wiseman, Judy 131
Woodford, Johnny 83
Woodham, Stephen 170
Wordsworth, William 49
Wright, Frank Lloyd 29, 30, 39, 45, 103-104
Wyer, John 94

Zagari, Franco 41, 62
Zimmer, Gregor 249
Zoelly, Barbara 68, 84-85
Zoelly, Pierre 68-69, 84-85
Zorzi, Uta 88
Zumthor, Peter 40, 233
Zurbuchen-Henz, Maria and Bernard 248

Bibliography

ABEN, Rob and Saskia DE WIT (eds.), *The Enclosed Garden*, 010 Publishers, Rotterdam, 1999.
ABRIOUX, Yves, *Ian Hamilton Finlay. A Visual Primer*, The MIT Press, Cambridge, Mass., 1992.
ADAMS, William Howard, *Grounds for Change. Major Gardens of the Twentieth Century*, Little, Brown and Co, Boston, 1993.
ADAMS, William Howard, *Roberto Burle Marx. The Unnatural Art of the Garden*, The Museum of Modern Art, New York, 1991.
AGNELLI, Marcella, *Gardens of the Italian Villas*, Weidenfeld and Nicolson, London, 1987.
ALDINGTON, Peter, 'The Landscape Obligation', *Landscape Journal*, 204 (1996), no. 19.
AMBASZ, Emilio, *The Architecture of Luis Barragán*, The Museum of Modern Art, New York, 1976.
AMBASZ, Emilio, *Architettura Naturale*, Electa, Milan, 1993.
ANDERSSEN, Maria Teresa, 'Landscape Architecture in Portugal', *Landscape Design*, December-January 1989–1990.
ANDERSSON, Sven-Ingvar and Annemarie LUND, *Havekunst i Danmark*, Arkitektens Forlag/Danish Architectural Press, Copenhagen 1990.
ANDERSSON, Sven-Ingvar and Steen HØYER, *C.Th. Sørensen – en havekunstner*, Arkitektens Forlag/Danish Architectural Press, Copenhagen, 1994.
ANDREWS, Malcolm, *Landscape and Western Art*, Oxford University Press, 1999.
AULENTI, Gae, *Gae Aulenti*, Electa, Milan, 1979.
BANN, Stephen, 'Live Unknown. The Garden Art of Ian Hamilton Finlay', *Lotus International*, no. 88, 1996.
BANN, Stephen, 'The Landscape Approach of Bernard Lassus. Part II', *Journal of Garden History*, 15 (1995).
BANN, Stephen, 'A Luton Arcadia. Ian Hamilton Finlay's Contribution to the English Neo-Classical Tradition', *Journal of Garden History*, 13 (1993).
BARDO, Pietro M., *The Tropical Gardens of Roberto Burle Marx*, Reinhold, New York, 1964.
BEARDSLEY, John, *Earthworks and Beyond. Contemporary Art in the Landscape*, Spacemaker Press, Washington, D.C., 1984.
BEARDSLEY, John, *Art and Landscape in Charleston and the Low Countries*, Spacemaker Press, Washington, D.C., 1998.
BELLCHAMBERS, Peter, 'French Lessons', *Landscape Design*, November 1994.
BERQUE, Augustin, 'Beyond the Modern Landscape', *AA Files*, no. 25, 1993.
BOWMAN, Rob (ed.), *Enclosed & Enchanted*, exh. cat., Oxford, Museum of Modern Art, 2000.
BOURNE, Ingrid, 'Landscape Architects in France', *Landscape Design*, December-January 1989–1990.
BRADLEY HOLE, Christopher, *The Minimalist Garden*, Mitchell Beazley, London, 1999.
BROOKES, John, *John Brookes' Natural Landscapes*, DK Publishing, New York, 1998.
BROOKES, John, *A Place in the Country*, Thames and Hudson, London, 1984.
BUCHER, Annemarie, (ed.), *Vom Landschaftsgarten zur Gartenlandschaft*, Hochschulverlag, Zurich, 1990.
CANTOR, Steven L., *Contemporary Trends in Landscape Architecture*, Van Nostrand Reinhold, New York, 1997.
CARL MILLES, exh. cat., Singapore, Singapore Art Museum, 1996.
CHARMANT, Anne de, 'Art and the Garden. Travels of the Contemporary Mind.' *Art and Design Magazine*, 1997.
CHATTO, Beth, *Beth Chatto's Gravel Garden. Drought-Resistant Planting through the Year*, Frances Lincoln, London, 2000.
CHURCH, Thomas, *Gardens Are for People*, Reinhold, New York, 1955.
CLARK, Kenneth, *Landscape into Art*, J. Murray, London, 1976.
COEN, Lorette (ed.), *Une envie de ville heureuse*, Ecole Nationale Supérieure du Paysage de Versailles, 1998.
COOPER, Guy and Gordon TAYLOR, *Paradise Transformed. The Private Garden for the Twenty-First Century*, Monacelli Press, New York, 1996.
COOPER, Guy and Gordon TAYLOR, *Gardens for the Future*, Conran Octopus, London, 2000.
COOPER, Paul, *The New Tech Garden*, Mitchell Beazley, London, 2001.
COURT, Sally, *The Modern Garden Makers*, Ward Lock, London, 1999.
Cox, Madison, *Private Gardens of Paris*, Weidenfeld and Nicolson, London, 1989.
CRIBIER, Pascal, 'Bleu de bleu', *Pages Paysages*, no. 3, 1990–1991.
CROWE, Sylvia, *Garden Design* (in cooperation with Thomas Gibson), Packard, Chichester, 1981.
CROWE, Sylvia, *The Landscape of Power*, Architectural Press, London, 1958.
CZERNIAK, Julia, 'Challenging the Pictorial. Recent Landscape Practice', *Assemblage*, no. 34, December 1997.
DARLEY, Gillian, 'Rethinking the Garden', *The Architects' Journal*, 206, 13 November 1997.
DAVEY, Peter, 'The Rebirth of the Garden', *The Architecture Review*, 186 (1989), no. 111.
DESCOMBES, Georges, *Il Territorio Transitivo*, Gangemi, Rome, 1988.
DICKY, Page, *Breaking Ground. Portraits of Ten Garden Designers*, Artisan, New York, 1997.
ECKBO, Garrett, *Landscape for Living*, Architectural Record, New York, 1950.
ELIOVSON, Sima, *The Gardens of Roberto Burle Marx* (with a preface by Roberto Burle Marx), Thames and Hudson, London, 1991.
ESTERAS MARTÍN, Emilio, *Parque Juan Carlos I*, Fundación Caja de Madrid, 1994.
FAIRBROTHER, Nan, *New Lives, New Landscapes*, The Architectural Press, London, 1970.
FIELDHOUSE, Ken and Shelia HARVEY, *Landscape Design. An International Survey*, Lawrence King, London, 1992.
FINCH, Paul, 'Combining Artifice and Nature in the Dordogne', *The Architects' Journal*, 202 (1995).
FISH, Margery, *We Made a Garden*, Faber, London, 1983.
FOSTER, Hal (ed.), *The Anti-Aesthetic. Essays on Postmodern Culture*, Bay Press, Washington, 1983.
FRAMPTON, Kenneth (ed.), *Technology, Place and Architecture. The Jerusalem Seminar in Architecture*, Rizzoli, New York, 1998.
FRAMPTON, Kenneth (ed.), 'In Search of the Modern Landscape', *Arquitectura*, 72 (July-August 1990).
FRANCES, Mark and Randolph T. HESTER (eds.), *The Meaning of Gardens*, The MIT Press, Cambridge, Mass., 1996.
GARNIER, Juliette, 'Jardins éphémères et expérience à suivre', *Le Moniteur de l'Architecture*, no. 73, 1996.
GARNIER, Juliette, 'Autour d'une bastide', *Le Moniteur de l'Architecture*, no. 68, 1996.
GARRAUD, Collette, *L'idée de nature dans l'art contemporain*, Flammarion, Paris, 1994.
GEUZE, Adriaan, *Adriaan Geuze/West 8. Landscape Architects*, Rotterdam, 1995.
GOLDSWORTHY, Andy, *Wood* (with an introduction by Terry Friedman), Viking, London, 1996.
GOLDSWORTHY, Andy, *Hand to Earth. Andy Goldsworthy Sculpture 1976–1990*, W.S. Maney & Son Ltd (in collaboration with The Henry Moore Centre for the Study of Sculpture), Leeds, 1991.
GRAAF, Jan de, 'The Gardens of West 8' in: *Die neuen Gärten – New Gardens*, Edition Topos 11, Munich, 1995.
GRAYSON TRUELOVE, James (ed.), *The New American Garden*, Spacemaker Press, Washington, D.C., 1998.
GRESWELL, Lucinda, 'A Muffled Modernism', *Landscape Design*, no. 193, 1990.
HARVEY, Shelia (ed.), *Reflections on Landscape. The Lives and Work of Six British Landscape Architects*, Gower Technical, Aldershot, 1987.
HAUXNER, Malene, *Fantasiens Have. Det moderne gennembrud i havekunsten og sporene i byens landskab*, Arkitektens Forlag/Danish Architectural Press, Copenhagen, 1993.
HEERY, Pat, 'French Blooming of Poetical Correctness', *The Architects' Journal*, 204 (1996), no. 10.
HOLDEN, Robert, 'Green Prosperity for Paris', *Landscape Design*, December 1992.
HOLDEN, Robert, 'Making Parks for the Future', *The Architects' Journal*, 204 (1996), no. 19.
HOTTENTRAGER, Grit, 'New Flowers. New Gardens', *Journal of Garden History*, 12 (1992), no. 3
HUGHES, Robert, *The Shock of the New*, Alfred A. Knopf, New York, 1991 (revised edition).
HUNT, John Dixon, *Greater Perfection. A Theory of Gardens*, University of Pennsylvania Press, Philadelphia, 2000.
HUNT, John Dixon, 'Bernard Lassus in Eden', *Eden*, no. 3, 1993.
HUNT, John Dixon and Joachim WOLSCHKE-BULMAHN (eds.), *The Vernacular Garden*, Dumbarton Oaks Research Library and Collection, Washington, D.C., 1993.
IMBERT, Dorothée, *The Modernist Garden in France*, Yale University Press, New Haven, 1993.
IMBERT, Dorothée, 'French Visions of the Modern Garden', *Gartenkunst*, 7 (1995), no. 2.
JACQUES, Michel (ed.), *Yves Brunier. Landscape Architect-Paysagiste*, Birkhäuser Publishers, Basel, 1996.
JAKOB, Michael, 'Experiencing Landscape as Art' in: *Kunst und Landschaft – Art and Landscape*, Edition Topos 14, Munich, 1996.
JAKOBSEN, Preben, 'Garden Pleasure Principles', *Landscape Design*, no. 220, 1993.
JARMAN, Derek, *Derek Jarman's Garden* (with photos by Howard Sooley), Thames and Hudson, London, 1995.
JELLICOE, Geoffrey, *The Guelph Lectures on Landscape Design*, University of Guelph, 1983.
JELLICOE, Geoffrey and Sudan JELLICOE, *Modern Private Gardens*, Abelard-Schuman, London, 1968.
JELLICOE, Geoffrey and Susan JELLICOE, *The Landscape of Man*, Thames and Hudson, London, 1975.
JENCKS, Charles, *The Architecture of the Jumping Universe*, Academy Editions, London, 1995.
JOHNSON, Jory, *Modern Landscape Architecture. Redefining the Garden*, Abbeville Press, New York, 1991.
JONES, Louisa, *Gardens in Provence*, Flammarion, Paris, 1992.
KASSLER, Elizabeth B., *Modern Gardens and the Landscape*, The Museum of Modern Art, New York, 1964.
KIENAST, Dieter, *In Praise of Sensuousness*, exh. cat., Swiss Federal Institute of Technology (ETH), Zurich, 1999–2000.
KIENAST, Dieter, 'The Garden as a Spiritual Landscape' in: *Die neuen Gärten – New Gardens*, Edition Topos 11, Munich, 1995.
KIENAST, Dieter, *Kienast. Gardens*, Birkhäuser Publishers, Basel, 1997.
KIENAST, Dieter and Christian VOGT, *Open Spaces*, Birkhäuser Publishers, Basel, 2000.
KINGSBURY, Noël and Piet OUDOLF, *Designing with Plants*, Conran Octopus, London, 1999.
KRAUSS, Rosalind, *The Originality of the Avant-Garde and Other Modernist Myths*, The MIT Press, Cambridge, Mass., 1986.
KROGG, Steven R., 'Art and the Landscape. A Symposium', *Landscape Journal*, 12 (1993), no. 1.
KROGG, Steven R., 'Roberto Burle Marx. The Unnatural Art of the Garden', *Landscape Journal*, 11 (1992), no. 1.
KROGG, Steven R., 'The Language of Modern', *Landscape Architecture*, 75 (1985), no. 2.
LANCASTER, Michael, *The New European Landscape*, Butterworth Architecture, Oxford and Boston, 1994.
LANCASTER, Michael, 'Seeing Colour', *Architectural Design*, 66 (1996), no. 3-4.
LANCASTER, Michael, 'Painting, Colour and the Landscape', *Landscape Design*, no. 168, 1987.
Landschaftsarchitekten – Landscape architecture in Germany, H.M. Nelte, Wiesbaden, 1997.
LANZARDO, Dario; Nuvolari, Francesco; Nuvolari, Mimma and Gianluca Trivero, *Giardini Segreti*, Giorgio Mondadori, Milan, 1995.
LAPENA, José and Elias TORRES, 'Juegos de artificio', *Arquitectura Viva*, March-April 1996.
LASSUS, Bernard, *The Landscape Approach*, University of Pennsylvania Press, Philadelphia, 1999.
LE CORBUSIER, *Towards a New Architecture*, Payson and Clarke, New York, 1927.
LENNOX-BOYD, Arabella, *Private Gardens of London*, Rizzoli, New York, 1990.
LEVISEUR, Elsa, 'Landart', *The Architecture Review*, 198 (1991), no. 1130.
LEVY, Leah, *Kathryn Gustafson. Sculpting the Land*, Spacemaker Press, Washington, D.C., 1998.
LOOTSMA, Bart, 'Adriaan Geuze and West 8', *Architecture d'Aujourd'hui*, no. 306, 1996.
LORIERS, Marie-Christian, 'Modernité, l'histoire et la géographie. Entretien avec Alexandre Chemetoff', *Techniques et Architecture*, August-September 1992.
LUND, Annemarie, *A Guide to Danish Landscape Architecture 1000–1996* (translated by Martha Gaber Abrahamsen), Arkitektens Forlag/Danish Architectural Press, Copenhagen, 1997.
LUND, Annemarie, 'Apt Danske', *The Architecture Review*, 1889 (1991), no. 1130.
LYALL, Sutherland, *Designing the New Landscape*, Thames and Hudson, London, 1991.
MATTEINI, Milena, *Pietro Porcinai. Architetto del Giardino e del Paesaggio*, Electa, Italy, 1991.
McKEAN, John and Simonetta DAFFARRA, 'The Other Garden City. Scarpa's Brion Tomb', *The Architect's Journal*, 202 (1995), no. 18.
MEYER, Elizabeth K., *Martha Schwartz. Transfiguration of the Commonplace*, Spacemaker Press, Washington, D.C., 1997.
MILES, Henry, 'Swedish Beauty', *The Architecture Review*, 198 (1991), no. 1130.
MIRALLES, Enric, *Some Ways of Remembering the Projects, 1986–1996*, Korean Architects, Seoul, 1996.
MOORHEAD, Steven (ed.), *Landscape Architecture*, Rockport, Maine, 1997.
NASH, David, *Form into Time*, Academy Editions, London, 1996.
NECKAR, Lance M., 'Strident Modernism/Ambivalent Reconsideration. Tunnard's Gardens in the Modern Landscape', *Journal of Garden History*, 10 (1990), no. 4.
NOGUCHI, Isamu, *A Sculptor's World*, Harper and Row, New York, 1968.
NONAS, Richard, 'City, Nature, Landscape and Art' in: *Kunst und Landschaft – Art and Landscape*, Edition Topos 14, Munich, 1996.
PEREIRE, Anita, *Gardens for the Twenty-First Century*, Aurum Press, London, 1999.
PETRANZAN, Margherita, *Gae Aulenti*, Rizzoli, New York, 1997.
PIERRAT, Jean-Philippe, 'Paysagistes. La nouvelle génération', *Le Moniteur de l'Architecture*, no. 1, May1989.
PIEAT, Jean-Paul, *Les jardins du futur. Conservatoire international des parcs et jardins et du paysage*, Chaumont-sur-Loire, 2000.

Plumptre, George, *Great Gardens, Great Designers*, Wardlock, London, 1994.
Plumptre, George, *The Garden Makers. The Great Tradition of Garden Design from 1600 to the Present Day*, Pavilion, London, 1993.
Pousse, Jean-Francois, 'Landscape Architecture Gets a Breath of Fresh Air' in: *Bäume – Trees*, Edition Topos 16, Munich, 1996.
Pousse, Jean-Francois, 'Le paysage sans cesse. Entretien avec Jacques Simon', *Techniques et Architecture*, no. 403, August-September 1992.
Richardson, Tim (ed.) *Martha Schwartz. The Complete Landscape Designs*, Thames and Hudson. London, 2004.
Schaal, Hans Dieter, *New Landscape Architecture*, Ernst & Sohn, Berlin, 1994.
Schäfer, Robert, 'Landscape Creation Today', *Space Design*, no. 6, Juni 1998.
Schröder, Thies, *Changes in Scenery. Contemporary Landscape Architecture in Europe*, Birkhäuser Publishers, 2001.
Sejournet, Jean de, *Jardins en Belgique*, Duculot, Brussels, 1989.
Sestoft, Jorgen, 'Om Modernistet og Modernisme', *Landskap*, 74 (1993), no. 3.
Sheard, Peter, 'Critical Landscape in the Ruhr's Renewal', *Landscape Architects' Journal*, 206 (1997), no. 1.
Shepheard, Peter, *Modern Gardens*, Architecture Press, London, 1953.
Siza, Alvaro, *Luis Barragán*, Reverte Ediciones, Mexico, 1996.
Steele, Fletcher, 'New Styles in Gardening', *House Beautiful*, 65 (1929), no. 3.
Steenbergen, Clemens and Wouters Reh, *Architecture and Landscape. The Design Experiment of the Great European Gardens and Landscapes*, Birkhäuser Publishers, Basel, 2003.
Steiner, Frederick, 'Dutch Master', *Landscape Architecture*, 79 (1998), no. 6.
Sudjic, David, 'It's not that I've got anything about plants', *Blueprint*, December 1995.
Thacker, Christopher, *The History of Gardens*, University of California Press, Berkeley and Los Angeles, 1979.
The landscape transformed, Academy Editions, London, 1996 (Report of a symposium on the restoration of landscape, held at the Architectural Association, Royal Academy of Arts, 17-18 March 1995).
Thompson, Marian, 'Sunset for Sutton Place', *Landscape Design*, no. 164, December 1986.
Tiberghein, Gilles A., *Land Art*, Art Data, London, 1995.
Tischer, Stefan, 'Virtual Garden Art in Video Clips' in: *Die neuen Gärten – New Gardens*, Edition Topos 11, Munich, 1995.
Trachtenberg, Marvin and Isabelle Hyman, *Architecture from Prehistory to Post-Modernism*, Prentice Hall, Englewood Cliff, NJ, 1986.
Treib, Marc (ed.), *Modern Landscape Architecture. A Critical Review*, The MIT Press, Cambridge, Mass., 1993.
Treib, Marc (ed.), 'Landscape on the Edge', *Landskap*, 71 (1990), no. 3-4.
Treib, Marc (ed.), 'Must Landscape Mean? Approaches to Significance in Recent Landscape Architecture', *Landscape Journal* 14 (1995), no. 1.
Truscott, James, *Private Gardens of Scotland*, Weidenfeld and Nicolson, London, 1988.
Tunnard, Christopher, *Gardens in the Modern Landscape*, Architectural Press, London, 1938.
Ullmann, Gerhard, 'Art in a Synthetic Park', *Garten+Landschaft*, 95 (1985), no. 8.
von Schoenaich, Brita, 'The Natural Garden in Germany', *Landscape Australia*, 18 (1996), no. 2.
Vroom, Meto J. (ed.), *Outdoor Space. Environments Designed by Dutch Landscape Architects since 1945*, Thoth, Bussum, 1995.
Walker, Peter and Melanie Simo, *Invisible Gardens. The Search for Modernism in the American Landscape*, The MIT Press, Cambridge, Mass., 1994.
Weilacher, Udo, *Between Landscape Architecture and Land Art*, Birkhäuser Publishers, Basel, 1996.
Weilacher, Udo, *Visionary Gardens. Modern Landscapes by Ernst Cramer*, Birkhäuser Publishers, Basel, 2001.
Weiss, Allen S., *Unnatural Horizons. Paradox and Contradiction in Landscape Architecture*, Princeton Architectural Press, New York, 1998.
Williams, Ron, 'Post-Modernism, A New Challenge', *Landscape Architectural Review*, March 1987.
Wilson, Andrew, 'The Way Ahead', *Landscape Design*, June 1996.
Wines, James, *Green Architecture*, Taschen, Cologne, 2000.
Wirtz, Peter, 'Directing the Walker's View' in: *Neue europäische Projekte – New European Projects*, Edition Topos 12, Munich, 1995.
Wolschke-Bulmahn, Joachim, 'The Ideology of the Nature Garden', *Journal of Garden History*, 12 (1992), no. 1.
Wolschke-Bulmahn, Joachim, 'The Wild Garden and the Nature Garden. Aspects of the Garden Ideology of William Robinson and Willy Lange', *Journal of Garden History*, 12 (1992), no. 3.
Wolschke-Bulmahn, Joachim and Gert Groening, 'Changes in the Philosophy of Garden Architecture in the Twentieth Century and Their Impact upon the Social and Spatial Environment', *Journal of Garden History*, 9 (1989), no. 2.
Wrede, Stuart en William Howard Adams (ed.), *Denatured Visions. Landscape and Culture in the Twentieth Century*, The Museum of Modern Art, New York, 1994.
Zagari, Franco, *L'Architettura del Giardino Contemporaneo*, A. Mondadori/De Luca, Milan/Rome, 1988.
Zoelly, Pierre, *Pictures of Paradise*, Birkhäuser Publishers, Basel, 1994.
Zoelly, Pierre, *'Anybody home?' Architectural Notes*, Birkhäuser Publishers, Basel, 1995.

Illustration and Photo Credits

The following list gives data relevant to the origin of illustrations and to photographic copyright only. Photographs are to be credited to the owners of the works of art cited in the captions, except as indicated below. Every effort has been made to contact copyright-holders of illustrations. Any copyright-holder whom we have been unable to reach or to whom inaccurate acknowledgement has been made is invited to contact the publisher. The numbers below refer to the pages, and the letters to the position of the illustration on the relevant page.

A&G Fotografia, Imola, photo Gabriele Angelini: 88; Alvar Aalto Säätiö Stiftelsen Foundation, Helsinki, photo Heikki Havas: 29c, 29e; Heather Ackroyd and Dan Harvey, represented by Nicky Childs at Artsadmin: cover illustration, 48, 49, 125; Patrick Altermatt: 189; Emilio Ambasz: 105; Sven-Ingvar Andersson, Copenhagen: 60–61; Stig L. Andersson, Copenhagen: 150, 151; Thorbjörn Andersson, Stockholm: 30, 31b, 32, 36, 40a, 98, 99; Archiv für Schweizer Landschaftsarchitektur, Rapperswil: 34a (in: 'Schweizer Garten,' 1933, no. 7, p. 198), 37; Arriol & Fiol Arquitectos: 113a; Artranspennine 98, The Storey Gallery, Lancaster, photo Emily Barney: 204; Thea Baert: 114, 115; The Barragán Foundation, Switzerland, photo Armando Salas, Portugal: 138–139; Marco Bay, Milan: 162–163, 164; Sara Black: 233ab; Nicola Browne, London: 5, 10–11, 13b, 14–15, 21, 22a, 40b, 41, 50a, 52, 53, 54, 55, 62, 70, 71, 72, 80–81, 88–89, 99, 108, 109, 110, 111, 116, 117, 118, 119, 126, 127a, 133, 136, 158b, 172–173, 174, 175, 180, 181, 182, 192, 194, 195, 196, 197b, 198, 200, 201, 202, 205, 206, 207, 216, 217, 239b, 240a, 242–243; Brioschi Bellinzona: 132; Karl-Dietrich Bühler, Genova: 87; Fernando Caruncho, Madrid: 148, 149bc; Ermano Casasco: 25, 142, 143, 191; Festival International des Jardins de Chaumont-sur-Loire, via Papyrus Media, Paris: 241 (photo JP Pigeat), 242; Copyright Christo 1976, photo: Jeanne-Claude: 224; Gilles Clément, Paris: 178, 179; Daniela Colafranceschi: 246; Nick Cunard, London: 94; Paul Deroose, Jabbeke: 222; Eli Devriendt, Ostende: 56–57, 58; Daniël Ost, Saint-Nicolas: 6–7, 171; Bart Dewaele: 236; Dia Center for the Arts, New York, collection Dia Art Foundation (Rozel Point, Box Elder County, Utah), photo Gianfranco Gorgoni: 223a; Elle Decoration, London, photo Richard Powers: 74a; English Heritage: 44b, 247 (photo Keith Paisley): 247; Farjadi Farjadi Architects, London: 106; Derek Fell Photography: 186, 187; Fondation Cartier pour l'art contemporain, Paris: 56a (photo Patrick Gries), 56b (photo Daniel Abadie), 127a (photo Ph. Chancel); Fondation Le Corbusier, Paris: 26–27, 29b; Edouard François: 131c; Jens Frederiksen: 47–48; Terence du Fresne: 59a; Jean-Pierre Gabriel, Bruxelles: 63, 65, 66, 67; Christine Gertsch, Hermance: 19, 90, 91; Thomas Gray: 215; Katrin Hagen, Vienna: 92, 93; Werner Hannappel, Essen: 223c; Heinrich Helfenstein, Zurich: 45b; Penelope Hill: 8–9, 18, 49b, 68, 69, 84, 85, 86, 95, 96–97, 120a, 121, 141b, 167, 176, 203, 208, 209, 229, 166, 218, 219, 230–231, 232a; Janet Hodgson: 233a; Bastiaan IngenHousz: 79; Inside Outside, Frans Parthesius: 73; Gabriele Jardini, Varese: 212–213, 224b, 225; Charles Jencks: 220, 221; Aloys Kiefer, Hamburg: 124, 129; Dieter Kienast: 232b; Copyright Jeff Koons, FMGB Guggenheim Bilbao, photo Erika Barahona Ede: 168–169; Tania Kovatz: 228; Jean-Michel Landecy: 134, 135; Luca Lauretti & Claudio Gaiaschi, Milan: 144, 145; Andrew Lawson Photography: 28, 35, 103, 137, 154, 155, 156, 157, 170a, 239a; Clare Littlewood: 160, 161; Richard Long: 223b; Kamel Louafi, Berlin: 244–245; Courtesy of the artist, Wolfgang Laib, and the Sperone Westwater, New York: 227; Bernard Lassus: 197a, 262; Lausanne Jardins 2000, photo Luc Chessex: 248; Lunica, Milan, photo Manuela Cerri: 24, 112, 113bc; Marianne Majerus, London: 11, 13a, 20, 74b, 75, 76, 131b; Duccio Malagamba, Barcelona: 101; Yann Monel: 17, 127b, 243, 249a, 250; Luc Monsigny, Berlin: 235; Courtesy The Museum of Contemporary Art, Los Angeles, Gift of Virginia Dwan, 1969–1970, photo William Nettles: 214; 2002 The Museum of Modern Art, New York, given anonymously: 29a; Clive Nichols Garden Photography: 17, 22–23, 170b, 191, 236b, 237, 240b, 253; Courtesy The Isamu Noguchi Foundation, Inc., Long Island: 39, 40; OMA (Office for Metropolitan Architecture), Rotterdam: 14; Christa Panick, Vellmar: rabat de la couverture toilée; Michael Paul, London: 183, 184, 185, 199; Alex Petzold, Bagnolet: 146, 152, 153; Marc Pouzol, Berlin: 249b; Courtesy Fondazione Prada, Milan, photo Attilio Maranzano: 226; Raderschall Landschaftsarchitekten, Zurich: 77, 78, 120, 166; Paul Raftery, Paris: 131a; The Rothschild Collection, Waddesdon Manor (The National Trust), photo Hugh Palmer: 188; Rotzler Krebs Partner, Winterthur: 252; Peter Slaets: 210–211; Niki de Saint Phalle, Sabam Belgium 2002: 205, 206, 207; Derek St Romaine Photography: 83; Anet Scholma: 34b; Martha Schwartz, Inc.: 43; Hisao Suzuki, Barcelona: 107; Scala, Florence: 103; Stefan Tischer, Berlin: 251; Julie Toll: 238; Laurence Toussaint: 149a; Paul Van Beek, Amsterdam, photo Bert Nienhuis: 158a, photo Pandion: 159; Jean-François Van den Abeele (Fris in het Landschap), Ghent: 210, 211; Bart Van Leuven, Ghent: 42, 64, 140–141; Christan Vermander-Thomas Van Mol & partners (Buro voor Vrije Ruimte), Ghent: 50–51; Vimagen fotógrafos: 31a; Claire de Virieu, Paris: 51b, 122, 123; Alan Ward, Newton, Massachusetts: 45a; Weber + Saurer, Solothurn, photo Pascal Hegner: 141a; Jürgen Weidinger, Berlin: 165; Hans Werlemann: 244; West8, Rotterdam, photo Jeroen Musch: 130; Courtesy of Western Pennsylvania Conservancy: 29d, 104; David Whyte: 25; Steven Wooster, London: 44a, 172ab

The Dutch pavilion at the EXPO 2000 in Hanover was designed by the office MVRDV, consisting of Winy Maas, Jacob van Rijs and Nathalie de Vries in cooperation with Stefan Witteman, Jaap van Dijk, Christoph Schindler, Kristina Adsersen and Rüdiger Kreiselmayer.

The following individuals have collaborated on the park of the EXPO 2000 in Hanover, conceived by Kamel Louafi: Dörte Eggert, Günter Maser, Patrick Bairstow, Theresa Gnoyke, Sabrina Schröder, Frank Scharping, Michael Klittich, Maren Brakebusch, Frank Gödeke, Martin Duthweiler, Klaus Overmeyer, Martin Winberger, Sabine Boomers and Bettina Schwarz.

The miniature railway park at the Lausanne Festival is a project by artists Jean Scheurer and Georges Abou-Jaoudé, landscape architect Joris de Castro, architect Ulrich Doepper, by Gérald Gilléron, coordinator of the Swiss Federal Railways (SBB/CFF/FFS), and by Pierre Philippe, consultant at the Swiss Federal Railways at Lausanne and Berne.

'L M'Aime' by Maria et Bernard Zurbuchen-Henz, œuvre of the Lausanne Festival, was conceived in cooperation with architect Philippe Gueissaz, student Séverine Gueissaz, garden architect Fabrice Schneider and civil engineer Etienne Lassere.

The archives and copyright of Luis Barragán are managed by The Barragán Foundation, Klünenfeldstrasse 20, CH–4127 Birsfelden, Suisse, e-mail: barragan.foundation@vitra.com